Graphic Arts & the South

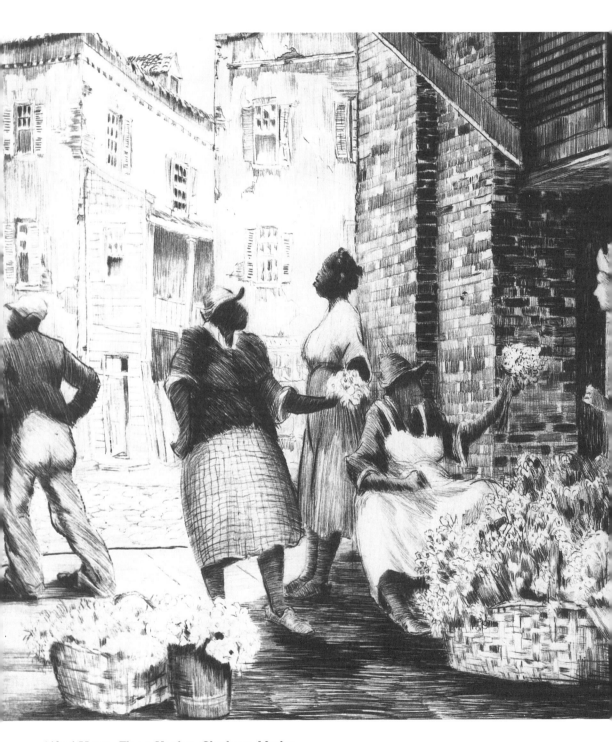

Alfred Hutty. *Flower Vendors, Charleston Market.*

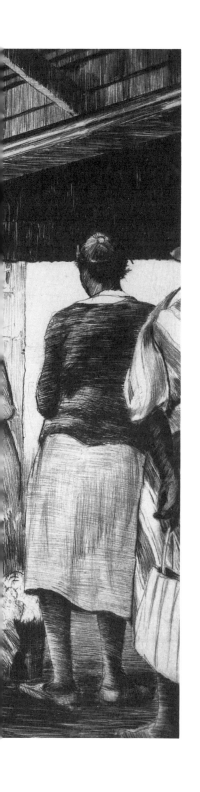

Graphic Arts & the South

PROCEEDINGS OF THE
1990 NORTH AMERICAN
PRINT CONFERENCE

Edited by Judy L. Larson

with the assistance of Cynthia Payne

THE UNIVERSITY OF ARKANSAS PRESS
FAYETTEVILLE 1993

97 96 95 94 93 5 4 3 2 1

This book was designed by Ellen Beeler using the typeface Plantin.

The paper used in this publication meets the minimum requirements of the American
National Standard for Permanence of Paper for Printed Library Materials Z39.48-1984. ⊚

Library of Congress Cataloging-in-Publication Data

North American Print Conference (1990: Atlanta, Ga.)
 Graphic arts & the South: proceedings of the 1990 North American Print
Conference / edited by Judy L. Larson with the assistance of Cynthia Payne.
 p. cm.
 Includes bibliographical references.
 ISBN 1-55728-266-8
 1. Graphic arts—United States—Themes, motives—Congresses. 2. Southern states in
art—Congresses. 3. Southern States—Popular culture—Congresses. 4. Politics in art—
Congresses. I. Larson, Judy L., 1952– . II. Payne, Cynthia, 1948– . III. Title. IV. Title:
Graphic arts and the South.
NC105.N67 1990
760'.0449975–dc20 92-25584
 CIP

CONTENTS

INTRODUCTION

The papers in this volume were presented in Atlanta, Georgia, at the symposium *Graphic Arts & the South,* one of a series of such symposia organized by the North American Print Conference. An informal group of curators, professors, and collectors, the North American Print Conference has convened each year since 1970 to present papers on the history of the graphic arts in North America.

The arts in America have given shape and definition to social attitudes, expressing and prioritizing a distinctly American point of view. The aim of the North American Print Conference is to use graphic arts as primary source material in the study of American cultural and political history. In 1990, the conference considered the contributions of the American South to the history of prints, photographs, illustrations, and drawings, interpreting these original materials in order to understand better the history and legacy of the region.

With the formation of the United States, the need arose for visual images that would embody the spirit of individuality and the distinctive features characterizing the American experiment in democracy. At the founding of the nation, the North and the South were already very different. The South's economy was agrarian, with its population living primarily in the small, insular communities which grew up around farms and plantations. In contrast, the industrialized North was organized on a network of large cities, and its population was mainly urban. Slavery, at issue from the very founding of the nation, formed the backbone of plantation life; yet the existence of the institution divided North and South. The South attracted poor European immigrants, who settled in the backwoods of North and South Carolina, Georgia, Alabama, Tennessee, and Mississippi, trying to eke out livings as small farmers, hunters, trappers, or riverboatmen. These "piney woods tackers"—an

unpretentious folk, survivors in a primitive, undeveloped country—represented the free spirit of the South. They were part of a romantic, enigmatic patchwork of simple country folk, rough-and-ready backwoodsmen and riverboatmen, aristocratic landowners, and Africans in bondage, among white-washed Greek Revival mansions in seas of cotton and tobacco, steamboats and barges, decaying cabins, and Civil War cemeteries. The mix provided colorful and varied archetypes for the creation of Southern characters.

David Tatham's essay, "The Half Horse–Half Alligator and Other Southern Members of the Jacksonian Bestiary," explores the distinctive geography and idiosyncratic character of the South by introducing the reader to a collection of mythic and hybrid animals that came to represent the Old South. European iconography proved inadequate for describing the democratic experience, so Americans in the Federal Republic created a national iconography that expressed the new nation's ideals. One Southern image, the "half-horse–half-alligator" that represented folk from the untamed backwoods—the free-spirited, "dirt-eating, ne'er do wells," first appeared in political cartoons. As Tatham observes, this and other hybrids mirrored the American population, peoples of mixed origins, half this and half that, who commingled to form a stronger, more spirited whole.

The commitment to democracy, the notion of a self-governing people, produced uncertainty in the young nation. Well-to-do and middle-class republicans feared the lower classes would seize power through majority vote, and, giving expression to the fear, the picaresque novel emerged in the South. Highly educated men, writing in the tradition of Southern story-telling, had their heroes speak in Southern dialect. Their characters were "tomato-nose men" with "pumpkin skin, tough and wrinkled," beards full of dirt, and feet as "tough as grissle." From the 1830s to the 1860s, the popularity of these humorous yarns in both the North and South led to the printing of multiple editions of favorites like Thomas B. Thorpe's *The Big Bear of Arkansas,* J. J. Hooper's *Some Adventures of Captain Simon Suggs,* and William T. Thompson's *Major Jones's Courtship.* Georgia Barnhill's essay focuses on the principal illustrator of these books of Southwestern humor, F. O. C. Darley. In 1844, Darley began illustrating the humorous works that became the foundation of Edward L. Carey and Abraham Hart's *Library of Humorous American Works.* Darley's pictorial interpretation of these witty novels greatly enhanced the written word.

Travel literature was also popular in America in the mid-nineteenth century. In the years immediately preceding the Civil War, two author-illustrators traveled in the South, often visiting the same sites, and recorded their impressions of the region. Frederick Law Olmsted, who adopted the pen name "Yeoman," and David Hunter Strother, as "Porte Crayon," became two of the most widely read and influential critics of the antebellum South. Olmsted, a Connecticut Yankee, and Strother, a Virginian, invite comparison. In her essay "David Hunter Strother: Mountain People, Mountain

Images," Jessie Poesch examines Strother, whose articles included descriptions of the land, character sketches, anecdotes about the people, and wood-engraved illustrations based on his drawings. Dana White discusses the multifaceted Frederick Law Olmsted. Olmsted's writings from his Southern trips, which included "Yeoman's" engaging observations on scenery, the discomforts of travel, language, and characters, were compiled as *The Cotton Kingdom* (1861). Like Strother's articles, Olmsted's book is illustrated with wood engravings based on his original drawings.

Though Strother and Olmsted offered what they perceived as objective descriptions of the antebellum South, the region retained an aura of mystery, and in readers' minds remained shrouded in myth. Gregg Kimball addresses one such myth that sought to promote the notion of a "natural social order" and represented slaves as living and laboring contentedly under the watchful, caring protection of kind masters. Even after the Civil War, the supposition of white supremacy continued to justify segregation in the South. Kimball examines disturbing images from American and European books, periodicals, political broadsides, journals, and ephemera which portray all blacks as happy and all planters as aristocrats. The images depict a South that never existed, yet they dominated the media and took on the semblance of reality as white Southerners assimilated the myth.

The Civil War's aftermath devastated the entire nation, but especially the South, which bore the physical scars of war, as well as the emotional scars of a lost cause. The grieving white Southern population faced radical social change. Prints and illustrations that circulated in the South at this time sought to ameliorate the hurt and reestablish Southerners' dignity. According to Mark Neely and Harold Holzer, many series of "lost-cause" prints circulated, but very few of the images focused on women. At first this seems a surprising omission, since so many Southern women, personally and professionally, supported the war effort. Neely and Holzer suggest that the reason for the omission may be Southerners' resistance to the feminization of their cause.

Sue Rainey also examines images of the South after the war. Northern publishers, she suggests, were eager to know more about the states south of the Mason-Dixon line, where few from their region, besides soldiers, had traveled. A positive, multifaceted portrait of the South's great cities, beautiful landscapes, and natural wonders emerged in two popular illustrated series: "Picturesque America" (1870–71), published in *Appleton's Journal,* and "The Great South" (1873–74), written by Edward King and published in *Scribner's Monthly.* Both series were later expanded and published as books. By concentrating on evidence of the South's revitalization, the publications helped advance an optimistic view of the future for North and South alike.

The South's recovery was a long, often painful process. Even into the twentieth century important cities like Charleston, South Carolina, continued to suffer economically. In Charleston's disrepair and decay, however,

many artists saw picturesque beauty. They captured its old lanes, Federal churches, and colonial mansions in paintings and prints. Alfred Hutty, a Yankee printmaker, stopped in Charleston in 1919 on his way to Florida and never left the city. He and other artists, playrights, and musicians spearheaded a cultural renaissance there. Boyd Saunders discusses the movement in his paper "Alfred Hutty and the Charleston Renaissance," introducing his readers not only to Hutty, but to John Bennett, DuBose Heyward, Elizabeth O'Neill Verner, and Alice Ravenel Huger Smith.

Finally, Caroline Mesrobian Hickman makes a careful study of two of southern Appalachia's graphic artists—printmaker Clare Leighton and photographer Bayard Wootten. In many ways the two women shared with Alfred Hutty the desire to document and preserve the South's unique beauty. While Hutty focused on the city, Leighton and Wootten promoted the dignity of the Appalachian people and the resplendence of their natural surroundings. Both women saw the area as a pristine Eden that would soon be ruined by industrialization. One using the tools of a wood engraver and the other a camera, they captured the land's unspoiled beauty and the simple, wholesome lives of the country folk.

The papers in this volume all deal with the lore of the South—its mystery, its secrets, its shame, and its continuing struggle to evolve. I would like to thank each of the authors for sharing insights into the graphic arts of the South, as well as the following individuals who contributed to the success of the conference and publication: John Ott (former director), Elaine Kirkland (former curator), and Ted Ryan (visual arts archivist), Atlanta History Center; Wilson Flemister (director, Special Collections) and Belinda Peters (professor), Clark Atlanta University; Linda Matthews (head, Special Collections) and Allen Tullos (professor, Institute of Liberal Arts), Emory University; and Margie McClellan and Cynthia Payne, curatorial assistants in American art, High Museum of Art. I would also like to extend special thanks to David Hesla, professor, Emory University, for his invaluable help with the editing of the papers and to David Sanders, associate director, the University of Arkansas Press, for his patience and guidance as the papers were transformed into a book.

Judy L. Larson
Curator of American Art
High Museum of Art

Graphic Arts & the South

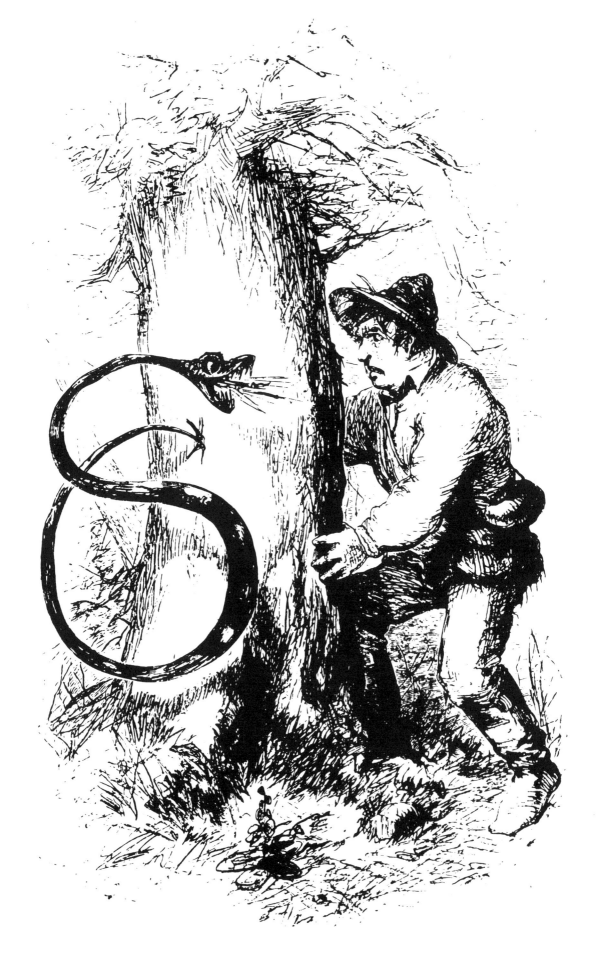

THE HALF HORSE–HALF ALLIGATOR AND OTHER SOUTHERN MEMBERS OF THE JACKSONIAN BESTIARY

A STUDY IN AMERICAN ICONOGRAPHY

David Tatham

In 1985 the American Antiquarian Society acquired a previously unrecorded, hand-colored, intaglio print titled *John Bull Making What He Calls a Demonstration on N. Orleans and a Kentucky Volunteer Meeting Him* (fig. 1). The print, which almost certainly dates from 1815, is unsigned. It may be the work of the Scottish-American graphic satirist, William Charles (1776–1820), who then resided in Philadelphia.[1] If, a century and a half later, the print had been known to Philip Hofer, the distinguished curator of graphic arts at Harvard University's Houghton Library, he would certainly and amiably have relegated it to his well-known category of "damned ugly prints."[2] Its importance rests, of course, not in the realm of refined expression in art but rather in the history of culture in Jacksonian America. It is a document that helps to explain how a people who, a generation earlier, had defined themselves as a nation now began to redefine themselves in distinctly regional terms.

The print is an allegorical political cartoon on the subject of the defeat of the British forces at the Battle of New Orleans in January 1815.[3] Americans under the command of Gen. Andrew Jackson won decisively in this final military engagement of the War of 1812. In the print, Britannia, her shield emblazoned with the crosses of Saints George and Andrew, sits enthroned on her island home, attended by a recumbent lion of state. This emblematic

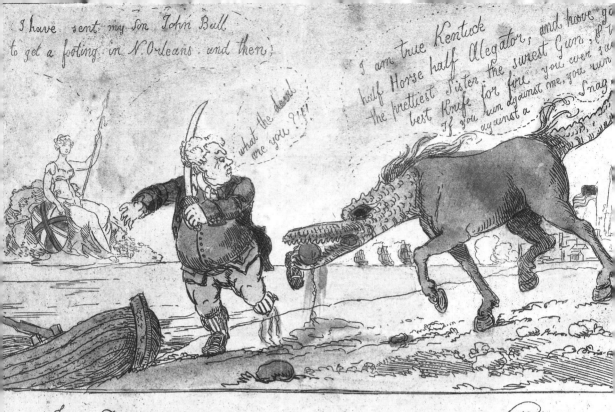

FIG. 1. William Charles (attributed), *John Bull Making What He Calls a Demonstration on N. Orleans and a Kentucky Volunteer Meeting Him*, 1815. Etching, 6" x 8", hand-colored. Courtesy of the American Antiquarian Society.

group had enjoyed widespread use as a symbol of British authority for fully a century.[4] Britannia says, "I have sent my son, John Bull, to get a footing in N. Orleans and then [. . .]." Americans conversant with the affairs of the day would have easily completed the thought—that *then* she would control the Mississippi River and the American West.

As a symbol, John Bull represented somewhat different things than did Britannia. He stood for England rather than the larger entity of Great Britain, and the world of the country squire and the coaching inn rather than that of Parliament and Windsor Castle. He was, in fact, less an allegorical figure than a character type, and this explains why Americans used him so much throughout the first quarter of the nineteenth century not only in the graphic arts but also on the stage and in literature of many kinds.[5]

This John Bull is in military guise. Uniformed, and with sword in hand, he turns in surprise and asks of a creature who has just bitten off part of one of his legs, "Who the Devil are you?" This is a good question, for while Britannia and John Bull were old troupers on the boards of allegory, the beast who here enters from the wings is an entirely new player. For this reason, he introduces himself:

> I am true Kentuck, half horse, half alegator [sic], and have the prettiest Sister, the surest Gun, and the best Knife for Fire you ever saw. If you run against me, you run against a Snag.

In 1815 this animal's colorful, braggartly comic way of speaking signified not only a Kentuckian but, more generally, rough-hewn backwoodsmen throughout the trans-Appalachian West and South.[6] As we will see, it would later be the way of speaking of Nimrod Wildfire, the hero of James Kirke Paulding's highly popular play of 1831, *The Lion of the West*.[7] It would then fill the pages of the various Davy Crockett almanacs in the 1830s and 1840s.[8] But the print precedes these uses. It includes one of the earliest published specimens of the vivid manner of speech that in 1815 was already the expected patter of the half horse–half alligator.

This mythical animal was among the first products of the impulse in Jacksonian America to create an indigenous regional iconography to augment, and perhaps even supplant, older symbols borrowed or adapted from European culture. An earlier, unsuccessful attempt on a national scale had been the effort to establish a peaceful native bird, the wild turkey, as a symbol of the United States. It seemed to its advocates to be better expressive of the new nation's democratic character than did the ill-tempered bald eagle, whose cousins had long served assorted tyrannies in Europe.[9] But by 1815, national symbols of any kind were proving inadequate to the task of distinguishing the new geographically and culturally diverse regions of a rapidly expanding country. The long-established ways of life and thought of Virginia had never been those of Massachusetts, but how different from both were the ways of the newly settled lands of the South and the West. No one would

confuse a native Alabamian with an Ohioan, and Kentuckians were something else again, at least as a popular stereotype of the time.

The precise origins of the concept of half horse–half alligator are uncertain, but it at first—around 1810—symbolized only the rough and tumble raftsmen of Kentucky who worked on the Mississippi and Ohio rivers, steering their flatboats downstream to New Orleans and alligator country and returning by steamboat.[10] Like their symbol, they were equally at home on land and water; they were hardy and agile, and when they fought among themselves, so the legends went, they were as strong as horses and bit like alligators. That observant visitor from England, Mrs. Frances Trollope, in her *Domestic Manners of the Americans* (1831), recalled seeing the type in the late 1820s on her steamboat passage up the rivers to Cincinnati. She wrote:

> The deck was occupied by the Kentucky flat-boat men, returning from New Orleans. . . . They are a most disorderly set of persons, constantly gambling and wagering, very seldom sober, and never suffering a night to pass without giving practical proof of the respect in which they hold the doctrines of equality, and community of property. . . . Their average height considerably exceeds that of Europeans, and their counternances, excepting when disfigured by red hair, which is not infrequent, [are] extremely handsome.[11]

The term soon generalized beyond raftsmen. When Mrs. Trollope journeyed to Baltimore from Cincinnati, and gained her first taste of East Coast culture, she breathed a sigh of relief and wrote that, "if we had not arrived in London or Paris, we had, at least, left far behind the 'half horse—half alligator' tribes of the West, as the Kentuckians call themselves."[12]

By the early 1830s, the fanciful concept of half horse–half alligator had been current in the United States for about twenty years. One of the earlier surviving allusions to it is in a lively letter written in January 1813 by J. K. Paulding, the *Knickerbocker* author, playwright, and close associate of James Madison. Writing to his friend, Congressman Morris Smith Miller of Utica, New York, Paulding referred to the reptilian part of this animal while supplying a liquorous substitute for the equine portion. More important, the letter documents how sharply Paulding perceived regional traits as early as 1813, especially those of the new South and West, and how he had already begun to incorporate into his writing the dialects, hyperbole, and regional imagery that eighteen years later would culminate in his play *The Lion of the West*. From his home in New York Paulding wrote,

> 'Fore Heaven Morris!—you have hit the nail on the head in your right description of the long limbed "Suthrons," who are a most potent set of roysterers, toss pots, and Barbecue villains, who will set you up all night carousing without minding it any more than nothing at all. . . . I would I were a longsided Virginian, a merry lander, or even a North Carolina Cracker, that I might drink without getting a headache the next day! Truly I say again Morris, these

Suthrons are a set of bitter lads. Yet I do like them . . . and they have not that mean hypocrisy, and narrow selfishness, which I beg to say is one of the precious "steady habits" of New England. In truth, my dear friend, the people of this country are deplorably ignorant of each other; and filled with sad prejudices. . . . A native of New England knows nothing of a native of the South, but what he learns from a travelling tinman, a captain of a skipper, or the misrepresentations of Dr. Morse [the geographer]. . . . You, my dear Morris, are now elevated to a position [the Congress] which will give you a thousand chances of associating with the distinguished men from the South, the North, the East, and the West . . . from the German of Pennsylvania who is more obstinate than an ass, to the nondescript Kentuckian who is "all alligator but his head, which is *aqua fortis,*" according to the assertion of a learned raftsman I once met.[13]

This was in 1813. In 1815, or soon after, the half horse–half alligator was pictorialized, perhaps for the first time, in the John Bull print. Then, in the 1820s and 1830s quite different images of the creature appeared on at least three broadsides. Each broadside printed the text of a song that celebrated the American victory at New Orleans. The author of the song's lyrics was Samuel Woodworth, the New York printer and literary jack-of-all trades.[14] One broadside (fig. 2) makes it clear, by reversing the parts of the John Bull

FIG. 2. *Half Horse–Half Alligator,* ca. 1824–32. Woodcut, ca. 2½" x 3¼", reproduced in Carl Sandburg, *The American Songbag* (New York, 1927). A variant of this image, engraved in wood, decorates the broadside "The Hunters of Kentucky," published in Boston ca. 1832 by L. Deming.

image, that while Kentuckians might claim to be half and half, there was no standard configuration of the halfs. A similar broadside woodcut, printed by L. Deming in Boston, is an adaptation of the first one, or perhaps its source, and has long served as a logo for a Massachusetts antiquarian book dealer.[15] The third broadside (fig. 3) includes an onlooker whose attitude of consternation is understandable, since the specimen of half horse–half alligator he observes appears to have had a mermaid in its lineage.

None of these broadsides included printed music, but Woodworth specified that his lyrics were to be sung to the traditional tune of "Miss Baily." His song enjoyed widespread popularity, becoming a staple of the American stage for at least a decade. It reinforced throughout the country the popular belief that Jackson was the hero of New Orleans, that Kentucky militiamen were the key to his success, and that these Kentuckians were, in their toughness and tenacity, like horses and alligators.

Woodworth cast his lyrics in the language of literary New York rather than in the robust new regional speech, but on stage his song gained a Western flavor in many performances by entertainers costumed as frontiersmen. Some evidence of what this costume may have been exists in the pictorial caption title of an edition of the song with music published in Philadelphia around 1824.[16] The engraved title vignettes, which may be the work of Thomas Birch, show the Kentuckian not as raftsman but as militiaman, in a fringed hunting shirt and shako, with knife, powder horn, and long rifle. Stage performers undoubtedly interpolated backwoods business into the piece, but the popularity of the song simply as a song was such that it soon entered folk tradition, where it survived vigorously into the early twentieth century.[17] Its long life helps to explain the continuing appearance of images of the half horse–half alligator in the graphic arts as late as the 1850s. Three of the song's eight stanzas are most relevant to our subject.

> We are a hardy, free-born race
> Each man to fear a stranger;
> Whate'er the game we join the chase,
> Despoiling time and danger,
> And if a daring foe annoys,
> Whate'er his strength and forces,
> We'll show him that Kentucky boys
> Are alligator horses.

> Now, Jackson he was wide awake,
> And was not scared at trifles,
> For well he knew what aim we take
> With our Kentucky rifles.
> He led us down to Cypress swamp,
> The ground was low and mucky,
> There stood John Bull in martial pomp
> And here was old Kentucky.

Half Harse, and Half Allegator.

Hunters of Kentucky.

Ye gentlemen and ladies fair
　Who grace this famous city
Just listen if ye've time to spare,
　While I rehearse a ditty ;
And for the ouportunity,
　Conceive yourselves quite lucky,
For 'tis not often that you see
　A hunter from Kentucky.
　　　Oh, Kentucky ; the hunters of Kentucky,
　The hunters of Kentucky.

We are a hardy, free born race,
　Each man to fear a stranger;
Whate'er the game we join in chase,
　Despising toil and danger;
And if a daring foe annoys,
　Whate'er his strength and forces,
We'll shew him that Kentucky boys
　Are Alligator Horses.
　　　Oh, Kentucky,

I 'spose you've read it in the prints,
　How Packenham attempted
To make old Hickory Jackson wince,
　But soon his scheme repented
For we, with rifles ready cock'd,
　Thought such occasion lucky,
And soon around the general flock'd
　The hunters of Kentucky.
　　　Oh ! Kentucky.

You've heard I 'spose how New-Orleans
　Is fam'd for wealth and beauty—
There's girls of every hue it seems
　From snowy white to sooty ,
So Packenham he made his brags,
　If he in fight was lucky,
He'd have their girls and cotton bags,
　In spite of old Kentucky.
　　　Oh ! Kentucky.

But Jackson, he was wide awake,
　And was'nt scar'd at trifles ;
For well he knew what aim we take,
　With our Kentucky rifles.
So he led us down to Cypress swamp,
　The ground was low and mucky ;
There stood John Bull in martial pomp,
　And here was old Kentucky,
　　　Oh ! Kentucky.

A bank was rais'd to hide our breast,
　Not that we thought of dying,
But that we always like to rest,
　Unless the game is flying ;
Behind it stood our little force.
　None wish'd it to be greater,
For every man was half a Horse,
　And half an Alligator.
　　　Oh ! Kentucky.

They did not let our patience tire
　Before they shew'd their faces ;
He did not choose to waste our fire,
　So snugly kept our places ;
But when so near we saw them wink,
　We thought it time to stop 'em.
And 'twold have done you good, I think,
　To see Kentucky drop 'em.
　　　Oh ! Kentucky.

They found, at last 'twas vain to fight
　Where lead was all their booty ;
And so they wisely took to flight,
　And left us all the beauty !
And now if danger e'er annoys,
　Remember what our trade is ;
Just send for us Kentucky boys,
　And we'll protect ye, ladies.
　　　Oh ! Kentucky.

Printed and Sold at NO. 25, High Street, Providence, by the Hundred, Dozen or Single.

FIG. 3. *Half Harse–Half Allegator* [sic], ca. 1824–32. Wood engraving, 2¼" x 2¾", from the broadside "The Hunters of Kentucky," published in Providence, Rhode Island. Courtesy of The Filson Club, Louisville, Kentucky.

A bank was rais'd to hide our breasts,
 Not that we thought of dying,
But that we always like to rest,
 Unless the game is flying.
Behind it stood our little force,
 None wished it to be greater,
For every man was half a horse,
 And half an alligator.

The point of this song, that Kentuckians contributed mightily to Jackson's victory, has been a persistent belief from the earliest reports of the battle. The recorded events of that day contradict it, however. The Kentucky militia, arriving at New Orleans as reinforcements just before the battle, were assigned to hold a flank. They did not succeed. In his official report of the conflict, Jackson wrote that the Kentuckians had "ingloriously fled." The people of that state vociferously protested these words. Not until 1828, however, the year of his first successful presidential campaign, did Jackson retract what he had said and substitute a less-offensive though hardly praiseworthy phrase. The disparity between the military and political realities on the one hand, and the popular mythic image of heroic Kentuckians on the other, reminds us how arbitrary a thing "truth" is, since in this instance the myth has prevailed as popular belief from 1815 to the present.[18]

The half-this and half-that manner of describing a person allowed endless variations. Some were strained and showed little humor or power of invention, such as the backwoodsman who in 1837 described himself as half chicken hawk and half steel trap.[19] More interesting were those who added extra ingredients to the basic recipe and heaped other animals about as garnish. In Paulding's *Lion of the West*, Nimrod Wildfire describes himself as,

Half horse, half alligator, a touch of the airthquake, with a sprinkling of the steamboat. . . . If I an't, I wish I may be shot. Wake, snakes, the June bugs are coming![20]

Then he rounds out the description with this much-quoted brag:

There's no mistake in me; of all the fellers on this side of the Allegheny mountains, I can jump higher, squat lower, dive deeper, stay under longer, and come up drier—there's no back out in my breed. I go the whole hog. I've got the prettiest sister, fastest horse, and ugliest dog in the deestrict—in short, I'm a horse![21]

Paulding's *Lion of the West* hardly originated this kind of humorous delivery, nor did he invent its choicest phrases. They permeated American popular culture in the 1820s. For example, in 1829, two years before Paulding's play, David Claypoole Johnston in Boston included an original depiction of the great hybrid (fig. 4) in his annual collection of engraved comic vignettes, which he titled *Scraps*. Astride a raft, Johnston's Ginooine Buster says,

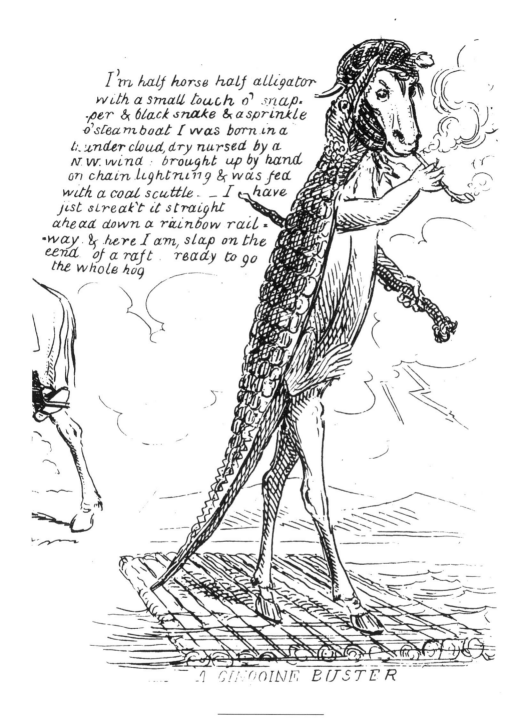

I'm half horse half alligator with a small touch o' snapper & black snake & a sprinkle o' steamboat I was born in a thunder cloud, dry nursed by a N.W. wind; brought up by hand on chain lightning & was fed with a coal scuttle. — I have just streak't it straight ahead down a rainbow railway. & here I am, slap on the eend of a raft, ready to go the whole hog

A GINOOINE BUSTER

FIG. 4. David Claypoole Johnston. *A Ginooine Buster*, 1829. Etched vignette, 2¾" x 1¾", from *Scraps No. 2 for the Year 1830*. Courtesy of the American Antiquarian Society.

I'm half horse half alligator, with a small touch o' snapper & black snake & a sprinkle o' steamboat. I was born in a thundercloud, dry nursed by a N.W. wind, brought up by hand on chain lightning & was fed with a coal scuttle. I have just streak't it straight ahead down a rainbow railway & here I am, slap on the eend [sic] of a raft, ready to go the whole hog.[22]

Johnston's figure wears the snapper as a cap and the snake as a cravat.

The half horse–half alligator was conceptually the most elaborate of the invented Jacksonian animals. It had no near parallel as an example of the transfer of distinctive animal characteristics to human beings. And it was intrinsically pictorial. But it was hardly alone. The prints, illustrated books, and magazines of the period show other animals that are either bearers of symbolic meaning or intimately associated with such symbols. This is true especially of broadside political cartoons which were products for the most part of the lithographic shops of the East.[23] They are full of rats, foxes, dogs, turtles, and even an alligator or two, symbolizing one thing or another, but their political topicality limits their interest compared to those images of animals that defined the more abiding particulars and peculiarities of a region.

Perhaps the richest source of such regional images pertaining to the South and West in the Jacksonian Era is that group of various publications called the Crockett almanacs. This genre consisted of several competing almanacs, each with Davy Crockett's name in its title. Most devoted some pages to illustrated fantastic accounts of the legendary man. Crockett almanacs appeared in New York, Boston, Philadelphia, and other Eastern cities, but the very first of them, published for the year 1835, carries a Nashville, Tennessee, imprint. This does not necessarily mean, however, that it was written, illustrated, and manufactured in Tennessee, and we shall return to this question presently.[24]

The Nashville Crockett almanac was inspired by the publication of two books about the celebrated and then-still-very-much-alive David Crockett. One of these books, presumably written by Matthew St. Clair Clarke, was the *Sketches and Eccentricities of Colonel David Crockett of West Tennessee,* published in New York in 1833. The other was Crockett's own (with help) *Narrative Life of David Crockett,* published in Philadelphia in 1834.[25] Both books, each in a different way, owed much to Paulding's play, *The Lion of the West,* since its chief character, the Kentuckian Nimrod Wildfire, was in part a caricature of the historical David Crockett. With the arrival of the almanacs, this circularity of borrowings, references, and allusions to the real David and the mythical Davy became a whirlwind.[26] The historical David Crockett has been characterized aptly as "half horse, half horse's ass," but the almanacs dealt nearly exclusively with the Davy of newly manufactured legend, and they greatly enlarged it. David Crockett's death at the Alamo in 1836 gave free rein to the legend-making process.

The Nashville almanacs came forth in seven successive annual numbers: a first series for the years 1835 through 1838 and a second series, "Volume 2," for 1839 through 1841. The inelegant, self-consciously primitive illustrations of the first series have been admired and often reproduced in the twentieth century, but little is known of their production.[27] No names are associated with them. It is tempting to assume that, as was true of most American pictorial printing of the time, they were the products of the graphic arts industries of the East. Some of the illustrations in the second series are signed by William Croome and John Manning as artists and Alonzo Hartwell as wood engraver. All three resided in Boston. Though the illustrations were engraved on wood and printed from stereotypes, and accordingly represented the highest technology of the day, the usual imprints for this kind of work are conspicuously absent, perhaps to imply a backwoods naivete. *Judy Coon* (fig. 5), from the 1836 almanac, is among the most primitive, and calculatedly so. The unrefined style of the illustration suits the subject, which is the destruction of a nest of wildcat kittens by Judy, who has let her toenails grow for the occasion.

The Nashville almanacs teem with alligators. If they are not so precisely symbolic as the equine-reptilian compound, they at least evoked something beyond themselves that reflected the still ongoing struggle to tame nature in America. These alligators are powerful things, but not invincible. In the relief cut in the 1836 almanac, *An Alligator Choked to Death* (fig. 6), a Crockett alter-ego, Ben Hardin (i.e., Harding) of Kentucky, fixes a reptile who had opened his jaws intending to bite him in two. Ben says,

> I jumped right down his throat. He kicked about and thrashed up the ground like an earthquake for a few minutes, but presently he give over, completely choked to death, and I found it hard work to get out again.[28]

This depiction of an alligator is a close adaptation of a wood engraving published two years earlier in Boston in *The People's Almanac*.[29] The borrowing of images was common enough in the world of utilitarian graphic arts, but in the 1830s it would have been easier to accomplish in a well-established publishing center such as Boston, with its many printmakers, than in Nashville. John Seelye has made an interesting case for Boston, and the publisher Charles Ellms, as the real center of production for the Nashville Crockett almanacs from their inception.[30] Nashville in the 1830s was an important regional center of publication, though not of pictorial printing. While it is possible that the illustrations were drawn and engraved in Boston for printing in Nashville, as a practical matter this seems unlikely.[31]

The idea that alligators could be a threat to daily life in regions as distant from their haunts as Tennessee and Kentucky was in itself humorous. Illustrations in the almanacs sometimes included subtropical habitats that

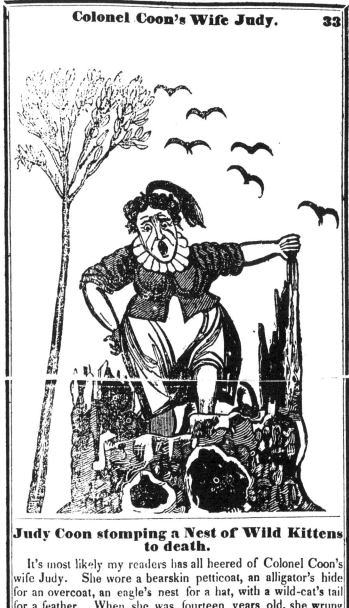

Judy Coon stomping a Nest of Wild Kittens to death.

It's most likely my readers has all heered of Colonel Coon's wife Judy. She wore a bearskin petticoat, an alligator's hide for an overcoat, an eagle's nest for a hat, with a wild-cat's tail for a feather. When she was fourteen years old, she wrung off a snapping turtle's neck and made a comb of its shell, which she wears to this day. When she was sixteen years old, she run down a four year old colt, and chased a bear three mile

FIG. 5. *Judy Coon,* 1835. Wood engraving, 4½" x 3⅜", from *Davy Crockett's Almanack, of Wild Sports of the West and Life in the Backwoods* [Nashville] for 1836. Courtesy of the American Antiquarian Society.

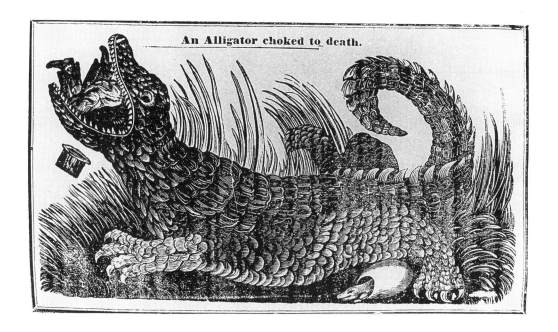

FIG. 6. *An Alligator Choked to Death*, 1835. Wood engraving, 3¾" x 6¾", from *Davy Crockett's Almanack, of Wild Sports of the West and Life in the Backwoods* [Nashville] for 1836. Courtesy of the American Antiquarian Society.

had no relation whatever to those states, undoubtedly borrowed from other pictorial sources. We see this anomaly in *A Tongariferous Fight with an Alligator* (fig. 7), from the 1837 Nashville almanac, which purports to depict Crockett's older daughter astride a thirty-seven-foot monster. Despite the beach and palms, the text claims that her mother has snared it outside their Tennessee home. She will dispatch it as soon as her little girl is done beating on it.[32] The almanacs are full of images of resourceful (to say the least) women contending with a hostile natural world. In this respect they echo and exaggerate countless tales of the ordeals of pioneer women, though by the mid-1830s frontier life was perhaps more a memory than a reality in much of Tennessee.[33]

One alligator was enough of a symbolic entity to merit a place in the Jacksonian bestiary. This was Davy's pet reptile, a tame and agreeable sort named Long Mississippi. With a docile companion, in *The Way They Travel in the West* (fig. 8) from the 1840 Nashville almanac, he formed a dolphin-like team to pull Davy through the waters of America.[34] In drawing, perspective, and detail, this illustration is far from the crudeness of *Judy Coon*.

In *The Wonderful Escape* (fig. 9), Long Mississippi carries Davy up Niagara Falls.[35] In another illustration, he descends a waterfall in another land, with Ben along for the ride, exemplifying, perhaps, a growing American interest in tourism.[36] Both of these illustrations of the mid-1840s can be attributed to

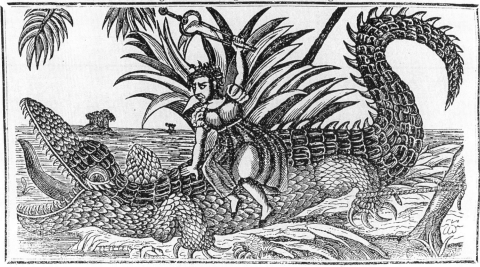

FIG. 7. *A Tongariferous Fight with an Alligator*, 1836. Wood engraving, 3½" x 6¾", from *Davy Crockett's Almanack, of Wild Sports of the West and Life in the Backwoods* [Nashville] for 1837. Courtesy of the American Antiquarian Society.

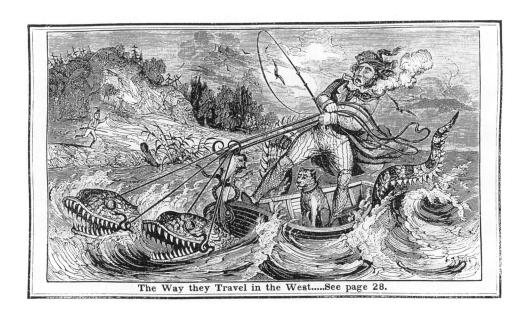

FIG. 8. *The Way They Travel in the West*, 1839. Wood engraving, 3¼" x 5⅜", from *The Crockett Almanac* [Nashville] for 1840. Courtesy of the American Antiquarian Society.

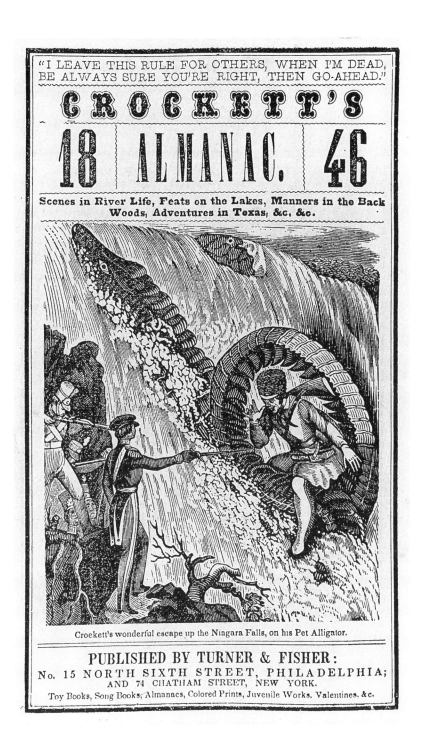

FIG. 9. John Magee (attributed), *The Wonderful Escape,* 1845. Wood engraving, 4½" x 3⅞", from *Crockett's Almanac* [Philadelphia] for 1846. Courtesy of the American Antiquarian Society.

John Magee, an artist active both in New York and Philadelphia. Magee signed several illustrations in the 1846 Crockett almanac published with different imprints in Philadelphia and Boston; other illustrations can be assigned to him on grounds of similarity of style.

With Long Mississippi the process of personification is clear: Crockett's pet is as good natured, quick-thinking, and countrywise as himself. This backwoods Orpheus and his patter have charmed the beasts of the big woods and bayou. Another of his pets was an amiable bear named Death Hug. He can be seen in the wood engraving *Crockett, Ben Hardin, and Death Hug "Going Ahead" of a Steamer* (fig. 10), probably drawn by Magee. Having been refused a berth on a riverboat because they had included a bear in their company, Davy and Ben cut a tree, fashioned paddles, launched their craft, and quickly outdistanced the steamer.[37] Death Hug "steers with his tail," Ben thumbs his nose at the sidewheeler, and Davy waves his Crockett flag, which consists of stars and stripes with his motto superimposed. That motto in full was: "Be always sure you're right, then Go Ahead!" It had great currency in the United States in the 1830s and 1840s when it reflected the spirit of a dynamic society on the move.

There was no need for Death Hug to have been barred from the steamboat, for he had many social graces. An illustration of this, probably by Magee, appears in the 1845 Philadelphia almanac, *Crockett, the Pet Bear, and Alligator Dancing the Polka* (fig. 11).[38] In a bucolic woodland glade, Davy and Death Hug lumber through the steps, watched by Ben and by Long Mississippi,

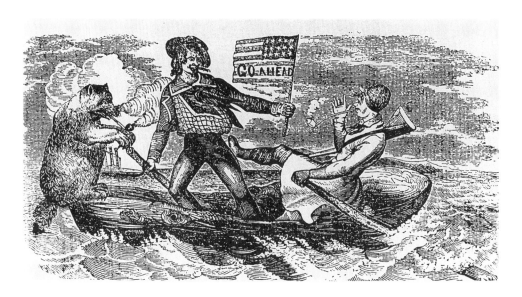

FIG. 10. John Magee (attributed), *Crockett, Ben Hardin, and Death Hug "Going Ahead" of a Steamer*, 1845. Wood engraving, 3¼" x 6¼", from *Crockett's Almanac* [Philadelphia] for 1846. Courtesy of the American Antiquarian Society.

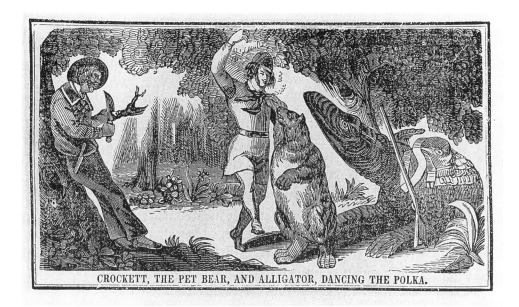

CROCKETT, THE PET BEAR, AND ALLIGATOR, DANCING THE POLKA.

FIG. 11. John Magee (attributed), *Crockett, the Pet Bear, and Alligator Dancing the Polka,* 1845. Wood engraving, 3¼" x 6¼", from *Crockett's Almanac* [Philadelphia] for 1846. Courtesy of the American Antiquarian Society.

who is saddled for another river excursion. Davy's posture parodies that of dancers on lithographed pictorial title pages of sheet music published during the polka craze of the 1840s. Later, Death Hug will carry Davy to Texas (fig. 12) and the Alamo, where according to some of the almanacs he did not die, but, Orpheus-like, still lived.[39] That, perhaps, marked the beginning of a Tennessee pattern.

Death Hug and Long Mississippi together represent tamed and exploited nature. Davy has removed their wildness, put them to work, and made them part of the "Go Ahead" spirit of Manifest Destiny that would within a few years tame the entire continent. It is one of the quiet ironies of American culture that the first Nashville Crockett almanac appeared in 1835, a year before the painter Thomas Cole's much-cited "Essay on American Scenery."[40] In that essay Cole extolls the transcendent moral, intellectual, and aesthetic values of the wilderness for those who would contemplate it. Finding nature already endangered in North America, his readers must have wondered at the implications of Davy's buffoonery, of his gobbling up the natural world and spitting it out again.

Curiously, the Crockett almanacs seem not to have contained pictorial images of the half horse–half alligator. Its career was not over, however, even though in 1824, before the arrival of the almanacs, James Akin, the much-practiced caricaturist, had offered a skeletal version of the animal, as if it

were dead (fig. 13).[41] His subject concerned Philadelphia politics: the dug-up beast represents the Kentuckian Henry Clay's Whig party. In 1852, Thomas B. Gunn revived the image when he included a hale and hearty specimen in a satiric drawing for the short-lived comic journal *Diogenes, His Lantern*.[42] This was his *Portrait of a Distinguished Mississippian,* with a "touch o' snapping turtle" showing its flippers (fig. 14).

The half horse–half alligator was an elaborate caricature of only one part of a complex, multifaceted regional culture. Other early images in the graphic arts conveyed different messages. One of the earliest images was an unsigned engraved title page for a piece of music by the Bohemian-American composer Anthony Philip Heinrich, *The Dawning of Music in Kentucky* (fig. 15).[43] This allegorical print of 1820 offers a beneficent natural world as the source of inspiration for the music it decorates. It incorporates some age-old elements (Apollo's lyre) while introducing new ones pertinent to the New World (stalks

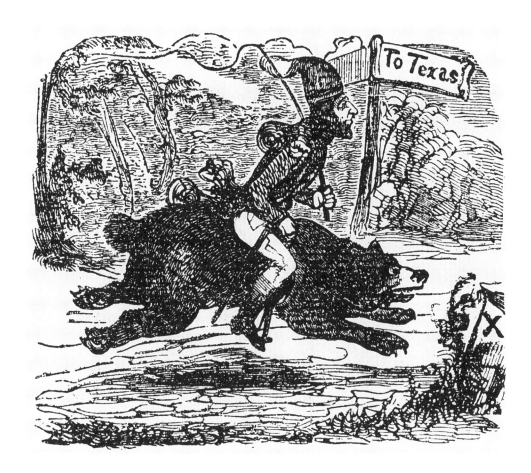

FIG. 12. John Magee (attributed), *To Texas,* 1844. Wood engraving, 3" x 3½", from *Davy Crockett's Almanac* [Boston] for 1845. Courtesy of the American Antiquarian Society.

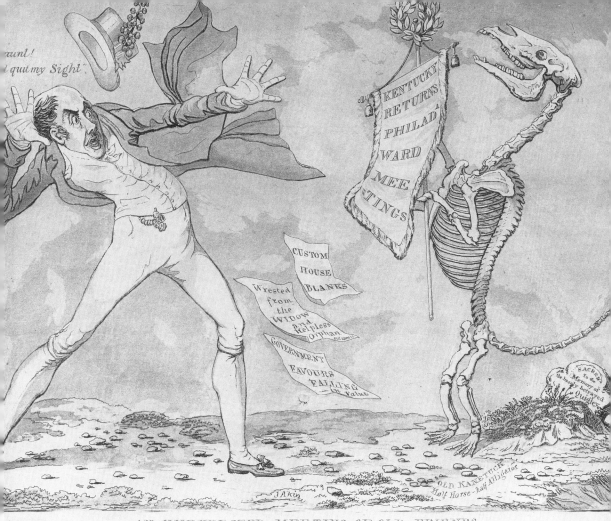

FIG. 13. James Akin. *An Unexpected Meeting of Old Friends*, 1824. Etching, 9½" x 12¾". By permission of the Houghton Library, Harvard University.

FIG. 14. Thomas Gunn. *Portrait of a Distinguished Mississippian,* 1852. Wood engraving, 3" x 2", from *Diogenes, His Lantern* for July 10, 1852. Courtesy of the American Antiquarian Society.

of Indian corn). The engraving prophesies a high culture for Kentucky. Indeed, by 1820 the foundations for such a culture were already evident in Lexington and elsewhere.[44] The arts, here represented by an open book of music and instruments, are elevated above the more utilitarian pursuits of agriculture (at lower left) and hunting (lower right). No alligators or ring-tailed roarers intrude into this idyllic image.

From all of this a few questions naturally arise. Was the animal iconography we have sampled in the graphic arts also evident in American painting? Hardly at all. Was it peculiar to the West and South in Jacksonian America? Very nearly so, except, as we have noted, in political cartoons. The only other allegorical animal of much significance to flourish elsewhere in this period was the striped pig of Massachusetts, which in 1838 became for a few years a symbol of both intemperance and good-natured deception. Why was the development of animal imagery so much richer in the West and South? Among several probable reasons are two of notable significance. First, the settlers of the Appalachians and the lands west and south of them, as David

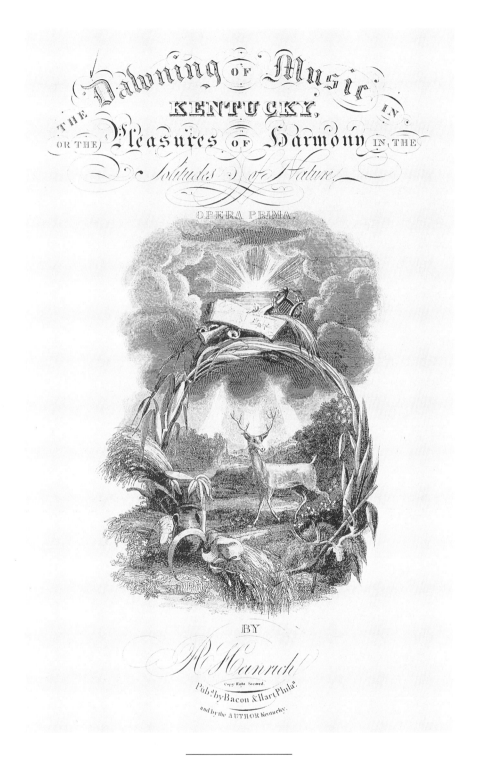

FIG. 15. Unknown artist. *The Dawning of Music in Kentucky,* 1820. Engraving, 6½" x 5". Private collection.

Hackett Fischer has shown so interestingly in his *Albion's Seed,* were mostly people whose roots were in the north of England, the lowlands of Scotland, and Ireland.[45] Their ways of speech, humor, and much else differed from those immigrants from southern and midland England who, considerably earlier, had dominated the seaboard regions of Colonial America and whose descendants moved on to settle Ohio, Michigan, and beyond in the north. The colorful, roisterous qualities of the Jacksonian West and South probably derive from northern British regional cultures at least as much as from the vaunted frontier experience. Second, geography encouraged this iconographic development. The cultural and topographic contrasts between Louisiana and Tennessee, or between Mississippi and Kentucky, were vividly apparent to travelers on the great river that linked these states together. But these geographical contrasts could be mediated symbolically, and so we find bayou alligators tethered outside Tennessee hill cabins, and the hunters of Kentucky at home in New Orleans.

This era of mythic and symbolic animals ended in the 1850s. By then they had no real relevance to the fast-arriving modern world of railroads, factories, mass circulation magazines, and overwhelming national issues. A backwoods culture survived throughout these regions, but it neither made nor required printed images.

We can gain an inkling of the changed times from the wood-engraved book illustration, *The Horn-Snake* (fig. 16), drawn by the able and prolific John McLenan. It appears in *Fisher's River,* a book of regional dialect humor by the North Carolinian minister and writer, Hardin Taliaferro, published in New York by Harpers in 1859.[46] Taliaferro writes knowingly and sympathetically about the backwoods Blue Ridge culture of a slightly earlier era, wishing to preserve some memory of it. He touches on local folklore, notably in the case of the mythical horn snake. This creature possessed astounding speed and traveled by taking its tail in its mouth and rolling like a hoop. Its spearhead tail was even more lethal than its bite. McLenan depicts Uncle Davy Lane in a moment of great good fortune, since the horn snake had missed him when it flung itself tail-first through the air, embedding its poisonous point in an oak tree instead. The snake's venom killed the tree.[47]

In his naturalistic drawing, McLenan makes Uncle Davy, the tree, and the pictorial space wholly believable. They are of our world. In this respect the illustration stands in sharp contrast to those allegorical and fantastical printed images of the previous generation. Only the detail of the horn snake comes from the world of the imagination, and it is a paltry example. By 1859, this serpentine relic of an older time, symbolic of a threatening natural world, had no place in the optimistically burgeoning industrial age. The horn snake defined only the backward parts of the South and the old West, parts where allegory and myth had shriveled into superstition. The new, modern nation had no call for this kind of iconography, nor any other uses for the denizens of the Jacksonian menagerie, and it packed the whole lot off to the world of history.

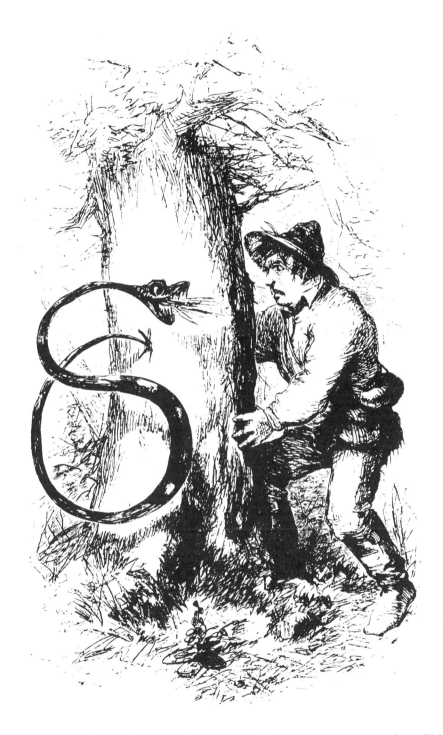

FIG. 16. John McLenan. The *Horn-Snake*, 1859. Wood engraving, 5″ x 3″, from *Fisher's River* by "Skitt" [Hardin Taliaferro] (New York, 1859). Courtesy of the American Antiquarian Society.

NOTES

1. Similarities in style support an attribution to Charles, as does the fact that few other American engravers on copper were capable of imaginative figure work, but enough doubts remain to make the attribution conjectural.

2. Hofer (1898–1984) often used this phrase to characterize inelegant prints of various kinds, memorably at programs of the Club of Odd Volumes in Boston in the 1970s.

3. For other graphic works relating to the subject, see John Carbonell, "Prints of the Battle of New Orleans," in Ron Tyler, ed., *Prints of the American West* (Fort Worth: Amon Carter Museum, 1983), pp. 1–12.

4. For Britannia as pictorial symbol, see Frank H. Sommer III, "Thomas Hollis and the Arts of Dissent," in John D. Morse, ed., *Prints in and of America to 1850* (Charlottesville: University Press of Virginia, 1970), pp. 111–59, and John Higham, "Indian Princess and Roman Goddess: The First Female Symbols of America," *Proceedings of the American Antiquarian Society* 100 (April 1990): 45–79.

5. Examples include James Kirke Paulding's *Diverting History of John Bull and Brother Jonathan* (Philadelphia: Inskeep and Bradford, 1812) and William Charles's etching *Bruin Becomes Moderator* (1815), described and illustrated in Frank Weitenkampf, *Political Caricature in the United States* (New York: New York Public Library, 1953), p. 20 and plate.

6. The roughness of the backwoods population of the South and West was recognized and explained as early as the 1830s. Matthew St. Clair Clarke, presumed author of the first book about Crockett, wrote in 1833 that in "the 'far off West,' where, from the transitory nature of its inhabitants, and from the fact that they are made up of representatives from every region between the two circles, it is impossible that talent can be as much respected, or as highly appreciated, as it is in a more settled society. A frontier country is no place for a man of modesty, or of refinement, or of delicacy. . . ." *Sketches and Eccentricities of Colonel David Crockett of West Tennessee* (New York: Harper, 1833), p. 62.

7. James Kirke Paulding, *The Lion of the West*, ed. James N. Tidwell (Stanford: Stanford University Press, 1954). This text, revised by John Augustus Stone and William Bayle Bernard for the London production of 1833, is the only version of the play to have survived. Paulding's original version opened in New York in 1831.

8. Richard M. Dorson, ed., *Davy Crockett: American Comic Legend* (New York: Rockland Editions, 1939). This is an anthology of excerpts from several Crockett almanacs published in various cities between 1835 and the mid-1850s. The selection does not convey the extent of the anti–African-American and anti–Native American flavor of the almanacs.

9. John James Audubon lamented the selection of the bald eagle as the "emblem of my country," and cited Benjamin Franklin's similar feelings. Scott Russell Sanders, ed., *Audubon Reader* (Bloomington: Indiana University Press, 1986), p. 111.

10. One of the earliest published reports of the use of the image in speech, and probably the source from which later uses developed, is in Christian Schultz, Jr., *Travels on an Inland Voyage*, 2 vols. (New York: Isaac Riley, 1810), 2:144–46. The author describes a heated exchange between two raftsmen in Natchez in 1808: "One

said, 'I am a man; I am a horse; I am a team. I can whip any man *in all Kentucky,* by G——d.' The other replied, 'I am an alligator; half man, half horse; can whip any *on the Mississippi,* by G——d.' The first one again, 'I am a man; have the best horse, best dog, best gun, and handsomest wife in all Kentucky, by G——d.' The other, 'I am a Mississippi snapping turtle: have bear's claws, alligator's teeth, and the devil's tail; can whip *any man,* by G——d.' This was too much for the first, and at it they went like two bulls, and continued for half an hour, when the alligator was fairly vanquished by the horse." This kind of speech became that of the legendary Mississippi raftsman, Mike Fink; Eudora Welty perpetuates it in her *Robber Bridegroom* (Garden City: Doubleday, Doran, 1942), pp. 9–10. For a history of the raftsman, see Michael Allen, *Western Rivermen* (Baton Rouge: Louisiana State University Press, 1990).

11. Frances Trollope, *Domestic Manners of the Americans,* ed. Donald Smalley (New York: Knopf, 1949), pp. 17–18.

12. Ibid., p. 205.

13. Ralph M. Aderman, ed., *The Letters of James Kirke Paulding* (Madison: University of Wisconsin Press, 1962), pp. 33–34.

14. None of the broadsides is dated. It is possible that the song was written for Andrew Jackson's presidential campaign in 1824. Woodworth's verses were first published in book form in his *Melodies, Duets, Trios, Songs and Ballads* (New York: James M. Campbell, 1826), pp. 221–23. Woodworth wrote one other durable lyric, "The Old Oaken Bucket" (1818).

15. I am grateful to Daniel Siegel of M&S Rare Books, Weston, Massachusetts, for information about the broadside printed by L. Deming.

16. "The Hunters of Kentucky," published by George Willig in Philadephia, probably in 1824, in which the piano part is by William Blondell. Reproduced in David Tatham, *The Lure of the Striped Pig* (Barre, Mass.: Imprint Society, 1973), plate 5.

17. Carl Sandburg, *American Songbag* (New York: Harcourt, Brace, 1927), p. 427.

18. Anderson Chenault Quisenberry, *Kentucky in the War of 1812* (Frankfort: Kentucky Historical Society, 1915), pp. 146–48.

19. *Davy Crockett's Almanack or Wild Sports of the West and Life in the Backwoods,* Vol. 1, No. 4, for 1838 (Nashville: for the author, 1837), p. 2.

20. Paulding, *Lion,* p. 21.

21. Ibid., p. 27.

22. David Claypoole Johnston, *Scraps No. 2,* for the year 1830 (Boston: the author, 1829), p. 4.

23. For numerous examples, see Bernard F. Reilly, Jr., *American Political Prints, 1766–1876* (Boston: G. K. Hall, 1991).

24. More than fifty Crockett almanacs were published between 1835 and 1856. Constance Rourke, *Davy Crockett* (New York: Harcourt, Brace, 1934), pp. 251–58. The Nashville almanacs are reproduced in Franklin J. Meine, ed., *The Crockett Almanacks: Nashville Series, 1835–1838* (Chicago: Caxton Club, 1955) and Michael A. Lofaro, ed., *The Tall Tales of Davy Crockett: The Second Nashville Series of Crockett Almanacs, 1839–1841* (Knoxville: University of Tennessee Press, 1987).

25. [Clarke], *Sketches and Eccentricities,* and David Crockett, *A Narrative Life of David Crockett of the State of Tennessee.*

26. Variants of the historical David and the mythical Davy are noted in John Seelye, "Cats, Coons, Crocketts, and Other Furry Critters—or Why Davy Wears an

Animal for a Hat," in Michael A. Lofaro and Joe Cummings, eds., *Crockett at Two Hundred: New Perspectives on the Man and the Myth* (Knoxville: University of Tennessee Press, 1989), pp. 153–78.

27. For example, the illustrations receive major attention in Joshua C. Taylor, *America as Art* (Washington: Smithsonian Institution Press, 1976), pp. 88–94, a book published for the occasion of the bicentennial of the United States.

28. *Davy Crockett's Almanack,* Vol. 1, No. 2, for 1836 (Nashville: the author, 1835), p. 16.

29. *The People's Almanac, 1834* (Boston: Charles Ellms, 1833), p. [33].

30. John Seelye, "A Well-Wrought Crockett," in Michael A. Lofaro, ed., *Davy Crockett: The Man, the Legend, the Legacy, 1786–1986* (Knoxville: University of Tennessee Press, 1985), pp. 21–45.

31. The first Nashville almanac's cover claims its publisher to be "Snag and Sawyer," a tongue-in-cheek fiction. The cuts were almost certainly printed from stereotypes rather than from woodblocks.

32. *Davy Crockett's Almanack,* Vol. 1, No. 3, for 1837 (Nashville: the author, 1836), pp. 8–9.

33. For images of women in the almanacs, see Michael A. Lofaro, "Riproarious Shemales: Legendary Women in the Tall Tale World of the Davy Crocket Almanacs," in Lofaro and Cummings, *Crockett at Two Hundred,* pp. 114–52.

34. *Davy Crockett's Almanack,* Vol. 2, No. 1, for 1839 (Nashville: the author, 1838), pp. 26–28. The image of Crockett riding a pair of alligators was perpetuated on a sailing card for the clipper ship David Crockett, built in 1853. The card is reproduced in Allan Forbes and Ralph M. Eastman, *Yankee Ship Sailing Cards,* Vol. III (Boston: State Street Trust Co.), p. 28.

35. *Crockett's Almanac, 1846* (Philadelphia: Turner and Fisher, 1845), front wrappper.

36. *Crockett's Almanac* (Boston: J. Fisher) for 1845.

37. Ibid, pp. 72–74.

38. *Crockett's Almanac, 1846* (Philadelphia: Turner and Fisher, 1845), p. [97].

39. Dorson, *Crockett,* p. 143.

40. Thomas Cole, "Essay on American Scenery," *The American Monthly Magazine,* New Series 1 (January 1836), pp. 1–12. Reprinted in John W. McCoubrey, ed., *American Art 1700–1960, Sources and Documents* (Englewood Cliffs, New Jersey, Prentice-Hall, 1965), pp. 98–110.

41. Maureen O'Brien Quimby, "The Political Art of James Akin," *Winterthur Portfolio* 7 (1972), pp. 59–112.

42. *Diogenes, His Lantern* 2 (July 10, 1852). Single issues of this comic weekly are titled simply *The Lantern.*

43. The engraving probably followed the composer's own design. Heinrich's sojourn in Kentucky (1818–1823) brought forth a number of compositions descriptive or evocative of that experience, including his *Sylviad.* William T. Upton, *Anthony Philip Heinrich* (New York: Columbia University Press, 1939).

44. For example, Transylvania University had been founded at Lexington as early as 1780.

45. David Hackett Fischer, *Albion's Seed: Four British Folkways in America* (New York: Oxford University Press, 1989).

46. Hardin Taliaferro, *Fisher's River (North Carolina): Scenes and Characters by "Skitt," "Who Was Raised Thar."* (New York: Harper, 1859).

47. Ibid., pp. 55–57. McLenan's illustration of this episode serves as the book's frontispiece.

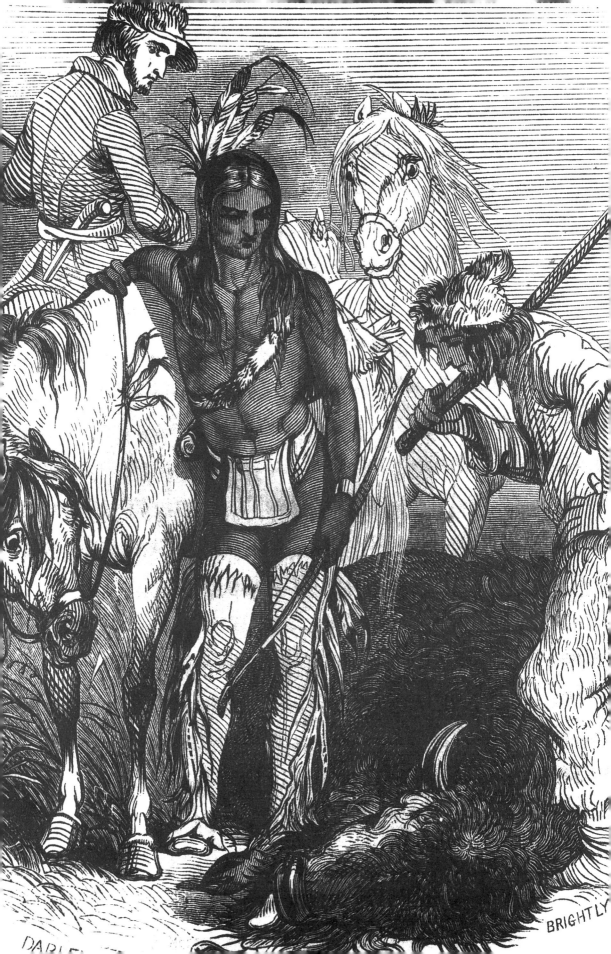

F. O. C. DARLEY'S ILLUSTRATIONS FOR SOUTHERN HUMOR

Georgia B. Barnhill

Over a period of just five years, from 1844 through 1848, the Philadelphia publishing firm of Carey & Hart commissioned F. O. C. Darley to illustrate ten works of humorous literature that described the manners and mores of the residents of the Southeastern states, including Tennessee, Georgia, Alabama, Louisiana, Mississippi, Arkansas, and Missouri.[1] This assignment required the young Philadelphia illustrator to capture the spirit and humor of this regional literature. According to historian Walter Blair, this literature appealed to Northern readers because in those states

> ways of living differed greatly among the inhabitants not only because many peoples mingled but also because various stages of civilization naturally were juxtaposed in stretches between settled sections and frontiers. Here, therefore, flourished striking contrasts which furnished excellent stuff for humor. Using these materials, a boisterous band of humorists produced a body of amusing narrative unsurpassed by any group in American literature.[2]

Unifying the series are nearly one hundred illustrations by Felix Octavius Carr Darley that match the tone and humor of the authors. Since Darley was at the beginning of his career as an illustrator, this body of work that established his reputation is particularly significant. Fortunately, Darley's

graphic contribution to the works of Southern humor is well documented. Correspondence concerning some of the illustrations exists, as do many of the original drawings. Because the books remained in print for several generations, the publications themselves are not rare. The existing documentation permits the examination of the collaborative nature of an illustrated work of fiction. The interactions among the publisher, author, illustrator, engraver, and reader will be the focus of this discussion.

Darley was born into a theatrical family in Philadelphia in 1822. He started to draw at an early age, and his artistic career was probably encouraged. His earliest employment, however, was as an apprentice clerk for the Philadelphia Dispatch Transportation Line from 1836 to 1840. A chance encounter with the Philadelphia writer and critic Thomas Dunn English (1819–1902) may have led Darley to enter the field of commercial illustration and design in the middle of 1840. His earliest illustrations appeared in the *Saturday Museum*, the Philadelphia newspaper edited by Edgar Allan Poe, in 1842. Within a year he became the staff artist for *Graham's Lady's and Gentleman's Magazine*. In 1844 he started to illustrate for the firm of Carey & Hart.[3]

Darley had published few illustrations before receiving Carey & Hart's first commission in 1844. In January 1843 he had signed a contract with Edgar Allan Poe to provide illustrations for a periodical to be called *The Stylus*, but no issues were ever published.[4] In 1843 Darley illustrated a series of literary sketches by Joseph Clay Neal (1807–1847), *In Town and About*, published by Louis A. Godey & Morton McMichael. This publication was issued in six parts, each containing three lithographs by Darley and letterpress text. Darley's illustrations depicted street scenes in Philadelphia. The next year, Darley illustrated Neal's *Peter Ploddy, and Other Oddities*, which was published by Carey & Hart. It is possible that Neal arranged this commission on Darley's behalf, initiating a long and very successful collaboration between the artist and publishing firm. The illustrations for both of Neal's publications reveal Darley's innate ability to provide realistic and spirited illustrations of everyday life and to capture pictorially the humorous spirit of the texts.

The proprietors of the firm that published Darley's illustrations were Henry Carey Baird and Abraham Hart. Baird inherited his portion of the firm from his uncle Edward L. Carey, a son of Mathew Carey, the prominent and very successful Philadelphia publisher active from 1785 until his retirement in 1829. At that time Edward L. Carey formed a partnership with Abraham Hart, who was just eighteen years of age. He had been active selling books for his mother's fancy goods shop. The firm reprinted English works of literature as well as textbooks, histories, and medical works. Unlike most American publishers, the firm actively promoted works by American authors. The partnership dissolved in 1849.[5]

By December 1845 Carey & Hart decided to create a series of popular books to be known as the *Library of Humorous American Works*. In all, eighteen titles were issued in the series between 1846 and 1849, two-thirds of

which pertained to the South. After the firm of Carey & Hart dissolved in 1849, Hart continued to reprint some titles of the *Library of Humorous American Works;* Baird controlled and reprinted the others. He in turn sold his printing plates to Getz and Buck, who published those titles from 1851 to 1854. The printing plates were then purchased by the Philadelphia firm formed by Theophilus Beasley Peterson. That firm kept some titles in print through 1881.[6]

Major Jones's Courtship

The first volume of Southern humor published by Carey & Hart was William Tappan Thompson's (1812–1882) *Major Jones's Courtship: Detailed with Other Scenes, Incidents and Adventures, in a Series of Letters by Himself.* The author used as his literary format letters ascribed to the fictional Major Jones, the first of which was published in a journal that he edited, the *Family Companion and Ladies' Mirror.* That journal failed and Thompson published further letters from the Georgia major in the *Southern Miscellany.* First printed in 1843 in Madison, Georgia, in a small and rare edition, it was reprinted a year later by Carey & Hart with illustrations by Darley. The author was a Northerner by birth, but a Southerner by choice. Although he had studied law with the secretary of the territory of Florida, he worked as a journalist and editor. *Major Jones's Courtship* is an epistolary novel covering a period of two years, during which young Joseph Jones, a major in the Pineville, Georgia, militia describes his courtship, marriage, and life with his wife, Mary, and their young son, Henry Clay. Scholars Hennig Cohen and William B. Dillingham describe Thompson's *oeuvre* as follows:

> Here and in the later *Sketches of Travel*, the humor is derived largely from misspellings, ludicrous grammar, and incongruous situations, especially those resulting from the country major's travels to the sophisticated city . . . Major Jones belongs to the upper middle class. With a small plantation and a few slaves (all faithful and fun-loving), he is a respectable, small-town lad who is always intelligent, if sometimes naive. He is completely honest in all things. He is a teetotaler, a devoted family man, and a loyal Whig. His impeccable morals, political certainty, and high sense of responsibility achieved for him an audience of genteel readers who frowned at more risque humor.[7]

The Carey & Hart "cost books" provide important documentation on their publications. Financial arrangements between the illustrator and publisher and between the author and publisher are delineated. The financial records also reveal that the paper for the illustrations was different from the paper used for the text and that the text and illustrations were printed separately. For illustrating *Major Jones's Courtship,* Darley was paid five dollars each for twelve illustrations. The anonymous wood engraver who translated

the drawings into relief blocks earned more—eight dollars for each one. Interestingly, according to the contract signed with Poe, Darley would have received seven dollars for each illustration for *The Stylus*. Darley's fee for future illustrations for Carey & Hart was seven dollars, not five. The author received one hundred dollars for the copyright. Most important, the "cost books" indicate the popularity of these books by noting reprintings. The first edition of two thousand copies of *Major Jones's Courtship* in May 1844 was quickly followed by additional printings later in 1844, and in 1845, 1847, and 1849. The entries in the cost book record the costs for the various papers, the illustrations (design, engraving, printing, and stereotyping), the stereotyping of the text, and the plates, copyright, and binding. For a few of the books, the number of copies sent out for review is also noted. In the case of *Major Jones's Courtship*, thirty copies went to editors, and "showbills" or printed advertisements were also issued. Total production costs came to just under four hundred dollars.[8]

The character of Major Jones was immensely popular, and Thompson continued to write letters from him. Thompson's *The Chronicles of Pineville* was published by Carey & Hart in March or April of 1845 with twelve illustrations by Darley (fig. 1). A third volume, *Major Jones's Sketches of Travel*, with eight illustrations by Darley was published in May 1848.

The Big Bear of Arkansas

In March of 1845, Carey & Hart published *The Big Bear of Arkansas and Other Tales*, illustrated by Darley and edited by William T. Porter. This collection consists of stories that appeared in the *Spirit of the Times*, a journal edited by Porter. Although the journal's early focus was on horse racing and field sports, Porter also filled its pages with popular English literature. Porter also reprinted lively anecdotes and stories found in the pages of Southern newspapers and periodicals. Some of the best of these sketches were later reprinted as a collection of stories under the title *The Big Bear of Arkansas*.

Although the genesis of *The Big Bear of Arkansas* is not clear, apparently the publisher initially approached Porter to edit a volume, for he responded to Carey & Hart in a letter dated January 18, 1845:

> I have no idea of the trouble of compiling such a volume but should imagine that each story would be introduced with some appropriate remarks. . . . I am fearful of being obliged to have several of the articles *copied* and many of them I should wish to amend somewhat. What think you of paying $60 for such a "job." I wish the book to do myself credit as well as the writers, and am confident of making the most entertaining volume in the country, of original American stories. Egotistical, you may well think, but what I state is true beyond a doubt. As the stories are not mine, I am free to express my opinion.[10]

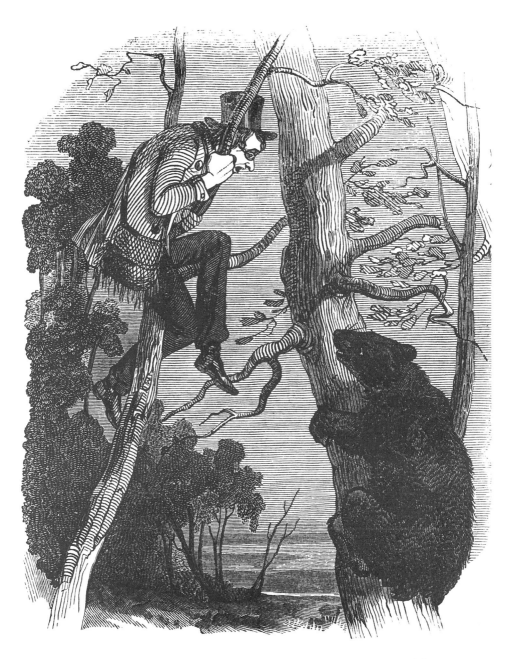

"He looked beneath and the bear was fast approaching!"

FIG. 1. Anonymous after F. O. C. Darley. "He looked beneath and the bear was fast approaching!" William T. Thompson, *Chronicles of Pineville* (Philadelphia: Carey & Hart, 1845), facing p. 93. 4" x 3¼". Courtesy of the American Antiquarian Society.

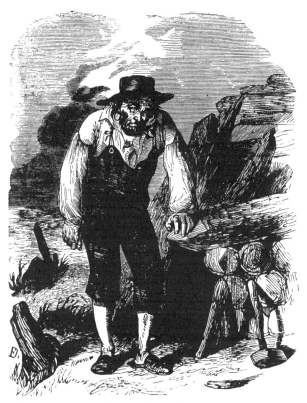

"Why, Capting, we must charge you three and a quarter THIS time."—*Page* 108.

FIG. 2. Anonymous after F. O. C. Darley. "'Why, Capting, we must charge you three and a quarter THIS time.'" *The Big Bear of Arkansas*, William T. Porter, ed. (Philadelphia: T. B. Peterson & Brothers, [n.d., ca. 1850]). Frontispiece. 4⅛" x 3³⁄₁₆". Courtesy of the American Antiquarian Society.

In retrospect, Porter's assessment of the potential of his projected book was modest. The whole corpus of Southern humor became known as the "Big Bear school of humor," named after the most successful story, "The Big Bear of Arkansas" by Thomas Bangs Thorpe.

Apparently Porter assembled the volume quickly, for a letter to Carey & Hart dated February 14, 1845, indicates that the publishers found the contents exciting and asked him to compile a second volume, even before the first was printed. In this letter Porter offered marketing advice:

> And here let me ask whether a notice and advertisement of "The Big Bear" etc. would not *tell* on its sale? It occurred to me that a strong puff of the different sketches in the "Spirit," none of them being mine, would at any rate, not "set it back any." Before writing it I should like to ascertain what particular sketches and the scenes, if convenient, Darley intends to illustrate. His illustrations that I have seen elsewhere are admirable.[11]

This letter reveals two important points. First, it indicates that Darley already had a considerable reputation. Second, Darley was to choose which

subjects to illustrate, not the editor or publisher. Since there were twenty-one stories, Darley had a great deal of latitude. Not only could he choose which stories to illustrate, but which scenes within each story. That must have been one of the most satisfying rewards of being an illustrator—reading the text and choosing the material to illustrate. These stories, full of wit and action, suited Darley's innate abilities, derived perhaps from the theatrical talents of his parents. At a time when most book illustrations were bland, Darley brought to his subjects a style of draftsmanship that captured the spirit of the text.[12]

Four of Darley's original drawings for *The Big Bear of Arkansas* are owned by the Beinecke Library; two are in the Department of Graphic Arts at the Princeton University Library; and one is owned by the Graham Gallery in New York. Typical of Darley's drawings for other books at this time, these are wash drawings over the barest hint of graphite. The drawing technique is masterly. The dark areas are built up with opaque layers of light wash enhanced by form-defining brush strokes. Details such as facial features are rendered with a fine brush. The drawings reflect a confident and sure hand guided by perceptive intelligence and an understanding of the authors' words. Like other illustrators of the era, Darley had to depend on the skills of wood engravers to translate the subtleties of the wash drawings into line engravings.

Carey & Hart employed the services of a number of wood engravers in Philadelphia and New York for their *Library of Humorous American Works.* One of the most prolific engravers was Joseph H. Brightly (b. ca. 1818), who provided about sixteen of the engravings on wood. He was probably the son of Henry A. Brightly, an English wood engraver who came to the United States between 1825 and 1835 and worked as a printer and wood engraver in Philadelphia. J. H. Brightly was active in Philadelphia from 1841 to 1854 and later worked in New York. He engraved all the illustrations for the *Chronicles of Pineville,* and his work appears in several of the other volumes as well.[13] In partnership, Reuben S. Gilbert and William B. Gihon engraved the illustrations for *Pickings from the Portfolio of the Reporter of the New-Orleans "Picayune."* Gilbert also worked by himself, and he was commissioned to do engravings that appeared in several of the volumes.[14] Henry W. Herrick's work, too, appeared in several of the volumes. He was born in 1824 in New Hampshire and worked in Concord and Manchester before embarking for New York to study at the National Academy. His family was acquainted with Samuel F. B. Morse, who encouraged the young man to go to New York.[15] Several other New York engravers, in addition, worked on Darley's illustrations: Benjamin F. Childs, Henry Kinnersley, Edward Bookout, Marx M. Hart, and Robert Roberts.[16] Still other illustrations were anonymously engraved. The large number of different engravers employed by Carey & Hart suggests that at this time wood engravers worked independently.

Two outstanding characteristics of all these engravers are their uniformity of style and their ability to work from tonal, not line, drawings. Although

many hands worked on Darley's drawings, the illustrations look remarkably uniform in the books. Creating dark areas with closely spaced lines is more difficult that using a deeper tone of wash, but these engravers were skilled in the process. The engravers were also adept at sustaining the vitality of Darley's draftsmanship.

An examination of several designs for *The Big Bear of Arkansas* reveals that the illustrations are most often dependent on the text for their meaning. Although occasional drawings, such as "Chunky's Fight with the Panthers" and "The Great Kalamazoo Hunt," are scenes of action and could stand alone without the text, the meanings of most designs are clarified by the stories. For example, "Billy Warrick's Courtship and Wedding" is understandable only when the reader is familiar with Warrick's courtship blunders and mishaps. Another example, the illustration for "The Bully Boat and Brag Captain," is a character study which indicates how closely Darley followed the text in his portrayal of the gritty dealer in cordwood, a typical character along the Mississippi River at docks where steamboats were refueled. The man is described as "a yellow-faced old gentleman, with a two weeks' beard, strings over his shoulders holding up to his armpits a pair of copperas-coloured linsey-woolsey pants, the legs of which reached a very little below the knee; shoes without stockings; a faded broad-brimmed hat, which had once been black, and a pipe in his mouth"[17] (fig. 2). Part of Darley's strength as an illustrator was his willingness to read and follow the text closely. This characteristic must have pleased the authors of the stories.

The *Knickerbocker Magazine* carried two brief notices of *The Big Bear of Arkansas*. The first, in May 1845, began "There is good fun in prospect." It favorably compared the stories with those by Hood or Dickens and mentioned that there would be twelve engravings by Darley, "four or five admirable specimens of which we have seen. Secure the volume, reader, when you see it announced." In July 1845, the magazine briefly noted that the text was "adorned with ten capital engravings by Darley."[18]

Porter inserted a "puff" for the book that included two of the illustrations in the March 22, 1845, issue of the *Spirit of the Times*. He wrote: "Darley, the artist, has especially distinguished himself in illustrating the volume. The rapidity with which the 'Spirit' is printed on a double Napier press, worked by steam, prevents our doing justice to the engravings, but those of which we have seen 'proofs' are spirited and graphic in an eminent degree." We can easily understand Porter's enthusiasm for Darley's drawings, for he wanted to sell copies of the book.

Thomas B. Thorpe, the author of the story "The Big Bear of Arkansas," wrote Carey & Hart complimenting Darley's designs. Thorpe (1815–1875) was born in Westfield, Massachusetts, and grew up in New York. He studied painting with John Quidor and then studied at Wesleyan University in Connecticut. In 1836 ill health forced him to seek a warmer climate, and he moved to Baton Rouge, Louisiana. There he stayed for twenty years, working

as a painter of portraits and wildlife, a newspaper editor, writer, postmaster, and politician. He contributed frequently to Porter's magazine, as well as to *Harper's New Monthly Magazine, The Knickerbocker Magazine,* and *Godey's Lady's Book.* His various stories were collected and published by Carey & Hart as *The Mysteries of the Backwoods* in 1845.[19] Thorpe saw the two illustrations for John S. Robb's "Swallowing an Oyster Alive" and Johnson J. Hooper's "Simon Suggs and Bill Playing 'Mumble the Peg'" in the *Spirit of the Times* (fig. 3). Although neither of these illustrated Thorpe's stories, Thorpe wrote to Carey & Hart:

> I saw to day the "Spirit" of Mar 22, with the two illustrations of Mr. Porter's sketches. I think them most excellent, and really works of superior art. The one "swallowing the oyster alive" is inimitable. The designs of the works mentioned above are also superior. My residence in the South has placed me behind the times in these matters, and you must therefore pardon my want of knowledge, in the excellence of wood cuts in illustrating fine works.[20]

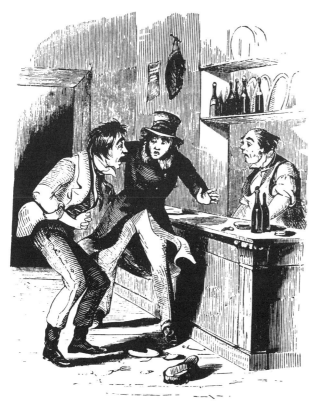

"O gracious!—what'll I do!—it's got hold of my innards already, and I'm dead as a chicken!—do somethin' for me, do—don't let the infernal sea-toad eat me afore your eyes."—*Page 85.*

Fig. 3. Anonymous after F. O. C. Darley. "'O gracious!—what'll I do! . . .'" *The Big Bear of Arkansas,* facing p. 82. 4$\frac{1}{16}$" x 3$\frac{3}{16}$". Courtesy of the American Antiquarian Society.

In an earlier letter, Thorpe had suggested to the publishers that his forth-coming volume of stories be illustrated with lithographs:

> If it is proposed to illustrate these sketches I can furnish illustrations myself drawn from life and consequently correct, a thing not possible when attempted by another artist unacquainted with the peculiar country. I would not, however, make any pictures unless they were engraved at least in the best style of Lithography. Six illustrations could be made on one stone, with a beautiful picture I have in my possession of "Tom Owen engaged in a Bee Hunt" as a frontispiece would complete the series. I do not mean I could draw the pictures on stone, but furnish the paintings to draw them from. If I should undertake this task, which I do not covet, I should expect that the correctness of the pictures would be their chief merit.[21]

A final letter from Thorpe, dated June 12, 1845, overflows with praise for Darley.

> I received some time since, six of the illustrations of the "Big Bear," by Darley. I consider them very fine indeed, remarkably fine and with myself at his elbow to give the exact character of our southwestern scenery, I cannot imagine better illustrating. They are far ahead of any thing ever before published anywhere. As far as I can learn Mr. Porter's volume meets with success, and I believe will create a wish in the public mind for something more of similar writing.[22]

Thorpe's assessment of the popularity of and future demand for these stories was absolutely correct. Carey & Hart also recognized the growing market and continued to publish additional volumes in the same vein.

Hooper also commented on the illustrations that appeared in the *Spirit of the Times* through one of his characters. The conclusion of "Captain Simon Suggs" includes an "autographic letter from Suggs" addressed "to the eddi-tur of the eest Allybammyun, la Fait, chambers Kounty, Al." The letter begins, "Der Johns—Arter my kompliments, &c. I set down to rite you a fu lines consarin of them hoss papers." Here Suggs refers to the *Spirit of the Times*. He suggests that "Johns" continue to send them. He continues:

> The picters is great. That wun bout me and Bill and old Jediar, I faults in only wun purtickler—it's got a punchum fence in the place of a rale one—which I never seed a punchum fence in my life exsept round a garding. Thar is a thing 'sprises me mightly; how in life did the feller as drawd that picter ever see Bill, which has been ded the rise of twenty year? I kin see how he got *my* feeturs on the count of your sendin of 'em on; but Bill's what bothers me! And thar he is, in the picter, with more giniwine nigger in him an you'll find nowadaze in a whole korn-field—owin to the breed bein so devilishly mixed. That uther picter, bout the feller swallerin the aushter, kums nigher draggin the bush up by the root an a most enny thing I ever see. Couldn't you git the printer to make me wun jist like it only about 4 foot squar?[23]

Using the voice of Suggs, Hooper expressed his approbation of Darley's efforts in no uncertain terms. Darley's close observance of the text pleased Hooper, in spite of Darley's error in depicting a fence made out of planks instead of rails.

Mysteries of the Backwoods

The success of the "Big Bear" was so great that Carey & Hart published a collection of Thorpe's own stories later the same year. *The Mysteries of the Backwoods; or, Sketches of the Southwest* had six illustrations by Darley. Carey & Hart anticipated that the volume would sell well and issued four thousand copies in the initial printing. In comparison, the first edition of *Major Jones's Courtship* numbered two thousand copies.[24] *The Saturday Museum* carried a notice of the book. "'The Mysteries of the Backwoods'—why should they not have mysteries as well as Paris?—is the title of a volume just published by Carey & Hart, with admirable illustrations by Darley, which we recommend to general purchase & perusal. It is from the pen of T. B. Thorpe, the editor of the 'New Orleans Commercial Times.' . . . This volume of mysteries contains many capital stories both grave and gay, which cannot be read otherwise than with great interest, both for their intrinsic merit and as illustrations of pioneer life. The pictorial embellishments are likewise admirably executed."[25] Again, the illustrations received praise, and Darley's name was already so familiar that he needed no introduction.

Among the illustrations is one for "A Piano in 'Arkansaw'" (fig. 4), a story that describes the arrival of a piano in the town of Hardscrabble, Arkansas. No one was sure what a piano was or how it looked. Some thought it was an animal! When two curious ladies of the town called, the owner observed, "that it had been much injured by bringing out, that the damp had affected its tones, and that one of its legs was so injured that it would not stand up, and that for the present it would not ornament the parlour."[26] Then two men went to see the piano, for one falsely claimed intimate knowledge of the thing. They entered the house when no one was home and finally found a strange looking object. The moment that Darley illustrated was the unveiling of the instrument. All were astonished, for what the two men earlier had found and described to their cronies was not the piano, but a new washtub with a crank and rollers! Darley focused on the astonishment on the face of Mo Mercer, the alleged authority on pianos in the town of Hardscrabble.

The editorial notice in *The Saturday Museum* mentioned that some of the stories were "grave." Darley was more than a caricaturist, as the illustration of the scene depicting the end of a buffalo hunt suggests. The two white men, "Breeches" and "Bags," hunted buffalo using long poles with blades attached to sever the hamstring of the buffalo, which was shot after falling helplessly to the ground. As one animal was about to be killed in this manner, an Indian arrived from nowhere. Hunting in the traditional manner on

*"She approached the **thick leafed table**, and removed the covering, throwing it carelessly and gracefully aside."—Page 28.*

FIG. 4. Reuben S. Gilbert after F. O. C. Darley. "She approached the thick leafed table, . . ." *The Mysteries of the Backwoods*, T. B. Thorpe, ed. (Philadelphia: Carey & Hart, 1846), facing p. 28. 4¹⁄₁₆" x 3¼". Courtesy of the American Antiquarian Society.

horseback with bow and arrow, the Indian killed the buffalo before Breeches could strike with his instrument. The chase and kill are carefully described in the text, and Darley illustrated the moment when the Indian dismounted. The narrator wrote, "There was a simplicity and beautiful wildness about the group, that would have struck the eye of the most insensible."[27] Darley's illustration is very sympathetic toward the Indian and his way of life (figs. 5, 6). Darley added his own comment to the text by contrasting the noble Indian and the scruffy white men. The Indian's torso was engraved to simulate a piece of sculpture, and he looked like a noble warrior. This was not the first time that Darley worked with such a subject. Some of Darley's earliest book illustrations were for a publication entitled *Scenes in Indian Life*, published in Philadelphia in 1843 by J. & R. Colon. He depicted additional scenes of Indians later in his career when he illustrated the novels of James Fenimore Cooper.

A Quarter Race in Kentucky

The second collection of stories edited by William Porter was published in March 1847. Entitled *A Quarter Race in Kentucky, and Other Sketches*, it has eight illustrations by Darley. *Godey's Lady's Book* carried the following brief review of the volume: "If any person has been so unfortunate as to have a [bank] note protested, and such things will happen in his race after dollars, he will need something to refresh him. Let him read the 'Quarter Race;' it is just the book for that purpose. The illustrations by Darley, are in his usual spirited style."[28] Of all the nineteenth-century periodicals, it is astonishing that only *Godey's Lady's Book* routinely included brief notices on these books of boisterous, and occasionally crude, humor. A female readership for these stories expands the commonly held notion of what literature was suitable for women.

Thomas Kirkman (1800–1864) was the author of "A Quarter Race in Kentucky." An Irishman by birth, Kirkman grew up in Nashville, Tennessee, and in 1821 moved to Florence, Alabama. He became a successful merchant, manufacturer, and plantation owner, and even imported race horses from England. Another of his stories, "Jones's Fight," appeared in the *Spirit of the Times* in 1840 and in *The Big Bear of Arkansas*. "A Quarter Race" appeared in the *Spirit of the Times* in 1836 before being reprinted in this collection of tales.[29] The illustration for the title story shows a group of men and "beasts" preparing for a horse race (fig. 7). The moment that Darley depicted occurs at the beginning of the story when two men, after some bantering, decide to race their horses. As the story continues, bets are made, the race is run, and it is a draw. The narrator is due some winnings, but instead receives a worthless promissory note, alluded to in the brief notice in *Godey's Lady's Book*.

A particularly spirited story illustrated by Darley in *A Quarter Race in Kentucky* is "Cupping on the Sternum." Written by Henry Clay Lewis, a

" There was a simplicity and beautiful wildness about the group, that would
have struck the eye of the most insensible.—*Page* 103.

Fig. 5. John H. Brightly after F. O. C. Darley. "There was a simplicity and beautiful
wildness about the group, . . ." *The Mysteries of the Backwoods*, facing p. 103. 4¹⁄₁₆" x 3³⁄₈".
Courtesy of the American Antiquarian Society.

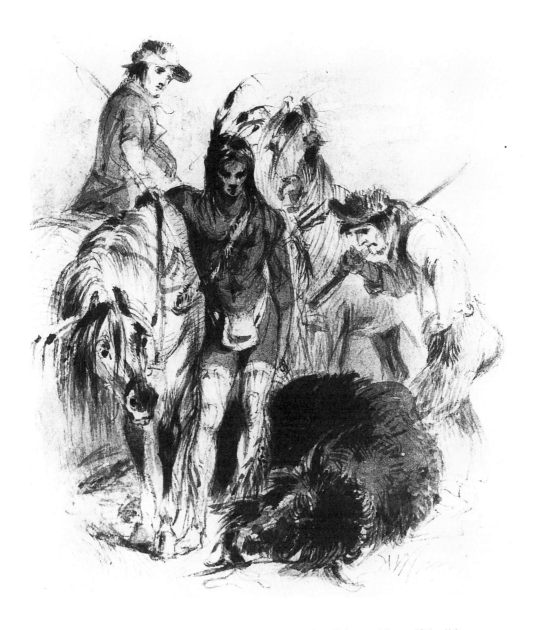

FIG. 6. F. O. C. Darley. Drawing for "There was a simplicity and beautiful wildness about the group . . ."; graphite and wash. 4¹⁄₁₆" x 3¼". Courtesy of the Betsy B. Shirley Children's Collection, Beinecke Library, Yale University.

A QUARTER RACE IN KENTUCKY,

AND OTHER TALES.

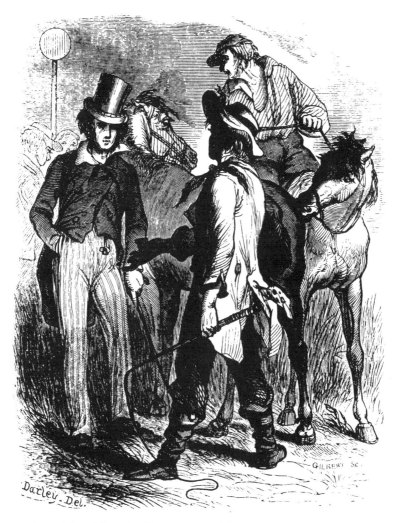

"A rough hewn fellow, who either was, or pretended to be, drunk, was bantering to run his mare against any horse that had ploughed as much that season."

EDITED BY W. T. PORTER, ESQ. OF THE N. Y. SPIRIT OF THE TIMES.

FIG. 7. Reuben S. Gilbert after F. O. C. Darley. "A rough hewn fellow, . . ." *A Quarter Race in Kentucky*, William T. Porter, ed. (Philadelphia: Carey & Hart, 1847). Title page. 4¼" x 3⁵⁄₁₆". Courtesy of the American Antiquarian Society.

young physician on the frontier, the story describes the humorous experience of a medical student who was asked to cup and blister the sternum of a black woman. The story derives its humor from the misunderstanding of the word "sternum." The inexperienced student decides that the sternum is the "stern" of the woman and proceeds to apply his cup to the wrong part of her anatomy. Darley picked a moment of high drama for his illustration—the patient's protestation when told to roll over. "'What!' shrieked she, rising straight up in bed, a great deal whiter in the face than she had been for many a day. "You cup me on de starn! You make de cussed 'cisions in my frame on *dem* parts! Massa young Doctor, tell me, for de lub of prostituted 'manity, is you in airnest? Oh no, cartainly, you is just joking—just making 'musement of de 'stresses of dis female!'"[30] (fig. 8).

Some Adventures of Captain Simon Suggs

The most popular of the books of Southern humor was Johnson Jones Hooper's *Some Adventures of Captain Simon Suggs, late of the Tallapoosa Volunteers.* This book presents scenes in the life of Simon Suggs, from his youth through middle age, when he decides to run for public office. Suggs has been described as "one of the most notorious rogues in Southern literature."[31] Hooper, born in Wilmington, North Carolina, in 1815, trained as a lawyer, then turned to editing a newspaper in LaFayette, Alabama, where he settled to work in his brother's law office. In 1842 he published his first humorous sketch, "Taking the Census in Alabama," in the *East Alabamian.* William T. Porter reprinted the story in the *Spirit of the Times.* Thus encouraged by Porter, Hooper continued to write stories, which eventually were published in two volumes. Carey & Hart commissioned Darley to create ten illustrations for *Some Adventures of Captain Simon Suggs,* for which they must have foreseen a considerable demand, since the first edition numbered at least three thousand copies (fig. 9). Other printings followed, including one in February 1846 of one thousand copies and another in April 1848 of another one thousand copies.[32] The importance of William T. Porter in the emergence of this volume is suggested by Hooper's dedication: "To William T. Porter, Esq. Editor of the New York Spirit of the Times, the Following Pages are Respectfully inscribed, As Well in Token of the Writer's Regard As Because If There Be humour in Them, They Could Have No More Appropriate Dedication."

The literary portrait of Simon Suggs is a self-portrait of Hooper, the author. In his description of the militia captain, Hooper revealed the following about himself:

> His head is somewhat large, and thinly covered with coarse, silver-white hair. . . . Beneath these almost shrubless cliffs, a pair of eyes with light-grey pupils and variegated whites, dance and twinkle in an aqueous humor which is constantly distilling from the corners. Lids

"What!" shrieked she, rising straight up in the bed, a great deal whiter in the face than she had been for many a day: "You cup me on de starn!"

FIG. 8. Gilbert & Gihon after F. O. C. Darley. "'What!' shrieked she, rising straight up in the bed, . . ." *A Quarter Race in Kentucky,* facing p. 186. 4¹⁄₁₆" x 3¹⁄₁₆". Courtesy of the American Antiquarian Society.

ADVENTURES OF

CAPTAIN SIMON SUGGS,

TAKING THE CENSUS, ETC.

Now, continued the old she savage, "them's the severest dogs in this country."
Page 151.

PHILADELPHIA: CAREY & HART.
1845

FIG. 9. Henry W. Herrick after F. O. C. Darley. " 'Now,' continued the old she savage, . . ." Johnson J. Hooper, *Some Adventures of Captain Simon Suggs* (Philadelphia: 1845). Title page. 4⅝" x 7⅜". Courtesy of the American Antiquarian Society.

without lashes complete the optical apparatus of Captain Suggs; . . . But the mouth of Captain Simon Suggs is his great feature, and measures about four inches horizontally. An ever-present sneer—not all malice, however—draws down the corners, from which radiate many small wrinkles that always testify to the Captain's love of the "filthy weed." A sharp chin monopolizes our friend's bristly, iron-grey beard. All these facial features are supported by a long and skinny, but muscular neck, which is inserted after the ordinary fashion in the upper part of a frame, lithe, long and sinewy, and clad in Kentucky jeanes, a trifle worn.[33]

A second illustration by Darley of Captain Suggs, with epaulettes on his "uniform," shows him from the front. His "lithe, long and sinewy" frame is quite evident, as is his down-turned mouth. Curiously, Darley omitted his beard from this illustration.

Pickings from the Portfolio of the Reporter of the New-Orleans "Picayune"

Dennis Corcoran (died 1858) was the author of *Pickings from the Portfolio of the Reporter of the New-Orleans "Picayune,"* published by Carey & Hart in February 1846. Little is known about Corcoran, and he does not appear in the standard reference sources about American or Southern literature. The sketches in his book are generally brief and concern incidents that he observed. These are not "tall tales" of frontier life, but boisterous anecdotes about life in New Orleans. The colorful people and their everyday circumstances described by Corcoran provided rich material for Darley. The illustrations for the volume demonstrate Darley's ability to invent the physical setting for a story when necessary and his willingness to follow the text closely when provided by the author with adequate descriptive text (fig. 10).

The frontispiece, for example, shows a barber confronting his customer in a barber's chair. The customer has a history of not paying for his shaves, and, as the story continues, the barber threatens to shoot him. At this point, the customer calls the police and they end up in court. The dialogue is amusing because of the French accents of the two men, but the anecdote fails to describe either the men or the shop. Darley invented the setting and succeeded in differentiating between the stylish customer and the barber by dressing the barber in short pants and a rumpled shirt (fig. 11).

The illustration for the story, "Tongue vs. Chops," which concerns a woman who accuses a butcher of selling poor quality meat to her, demonstrates Darley's willingness to follow the author's description closely (figs. 12, 13). In this instance, Corcoran described the woman as follows:

A tall, slatternly looking woman, wearing a dingy old silk bonnet which was "knocked into a cocked hat," appeared yesterday before Recorder Baldwin. Her hair hung about "every which way," as if she was preparing to enact the heroine in a melo-drama, . . . The nether end of her garments were covered with a considerable sprinkling of

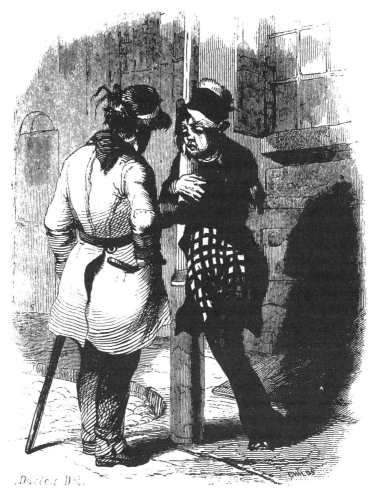

PICKINGS

from the

PORTFOLIO OF THE REPORTER

of the

New-Orleans "Picayune."

"Charley, old feller," said Jim, "I's not what I used to was—I aint myself—I aint nobody—I aint nothing—I wish I was! I have wound up my affairs, and am in a state of liquor-dation."

PHILADELPHIA: CAREY & HART.

1846.

FIG. 10. Benjamin F. Childs after F. O. C. Darley. "'Charley, old feller,' said Jim, . . ." *Pickings from the Portfolio of the Reporter of the New-Orleans "Picayune"* (Philadelphia: Carey & Hart, 1846). Title page. 4¼" x 3¼". Courtesy of the American Antiquarian Society.

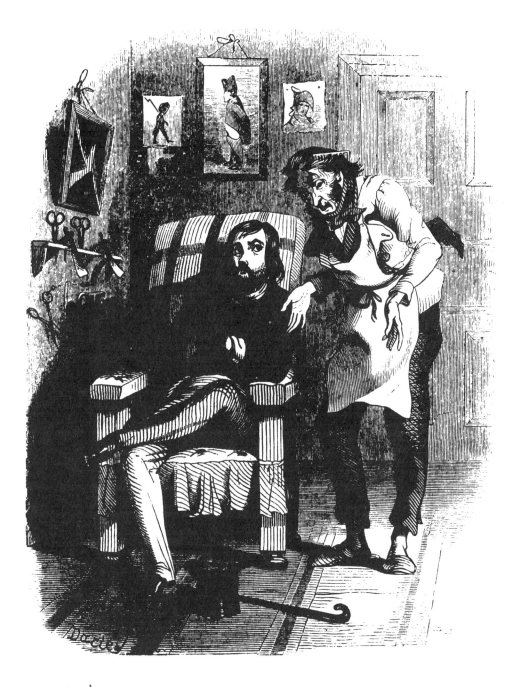

" I shave you one time—you say you pay—I say vera good." (He shrugs the shoulders.)—*Page* 171.

FIG. 11. Anonymous after F. O. C. Darley. " 'I shave you one time . . .' " *Pickings from the Portfolio of the Reporter of the New-Orleans "Picayune"* (Philadelphia: Carey & Hart, 1846). Frontispiece. 4½" x 3⅝". Courtesy of the American Antiquarian Society.

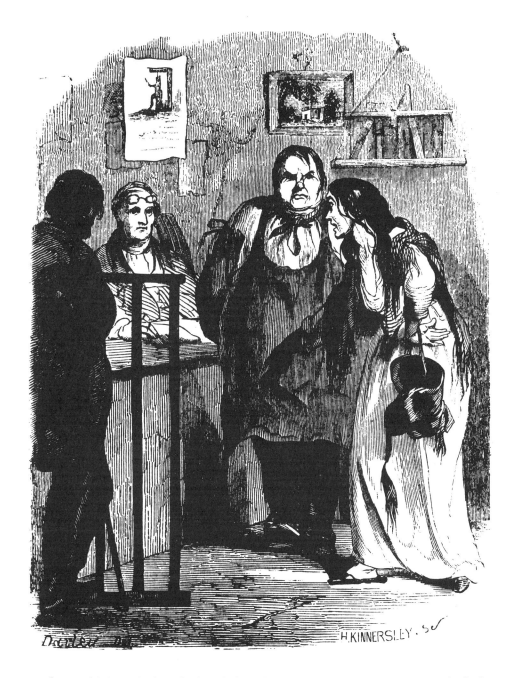

"It was this barrel of packed pork, here," pointing to the butcher, "what kicked up the rumpus."

FIG. 12. Henry Kinnersley after F. O. C. Darley. "'It was this barrel of packed pork, here, . . .'" *Pickings from the Portfolio of the New-Orleans "Picayune"* (Philadelphia: Carey & Hart, 1846), facing p. 73. 4³⁄₁₆" x 3⁵⁄₁₆". Courtesy of the American Antiquarian Society.

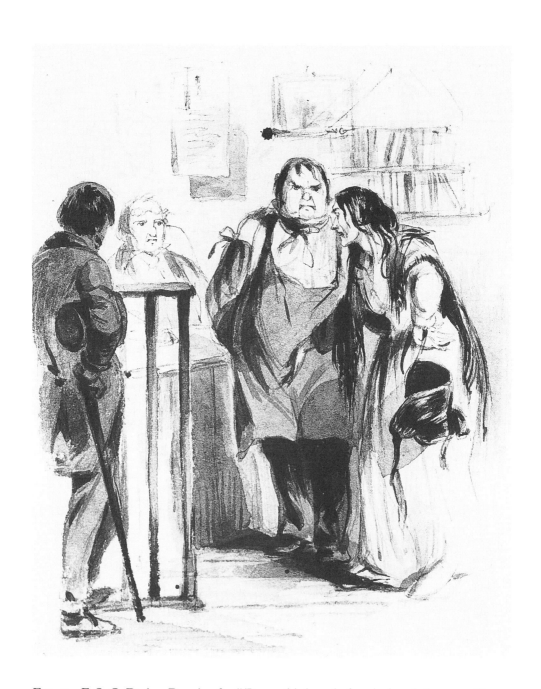

FIG. 13. F.O.C. Darley. Drawing for "'It was this barrel of packed pork, here, . . .'";
graphite and wash. 4⅜" x 3⅜". Courtesy of the Betsy B. Shirley Children's Collection,
Beinecke Library, Yale University.

mud, and her shoes went flap, flap against her heels as she walked along, like the spring-board of a rat trap. She had small peevish looking eyes, concave jaws, and a nose as sharp as a shoemaker's knife.

The rather robust butcher was described as

a man who seems to have devoted a principal part of his life to the science of eating; he was so fat that the fever and ague couldn't touch him with a ten foot pole, his hair was clotted and greasy, his face was red and round, his nose lay in between his cheeks like a parsnip between a pair of beef kidneys, and his eyes were like two newly cast lead balls in a bucket of water. He wore a blue apron, and sleeves fastened on with running strings over the shirt to match; he is as our readers no doubt anticipated, a knight of the cleaver, or butcher.[34]

These rather coarse, but wonderfully humorous, descriptions are matched by the wit and precision of Darley's hand. It seems obvious that Darley enjoyed presenting visually the author's text.

Streaks of Squatter Life

John S. Robb (ca. 1813–1856) made his reputation as the author of "Swallowing an Oyster Alive," one of the stories included in Porter's *The Big Bear of Arkansas*. Born in Philadelphia, Robb wandered the country working as a printer in various newspaper offices before settling in St. Louis, where he worked for the St. Louis *Reveille* under the editorship of Joseph M. Field, another of the humorist-journalists. In 1849, Robb left St. Louis to cover the gold fields of California for the *Reveille*. He began writing humorous sketches in 1844. He collected several of his pieces from the *Reveille* and wrote other pieces that were published in 1847 as *Streaks of Squatter Life, and Far-West Scenes.*[35] Again, Darley translated the author's words into an amusing illustration. The title page vignette presents a Missouri politician known as "Old Sugar," described by Robb as an

old man, apparently about fifty years of age, and clad in a coarse suit of brown linsey-woolsey. His pants were patched at each knee, and around the ankles they had worn off into picturesque points—his coat was not of the modern close-fitting cut, but hung in loose and easy folds upon his broad shoulders, while the total absence of buttons upon this garment, exhibited the owner's contempt for the storm and the tempest. A coarse shirt, tied at the neck with a piece of twine, completed his body covering. His head was ornamented with an old woollen cap, of diverse colors, below which beamed a broad, humourous countenance, flanked by a pair of short, funny little grey whiskers. A few wrinkles marked his brow, but time could not count them as sure chronicles of his progress, for *Sugar's* hearty, sonorous laugh oft drove them from their hiding place. Across his

shoulder was thrown a sack, in each end of which he was bearing to the scene of political action, a keg of *bran new whiskey*, of his own manufacture . . .[36]

This and other illustrations for the stories show Darley's success at precisely portraying characters according to the author's desires (fig. 14).

The Drama in Pokerville

Joseph M. Field (1810–1856) was an Irishman like Thomas Kirkman, the author of "A Quarter Race in Kentucky." He studied law briefly, but settled into a theatrical career that took him to Boston, New York, and New Orleans. He joined the company of Sol Smith and traveled throughout the South. He began writing for the New Orleans *Picayune* in 1839 and went abroad as a special correspondent a year later. In 1844, he helped establish the St. Louis *Reveille*, which occupied him until the newspaper folded in 1850, at which time he returned to the stage. He wrote several plays, but is best remembered for the sketches he wrote for the *Reveille*. The earlier sketches were collected in *The Drama in Pokerville, the Bench and Bar of Jury-Town, and Other Stories,* first issued in 1847.[37]

The frontispiece for *The Drama in Pokerville* illustrates the brief sketch "A Sucker in a Warm Bath," set in New Orleans. The bath was of a new design, with spigots for hot and cold water and a handle for draining waste water. The man hiding behind the door did not understand the machinations of these new inventions, and proceeded to run a tub of boiling hot water that not only overflowed the tub, but burned him as well. He finally had no recourse but to call the proprietress of the bathhouse, Mrs. McTowell, an "Irish lady" whose girth is compared to that of the legendary Falstaff. The poor man, naked, "half opened the door 'fore I recollected about my *cos-toome!* Back went old fatty against the centre-table, and broke a pitcher, and I hopped on to a chair, and into my skin; and then I broke for the opposite bathing-rooms, and locked myself in, and told the old woman I'd give her ten dollars, if she would swob up, hand me my shirt, and say nothing about it!"[38] Darley cleverly captured the scene without exposing too much of the man's naked flesh. It may be that Darley was sensitive to his female readership and the prudishness of mid-nineteenth century society (fig. 15).

"Your turn next, sir" illustrates an anecdote set in a barber's shop in St. Louis. The sketch holds little literary interest, but Darley ably captured the foppishness of the shop's clientele by elongating the legs of the men and creating an elegant silhouette for the departing customer. The narrator has had to wait his turn and describes his impatience very well. Finally, he settles in the upholstered chair with its headrest. "Ah, isn't such a chair a comfort?" He describes being shaved in flowing terms and continues, "If you would subdue your enemy, put him into a soft chair and shave him! How the strings about your heart relax! No more straining and tightening; thoughts of ease— ideas of charity—they come and go, and now you are on the confines of

STREAKS OF SQUATTER LIFE;

AND SCENES IN THE FAR WEST.

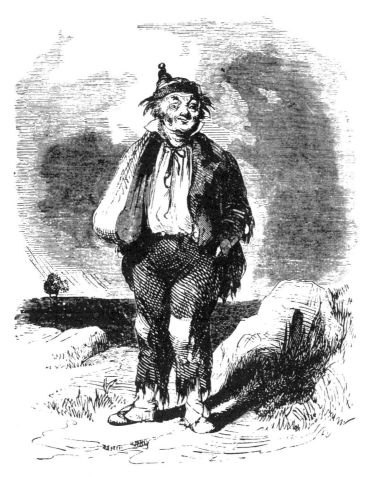

OLD SUGAR: THE STANDING CANDIDATE.—*Page 92.*

PHILADELPHIA:

T. B. PETERSON & BROTHERS.

FIG. 14. Anonymous after F. O. C. Darley. "Old Sugar: The
Standing Candidate," John S. Robb, *Streaks of Squatter Life*
(Philadelphia: T. B. Peterson & Brothers, ca. 1850). Title page.
4¼" x 3⅜". Courtesy of the American Antiquarian Society.

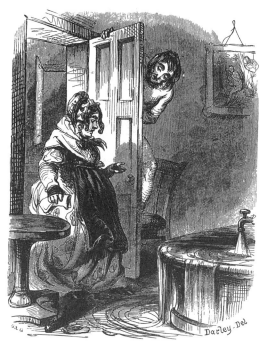

A SUCKER IN A WARM BATH.
"Back went old *fatty* against the centre-table."

Fig. 15. Gilbert & Gihon after F. O. C. Darley. "A Sucker in a Warm Bath," Joseph M. Field, *The Drama in Pokerville* (Philadelphia: Carey & Hart, 1847). Frontispiece. 4⅜" x 3⅜". Courtesy of the American Antiquarian Society.

dream-land!"[39] In this instance, the author provided relatively few details for the setting, but Darley captured the sybaritic nature of the experience as described by Field.

The illustrations by Darley executed for Carey & Hart represent a remarkable accomplishment, particularly given that the artist was at the beginning of his professional career. In the above-mentioned books alone, there are close to one hundred illustrations. And at the same time, Darley was illustrating many other books for Carey & Hart and other publishers in New York and Philadelphia.[40] During this brief period, Darley maintained a remarkably consistent drawing style and demonstrated his ability to work independently of an author's text while still capturing the spirit.

Critical response to the drawings was positive, although the notices that appeared in the popular journals are all too brief. The publishers issued the humorous books with illustrated paper covers and stressed Darley's role as illustrator on the title pages and covers. It seems reasonable to conclude that illustrations helped sell the books. The response to Darley's illustrations by the public and critics was sufficiently positive that Carey & Hart commissioned him to provide illustrations for all eighteen volumes of the *Library of Humorous American Works* issued between 1846 and 1849; succeeding publishers kept the illustrations and texts in print for many years thereafter.

NOTES

1. Contemporary reviews referred to these picaresque novels as "Southwestern humor." In the context of current geography, this paper will refer to it as "Southeastern humor" or merely as "Southern humor." The authors, titles, and years of publication of these volumes are as follows: William T. Thompson, *Major Jones's Courtship* (1844), *The Chronicles of Pineville* (1845), and *Major Jones's Sketches of Travel* (1848); William T. Porter, *The Big Bear of Arkansas* (1845), and *A Quarter Race in Kentucky* (1847); Thomas B. Thorpe, *Mysteries of the Backwoods* (1846); Johnson J. Hooper, *Some Adventures of Captain Simon Suggs* (1845); Dennis Corcoran, *Pickings from the Portfolio of the Reporter of the New Orleans Picayune* (1846); John S. Robb, *Streaks of Squatter Life* (1847); and Joseph M. Field, *The Drama in Pokerville* (1847).

2. Walter Blair, *Native American Humor (1800–1900)* (New York: American Book Company, 1937), p. 62.

3. Delaware Art Museum, "*. . . illustrated by Darley*" (Wilmington, Delaware: The Delaware Art Museum), 1978, pp. 1–6.

4. Contract in the collections of The Henry E. Huntington Library.

5. *Trade List of Books, published by Carey & Hart, Philadelphia*. Broadside dated March 1, 1843, in the collection of the American Antiquarian Society.

6. For a history of the Carey & Hart firm, see the *Dictionary of Literary Biography* (Detroit: Gale Research Company, 1986), Vol. 49, pp. 80–83. Judy L. Larson was kind enough to share with me her unpublished essay "Suggs, Sucker and Sut: A Cast of Southern Comic Characters, 1833–1867," which includes information on the publication history of these books.

7. Hennig Cohen and William B. Dillingham, *Humor of the Old Southwest* (Boston: Houghton Mifflin Company, 1964), p. 121.

8. Carey & Hart Cost Book, Vol. 2, May 20, 1843–June 14, 1845, Edward Carey Gardiner Collection, Historical Society of Pennsylvania (HSP).

9. Darley was paid $70 for ten designs; the cost of engraving was $120. Porter received $100 for his work. The first edition was four thousand copies and an additional fifteen hundred copies were issued in June. Carey & Hart Cost Book, Vol. 2.

10. Letter, William T. Porter to Carey & Hart, F. J. Dreer Collection, Historical Society of Pennsylvania, quoted in Nelle Smither's master's thesis, "Library of Humorous American Works" (Columbia University, June 1936), pp. 7–8.

11. Manuscript letter, William T. Porter to Carey & Hart, The New-York Historical Society, quoted in Nelle Smither, "Library of Humorous American Works," p. 8.

12. Not all commissions were as sympathetic to his talents or as easily completed. Darley wrote to Carey & Hart on April 25, 1849, about a book of poetry edited by Frances Osgood for which he was preparing drawings. He lamented, "Unfortunately for me Mrs. Osgood's poetry is not over suggestive but is easily digested, being of a very light character. Mrs. Sigourney's was rather on the *heavy* side. It certainly makes a charming variety (of course this is all in *confidence*)." Even worse, the two drawings he did prepare for Mrs. Osgood's poetry were lost in transit, and he had to

do another as a substitute. Letter in the Charles Henry Hart Autograph Collection, Archives of American Art Film D5, and letter dated September 10, 1849, from Darley, presumably to Carey & Hart, Pierpont Morgan Library.

13. George C. Groce and David H. Wallace, *The New-York Historical Society's Dictionary of Artists in America, 1564–1860* (New Haven and London: Yale University Press, 1957), p. 81.

14. Groce and Wallace, *op. cit.*, p. 258.

15. Diana Korzenik, *Drawn to Art. A Nineteenth-Century Dream* (Hanover and London: University Press of New England, 1985), p. 29.

16. Information on all these engravers appears in Groce and Wallace's *Dictionary.*

17. William T. Porter, ed., *The Big Bear of Arkansas, and Other Tales* (Philadelphia, 1845), pp. 107–8. The other illustrations mentioned above are in the same volume.

18. *The Knickerbocker Magazine* 25 (May 1845): 470; 26 (July 1845): 94. It is curious how numbers fluctuate. Carey & Hart paid Darley for ten designs, not twelve.

19. Cohen and Dillingham, op. cit., p. 267.

20. Letter dated April 1, 1845. Thomas B. Thorpe to Carey & Hart, Gratz Collection, Historical Society of Pennsylvania.

21. Letter dated March 8, 1845. Thomas B. Thorpe to Carey & Hart, Edward Carey Gardiner Collection, H. C. Baird Papers, HSP.

22. Letter, Thomas B. Thorpe to Carey & Hart, Edward Carey Gardiner Collection, H. C. Baird Papers, HSP.

23. Johnson J. Hooper, *Some Adventures of Captain Simon Suggs* (Philadelphia: Carey & Hart, 1845), pp. 141–42.

24. Darley was paid $44 for the illustrations, and Thorpe received $250 as a copyright fee. Carey & Hart Cost Book, Vol. 3, Edward Carey Gardiner Collection, HSP.

25. *The Saturday Museum,* December 13, 1845.

26. Thomas B. Thorpe, *The Mysteries of the Backwoods; or, Sketches of the Southwest* (Philadelphia, 1846), pp. 22–23.

27. Ibid., p. 103.

28. *Godey's Lady's Book,* 34 (March 1847): 175.

29. Cohen and Dillingham, op. cit., p. 60.

30. William T. Porter, ed., *A Quarter Race in Kentucky, and Other Sketches* (Philadelphia: Carey & Hart, 1847), p. 186.

31. Cohen and Dillingham, op. cit., p. 203.

32. Darley again received just $7.00 for each of the drawings. Carey & Hart Cost Book, Vol. 2, entry for June 16, 1845, and Vol. 3, entry for August 25, 1845, Edward Carey Gardiner Collection, HSP. Six drawings for the volume are located at the Graham Gallery in New York.

33. Hooper, *Some Adventures of Captain Simon Suggs,* pp. 6–7.

34. Corcoran, *Pickings from the Portfolio,* pp. 72–73. The drawing is in the Betsy B. Shirley Children's Collection, Beinecke Library, Yale University.

35. Cohen and Dillingham, op. cit., p. 142.

36. John S. Robb, *Streaks of Squatter Life, and Far-West Scenes* (Philadelphia: Carey & Hart, 1847), p. 92.

37. Cohen and Dillingham, op. cit., p. 96.

38. Joseph M. Field, *The Drama in Pokerville, The Bench and Bar of Jury-Town, and Other Stories* (Philadelphia: Carey & Hart, 1847), p. 102.

39. Field, *Drama in Pokerville,* pp. 171–72.

40. For a chronological list of these titles, see Theodore Bolton's *The Book Illustrations of Felix Octavius Carr Darley* (Worcester: American Antiquarian Society, 1952). Most of the research for this essay was conducted during the summer of 1986 when the American Antiquarian Society granted me a three-month research leave, for which I remain grateful. The Bibliographical Society of America and the American Philosophical Society generously supported this research with fellowships. Finally, I should like to express my gratitude to Betsy Beinecke Shirley for generously sharing with me her drawings by Darley.

DAVID HUNTER STROTHER

MOUNTAIN PEOPLE, MOUNTAIN IMAGES

Jessie F. Poesch

O n Thursday, April 17, 1862, Capt. David Hunter Strother was
encamped near Woodstock, not far from Manassas, serving under
Maj. Gen. Nathaniel P. Banks, commander of the United States
Army of the Shenandoah. It had been a bright day, and Captain Strother
wrote in his diary:

> I got breakfast and rode forward at a trot. The columns of smoke in
> our front showed the Rebels were alert and at their usual work,
> bridge burning. . . . The bridge over the stream at the farther end of
> the village was also burnt . . . The bridge with the turn of the road I
> remembered perfectly and it recalled poetically to my mind how my
> life had been connected with this Valley. In it I was born. The first of
> my boyish exploits which gave me boyish notoriety was my pedes-
> trian tour up this valley with my companion Ranson. Twenty years
> after, I made the tour with three ladies and servant, which journey
> produced the Porte Crayon Papers. And now nine years after, I ride
> in the panoply of war—alone, alone—in the midst of the armed
> hosts. Today the Valley justifies all my praise of its beauty. The
> balmy spring air, the broad green meadows, the rocky crest of
> Peaked Mountain, and the fading range of blue hills invest the scene
> with marvelous beauty. The General seemed enraptured with it and
> never ceased to remark it, even amidst the excitement of the pursuit.[1]

Strother was forty-five years old at the time and had been with the Union army since his enlistment in July of the preceding year. He was initially a civilian topographer, then served for a time with Gen. David Birney. In late February, he was assigned to the staff of General Banks.

During the decade preceding the Civil War, Strother had established himself as one of the best-known writer-artists for *Harper's New Monthly Magazine;* his was often the lead article of an issue. Early on he assumed the nom de plume of "Porte Crayon," and thus often recorded his opinions or reactions in the third person.[2] His semi-fictionalized articles were based on his travels and observations. Each article was illustrated with wood engravings based on his own drawings. Strother resumed his writing and illustrating career after the war, though less vigorously and with less success. In his dual career of writer and artist-illustrator he published over seventy-two articles and over eight hundred identifiable engravings. Though he did not cut the wood for the engravings, in most cases he drew his images on the wood, copying or modifying his original drawings in the process. There is a strong sense of vitality in the wood engravings due in part, surely, to the fact that a different hand was not involved in drawing on the wood. In addition, he did many more drawings and probably over one hundred oil paintings. It was a prolific and productive career.[3] Though almost forgotten now, he was well known in his own lifetime.

Strother was to become known as a humorist, with a fine wit and sense of irony. But as I read and reread his work, I realize that this was a very complex and thoughtful man, sharp-eyed and clear-headed. He was steeped in poetry and literature, which he frequently quoted, and he appreciated the truths about the human condition which poetry can often best reveal. His seemingly simple and straightforward drawings are similarly truthful. His travel writing mixed adventures and amusing incidents with factual information and astute observation. Travel genre enjoyed great popularity in this period. *Harper's Monthly* and other illustrated periodicals regularly carried similar features, though few writers or illustrators were as witty as Strother.

As Strother indicated in the 1862 note in his diary, his entire life was closely connected with his native Shenandoah Valley and its surrounding mountains. For this paper I shall focus on just a few of the texts and related illustrations that deal with Southern mountain people and mountain images.

David Hunter Strother was born in 1816 in Martinsburg, Berkeley County, in what was then Virginia. Until age twelve he studied at the village academy. Having shown an interest in the arts, he was then sent to Philadelphia where he studied for a short time with Luigi Persico, an Italian sculptor and miniature painter, and then with Pietro Ancora, an Italian drawing master,[4] whose pupils included John Neagle and John Gadsby Chapman. This early exposure to traditional academic drawing, though brief, clearly served him well in subsequent years. In 1832–33 he studied at Jefferson College in Canonsburg, Pennsylvania, after which he spent a few years in the desultory study of law

and medicine. In the fall of 1835, he and his friend, James Ranson, made "the pedestrian tour up the valley." It was a memorable five-hundred-mile hike up to the Natural Bridge and across the Blue Ridge into the Virginia Piedmont.[5] In 1836, apparently encouraged by John Gadsby Chapman, he began a two-year period of study with Samuel F. B. Morse, then president of the National Academy and professor of painting at New York University.[6] He returned to Martinsburg in the summers. From the fall of 1838 until the winter of 1839 he traveled, visiting Ohio, Indiana, Illinois, Missouri, and Kentucky. He later wrote, in the third person, that he had spent this time "principally in hunting, fishing, sight-seeing and adventure, exercising his art at intervals, only as it became necessary to replenish his purse."[7] In 1839–40 he had a productive year in Martinsburg and nearby Shepherdstown, producing forty-one paintings.[8]

Both Morse and Chapman, who had traveled together in Italy in 1830, encouraged Strother to study in Europe. Hence, using his own earnings, and with the help of his father, the twenty-four-year-old artist left for Europe in November 1840. He was to spend three years there, first in Paris, then Florence and Rome. In a self-deprecating way he later recorded, again in the third person, that

> Here, as at home, he gave the smallest portion of his time and effort to the specialty he had adopted, but devoted himself mainly to literature, music, and the modern languages. His favorite occupation, however, was the observation of men and manners, to which end he travelled over a great portion of Italy on foot, seeking by-roads, obscure districts, and towns not named in guide books.[9]

He made a number of sketching trips into the Appenine Mountains, visiting the monks at Vallambrosa and nearby mountain villages.[10] Even more ambitious was the two-hundred-mile hike "through the mountains, by a circuitous route, from Rome to Naples," which he and a friend made.[11] In these ways he came to know the peasants and mountain peoples and was able to indulge his love of adventure and of the outdoors.

His letters home were lively, full of acute observations and descriptions. His father recognized their literary value and had them published in the local newspaper. Though he was not to launch his literary career until a decade later, the quality of the writing presaged his future work. Strother did sketch, study, and paint while in Europe. He seems not to have been drawn to the works of the great masters, but to the works of artists such as Leopold Robert (1794–1835) and to G. Dura (ca. 1829–1837).[12] Both of these men produced popular works depicting Italian peasant life.[13]

Strother had difficulty after his return to America in 1843. He was unwilling or unable to develop a career as a portrait painter or as a landscape or history painter, and there seemed to be no other role for an artist to fill. His literary biographer has described the next two years as a "phase of profound

pessimism and cynicism."[14] His friend, John Gadsby Chapman, helped to rescue him. Chapman was now deeply involved in the creation of designs for wood engravings to serve the burgeoning new market for illustrated publications. Later, writing of these years in the third person, Strother noted that

> . . . in 1845 [he] took up his residence in New York where, under the direction of John G. Chapman, he acquired and practiced the art of drawing on wood for the engravers, illustrating a number of tracts, books and pamphlets.
>
> For the next four years, he passed his time between New York and Virginia, dividing his summers between wild sports in the mountains and gay society at the Virginia Springs, and working at the graphic arts during the winter languidly, like one who has not yet found his true vocation.[15]

Sometime around 1850 he was asked by his father's old friend, John Pendleton Kennedy, to do illustrations for a reprint of *Swallow Barn*, which Kennedy had originally published in 1832. The revised 1851 edition carried, on its title page, "With Twelve Illustrations by Strother." Some of the engravings were based on drawings already in Strother's portfolio, while others were prepared apparently to illustrate the text. The frontispiece was based upon a drawing of a barn in Jefferson County, Virginia, owned by a relative named Joe Crane.[16] According to the artist's inscription, the drawing was done in 1847 and 1850, possibly first done in 1847 and then refined, with more subtle shading, in 1850. A beautifully finished drawing such as this proves that his summers had not been spent totally in "wild sports and gay society."

A number of other surviving drawings attest to the fact that he drew with some regularity, maintaining a disciplined control over his art. Among these is a sheet with two pen-and-ink images. Above is a horse in profile and below is a languid young gentleman with tall straw hat, lounging on a cushioned cot (fig. 1). The artist has inscribed "Berkeley Springs Va / August 1846" below the latter. Strother's father ran a hotel in Berkeley Springs, and his son helped him to manage it during the summer seasons.

One of his "wild sports in the mountains" in the summer of 1851 was a hiking, hunting, and fishing trip into the wilderness area around Blackwater Falls in Randolph County, Virginia (now West Virginia), with several friends. The "expedition" was led by Strother and his close friend, Philip Pendleton Kennedy, the youngest brother of John Pendleton Kennedy.[17] The trip was written up by young Pendleton and published in 1853 as *The Blackwater Chronicle*. This now-rare volume included a few illustrations by Strother.[18] These reveal Strother's interest in observing "men and manners." A portion of a page of drawings of "Blackwater Characters" (fig. 2), apparently made while on this expedition, includes two sketches of a gawky, awkward countryman and a sketch of two "fat lawyers." The latter pair were probably among the Eastern fishermen who gathered in the summer and fall at Winston's

FIG. 1. David Hunter Strother. Horse in profile, and young man reclining on a sofa. Sketches inscribed "August 1846" and "Berkeley Springs Va August 1846." Drawings, pencil, ink, and ink washes on ecru paper. 13½" x 9¹³⁄₁₆". West Virginia and Regional History Collection, West Virginia University Libraries.

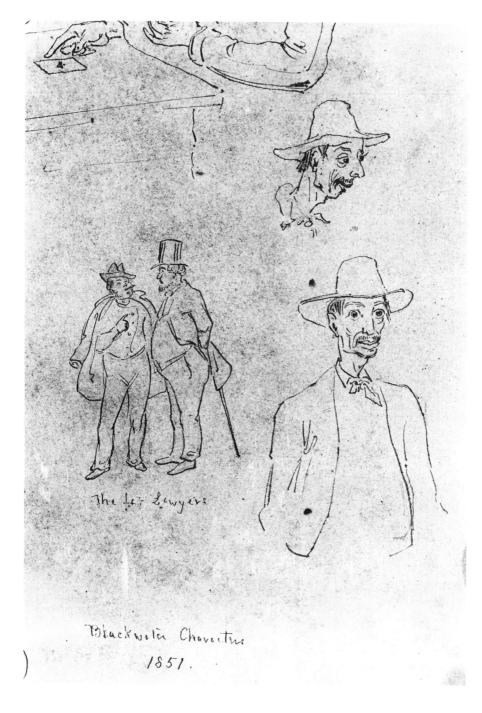

FIG. 2. David Hunter Strother. Sketches inscribed "The fat lawyers" and "Blackwater Characters 1851." Drawings, ink on pale beige paper. Detail from sketchbook page, 10⅝" x 7⅝". West Virginia and Regional History Collection, West Virginia University Libraries.

hotel on the Blackwater River. Another finished drawing of ink, wash, and white body color, dated June 1851, shows a "Hut on the Winston Farm" (fig. 3). This ramshackle structure and adjacent outbuilding seems lovingly rendered. Strother calls the viewer's attention to details like the rough-hewn boards and logs, a woodman's axe leaning against the minimal porch, and harnesses hung outside. A touch of domesticity is suggested by the crude laundry line.

Strother helped to organize a second sporting expedition into the same untrammeled region in the spring of 1852. With the success of his *Swallow Barn* illustrations now behind him, he may already have had the idea of doing some sort of narrative illustrations for publication. At any rate, he clearly made a whole series of sketches and finished drawings. In the early months of 1853 he was in New York and was encouraged by his engraver friend, Charles Edmond, to show his sketches to Fletcher Harper of Harper and Brothers.[19] This prestigious firm then commissioned him to write the story of this expedition and to redraw his sketches on wood blocks for illustrations. This was the beginning of what was to be a long association with Harper and Brothers.

The first issue of *Harper's New Monthly Magazine* was published in June of 1850, with the avowed purpose of providing a "variety of reading matter" accompanied by "many pictorial illustrations" and of creating a journal that "shall make its way into the hands or the family circle of every intelligent citizen of the United States."[20] By May of 1853, at the end of their third year, they were producing a monthly edition of 118,000 copies, and circulation was still increasing.[21] The first few issues feature stories and articles mostly derived from abroad. The editors, however, soon began to include original articles on American subjects, thus providing "at the cheapest price and in the most elegant style, the choicest literary matter, original and selected, which American writers and the pages of current literature will supply."[22] Descriptive, informative, illustrated articles of places near and far—Australia; Cuba; Washington, D.C.; Paris; and Peru—were popular and regular features.

By 1854 there clearly was growing dissension between North and South, and the editors found it necessary to further elaborate their policies: "[The magazine] has subserved no sectional or party interests; and not an article has been admitted into its pages to which any reasonable or just exception could be taken. The strict oversight that has secured this result will still be maintained. The Magazine will, as heretofore, be in all respects National, not Sectional."[23] Strother was an acute observer and tried to remain moderate in his political views. He disliked the fanatical opinions found on both sides.[24] His father was an ardent Federalist, and both shared a strong love of the history of the Republic. Strother was deeply attached to his own region, but his outlook was broad and national, enriched by his travel and his experiences with the sophisticated company he kept at the hotel at Berkeley Springs. In keeping with the magazine's policy, he kept his political opinions out of his articles.

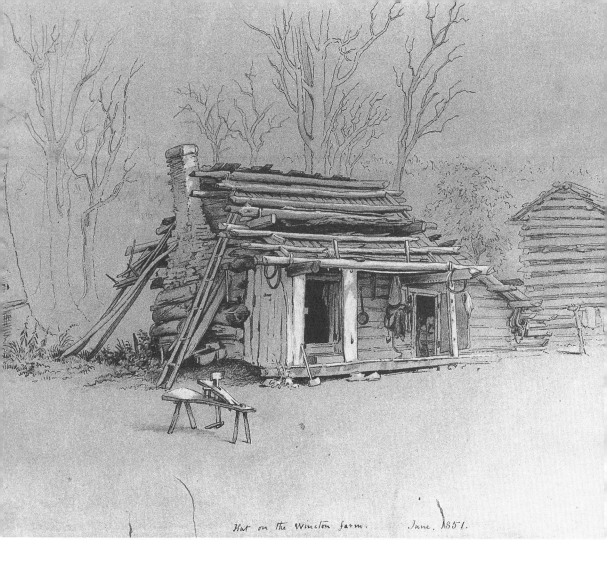

Hut on the Winston farm. June, 1851.

FIG. 3. David Hunter Strother. Inscribed "Hut on the Winston Farm. June 1851." Drawing, pencil, ink, ink washes, and white body color on ecru paper. 9¼" x 12". West Virginia and Regional History Collection, West Virginia University Libraries. This served as the basis for a wood engraving of "Thornhill's Cabin" in Strother's article "The Virginian Canaan" in *Harper's New Monthly Magazine* 8 (December 1853), p. 21. A group of figures was added in the right foreground.

Strother's first piece in *Harper's Monthly,* in December 1853, titled "The Virginian Canaan," was an account of masculine sport during an adventurous hunting and fishing trek with several friends into the wilderness area "from seven to nine hundred square miles, entirely uninhabited" in Randolph County.

The group was composed of six sportsmen, whose names and personalities were semi-fictionalized. They included an "author of some distinction" whom he called Mr. Penn; then one who was "a fine, athletic sportsman"; the third was Mr. Jones, a stout "not to say fat" man who was "equally fond of rural sports and personal comforts"; another was "Mr. Smith, a gentleman of imposing presence, of few words"; the fifth was X.M.C., an ex-member of Congress; and the sixth was Porte Crayon, the artist-author.[25] They were joined by two mountain men who served as guides, Thornhill and Conway. Strother made a drawing of Conway, which appeared as an engraving, showing Conway seated astride a log, jackknife in hand (fig. 4). In his writing Strother was never strong on plot or structure, but was adept at visual and verbal descriptions. Of Conway he wrote:

> Conway was the most accomplished of woodsmen: small in stature, narrow-shouldered, and weasel-faced—insensible to fatigue, to hunger, or the vicissitudes of the weather, a shrewd hunter, a skillful fisher, unfailing in resources, he was ready in every emergency. He could build a comfortable house and furnish it in a day, with no other material than what the forest afforded, and no other tools than his ax and jack-knife. Nor was he destitute of the arts of civilized life. He could mend clothes and cobble shoes with surprising dexterity; and any one who has visited his cabin may have observed an old fiddle hanging beside his powder-horn and pouch. When in camp his pipe was never out; he smoked before and after meals, when at work and when idle. He talked but little, but occasionally told a quaint story of his hunting adventures, or cracked a dry joke; and the sharp twinkle of his gray eye, when any thing humorous was in question, showed the keenness of his appreciation of good-natured fun.[26]

On one of the rainy days in camp "Old Conway, with his jack-knife, passed his time in manufacturing wooden spoons, plates, and water-tight baskets."[27] Here is a prototype of one of the storytelling, fiddle-playing, self-sufficient woodsmen-craftsmen who were "rediscovered" in the 1920s by Allen H. Eaton, social workers, folklorists, and subsequent generations of scholars, and memorialized beautifully in Eaton's landmark study, *Handicrafts of the Southern Highlands,* first published in 1937.[28]

Thornhill was the other guide, "an intelligent, energetic, good-tempered fellow." Strother characterized his dwelling as

> . . . a specimen of rural architecture not noticed by Downing, nor characterized by any of the writers on that subject. Porte declared it looked like the connecting link between a hut and a wood-pile. But,

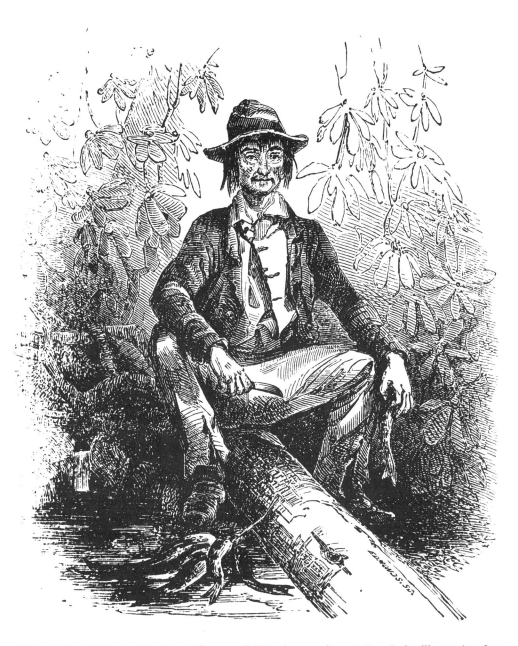

FIG. 4. David Hunter Strother. "Conway." Wood engraving. 3⅞" x 3". An illustration for Strother's article "The Virginian Canaan" in *Harper's New Monthly Magazine* 8 (December 1853), p. 22. Howard-Tilton Library, Tulane University.

like the pearl in the oyster, the gem of disinterested hospitality is found as frequently in these humble abodes as in the proudest mansions of our good old State.[29]

No single picture of Thornhill is included among the illustrations, though Strother had made a sketch showing him as a quiet figure seated on the ground. The dwelling, that cross between a hut and a woodpile, was illustrated on page 21 in his article. For this he used his 1851 drawing (fig. 3), adding a large tree stump and a group of figures in the foreground. The reference to Downing shows Strother's awareness, and that of his readers, of what was being talked about in architectural circles.[30]

In a dramatic yet absurd episode of "The Virginian Canaan" Strother provided a vivid description of the Falls of the Black Fork of Cheat River. This came in the middle of his narration of how he and his companions straggled and struggled through the stream, only to slip into an unexpected chasm:

> Into this abyss the wild stream leaped, falling into a black pool scintillating with foam and bubbles. Here it seemed to tarry for a moment, to gather strength for another and more desperate plunge; then another and another, down! down! down!—and down went the explorers, shouting, leaping, sliding, tumbling, catching the spirit of the scene, until they seemed as wild and restless as the torrent. Tarry upon this shelving platform of rock and look up. A succession of silvery cascades seem falling from the clouds; the pines we saw beneath our feet, now rise clear and diminuitive against the blue sky. Below the stream still pours down the yawning chasm. We can see it foaming far down, until rock and trees are dim in the distance.[31]

They reached bottom by treacherous maneuvers over a fallen tree branch, then by grabbing rhododendron thickets and sliding down yet another fallen log.

One calamity followed another. Pridefully, two of these gentlemen sportsmen had equipped themselves with the finest of fishing rods, "superbly balanced; . . . the very thing for brook-fishing."[32] But when they took their fine rods out of their elegant cases, "Smith's foot slipped, and he came down upon the point of his rod, splintering it to the last joint. Penn had a magnificent fling, but having forgotten to attach his line to the reel, three of the joints went over the falls."[33] Capturing the unfortunate, yet humorous, moment, Strother made a finely finished drawing (fig. 5) that served as the basis for the wood engraving used in the text. In it he catches something of the beauty of the falls. At the same time, the figures of the two sportsmen are near caricatures. The spindly Penn shows consternation as his fine rod falls apart, while the overweight Jones flounders in the water. In addition to the adventurous story, Strother's text and pictures informed his readers of an area of America unfamiliar to most of them.

On yet another day they worry and mourn when they think they see the body of poor Penn, who had been out fishing, tumbling in the falls: ". . . he's

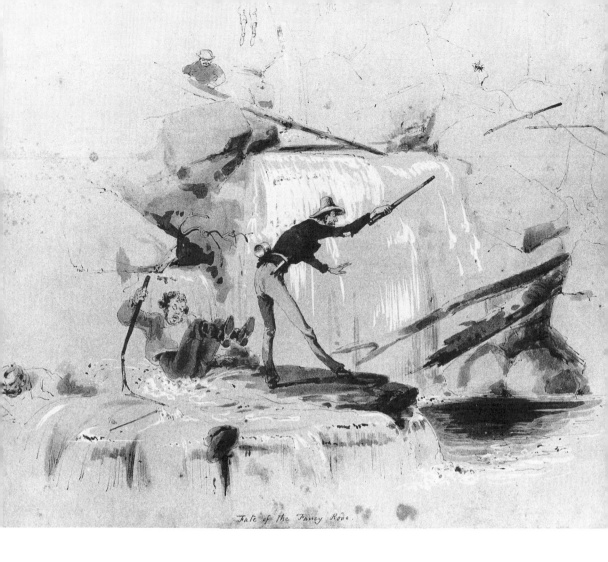

Fig. 5. David Hunter Strother. Inscribed "Fate of the Fancy
Rods." Drawing, pencil, ink, and ink washes with white body
color on ecru paper. 9½" x 12⅛". West Virginia and Regional
History Collection, West Virginia University Libraries. This
drawing served as the basis for a wood engraving in Strother's
article "The Virginian Canaan" in *Harper's New Monthly
Magazine* 8 (December 1853), p. 30.

over the falls, he's gone." When, somewhat later, he appeared "all forlorn and dripping," X strikes an attitude and greets him with a parody of Hamlet's address to the Ghost of the King, in Act I, Scene IV:

> A ghost of shreds and patches. I'll call thee Penn.
> Oh answer me, let me not burst in ignorance; but tell
> How many fish you've caught—and where's the otter?[34]

This is frivolous material, and literate material. (No citation to Shakespeare or to the title of the play was deemed necessary.) If Strother is, by twentieth-century standards, both prolix and perhaps too literary, one realizes that *Harper's* general readers were sufficiently well-read to appreciate his many literary asides, asides folded here into a tale of sport, eating bread and bacon, hard climbs, unsuccessful hunts, rainy days, and slippery streams.

At the beginning of this article, the first of his for *Harper's Monthly*, he had put forth a disclaimer about his abilities that was to catch the tone of most of his work. Referring indirectly to himself as Porte Crayon, he wrote:

> The sprightly sketches which illuminate this unskillful narrative . . .
> shall be the only introduction to our friend PORTE CRAYON. He
> has rendered the subjects with great truthfulness, and has exhibited
> even some tenderness in the handling of them. If he has nothing
> extenuated, he has, at least, set down naught in malice. Porte,
> indeed, modestly remarks that his poor abilities were entirely inade-
> quate to do justice either to the sublimity of the natural scenery or
> the preposterous absurdity of the human species in that memorable
> expedition.[35]

It is fair to say that, in his many articles and illustrations, Strother was seldom, if ever, to show malice, though he had a strong sense of irony. His affectionate yet objective view of humankind enabled him to see "the preposterous absurdity of the human species." Though proud of the "truthfulness" of his drawing, he was, throughout his life, to express a certain frustration at his inability to capture the "sublimity of the natural scenery."

The "Virginian Canaan" piece was deemed a success by Harper and Brothers. Strother next developed a series titled "Virginia Illustrated, Adventures of Porte Crayon and His Cousins," which included five articles, called papers, published between December 1854 and August 1856. All were based on a trip made in the late fall of 1853 up the Valley of Virginia and into the Piedmont. He was accompanied by three women, his "cousins," one of whom was probably his young wife, another his sister, and the third, "Doris Dimple," possibly a cousin. There was also a tall, portly Negro driver, called Little Mice.[36] Strother's depictions of his female companions, gentle middle-class women, are less individual than those of other people whom they encountered, and, as with all of his subjects, are sometimes shown as figures of fun. All are given fictitious names, as in "The Virginian Canaan," but the narrative is only a slightly fictionalized account of their experiences. This is a

more sedate journey to which the women readers could relate more easily. The episodes are entertaining, but also informative about the people and the places of the region.

In Strother's illustrations to *Swallow Barn* he had already established a reputation for his renderings of Negroes, albeit they were pictured as white people saw them, as faithful retainers.[37] As a native of the upper South, he had grown up with black acquaintances and slave servants, knew them as individuals, and accepted the status quo. Though there is evidence that by 1849 he questioned the economic viability of the slave system, he was not an abolitionist. Strother was typical of many white men of the 1850s, North or South, who doubted that the average Negro had the potential ever to acquire the intellectual, economic, or social status of white people.[38] In the "Virginia Illustrated" series Strother depicted a number of blacks who lived in the mountain regions of Virginia. Though his portrayal of blacks often showed them in stereotypical roles, he nonetheless captured them as individuals, men and women of the working world. One example is in the second paper of the series. There is a large wood engraving of "The Wagoner" (fig. 6), a specific individual who had attracted Strother's attention and who must have posed for a drawing. The text makes only a passing reference to their meeting "a lonely teamster" who greeted them with a characteristic salute—"a crack of the whip."[39] In the engraving the clothing was precisely observed, right down to the gloves, kerchief, and shoes. Though only incidental to his story, Strother used the engraving to illuminate the context of the article. Picture and text are intertwined. Other portraits were more directly related to his stories. In comparing Strother's work with other artist-writers for *Harper's Monthly*, I find it is these portraits of individuals that distinguish his work. Most illustrators working for Harper and Brothers did landscapes or anecdotal sketches, but few others succeeded as much as Strother in bringing a sense of specific people to the pages of the magazine.

One suspects that sometimes Strother developed his stories around drawings in his portfolio which he particularly liked. A good example of a drawing which apparently inspired a story can be found in a sketch of a black cook and a verbal description of her. In the fourth article in the "Virginia Illustrated" series, Strother described bringing squirrels he had shot to the woman in a house where they had stopped for a meal. "I have just seen the cook; not merely a black woman that does the cooking, but one . . . whose skill is not of books or training, but . . . who flourishes her spit as Amphitrite does her trident, whose ladle is as a royal sceptre in her hands, . . . who brazens her mistress, boxes her scullions, and scalds the dogs."[40] The wood engraving illustrating this text was based on a drawing in his portfolio of an acquaintance in Berkeley Springs, a drawing which, his notation indicates, he had commenced in 1853, but "Completed Decem. 2nd 1873" (fig. 7). (From this and similar notations we learn how he reworked some of his drawings in old age.) In the engraving, as was often the case, Strother added the setting

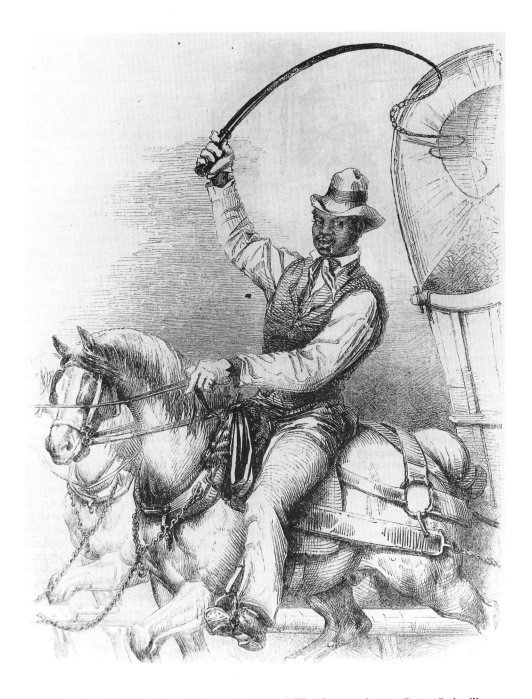

FIG. 6. David Hunter Strother. "The Wagoner." Wood engraving. 5⅞" x 4½". An illustration for Strother's article "Virginia Illustrated, Second Paper" in *Harper's New Monthly Magazine* 10 (February 1855), p. 300. Howard-Tilton Library, Tulane University.

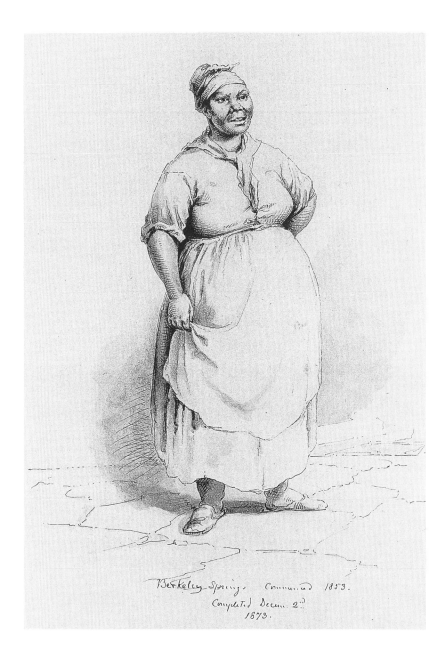

FIG. 7. David Hunter Strother. A woman cook or servant. Inscribed "Berkeley Springs Commenced 1853. Completed Decem. 2nd 1873." Drawing, ink, and ink wash on pale beige paper. 10¾" x 7½". West Virginia and Regional History Collection, West Virginia University Libraries. This was used as the basis for a wood engraving titled "The Cook" by Strother, illustrating his article "Virginia Illustrated, Fourth Paper" in *Harper's New Monthly Magazine* 12 (January 1856), p. 177. A kitchen setting was added to the engraving.

For this typical rural kitchen, he introduced a grill in front of the fireplace, a chain for a spit, and pails for water on a simple table.

Strother's feeling for the individuality of blacks is made explicit in a statement that appears in a later essay published in December 1858. He told of a comment he had heard some time ago by an Irishman who had arrived "in one of our Southern cities" and had lost his trunk. When asked how it happened, the newcomer replied that a "big black nagur" had taken it. When then asked if he would know the man if he saw him, the Irishman replied, "There was a hundred of thim; and how can ye tell one nagur from another any more than ye can tell one sheep from another." Strother then made his own comment: "Those unacquainted with the *personnel* of the peculiar institution are apt to think like the innocent Paddy; yet we are not sure but the African face presents as strong and remarkable varieties of character as that of the Caucasian."[41] He then described and illustrated two very different-looking black men and three white men, each of singular appearance.

Strother's particular kind of conservatism, a love and admiration for the accomplishments of the American Revolution and for the whole nation, led him to join the Union army. In a passage in his "Personal Recollections of the War," based on his Civil War diaries and published in 1867, he showed insight into the feelings and perceptions of the Negroes, and a recognition of the blindness to those feelings on the part of whites on both sides of the line. In 1862 he had noted in his diary that, when the Federal troops were loosing skirmish after skirmish, he had had difficulty finding a white man in the Charlestown area willing to gather information behind the lines, for fear they would be spotted by the Rebels. He noted that though the Confederates watched every white man's actions with "a most jealous scrutiny, the negroes were permitted to run hither and thither as if they had been merely domestic animals not fit to eat." Strother continued his comment:

> This was the Southern theory . . . Yet singularly enough, the negro in his simplicity, his unlettered ignorance, his servile seclusion, seemed to have clearer and more comprehensive views of the upshot of this great question than either of the free, educated, and enlightened contestants. Blinded and inflamed by the madness of partisan politics the white man spurns away the patent facts that encumber his path . . . , taking counsel only of his excited passions or conceited theories. The humble negro, gathering crumbs from his master's table, finds enough to satisfy him. There is scarcely an officer in our division who will acknowledge or believes that he is warring for the abolition of negro slavery. The Southern people, on the other hand, talk and act as if they had no idea that such a thing could be accomplished by any power human or divine. . . . The negro knows this war is for his liberation, and has implicit faith in its accomplishment.[42]

He illustrated this passage with a discerning engraving showing a black waiter standing quietly, while white diners in the background are talking as if

the waiter were not there (fig. 8). The caption reads, "How the Idea Got into Their Heads," implying that the thoughtful waiter had listened and understood, better than the diners, the import of the issues and events of the war that would lead to freedom for slaves. Though some of Strother's depictions of blacks were caricatures—as were some of his depictions of whites—this is not one. It suggests the difficult role of a thoughtful, intelligent black during the era of slavery.

Strother's various expeditions provided him with a wealth of material about the upper South and its people. In the "Virginia Illustrated" series he told how he and his traveling companions visited towns and institutions in the Valley of Virginia and the adjacent mountains. He illustrated the imposing and handsome neoclassical and Greek Revival structures, such as the Asylum for the Deaf and Dumb near Staunton, which appeared in *Harper's Monthly* (February 10, 1855, p. 290). He documented these structures and,

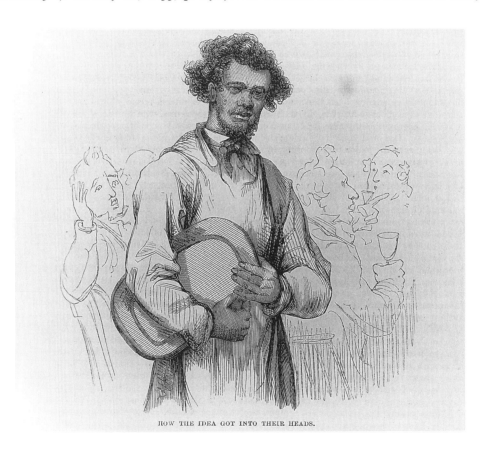

HOW THE IDEA GOT INTO THEIR HEADS.

FIG. 8. David Hunter Strother. "How the Idea Got into Their Heads." Wood engraving. ⅜" x 4½". An illustration for Strother's article, "Personal Recollections of the War, by a Virginian. Fifth Paper," in *Harper's New Monthly Magazine* 34 (January 1867), p. 177. Howard-Tilton Library, Tulane University.

Miss Katie Shackluyt.

FIG. 9. David Hunter Strother. A country cottage. Inscribed "Miss Katie Shackluyt." Drawing, pencil, ink, and ink washes on light beige paper. 9⅛" x 12". West Virginia and Regional History Collection, West Virginia University Libraries. This was used as the basis for a wood engraving by Strother published in *Harper's New Monthly Magazine* 13 (August 1856), p. 315, titled "Private Entertainment." Figures, horses, and a carriage were added to the engraving.

in so doing, informed his readers about the architecture of the region. At the University of Virginia he found that the ensemble of buildings had "a very pleasing and pretty effect, but the buildings are too low, and the architecture lacks finish."[43] More to his liking, for he seems to have loved the simpler dwellings of the region, was a house identified in the published text as "Miss Katy Shackley's quaint, old-fashioned cottage," where the party stayed for a night.[44] The preliminary drawing (fig. 9) was elaborated upon by the addition of figures, horses, and a carriage when it was transformed into the wood engraving that appeared in *Harper's Monthly* (August 13, 1856, p. 315).

Strother not only extolled the beauties of the Valley, but told something of the history, recording how the Scotch-Irish and Germans had emigrated from New York, New Jersey, and Pennsylvania into the Valley. Then, bringing it up-to-date, he told of his group's meeting with some contemporary emigrants; they were moving westward to Nicolas County, which one of the emigrants described as the proverbial "land of promise—pleasant, fertile, and abounding in fish and game." The conservative-spirited Porte Crayon was glad that they were not leaving the state: "I don't like the idea of building up new States in the Far West when the old ones are scarcely finished."[45] His engraving of the "Emigrant's Halt" was developed from a drawing of horses

and a wagon. Still other of the panoply of individuals they met included a swaggering student at the University of Virginia who, according to letters home, studied nineteen hours a day, and a group of hunters who walked "with the swinging stride peculiar to the mountaineer." Strother illustrated these men (fig. 10) and described them in some detail:

> Their hunting-shirts and trousers were of mountain jeans colored with hickory bark, but torn, stained, and begrimed with dirt until the original dye was almost invisible. Some wore deer-skin leggings, and carried packs, while every one was accoutred with a wicked-looking knife, a powder horn, and bullet-pouch, and carried at a slope or trail a long rifle.[46]

A dyspeptic valetudinarian (fig. 11) was used to illustrate a description of the Berkeley Springs resort. Here, too, Strother modified an earlier drawing from his portfolio (see fig. 1) to illustrate a nineteenth-century lounge lizard. He reversed the drawing, changed the face of the subject, and added the figure of a black servant boy shown from the rear. Modifications of drawings into engravings, as seen here, help demonstrate the way Strother sometimes modified earlier drawings or combined them with new ones in order to fit the text at hand.

A legendary storyteller, a cattle drover, a country squire, an old lady winding yarn, domestic scenes such as one of his female companions unpacking, as well as scenes of the group's adventures when exploring Weyer's Cave or climbing the Peaks of Otter, are among the many other illustrations to the "Virginia Illustrated" series. Such was the popularity of "The Virginian Canaan" article and the "Virginia Illustrated" series that Harper and Brothers reissued them as a separate book in 1871.[47]

Another characteristic of Strother's writings and illustrations is his technical process. His informative descriptions and illustrations of how things were done in the working world are found frequently in the articles that followed his "Virginia Illustrated" series in *Harper's Monthly,* such as the four articles titled "North Carolina Illustrated" and the seven articles in the series called "A Winter in the South."[48]

An example of this interest in technical processes is found in his descriptions of mining operations in the article about "The Gold Region" of North Carolina, published in August 1857, based on a visit he made in April of 1856.[49] He started this paper with a quotation from a relatively recent article about the discovery and beginnings of the mining of gold in the area west of the Yadkin, between that river and the Catawba, in the rolling hill country of Rowan, Cabarras, and Mecklenburg counties.[50] The illustrations include a general view of the Gold Hill Works, based very precisely on a drawing done during his visit. Strother was shown about by the foreman of one of the working gangs, Matthew Moyle, whom he described as "a Cornish man, a handsome manly specimen of a Briton."[51] Strother made a full-length drawing,

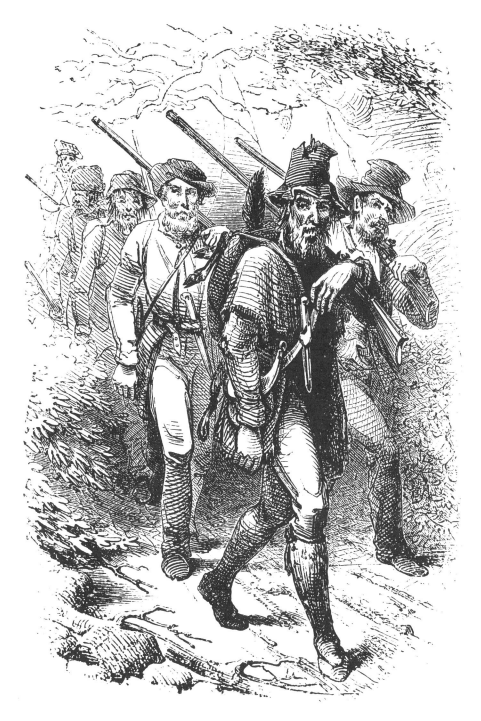

FIG. 10. David Hunter Strother. "The Hunters." Wood engraving. 4¾" x 3". An illustration for Strother's article "Virginia Illustrated, Third Paper," *Harper's New Monthly Magazine* 11 (August 1855), p. 300. Howard-Tilton Library, Tulane University.

FIG. 11. David Hunter Strother. "The Valetudinarian." Wood engraving. 3¹⁵⁄₁₆" x 4½". An illustration for Strother's article "Virginia Illustrated, Fifth Paper," *Harper's New Monthly Magazine* 13 (August 1856), p. 317. Howard-Tilton Library, Tulane University. This is a modification of an 1846 drawing; see figure 1.

showing a standing Mat Moyle holding a pickax and wearing a hat to which a burning candle was affixed with a wad of clay. He did a separate drawing of another miner, Nickey Trevathan (fig. 12). In his engraving, published in August 1857, he combined the two. His text was very specific in the description of the miners' garb. Each wore a coat "with short sleeves and tail, and overalls of white duck," as well as a "round-topped wide-brimmed hat of indurated felt, [which] protected the head like a helmet." Strother was equally specific in describing the details of the ladder shaft with intermittent slippery platforms on it, which he illustrated. Partly tongue-in-cheek, he described his suppressed fears as he agreed to descend "until you reach China" if need be. Reaching the bottom, they proceeded along a horizontal opening, at the end of which "they found a couple of Negroes boring in the rock with iron sledge and auger." Here, too, he made a drawing which later served as the basis for an engraving. They descended still further, and there huddled with a number of Negroes awaiting "the explosion of a number of blasts in the main gallery." When they thought they had seen enough "in these dripping abodes," they decided to reascend. They chose the potentially

Nickey Trevathan
A Cornish man at Gold Hill mines
North Carolina
1856.

FIG. 12. David Hunter Strother. A miner. Inscribed "Nickey Trevathan, A Cornish Man at Gold Hill mines North Carolina 1856." Drawing, ink, and ink washes with white body color on light beige paper. 9^{11}/$_{16}$" x 6^{5}/$_{16}$". West Virginia and Regional History Collection, West Virginia University Libraries. This and a drawing of Matthew Moyle were used as the basis for a wood engraving for Strother's article "North Carolina Illustrated. The Gold Region" in *Harper's New Monthly Magazine* 15 (August 1857), p. 292. In the caption of this engraving the miner's last name is spelled "Trevethan," and the names are reversed.

dangerous but easier method of riding up on the ore bucket. "Moyle . . . encouraged them with the assurance that they did not lose many men that way." Their successful ascent was ensured by the quick action of the Negro, who, when an accident with the pump machinery below had occurred, pulled the signal rope connected with the engine house.[52] Skillfully using text and pictures, Strother informed his readers about the technical processes of gold mining, provided insight into some of the daily perils of the lives of the miners, and also was able to beguile and amuse them. He did not fail to record some pertinent economic and social facts, such as that the Gold Hill Works belonged to a Northern company, that they gave employment to about three hundred persons and seemed to be in a highly prosperous condition, and that Negroes were "found to be among the most efficient laborers."[53] In these comments one can read a subtle indication of some of his political views and perceptions.

As the tensions increased between North and South, Strother found that though he had no sympathy for the abolitionists, he had even less for the secessionists. As with many men living in the border regions, he had to cast his lot with one side or the other, even as close friends and relatives made opposite choices. It was impossible to remain neutral. On July 9, 1861, he offered his services to the Union army.[54]

During the war Strother "served in ten campaigns, twelve pitched battles, and twenty-two actions."[55] At the end he was given the honorary brevet of brigadier general. For a brief time he served as adjutant general of Virginia. Then in May 1866 "he resigned this office and retired to his home at the Berkeley Springs, to recuperate his broken health and fortunes."[56] Between June 1866 and April 1868 *Harper's Monthly* published eleven articles or papers, his "Personal Recollections of the War by a Virginian," a serious and detailed chronicle of his experiences through 1862.[57] A series of children's stories, "The Young Virginians," also set in the mountainous region, came from his pen and was published by the short-lived *Riverside Magazine* between February 1868 and December 1870.

The last notable series he wrote and illustrated was titled "The Mountains," ten articles about the people and places in his beloved home territory, now West Virginia. Published between April 1872 and September 1875, these semi-fictional stories are short on plot and strong on evocative descriptions of the mountains and characterizations of its people. Using a conversational style, he imparted a wide range of information on geography, geology, natural history, and on what today might be called social history or material culture—that is, information about the people of the mountains, their homes, and their lands.

Because he obviously still had on hand a portfolio of drawings made in the productive 1850s, and also no doubt because he was pressed for time and money, he made skillful use of a number of his earlier drawings to illustrate this mountain series. Among these is an illustration of an interior, based on a drawing of Aaron Armantrout's cabin, done July 1, 1854 (fig. 13). It is rich in

FIG. 13. David Hunter Strother. Interior of a mountain cabin. Inscribed "John Cassin, Berney Wolff [his traveling companions] & Strother. Aaron Armantrout's July 1st 1854." Drawing, pencil, ink, and ink washes with white body color on light grey-green paper. 9⅛" x 12⁵⁄₁₆". West Virginia and Regional History Collection, West Virginia University Libraries. This served as the basis for a wood engraving to illustrate Strother's article "The Mountains II" in *Harper's New Monthly Magazine* 44 (May 1872), p. 813. The engraving is a reversed image, and the figure of a woman was added by the artist.

precise visual documentation, including all manner of pots and pans, dishes, a towel with fringed edge, books, an inkwell with quill, and a rifle.

If there was a certain timelessness in simple mountain structures, there was also a timelessness in the appearance and nature of some of the mountain people. An engraving of a loquacious, "seedy-looking" customer at a country store, all too willing to impart unnecessary and incorrect information, was titled "The Schoolmaster," in the May 1872 mountain story.[58] This was based on an April 19, 1859, drawing made at St. John's, Virginia, a railroad stop near Berkeley Springs. An 1857 drawing of his sister Emily (1820–1904) and a friend Mahala, shown well dressed but barefoot, as was no doubt the custom even in middle-class homes (fig. 14), was the basis for an engraving that Strother used to illustrate an episode in which he told of girls who forded a stream on their way to an evening's frolic. He described these girls as "mountain nymphs" who did not overload their appearance with the fashions of the day—"not a hoop, chignon, bustle, panier nor furbelow" was worn by them.[59]

Other drawings of mountain characters were apparently made for "The Mountains" series, showing that Strother's hand was as skillful as before. A full-length drawing of an acquaintance, made in April 1872 (fig. 15), served as the basis for an engraving titled "Jake Nelson, The Volunteer," published in November 1872. The fictitious Nelson, "the dashing bear fighter," in this case had the courage to volunteer to dance with the elegant "Rhoda Dendron," a widow who numbered among the author's fictitious traveling companions.[60]

Because he loved nature, the beauty of the mountains, and the straightforward simplicity of mountain people, Strother was critical of the consequences of "Progress." When he described the start of the trip the group was to make to the mountains, he wrote, "I was anxious to get into the mountains before the steam-horses and bill-posters of our progressive civilization had defiled the temples of Nature, and in time for trout." This was accompanied by an engraving, "The Van of Civilization" (fig. 16), in which two bewildered bears look upon ads, for everything from Bear's Oil to Yeast, painted or carved upon the rocks.[61] On another occasion he described the "virgin freshness" of one of the "vast tracts of primitive forest" through which they were passing. "But on issuing from the . . . verdant archways of nature's temples into a mountain *improvement* one feels as if approaching the lair of some obscure and horrible dragon. Death, desolation and decay are visible on every hand. Skeleton forests, leafless, lifeless, weather-beaten, and fire-blasted; heaps of withered branches; . . ."[62] The word picture Strother painted is more biting than his illustration of a forest clearing with dead and dying trees. Strother used the words of one of his characters, the Major, to explain if not defend the despoiler of the land whom the author had attacked in his diatribe:

> He is, in brief, a representative man among a people who now consider the "destruction of timber" one of the primary duties and leading virtues of our race; but he who has traveled in older countries,

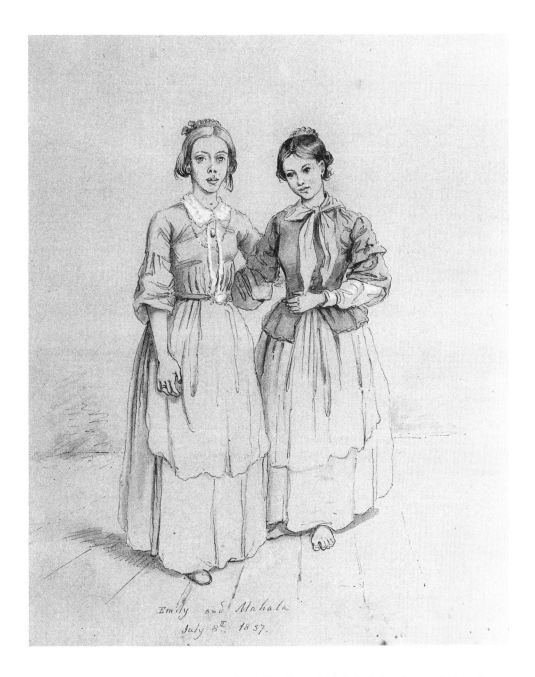

FIG. 14. David Hunter Strother. Inscribed "Emily and Mahala July 8th 1857." Drawing, ink, and ink washes with white body color on light beige paper. 11⁵⁄₁₆" x 9⅞". West Virginia and Regional History Collection, West Virginia University Libraries. This was the basis for a wood engraving titled "Over the Water," used to illustrate Strother's article "The Mountains V" in *Harper's New Monthly Magazine* 45 (September 1872), p. 512. In the engraving the young women are shown only three-fourths length and are carrying their shoes. Background details were added.

FIG. 15. David Hunter Strother. Inscribed "D. H. Strother Rankin Berkeley
Springs April 20th 1872." Drawing, ink, and ink wash on light beige paper.
14" x 20". West Virginia and Regional History Collection, West Virginia University
Libraries. This was the basis for a wood engraving used to illustrate Strother's
article "The Mountains VI" in *Harper's New Monthly Magazine* 45 (November
1872), p. 805. In the engraving the subject is shown only three-fourths length, his
left arm raised over his head, and a few figures were sketched into the background.

and has seen the actual results of this savage wasting, may hope to see the day when the poet's view on this subject will control both politician and people.[63]

In another passage Strother mocks the values which "Progress" asserts:

> . . . why do men till the soil, or delve in mines, or work in factories, or serve their country, but to get the wherewithal to dress their wives and daughters? And what are steamships and railroads built for but to carry produce to market and bring back dry goods? And what are free schools and seminaries established for but to teach the girls to read and understand the patterns in Harper's Bazar?[64]

One could argue that this anticipates Thorstein Veblen's more learned economic theories of conspicuous consumption, first published in 1899.[65]

Strother's engraving of "Civilizing Influences," showing several female bears looking at *Harper's Bazar,* playfully demonstrated his point. Two small vignettes, only indirectly related to the text in another article, in which both highways and byways are mentioned, make a similar point (figs. 17, 18). Contemporary fashion favored "buy-ways" all too much.[66] In this casual visual aside, Strother further illuminated his text and made a sharp comment on the materialism of the 1870s.

During most of the last years of his life, from 1879 to 1885, Strother was employed as the U.S. Consul General in Mexico, yet another role for him. His literary talents were used for official dispatches, letters to his son, and his regular diary entries. He made occasional drawings, and during these late years went over many of his old drawings, annotating and sometimes completing or improving them.

When he died in 1888 the writer of his obituary in *The New York Times* of March 9, 1888, wrote that Strother's nom de plume of Porte Crayon had been "almost a household word 30 years ago when *Harper's Magazine* was embellished by his crayon sketches, and made interesting by his delightful descriptions of Southern life." Strother's work has been largely neglected, in part because the travel narratives he specialized in went out of style, partly because his work is scattered in over fifty monthly journals rather than being found in anthologies or books of the period, and partly because he was both writer and artist; he does not easily fit into the study of one category or the other.

Strother's articles were among the first to introduce the general reader in the United States to the peoples of the Southern mountains and their homeland. His aim was to inform and to entertain. This he did with word and image. His work, designed for popular appeal, represents the result of an unusual combination of artistic and literary talents. A complex man, he was a sportsman and man of action, but also an inward-turning artist-writer who worked alone. Though contemplative, he was not a philosopher. Though capable of being subtly analytical, he was not a political or social advocate,

FIG. 16. David Hunter Strother. "The Van of Civilization." Wood engraving. 4¹⁵⁄₁₆" x 3½".
An illustration for Strother's article "The Mountains I" in *Harper's New Monthly Magazine*
44 (April 1872), p. 671. Howard-Tilton Library, Tulane University.

FIG. 17. David Hunter Strother. "The High Ways." Wood engraving. 3" x 3". An illustration for Strother's article "The Mountains IX" in *Harper's New Monthly Magazine* 49 (July 1874), p. 156. Howard-Tilton Library, Tulane University.

nor was he a gatherer of statistics, though he often presented factual information about the settings he described. Nor was he a novelist who created carefully constructed plots. Nonetheless, he often succeeded in portraying simple, and not-so-simple, truths about the "men and manners" he observed; in so doing he caught or implied truths about mankind on a broader scale, as those who are categorized as humorists are often able to do. His was a broadly tolerant and cosmopolitan point of view. He was aware of human weaknesses and foibles. He was not idealistic, but was realistic and pragmatic, skeptical and

FIG. 18. David Hunter Strother. "The Buy Ways." Wood engraving. 3½" x 3". An illustration for Strother's article "The Mountains IX" in *Harper's New Monthly Magazine* 49 (July 1874), p. 158. Howard-Tilton Library, Tulane University.

sharply observant. As an artist he found his metier in line and tone drawings, translated onto wood for engravings. His vivid visual depictions of individuals were seldom matched in contemporary publications. He earned his living by skillfully combining words with images, both of his own creation, and it is this that makes the best of his work coherent and appealing.

NOTES

1. Cecil D. Eby, Jr., ed. and intro., *A Virginia Yankee in the Civil War. The Diaries of David Hunter Strother* (Chapel Hill: University of North Carolina, 1961), p. 29. This portion of Strother's diary, modified and elaborated, was published by Strother in "Personal Recollections of the War by a Virginian, Sixth Paper," *Harper's New Monthly Magazine* 34 (March 1867), pp. 430–31. For a biography of Strother, with a focus on his literary career, see Cecil D. Eby, Jr., *"Porte Crayon": The Life of David Hunter Strother* (Chapel Hill: University of North Carolina Press, 1960). This is a revised and shortened version of his dissertation, "A Critical Biography of David Hunter Strother ('Porte Crayon')," University of Pennsylvania, 1958.

2. It is possible that Strother's choice of the pseudonym Porte Crayon was a subtle compliment to the talents of Washington Irving, who used the nom de plume Geoffrey Crayon. Strother very probably met Irving in the summer of 1853 when the latter visited Strother's father's hotel at Berkeley Springs, now West Virginia. Strother and Irving shared a common literary heritage, an appreciation of history, and a love of the New World as opposed to the old; thus Strother's literary style and choice of type of subject may owe something to Irving. Eby, Strother's literary biographer, has suggested, however, that "if Strother had any open books on his table while he was writing his own narrative, they were Samuel Kercheval's history of the Valley of Virginia, William Burke's account of the Virginia Springs, and Andrew Burnaby's book of travel." See *"Porte Crayon,"* pp. 70–71, 86.

In a passage in "Virginia Illustrated, Fifth Paper," *Harper's Monthly* 13 (August 1856), p. 308, there is a joking reference to an encounter with someone who mistakes Crayon for Crane. Strother's choice of the name was also possibly a punning reference to his friends the Cranes.

3. For the listing of all of Strother's publications, see Appendix A in Eby, *"Porte Crayon,"* pp. 227–31. Eby omits from this a long, illustrated poem titled "Pompey's Philosophy, Imitated from the French," which appeared in *Harper's Weekly* 2 (April 3, 1858), pp. 212–13. This is not identified as by Strother or by his pseudonym, Porte Crayon, but in the index to the illustrations of this volume, in parentheses, it states: (7 illustrations by Strother). This feature article is atypical of his work in that the illustrations relate to a poem rather than to a prose text, and that the focus is entirely on blacks. In biographical notes apparently prepared by Strother for John S. Hart's *A Manual of American Literature* (Philadelphia: Eldredge & Brother, 1872), p. 458, he indicates that he wrote the verse. I have not located the French source that it purportedly imitates.

Between December 1853 and July 1861 Strother had published twenty-seven articles in *Harper's Monthly.* Of these twenty-seven articles, fourteen were the first or lead article of the issue, and they averaged twenty pages in length. Usually around twenty wood engravings accompanied each article. Some were small vignettes, taking up a portion of a single column, while others ranged from one-fourth to three-fourths of a page in size. By July of 1861, when the last of his prewar articles was published, *Harper's Monthly* had published 410 of his drawings. He had also written

four shorter articles for *Harper's Weekly*, accompanied by twenty-one wood engravings, making a total to that date of 431 illustrations in these two journals.

Between June 1866 and January 1879 he wrote twenty-eight more articles for *Harper's Monthly*, of which eight were lead articles. These varied in length from fifteen pages to twenty-five, and were illustrated with ten or twelve wood engravings each. He also wrote and illustrated a series of children's stories for *Riverside Magazine* between December 1867 and December 1870. These were about seven pages in length and each was usually illustrated with three wood engravings. There were several other articles, including another in *Harper's Weekly* in 1876 and one for *Lippincott's Magazine* in 1879, both of which were illustrated.

There are several other publications listed by Eby, *"Porte Crayon,"* which I have not yet located or examined and which may or may not be illustrated. I believe those mentioned above are the most important. In the count above I did not include the drawings he made for the engravings (or the engravings) he apparently made between the fall of 1845 and 1851 when he worked anonymously for various publishers in New York. See Eby *"Porte Crayon,"* pp. 52–53, 63.

4. For brief biographical information on these artists, see entries in George C. Groce and David H. Wallace, *The New-York Historical Society's Dictionary of Artists in America, 1564–1860* (New Haven and London: Yale University Press, 1957). Biographical data re Strother is from Eby, *"Porte Crayon,"* and from the entry in Hart, *Manual of . . . Literature,* pp. 457–59. The latter is apparently a condensed version of biographical material prepared by Strother for Hart; see Eby, "A Critical Biography," p. 24, n.40.

5. Eby, *"Porte Crayon,"* pp. 17–20.

6. Ibid., pp. 20–21. See also Georgia S. Chamberlan, "John Gadsby Chapman, Painter of Virginia," *Arts Quarterly* 24 (Winter 1961), pp. 378–90.

7. Hart, *Manual of . . . Literature,* p. 458.

8. Eby, *"Porte Crayon,"* p. 28, and family papers.

9. Hart, *Manual of . . . Literature,* p. 458.

10. "Pen and Ink Sketches of an Artist, Number VI," from Florence, April 8, 1841. Published in *The Martinsburg Gazette,* September 30, 1841.

11. "Pen and Ink Sketches of an Artist, Number XI," from Florence, July 15, 1842. Published in *The Martinsburg Gazette,* October 6, 1842.

12. I hope to discuss Strother's years in Europe in another study. Two lithographs by Dura, a little-known Neopolitan lithographer, were among Strother's papers owned by his grandson, the late David H. Strother, whom I visited several years ago.

13. At one point Strother apparently had a collection of engravings, but many of these were destroyed or taken by Confederates who ransacked his home during the Civil War. Strother, "Personal Recollections of the War," *Harper's Monthly* 33 (October 1866), pp. 566–67.

14. Eby, *"Porte Crayon,"* p. 48.

15. Hart, *Manual of . . . Literature,* p. 458.

16. I am grateful to the late David H. Strother II, who, several years ago, allowed me to study and to photograph most of the drawings in his collection. The photographs were taken by Andrei Lovinescu. The drawings have subsequently been acquired by the West Virginia and Regional History Collection of the West Virginia University Library. I am grateful to Dr. John A. Cuthbert, curator, and his staff for

permission to study this collection further and to reproduce the drawings used to illustrate this article. All drawings referred to are in this collection.

17. Eby, *"Porte Crayon,"* pp. 63–66.

18. [Philip Pendleton Kennedy], *The Blackwater Chronicle. A Narrative of an Expedition into the land of Canaan, in Randolph Co. Virginia.* By "the Clerke of Oxenforde." (New York: Redfield, 1853).

19. Eby, *"Porte Crayon,"* p. 68, and Hart, *Manual of . . . Literature,* p. 458.

20. "A Word at the Start," *Harper's Monthly* 1 (June 1850), pp. 1–2.

21. "The Third Year Closed," *Harper's Monthly* 6 (December–May 1852–53), p. ii.

22. "Advertisement—Volume VIII," *Harper's Monthly* 8 (December 1853–May 1854), p. ii.

23. "Advertisement—Volume IX," *Harper's Monthly* 9 (June–November 1854), p. ii.

24. Eby, *"Porte Crayon,"* pp. 57–58.

25. [Strother], "The Virginian Canaan," *Harper's Monthly* 8 (December 1853), p. 19.

26. Ibid., pp. 33–34.

27. Ibid., p. 33.

28. (New York: Russell Sage Foundation, 1937.)

29. [Strother], "The Virginian Canaan," *Harper's Monthly* 8 (December 1853), p. 21.

30. A. J. Downing had made his initial reputation as a horticulturist and a designer and advocate of rural cottages in the 1840s. First published in 1842, his *Cottage Residences* had gone through four editions by 1853. His *Architecture of Country Houses,* first published in 1850, had gone through three editions. In the 1850s both were enormously influential and popular.

31. [Strother], "The Virginian Canaan," *Harper's Monthly* 8 (December 1853), p. 29.

32. Ibid., p. 20.

33. Ibid., p. 30.

34. Ibid., p. 35.

35. Ibid., p. 19.

36. For identification of the members of the party, Eby, *"Porte Crayon,"* pp. 75–78.

37. In his 1851 illustrations for *Swallow Barn,* Strother had pictured black people. His work from 1854 onward regularly included individual portraits of African-Americans. Yet, rather astonishingly, Elwood Parry in his *The Image of the Indian and the Black Man in American Art, 1590–1900* (New York: Braziller, 1974) made no mention whatsoever of Strother's numerous published engravings.

38. Eby, *"Porte Crayon,"* pp. 60–61, describes an 1849 visit of Strother to Tidewater Virginia when Strother expressed doubts of the economic viability of the slave system. See also pp. 78–79, 82, 107, 129, 154–55, and 190–91, re Strother's attitude toward race.

39. [Strother], "Virginia Illustrated, Second Paper," *Harper's Monthly* 10 (February 1855), pp. 299–300.

40. [Strother], "Virginia Illustrated, Fourth Paper," *Harper's Monthly* 12 (June 1856), pp. 176–77.

41. [Strother], "A Winter in the South, Seventh Paper," *Harper's Monthly* 18 (December 1858), p. 6.

42. [Strother], "Personal Recollections of the War By a Virginian," *Harper's Monthly* 34 (January 1867), p. 176.

43. [Strother], "Virginia Illustrated, Fifth Paper," *Harper's Monthly* 13 (August 1856), p. 304.

44. Ibid., pp. 314–15.

45. [Strother], "Virginia Illustrated, Fourth Paper," *Harper's Monthly* 12 (January 1856), pp. 159–60.

46. [Strother], "Virginia Illustrated, Third Paper," *Harper's Monthly* 11 (August 1855), p. 300.

47. [Strother], *Virginia Illustrated: Containing A Visit to the Virginian Canaan, and the Adventures of Porte Crayon and His Cousins. Illustrated from Drawings by Porte Crayon* (New York: Harper and Brothers, 1871). This also contained Strother's article, "The Bear and the Basket-Maker," first published in *Harper's Monthly* 13 (June 1856), pp. 18–25.

48. The "North Carolina Illustrated" series was published in *Harper's Monthly* in vols. 14 (March 1857, pp. 433–50, and May 1857, pp. 741–55); 15 (July 1857, pp. 154–64, and August 1857, pp. 289–300). The "Winter in the South" series in 15 (September 1857, pp. 433–51; October 1857, pp. 594–606; and November 1857, pp. 721–40); 16 (January 1858, pp. 167–83, and May 1858, pp. 721–36); 17 (August 1858, pp. 289–305) and 18 (December 1858, pp. 1–17).

49. [Strother], "North Carolina Illustrated, IV The Gold Region," *Harper's Monthly* 15 (August 1857), pp. 289–300. Eby, *"Porte Crayon,"* pp. 90–93.

50. Strother quotes George Barnhardt, "A Sketch of the Discovery and History of the Reed Gold Mine, in Cabarras County, North Carolina, being the first Gold Mine discovered in the United States," of January 1848, citing Wheeler's history of the state. This is from John Hill Wheeler, *Historical Sketches of North Carolina from 1584 to 1851* (Philadelphia: Lippincott, Grambo, 1851), 2 vols.

51. [Strother], "North Carolina Illustrated, IV The Gold Region," *Harper's Monthly* 15 (August 1857), p. 291.

52. Ibid., pp. 294–95.

53. Ibid., pp. 297–98.

54. For a discussion of Strother's political views and experiences in the years immediately preceding his joining the Union army, see Eby, *"Porte Crayon,"* pp. 103–15.

55. Hart, *Manual of . . . Literature,* pp. 458–59. This text, as noted above, was written in the third person by Strother.

56. Ibid.

57. For an analysis of this, and for excerpts from his Civil War diary, see Eby, ed. and intro., *A Virginia Yankee in the Civil War* (Chapel Hill: University of North Carolina Press, 1961).

58. [Strother], "The Mountains II," *Harper's Monthly* 44 (May 1872), pp. 804–5.

59. [Strother], "The Mountains V," *Harper's Monthly* 45 (September 1872), pp. 512–14.

60. [Strother], "The Mountains VI," *Harper's Monthly* 45 (November 1872), pp. 805–6.

61. [Strother], "The Mountains I," *Harper's Monthly* 44 (April 1872), p. 671.

62. [Strother], "The Mountains VII," *Harper's Monthly* 46 (April 1873), pp. 675–77.

63. Ibid.

64. [Strother], "The Mountains VI," *Harper's Monthly* 45 (November 1872), pp. 806–7.

65. Thorstein Veblen, *The Theory of The Leisure Class* (New York: Macmillan, 1912), especially chapter 7 on "Dress as an Expression of the Pecuniary Culture," pp. 167–87.

66. [Strother], "The Mountains IX," *Harper's Monthly* 49 (July 1874), pp. 156–58.

TWO PERSPECTIVES ON
THE COTTON KINGDOM

"YEOMAN" AND "PORTE CRAYON"

Dana F. White

In "Class and Culture in Modern America: The Vision of the Landscape in the Residences of Contemporary Americans," sociologist David Halle asserts:

> For every period except the modern, we look at art as it was displayed, and as it was seen by the contemporary viewer. Who would think, for example, of medieval art without thinking also of the cathedral and church in which the spectator saw the works? Who would consider the art of ancient Egypt and China apart from the funeral tombs of the aristocracy, for whose use and delight in the afterworld much of it was destined? Who would study Roman art without looking as well at the public monuments that celebrated and demonstrated political power to the populace of the city? In all of these cases we consider art in the context in which it was viewed at the time, and we link its meaning to the material environment in which it was located.[1]

My purpose here is to view the travel accounts of Frederick Law Olmsted and David Hunter Strother as they were seen by their contemporaries. To accomplish this, I shall attempt to relate the verbal descriptions and visual representations of each within the contexts of their stated intentions and their published works. I examine each narrator, in turn, and conclude with a

comparative perspective—a special scene portrayed vividly, each in his best manner, by these two important observers of the antebellum South.

Frederick Law Olmsted

I once had the temerity to suggest to Olmsted's biographer, the formidable Laura Wood Roper, that there were, in fact, two Olmsteds—the lesser-known travel writer and the more famous landscape architect. "There was *never* but one Olmsted," she responded; "it's scholarly diplopia that saw two of him."[2]

Still, in our collective imaginations, there *are* two Olmsteds. The later, and more famous, Olmsted, we must block out: the creator of Central Park, Prospect Park, and the open-spaces systems for Buffalo, Chicago, and Boston; the designer of the grounds of the U.S. Capitol in Washington and of Biltmore in Asheville; the planner of the 1893 World's Columbian Exposition in Chicago; and the designer of the suburbs of Riverside in Chicago and Druid Hills in Atlanta. It is to the other and earlier Olmsted that we must turn: Olmsted the observer, the recorder, and the foremost critic of the Cotton Kingdom.

Frederick Law Olmsted has long been recognized by historians as one of the most influential authorities on the antebellum South. His three-part series "Our Slave States," later condensed into *The Cotton Kingdom*, has been celebrated by historian John Hope Franklin, who maintains that "Olmsted's reports were simply too unique and, indeed, too overpowering for his day and ours to share the spotlight with someone else"; castigated by Agrarian Frank L. Owsley as the work of a man "possessed of unusual skill in the art of reporting detail and of completely wiping out the validity of such detail by subjective comments and generalizations"; admired by historian Clement Eaton as the products of a writer "who is generally regarded as a star witness against the Southern slave system"; and called into question by historian John W. Blassingame because "in spite of the bias charged against him, scholars can still trust Olmsted because he had character" and reputation, glossing over, in the process, some serious questions about his work.[3]

The American South was, in a sense, Olmsted's "first frontier," and it remained always somewhat of an enigma to him in both his social criticism and, indeed, his later landscape design. Although it is true that Olmsted had sailed to Asia and traveled in Europe before his initial venture South in 1852, his writings also suggest that he experienced a minimum of "culture shock" in both instances. In China, he saw little of the land and its people, acquiring there what amounted to a tourist's view of one major port. In Great Britain, as *Walks and Talks of an American Farmer in England* attests, he found, rather than a strange land, a new "home" (fig. 1). And on the Continent, about which we have the least information on record, little, it would seem, impressed him deeply or lastingly enough for him to record it at length and in print. With the American South, it was otherwise.

To begin with, the South occupied, in a variety of ways, Olmsted's time and efforts for much of the period between 1852 and 1866. During these

WALKS AND TALKS

OF AN

AMERICAN FARMER IN ENGLAND.

FIG. 1. Title page, Frederick Law Olmsted, *Walks and Talks of an American Farmer in England* (New York: George P. Putnam, 1852). Wood engraving by J. W. Orr, after Frederick Law Olmsted; 2¼" x 2⅜".

years he visited the region twice; wrote some seventy articles and three books concerning it—*A Journey in the Seaboard Slave States* (fig. 2), *A Journey through Texas* (fig. 3), and *A Journey in the Back Country;* and oversaw the editing of still another book, the previously mentioned *Cotton Kingdom,* the summary volume of his "Our Slave States" series. In addition, he managed, for a time (1855–56), a major antislavery periodical, *Putnam's Monthly Magazine,* and served as co-editor, throughout much of its first year (1865–66), of the still more famous *Nation.* Finally, he served, during the opening years of the Civil War, as secretary general of the United States Sanitary Commission, the civilian arm of the Union forces' medical establishment; contributed to *Hospital Transports,* the account of Sanitary's efforts in the Peninsular Campaign; campaigned for the Union ticket in California during the election of 1864; and provided information favorable to the Union cause to sympathetic British journalists—most notably to E. L. Godkin, his future co-editor of *The Nation.*

During his early childhood, Olmsted's father was wont to pack up the family and set out from settled Hartford, Connecticut, into the mountains of

FIG. 2. "The large majority of the dwellings were of logs, and even those of white people were often without window glass." Frederick Law Olmsted, *A Journey in the Seaboard Slave States* (New York: Dix & Edwards, 1856), p. 385. Wood engraving by Richardson/Cox, after Frederick Law Olmsted; 3¼" x 3½".

New England and on into upper New York State, with young Fred and other siblings perched upon the rears of their parents' horses. Throughout his school years—among the most undisciplined imaginable—young Fred was allowed to wander freely from village to village, from one family friend's or relative's home to another. Later in life, during the middle of the American Civil War, the mature Olmsted would reflect on the consequent "Bedouin nature in my composition."[4]

His first great personal adventure, sailing before the mast to China in 1843, almost certainly sharpened his senses of observation. Following the

example of Richard Henry Dana, and sharing the experiences of his contemporaries, Herman Melville and Charles Nordhoff, Olmsted learned to observe in a new setting. Seamen aboard "ragwagons" during the age of sail had the opportunity to develop special skills of observation and recall. The timeless motion of vessels, the overwhelming surround of sea and sky, and the tedious hours of watch combined to condition, train, or perhaps even create a remarkable generation of writers-observers.[5]

Even before experience and training are factored in, Olmsted's disposition suited him for the role of literary traveler. He possessed, first of all, what Edmund Wilson has described as "extraordinary resourcefulness."[6] In a sense, he was the archetypal Yankee handyman. Then, too, he often seemed a typical Yankee know-it-all. In the preface to *A Journey in the Seaboard Slave States,* Olmsted admitted that if his own writing had "one fault—it is too fault-finding . . . so at the outset, let the reader understand that he is invited to travel in company with an honest growler."[7] For a variety of reasons—personal experience on the road, for most of us, being the most dominant—an "honest growler" usually makes for a better guide than an uncritical booster.

Last, but not least, in this brief catalog of Olmsted's native skills was his ability to convince. Simply put, he was an able advocate. In Volume IV of his

FIG. 3. Frontispiece, Frederick Law Olmsted, *A Journey Through Texas: or, a Saddle-Trip on the Southwestern Frontier* (New York: Dix, Edwards & Co., 1857). Wood engraving by Richardson/Cox, after Frederick Law Olmsted; 5½" x 3⁹⁄₁₆".

edited papers, for example, which covers the Civil War years, his exchanges with his lifelong friend and fellow reformer, Charles Loring Brace, demonstrate Olmsted's powers of debate.[8] Even when Olmsted misjudged the current leadership or military situation, his assaults on Brace were devastating, to the point that, for the reader today, Olmsted's "My Dear Charley" degenerates into "Poor Old Charley" under his correspondent's withering prose.

Not only was Frederick Law Olmsted blessed with the right disposition, skills, and experiences for a travel writer, but he was also a self-conscious observer. Most important for our purposes, his scattered musings about observation enlarge upon both the "what" and the "how to" of observing.

In an 1855 letter to his sister Bertha, who was making her first trip to Europe, her big brother advised:

> Emerson and J. R. Lowell have both been decrying the value of foreign travel; and if everybody travelled as they travelled and as nearly all do travel in these days, they were right. Shakespeare knew better and in his days it was impossible to travel as people do & will now. The great advantage of travel should be, that by it, habits of mind, which do not originate in the will & individual needs, wants and temperament, but in the warping & moulding effect of rigid circumstances, *may* be, and if it is best they should be, will be, if one please, warmed & melted away. Therefore keep home warm in your affections & your recollections, but not in your habits. And the great key to good in foreign travel is to place oneself in situations & circumstances, where one will be most liable to *accidents*. I don't mean disagreeable accidents. To place oneself where (I mean) one does not know *what to expect next*.
>
> ◆ ◆ ◆
>
> You will learn . . . by accident—all you can do is to put yourself in the way of accidents. Strolling the streets without an object leads you unconsciously to it. Looking for nothing, cast your eyes down by accident you will see gold. And this is not true of information alone. The best thoughts come to us unawares; not by study; that is, not directly by study. But if entirely without study, you will not have knowledge enough or strength enough to pick up the gold you stumble upon. But don't let study be the end—only the means. Get provisions on board & use the charts others have prepared, but don't neglect voyages of discovery yourself. It is in the streets & parks, on the bridges & in the omnibuses, in the placards and in the street cries, as much—ten times more—you are to learn as in the classes, at the theatre, in the newspapers & from the professors.
>
> I want you by all means, also, if you can in any way accomplish it, to get out into the country, & when you are there try hard to put yourself in the way of having relations with something beside other *ruralists* merely; try to find (by accidents) what the real people of the country are—the men who are planting beets & thatching cottages and whittling sabots & the women who are tethering cows & carry-

ing water and who go out white-washing & cleaning house. You will never see much of such people when you try to, but you must travel or live or stroll or have a passion for something else which incidentally, when you don't expect, will bring you against such people.[9]

Earlier still, upon returning to America after his English and Continental sojourns with the aforementioned Charles Loring Brace, Olmsted criticized his long-suffering friend's accounts of his observations. As Regionalist Broadus Mitchell has summarized the account:

"To judge from your letters," Olmsted said, "you have seen and learned very little of German *life*—only public and newspaper life, things that any superficial stranger passing through with two letters of introduction and a supply of railroad tickets . . . and an almanack might write." He was sorry that Brace tried to give the impression of being longer resident in Germany than was the case, and that he tried to generalize when he had not the means of doing so. "Why not tell us what you *did, saw,* and *said,* and what was said by others? . . . What's the use of mysteriousizing about and giving us a dim idea." He should rather write letters "domestic and human." "You should be able to state personal interviews, conversations, observations of particular persons and things; personal adventures, usages, superstitions, &c., &c., that would be valuable to Greely himself as well as interesting to Aunt Maria."

◆ ◆ ◆

"Now tomorrow—wherever you are when you get this—walk out into the most uninteresting part of the country, six miles; then ask for the nearest common school house. Remember how it looked, far off and near; go to the door and knock and tell us what wood the door is made of and particularly whether the boys cut it with their knives and if so what they cut. Describe the boy or man that comes to the door. Say every word you say to him and he to you. And then of the master . . . ask leave . . . to go home and dine with him, and tell us everything he says and all about the house and garden and farm and farmer's wife and daughter, or shoemaker or pettifogger as the case may be. And don't talk about government with them, but about their neighbors and who is going to be married and what they think of the minister's wife and the way the choir behaved last Sunday. Do for the sake of human brotherhood do this tomorrow. You can make four or five letters of it . . . and they will be worth all the rest you have written this winter." Brace ought to give more of the "Pedestrian Correspondent's subjects—poor, the working classes. Do walk out and talk with the farm servants, and the waiters, and the soldiers and the beggars." And so Olmsted wanted him to go into Hungary, and tell whether the peasants had board floors to their houses, and glass in their windows, and how the land was held—"facts, not speculations."

Thrown into an Austrian prison, Brace had become fervid on such large subjects as tyranny and democracy in Europe. Olmsted tried to bring him to earth, writing him, "I anticipate your most interesting letters now, describing Austrian prison discipline—size of your cell, weight of your chain, etc.; your conversations with your keeper; how you were fed. . . ."[10]

Years later in 1878, the "retired" travel writer Olmsted provided advice for a novice in the field, Jonathan Baxter Harrison, who intended to replicate Olmsted's travels in the American South:

> There are two ways by which a traveller can get information of the opinions inclinations and tendencies of a population the particular characteristic of which is feebleness of community. One is by taking the judgment of well-informed and leading men, of which there are in the South two classes to be sought. The first by letters of introduction; the second, as Mr. Harrison proposes, by such chance acquaintance as one may hit upon at inns and in public conveyances. Of the latter class my best finds were coarse men with whom I could take a glass of toddy in the bar room. . . . To proceed in this way in the South one should be prepared to stay not only at the inns which are the resort of the farmers, drovers and small country traders . . . in the larger towns, . . . but should do a good deal in the smaller places. . . .
>
> The other process is to get below second hand information by personal acquaintance with the people in their homes. For this a man must go on horseback and take his chances.[11]

Turning again to the work of a contemporary travel writer, Olmsted found fault with the Civil War accounts of William H. "Bull Run" Russell:

> Nothing was more unsatisfactory to me in Mr. Russell's book than his picture of the American on the prairies of Illinois. I knew that it must be incomplete and untrue in its incompleteness from the mere statistics of Illinois, but I thought that there must have been more that was disagreeable and unpromising in the condition of our prairie population than I have before supposed and less that would be agreeable to see than I had imagined, or that so keen, careful and generally good humored an observer as Mr Russell would not have failed to see it. Yesterday was my first day on the prairies of the free states, I am glad to be obliged to think that either Mr. Russell was very unfortunate, or that I was very fortunate in my experience. And yet I saw some of the most disagreeable people and one of the most tiresome landscapes that I ever met with. I saw all that Mr Russell describes so graphically and most of it was as hateful to me as it was to him. But I saw a good deal that he did not see and which would have made his first day on the Illinois Central Railroad much pleasanter if he had seen it.

I will describe some things that I saw.

First; two small, low, very rude, log-cabins, connected by a roof so as to make a third apartment open to the weather and the road on one side; by the side of it a long corn-crib, both standing in the midst of a small (for the prairies) corn-field, in which stood a number of very poor horses and cattle. A man and woman and a number of children were sitting, lounging or moving listlessly in the roofed space or before it. They were ill-dressed, perhaps ragged; dirty and forlorn looking. The picture was very familiar to me and I have described it before. I could swear that man moved to "The Illineyes" from the slave states many years ago; that he has got corn and hogs more than enough, sells enough to buy tobacco, molasses and store-goods, and to warrant not a few visits to one of the dram-shops of which too many were seen by Mr. Russell; that he thinks it's getting too close settled round here, but don't want to go north, and don't want to go back to "a nigger state" and don't find any place in Southern Illinois that is not getting too close settled up to suit him to begin on, so he can't be induced to sell out to his neighbors who would gladly unite to pay him twice the market value of his property to get him to move away from them. I could swear that he has never written a letter in his life; that he takes no newspaper, that he thinks the Vice President is a mulatto, that the President is a despot, that he means to resist the execution of the Conscription Act and to refuse to pay any war taxes; that he thinks Northern and Southern Illinois ought to be two states, and that he hates a Yankee "worse than a nigger"; that he is in short a poor white of the South out of place. There are many such in Southern Indiana and Illinois. He has his good qualities. He helped to drive the Indians away from here, as well as the panthers and wolves. And much as I pity him and his children, if I was obliged to live here on the prairie, I would rather live under his roof than in a wigwam, I would rather be him than to be the savage that I have seen. He has done some work by which others have benefitted as well as himself. He has not the smallest particle of servility; I should not be surprised if he were a member of some church and meant to do God's will, according to his light; and on the whole I must say that I think that the average English agricultural laborer leads even a less enviable life than this poor man on the prairies. He never had any fear that he could not get food for his children or that he might have to come on the parish.[12]

Let us conclude this section on Olmsted's theories of observation with one final, brief, and somewhat uncharacteristic item of self-criticism by "Yeoman": "This is a poor report of the opening of our conversation. I perceive that I have failed to catch the style of General Rosecrans's language, which was in the highest degree direct, forcible and plain, boldly idiomatic and with frequent unhesitating reference to fundamental religious principles, but I have followed my memory of his very words as precisely as possible."[13]

A tally of Olmsted's miscellaneous "rules for the road" would include the following points:

1. Be critical, even to the point of seeming a growler—albeit "an honest growler."
2. Avoid the Grand Tour, the established route, the accepted authorities: "a man must go on horseback and take his chances."
3. Maintain an openness to "accidents"—to the spirit and rhythm of the place.
4. Look and listen. Observe details; add detail to detail; catalog details. Avoid generalization; report the particular—as observed.
5. Know what you are observing—study it, learn it. Develop resourcefulness—better still, "extraordinary resourcefulness."

Such are the imperatives that shaped Olmsted's travel accounts and influenced the illustrations that graced them.

To begin with, the twenty-five woodcuts that illustrate his books—fourteen in *Walks & Talks* (fig. 4); ten in *Slave States* (figs. 5, 6), and one in *Texas*—are, at best, third hand. Concerning the *Walks & Talks* series, we know that Olmsted's original sketches were redrawn by Marryat Field and then engraved

FIG. 4. "Scenery of Salisbury Plain." Frederick Law Olmsted, *Walks and Talks of an American Farmer in England* (New York: George P. Putnam, 1852), opp. p. 139. Wood engraving by J. W. Orr, after Frederick Law Olmsted; 2¼" x 3⅜".

FIG. 5. "We stopped for some time, on this plantation, near where some thirty men and women were at work, repairing the road." Frederick Law Olmsted, *A Journey in the Seaboard Slave States* (New York: Dix & Edwards, 1857), p. 387. Wood engraving, possibly by B. H. or P. D., after Frederick Law Olmsted; 3⅛" x 3⅝".

by John William Orr.[14] Concerning the *Slave States* and *Texas* illustrations, we know nothing, for all of Olmsted's original sketches (including the *Walks & Talks* series) have been lost—probably in a fire at his Staten Island home during the 1860s.

We have evidence, all the same, that Olmsted continued to sketch on his southern tour. In South Carolina, for example, he notes that "I occupied myself in making a sketch of the nursery and the street of the [slave] settlement in my note-book"[15] (fig. 7). It seems safe to assume, then, that the illustrations in his books approximated his initial sketches—remembering always that the woodblock engraver possessed the "editorial power" to add or subtract "details." Given his self-confessed tendency to *growl*—a lifelong propensity: Olmsted *never* showed patience with interference—had any artist-

Fig 6. "I shall not soon forget the figure of a little old white woman, wearing a man's hat, smoking a pipe, driving a little black bull with reins . . ." Frederick Law Olmsted, *A Journey in the Seaboard Slave States* (New York: Dix & Edwards, 1857), p. 415. Wood engraving by Duggan, after Frederick Law Olmsted; 2⁹⁄₁₆" x 3⁷⁄₈".

engraver transformed his sketches beyond his wishes, "Yeoman" could certainly have been expected to *howl*!

Olmsted's illustrations, both of England and the American South, exemplify his "rules for the road." The illustrations are critical, concern the ordinary, include the accidental, provide details, and display their creator's resourcefulness—his grasp of the technical and the specialized. In sum, they supplement his written accounts—no more.

The illustrations for Olmsted's first two travel accounts portray "Our Slave States": south from the denuded tobacco states of Virginia and North Carolina; into the prosperous rice and cotton country of South Carolina; and westward across Georgia, Alabama, Mississippi, Louisiana, and into east Texas—the cotton frontier (fig. 8). And *frontier* is the operative word. For Yeoman ventured south to describe its agriculture, and he found an economy and a culture hostage to the system of chattel slavery. For Frederick Law Olmsted, it was *not* a pretty picture. His words and the illustrations provided to enlarge upon them demonstrate this without question.

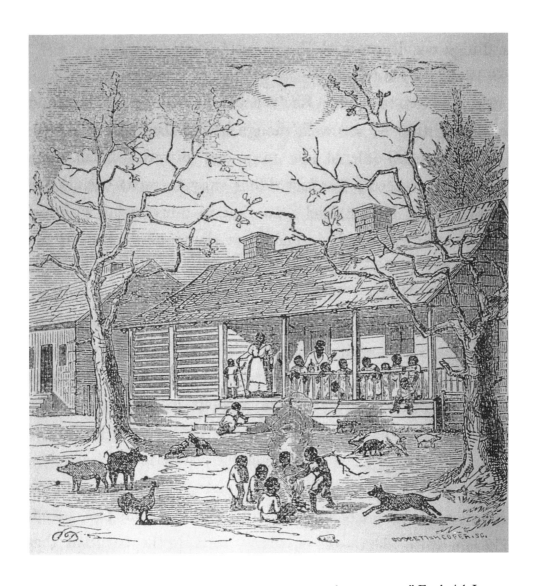

FIG. 7. "The cabin nearest the overseer's house was used as a nursery." Frederick Law Olmsted, *A Journey in the Seaboard Slave States* (New York: Dix & Edwards, 1857), p. 423. Wood engraving by Bobbett Hooper, after Frederick Law Olmsted; 3⅜" x 3⅜".

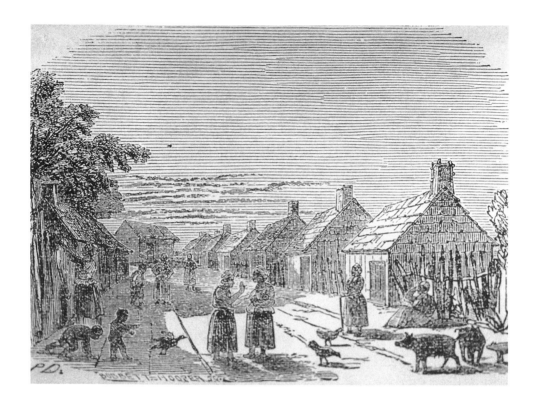

FIG. 8. "I came by chance upon the negro quarters of a large plantation, which were built right upon what appeared to be a public road." Frederick Law Olmsted, *A Journey in the Seaboard Slave States* (New York: Dix & Edwards, 1857), p. 629. Wood engraving by Bobbett Hooper, after Frederick Law Olmsted; 2½" x 3¾".

David Hunter Strother

As Frederick Law Olmsted used illustrations to supplement his verbal descriptions, David Hunter Strother crafted verbal texts to frame his wood-cuts. His immediate artistic ideal and inspiration was America's first major popular writer Washington Irving, whose "Geoffrey Crayon" suggested "Porte Crayon," and whose influence was such that Strother's biographer Cecil D. Eby, Jr., classified his subject as a "Southern Knickerbocker."[16] The disciple developed and mastered his own version of his mentor's "frame story" for his own artistic purposes.[17]

The "frame" for a typical story was the narrative account of "Porte Crayon" and his traveling companions—some combination of male friends, female relatives, and servants. Strother's blending of felicitous prose with arresting drawings created a publishing sensation during the age of "illustration mania."[18]

The Dismal Swamp

Strother and Olmsted were not only contemporaries who traveled the South at the same time, but they also described some of the same places. I shall focus here on one setting, the Dismal Swamp, so as to compare the two, and conclude with some speculations as to why an Olmsted revival (or renascence) took place but a Strother revival did not.

"The Dismal Swamp," which was published in the September 1856 issue of *Harper's New Monthly Magazine,* was a typical Porte Crayon tale that sought to entertain, instruct, edify, and amuse.

It opens on February 2, with a visit from the narrator "P——" to Porte Crayon, who proclaims his intention to venture south: "What though the snow lies deep and the wind howls—spring is coming!"[19] (February 2, of course, is Groundhog Day and, as Crayon's servant "Uncle Jim" notes, the signs suggest deep winter, which, in fact, sets in at once, thus postponing our hero's departure day until March 9.) Crayon determines not to include "the ladies"—his beautiful nieces. P—— concurs, since "besides their exorbitant claims on one's time and attention, it is a confounded tiresome business lugging them along in a narrative, if perchance we should conclude to write an account of your travels in the southern climes."[20] And, of course, "we" will write such an account, an illustrated one to boot, for "without his sketches Porte Crayon scarcely rises above the commonplace."[21]

The travel narrative opens in Suffolk, Virginia, and proceeds rapidly into the swamp, a presence that "has haunted my imagination from my earliest recollection."[22] As the barge bearing Porte Crayon approaches the focal point of the swamp, his bargemen Ely Reed and Jim Pierce, too, anticipate "*the lake*" (fig. 9).

> The bargemen seemed to bend to the poles more vigorously. I was glad to hear them pant, for it sounded like life. With a louder note I again broke forth,
>
> "Oh! when shall I see the dusky lake?"
>
> The perspective lines were run out at last. We turned a reedy point, and a broad sheet of water lay before us. Ely Reed threw up his hand and cried, "The lake!" Jim Pierce yelled, "The lake! the lake!" "The lake!" I shouted, and then quickly relapsed into silence.
>
> The barge was made fast to the shore, hard by the entrance of the canal. I signed to the men to land the baggage, and then, by creeping through the reeds and leaping from tussock to tussock, I got off far enough to be out of sight, and out of the sound of their voices, and seated myself upon a cypress root. There it was—the dream of my childhood fulfilled. It was neither new nor strange. I had seen it a thousand times in my waking and sleeping dreams, as I saw it then; the broad expanse of dusky water with its dim circling shores, the same dark leaden waves rolling over its surface and losing themselves

FIG. 9. "The Barge," *Harper's New Monthly Magazine*, September 1856, p. 444. Wood engraving, after David Hunter Strother; 3⅞" x 4⁵⁄₁₆".

silently among the reeds and rushes. Then those gigantic skeletons of cypress that rose so grandly in the foreground, their wild, contorted limbs waving with weepers of funereal moss, that hung down even to the water. It was complete at all points, a picture of desolation—Desolation. He that is happy, whose love is true, whose debts are paid, whose children blooming, may find strange pleasure in thus fancifully wooing this awful phantom; but when inexorable fate has laid its icy grasp upon the heartstrings, then a man puts this by impatiently, and beckons joy to come—even folly and frivolity are welcomer guests to him.

I have seen the lake, and a life long yearning has been gratified. I have seen the lake, and the romance of boyhood is undisturbed. I have seen the lake, and the recollection still enhances the mournful beauty of the old song.[23] (figs. 10, 11, 12)

FIG. 10. "Lake Drummond," *Harper's New Monthly Magazine*, September 1856, p. 445. Wood engraving, after David Hunter Strother; 4⅜" x 5¾".

After this powerful description of Lake Drummond—or, perhaps, Lake Sublime—Porte Crayon describes his companions, the operations of the Dismal Swamp Land Company, and the work of the slaves employed in the operations—both company owned and hired out. In these half-dozen pages, Strother provides detail (*à la* Olmsted) to instruct the serious reader. After instruction the reader is treated to adventure.

> The desire to eat forbidden fruit and see forbidden sights is the natural inheritance of the human race. Now I had long nurtured a wish to see one of those sable outlaws who dwell in the fastnesses of the Swamp; who, from impatience of servitude, or to escape the consequences of crime, have fled from society, and taken up their abode among the wild beasts of the wilderness. I had been informed that they were often employed in getting out lumber by the Swamp hands, and although I had been told there would be danger in any attempt to gratify this fancy, I determined to visit the spot where the shingle-makers were at work, to see what I could [fig. 13]. I had previously ventured to question my men on the subject, but they

JIM PIERCE.

FIG. 11. "Jim Pierce," *Harper's New Monthly Magazine*, September 1856, p. 446. Wood engraving, after David Hunter Strother; 3⅞" x 2¾".

CAMP ON THE LAKE.

FIG. 12. "Camp on the Lake," *Harper's New Monthly Magazine,* September 1856, p. 447. Wood engraving, after David Hunter Strother; 3⅞" x 4½".

evaded the questions, and changed the conversation immediately. I therefore ordered them back to the boat to prepare dinner, and walked alone along the causeway. When I had gone a mile or more I heard the sounds of labor, and saw the smoke from a camp-fire. I here left the causeway, and made my way with the greatest difficulty through the tangled undergrowth. It is impossible to estimate distance under these circumstances, but I crawled and struggled on until I was nearly exhausted. At length my attention was arrested by the crackling sound of other footsteps than my own. I paused, held my breath, and sunk quietly down among the reeds.

About thirty paces from me I saw a gigantic negro, with a tattered blanket wrapped around his shoulders, and a gun in hand. His head was bare, and he had little other clothing than a pair of ragged breeches and boots. His hair and beard were tipped with gray, and

Fig. 13. "Carting Shingles," *Harper's New Monthly Magazine,* September 1856, p. 450. Wood engraving, after David Hunter Strother; 4" x 4¼".

his purely African features were cast in a mould betokening, in the highest degree, strength and energy. The expression on the face was of mingled fear and ferocity, and every movement betrayed a life of habitual caution and watchfulness. He reached forward his iron hand to clear away the briery screen that half concealed him while it interrupted his scrutinizing glance. Fortunately he did not discover me, but presently turned and disappeared. When the sound of his retreating foot steps died away, I drew a long free breath, and got back to the causeway with all haste. There I sat down to rest, and to make a hasty sketch of the remarkable figure I had just seen.[24] (fig. 14)

The adventure over, the quarry sighted, sketched, and identified by Jim Pierce, it is time to leave the swamp. Porte Crayon returns to the town of Suffolk, where he recounts an amusing anecdote about "a character": "Uncle Alick, a reverend gentleman of color who resides on the border of the swamp," and who has a theological bias against local Irish workmen. The tale ends.

It opened with an amusing scene; proceeded to an edifying spectacle—the sublime in nature; advanced to an instructive account of the local economy; climaxed with the encounter with the "sable outlaw" Osman; and concluded with a final amusing anecdote. All in all, a roller-coaster ride for the emotions—one powered by the woodcuts, especially that of Osman.

But what of Olmsted's Dismal Swamp?

Predictably, Olmsted's narrative is straightforward: it is an account, not a tale. It opens with a physical description of the area, statistics on the products produced, and speculation as to its agricultural potential. But Olmsted's main focus is upon the lumbermen: slaves who, unlike their confreres on plantations, work and live like freemen. Such is the essential lesson of his account: Any degree of freedom alters human action—even for these "quasi freemen."[25]

Like Strother, Olmsted is interested in "runaways in the swamp." Yeoman's account stands in sharp contrast to Porte Crayon's.

Runaways in the Swamp

While driving in a chaise from Portsmouth to Deep-river, I picked up on the road a jaded looking negro, who proved to be a very intelligent and good-natured fellow. His account of the lumber business, and of the life of the lumbermen in the swamps, in answer to my questions, was clear and precise, and was afterwards verified by information from his master.

He told me that his name was Joseph, that he belonged to a church in one of the inland counties, and that he was hired out by the trustees of the church to his present master. He expressed entire contentment with his lot, but showed great unwillingness to be sold to go on to a plantation. He liked to "mind himself," as he did in the swamps. Whether he would still more prefer to be entirely his own master, I did not ask.

FIG. 14. "Osman," *Harper's New Monthly Magazine*, September 1856, p. 452. Wood engraving, after David Hunter Strother; 5⅛" x 4".

The Dismal Swamps are noted places of refuge for runaway negroes. They were formerly peopled in this way much more than at present; a systematic hunting of them with dogs and guns having been made by individuals who took it up as a business about ten years ago. Children were born, bred, lived and died here. Joseph Church told me he had seen skeletons, and had helped to bury bodies recently dead. There were people in the swamps still, he thought, that were the children of runaways, and who had been runaways themselves all their lives. What a life it must be; born outlaws, educated self-stealers; trained from infancy to be constantly in dread of the approach of a white man as a thing more fearful than wild-cats or serpents, or even starvation.

There can be but few, however, if any, of these "natives" left. They cannot obtain the means of supporting life without coming often either to the outskirts to steal from the plantations, or to the neighborhood of the camps of the lumbermen. They depend much upon the charity or the wages given them by the latter. The poorer white men, owning small tracts of the swamps, will sometimes employ them, and the negroes frequently. In the hands of either they are liable to be betrayed to the negro-hunters. Joseph said that they had huts in "back places," hidden by bushes, and difficult of access; he had, apparently, been himself quite intimate with them. When the shingle negroes employed them, he told me, they made them get up logs for them, and would give them enough to eat, and some clothes, and perhaps two dollars a month in money. But some, when they owed them money, would betray them, instead of paying them.

Dismal Nigger Hunting

I asked if they were ever shot. "Oh, yes," he said, "when the hunters saw a runaway, if he tried to get from them, they would call out to him, that if he did not stop they would shoot, and if he did not, they would shoot, and sometimes kill him.

"But some on 'em would rather be shot than be took, sir." he added, simply.

A farmer living near the swamp confirmed this account, and said he knew of three or four being shot in one day.

No particular breed of dogs is needed for hunting negroes; blood-hounds, fox-hounds, bull-dogs, and curs were used, and one white man told me how they were trained for it, as if it were a common or notorious practice. They were shut up when puppies, and never allowed to see a negro except while training to catch him. A negro is made to run from them, and they were encouraged to follow him until he gets into a tree, when meat is given them. Afterwards they learn to follow any particular negro by scent, and then a shoe or a piece of clothing is taken off a negro, and they learn to find by scent who it belongs to, and to *tree* him, etc. I don't think they are

employed in the ordinary driving in the swamp, but only to overtake some particular slave, as soon as possible after it is discovered that he has fled from a plantation. Joseph said that it was easy for the drivers to tell a fugitive from a regularly employed slave in the swamps.

"How do they know them?"

"Oh, dey looks *strange.*"

"How do you mean?"

"*Skeared* like, you know, sir, and kind' o strange, cause dey hasn't much to et, and ain't decent [not decently clothed], like we is."

When the hunters take a negro who has not a pass, or "free papers," and they don't know whose slave he is, they confine him in jail, and advertise him. If no one claims him within a year he is sold to the highest bidder, at a public sale, and this sale gives title in the law against any subsequent claimant.[26]

No adventure here; no romanticizing. Just the facts, and the facts verified: stark facts about one special condition of life. "What a life it must be!" Olmsted rightly lamented, "born outlaws, educated self-stealers."

Two Perspectives—One Renascence

The Olmsted revival has occupied much of my attention over the past two decades and has been the subject of longish articles describing it.[27] Notes for a third piece on this phenomenon occupy a significant space on my shelf of "projects in progress, but as yet uncompleted." I call this particular effort "Huxtering a Hero." But I doubt that I, or anyone else, will ever approach David Hunter Strother in this fashion.

In his preface to *Old South Illustrated,* Cecil Eby expressed the hope "that the present book will reveal to the public the writings and drawings of a man who a hundred years ago was one of our popular and well-known literary figures" and that a revival of interest in said artist would follow.[28] Later in that same essay, Eby attempted to explain "why he is not better known" and, then provided a partial answer to his own question: "because he put his creative energy into two channels, art and literature, rather than one. He became that distressing thing for cultural historians, the anomaly."[29] Perhaps, but another "a" word suggests itself: an anachronism.

As I attempted to demonstrate in my analysis of Strother's "Dismal Swamp," he accomplished much—too much! He attempted, in one short tale, to cover almost the complete range of human emotions for *his readership,* the subscribers to *Harper's.* In that effort, he lost future readers—a century-and-a-quarter's worth.

But let me reserve the final word for Olmsted, who in 1855 advised a correspondent:

> What you want to do for Harper is to write some lively narratives or Life Sketches & send them piquant *illustrations*—anything that is

really new—new in Paris as well as here. I am sure you could strike some rich vein in Paris that has not been opened.

If you have seen Harper, you have seen, at times past, sketches in Paris, street & cafe sketches. They were not very good. I suppose Dick Tinto furnished them. They were not of narrative or continuous interest enough & the illustrations were too much in the Charivari style & that of the light French literature—looked too like copies not from nature but from other woodcuts. The writing was too spotty & there was too great an exertion to point a moral at frequent intervals.

The Porte Crayon sketches are nearer what are wanted, but are too affected & too evidently made for the purpose.[30]

NOTES

1. David Halle, "Class and Culture in Modern America: The Vision of the Landscape in the Residences of Contemporary Americans," *Prospects: An Annual of American Cultural Studies,* vol. 14 (1989), p. 373.

2. Letter dated August 13, 1977, Laura Wood Roper to the author.

3. John Hope Franklin, *A Southern Odyssey: Travelers in the Antebellum North* (Baton Rouge: Louisiana State University Press, 1975), p. xiii; Frank L. Owsley, *Plain Folk of the Old South* (Chicago: University of Chicago Press, 1965), p. 2; Clement Eaton, *The Mind of the Old South,* rev. ed. (Baton Rouge: Louisiana State University Press, 1967), p. 197; John W. Blassingame, ed., *Slave Testimony: Two Centuries of Letters, Speeches, Interviews, and Autobiographies* (Baton Rouge: Louisiana State University Press, 1977), pp. xxxi–xxxii.

4. Jane Turner Censer, ed., *Defending the Union: The Civil War and the U. S. Sanitary Commission, 1861–1863,* vol. IV in *The Papers of Frederick Law Olmsted* (Baltimore: The Johns Hopkins University Press, 1986), p. 572.

5. John Livingston Lowes, *The Road to Xanadu: A Study in the Ways of the Imagination* (New York: Vintage Books, 1927 and 1955), chapter XVII ("A Sea-Change").

6. Edmund Wilson, *Patriotic Gore: Studies in the Literature of the American Civil War* (New York: Oxford University Press, 1962), p. 220.

7. Frederick Law Olmsted, *A Journey in the Seaboard Slave States, with Remarks on Their Economy* (New York: Dix & Edwards, 1856), p. ix.

8. *The Papers of Frederick Law Olmsted,* IV, esp. pp. 413–21.

9. Charles E. Beveridge and Charles Capen McLaughlin, et al., eds., *Slavery and the South, 1852–1857,* vol. II in *The Papers of Frederick Law Olmsted* (Baltimore: The Johns Hopkins University Press, 1981), pp. 340–41.

10. Broadus Mitchell, *Frederick Law Olmsted: A Critic of the Old South* (Baltimore: The Johns Hopkins University Press, 1924), pp. 45–47.

11. Letter dated September 19, 1878, Frederick Law Olmsted to Charles Eliot Norton, Norton Papers, Harvard University.

12. *The Papers of Frederick Law Olmsted,* IV, pp. 549–50.

13. Ibid., p. 541.

14. Howard L. Preston and Dana F. White, "Knickerbocker Illustrator of the Old South: John William Orr," in White and Victor A. Kramer, eds., *Olmsted South: Old South Critic/New South Planner* (Westport, Conn.: Greenwood Press, 1979), p. 92.

15. Olmsted, *Journey in the Seaboard Slave States,* p. 424.

16. Cecil D. Eby, Jr., *"Porte Crayon": The Life of David Hunter Strother* (Chapel Hill: The University of North Carolina Press, 1960), p. 218.

17. Ibid., pp. 75–76.

18. Preston and White, "Knickerbocker Illustrator," *Olmsted South,* p. 91.

19. "The Dismal Swamp. Illustrated by Porte Crayon," *Harper's New Monthly Magazine* XIII (September 1856), p. 441.

20. Ibid., p. 442.

21. Ibid., p. 443.

22. Ibid., p. 443.

23. Ibid., pp. 445–46.

24. Ibid., pp. 452–53.

25. Olmsted, *A Journey in the Seaboard Slave States*, pp. 149–63.

26. Ibid., pp. 159–61.

27. Dana F. White, "A Connecticut Yankee in Cotton's Kingdom," in *Olmsted South*, pp. 11–49, and "Frederick Law Olmsted, The Placemaker," in Daniel Schaffer, ed., *Two Centuries of American Planning* (Baltimore: The Johns Hopkins University Press, 1988), pp. 87–112.

28. *The Old South Illustrated by Porte Crayon [David Hunter Strother], Profusely Illustrated by the Author,* ed. with an introduction by Cecil D. Eby, Jr. (Chapel Hill: University of North Carolina Press, 1959), p. vi.

29. Ibid., p. xiv.

30. *The Papers of Frederick Law Olmsted,* II, p. 343.

The author thanks the Woodruff Library at Emory University for their generous permission to photograph the images used to illustrate this paper.

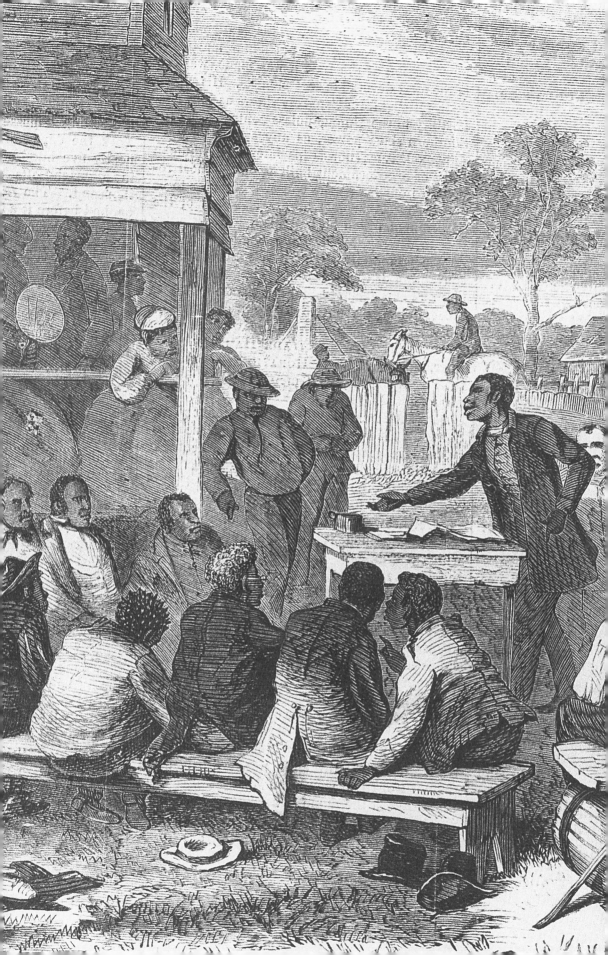

"THE SOUTH AS IT WAS"

SOCIAL ORDER, SLAVERY, AND ILLUSTRATORS IN VIRGINIA, 1830–1877

Gregg D. Kimball

The images created by David Hunter Strother, Eyre Crowe, William Ludwell Sheppard, and other nineteenth-century illustrators reveal a great deal about the changing nature of race relations and the social order in Virginia from the antebellum period through Reconstruction. This article will juxtapose pictorial representations of the South to the reality of race relations in Virginia. Published in travel books, periodicals, and broadsides, these popular illustrations reflect the artists' views, tempered by the expectations of their readers in the North, the South, and England. The images gauge the public's mood and suggest what was acceptable about slavery. Finally, the illustrations reveal publishers' attitudes toward African-Americans and race relations.

Numerous contradictions characterized the issues of race relations in the second half of the nineteenth century. These contradictions served to distort and intensify the image of race relations. Many of the earliest plantation novels were set in Virginia and represent the South as a charming and picturesque region where race relations were harmonious. Yet the state was undergoing an agricultural revolution, coupled with the rise of commerce and industry in its towns and cities. By the 1850s Virginia's trade networks and railroads tied it to the north and west by carrying grains, iron, and other commodities. But Virginia was also a vital link in the infamous Southern

slave trade, a fact belying the image of the paternalistic master promoted in the plantation myth. Following the Civil War, Virginia was the first state of the "New South," and its leaders both championed its black population as loyal and industrious and reviled it as lazy and indolent. Although one of the first states to emerge from Reconstruction in 1870, Virginia lived with the legacy of racially charged politics for many generations. The authors and illustrators who explored these apparent contradictions revealed cultural biases in their stories and pictures. This paper will examine their perceptions of the South and will interpret the evolution of social order and race relations in Virginia from 1830 to 1877.

The emergence of the "plantation myth" in the late antebellum period reflected both a defense of slavery based on paternalism and the challenge to rural planter culture created by economic and urban development. Virginia was becoming a commercial, urban-centered state, threatening the planter aristocracy's control. When the Civil War began, Virginia's urban centers accounted for almost 10 percent of the state's population.[1] Manufacturing increased dramatically, and the state counted over five thousand such enterprises by 1860.[2] Virginia supplemented basic industries such as mining, lumbering, brickmaking, and stonecutting with more advanced sectors such as ironmaking, tobacco processing, and commercial flour milling. Virginia boasted one of the most highly developed railroad networks on the Eastern Seaboard, and several older canal systems provided additional economic connections. Geographically at the nexus of north and south, Virginia ports traded with cities to the north and sent commodities southward. The state enjoyed a thriving flour trade with South America.

The rise of Richmond and other Virginia cities gave cause for some to "deplore the departure of what were called the leading classes of Richmond from the frank, simple and unostentatious manners and customs of the old Virginian character."[3] A new and powerful group of industrialists exerted influence on city politics, and nonproperty-holding men of the working class were belatedly enfranchised by the state constitution of 1850–51. It is no surprise that these changes prompted the writing of numerous novels and histories which enshrined the plantation myth and venerated Virginia's early aristocracy. But even these sympathetic works imbued the aristocracy and their plantations with an air of impending doom and decay. The best-known work of this literary genre, *Swallow Barn* by Baltimorian John Pendleton Kennedy, portrays an idyllic but hopelessly archaic Virginian plantation society, predicated on an obsolete system of labor.[4]

The first edition of *Swallow Barn* was unillustrated, but the second edition, published in 1851, was illustrated by Kennedy's Virginia relative David Hunter Strother. Strother was from western Virginia, an area that was transformed into a battlefield during the Civil War. Strother, in fact, fought as a Union officer. *Swallow Barn* portrays what was perceived as the "natural" social order of the plantation, with happy slaves and noble, aristocratic

planters. Despite Kennedy's and Strother's own reservations about the practicality and morality of slavery, the bucolic tone of Strother's illustrations reaffirmed the view of plantation life as free from affectation and artificiality. Kennedy's description and Strother's illustration of slaves and horses treading out grain comform to the image of languid and easy plantation life: "These [horses] were managed by some five or six little blacks, who rode like monkey caricaturists of the games of the circus, and who mingled with the labors of the place that comic air of deviltry which communicated to the whole employment something of the complexion of a past-time"[5] (fig. 1).

Popular histories also addressed the nature of plantation society. Henry Howe's *Historical Collections of Virginia* was a best-selling travelogue illustrated primarily by engravings of natural wonders, cityscapes, and the homes of Virginia's founders. But consistent with Howe's reputation as "Virginia's first social historian," the book also included illustrations of everyday life.[6] A pair of illustrations contrast tidewater Virginia with the mountain regions (fig. 2). The first illustration, entitled "Life in Eastern Virginia. The Home of the Planter," shows

> a colored woman strutting across the yard with a tub of water on her head. Near her is a group of white and black miniature specimens of humanity, playing in great glee . . . Under the shade of the porch sits the planter, with a pail of water by his side, from which, in warm weather, he is accustomed to take large droughts . . . on the right are the quarters of the blacks, where is seen the overseer, with some servants.[7]

Facing this illustration is "Life in Western Virginia. The Home of the Mountaineer." Here a backwoods Buckskin stands with his gun and dog beside a log cabin. One cannot help but notice the similarities between the mountaineer's cabin and the slave quarters in the previous picture.

Howe elaborated on the diversity of plantation life and frontier life. Speaking of the mountaineer, he wrote:

> The inhabitants of the mountain counties are almost perfectly independent. Many a young man with but a few worldly goods, marries, and, with an axe on one shoulder and a rifle on the other, goes into the recesses of the mountains, where land can be had for almost nothing. In a few days he has a log-house and a small clearing. Visit him in some fine day thirty years afterwards, and you will find he has eight or ten children—the usual number here—a hardy, healthy set; forty or fifty acres cleared, mostly cultivated in corn.[8]

Howe expressed his personal point of view on the mountaineer, commenting that he ". . . may not have the fine house, equipage, dress &c., of the wealthy planter, yet he leads a manly life, and breathes the pure air of the hills with the contented spirit of a freeman."[9] The adjectives used to describe the "freeman" are positive and must have rung true with Howe's Connecticut

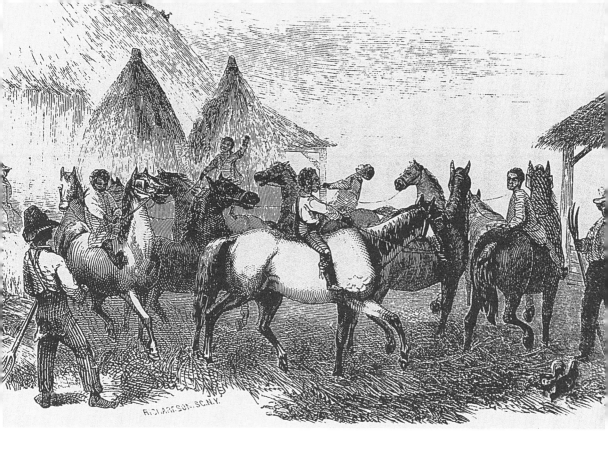

FIG. I. "Treading out grain." Wood engraving from John
Pendleton Kennedy, *Swallow Barn; or, A Sojourn in the Old
Dominion.* Revised edition, with twenty illustrations by Strother
(New York: G. P. Putnam and Company, 1851), opp. p. 446.
3½" x 5½" (image). Courtesy of the Virginia State Library and
Archives, Richmond, Virginia.

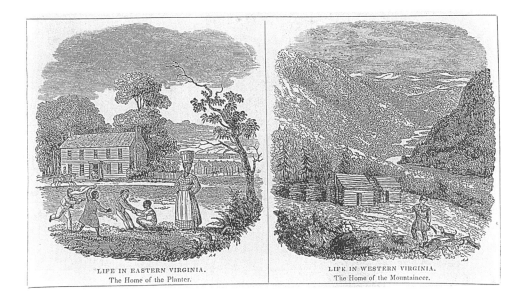

LIFE IN EASTERN VIRGINIA.
The Home of the Planter.

LIFE IN WESTERN VIRGINIA.
The Home of the Mountaineer.

FIG. 2. "Life in Eastern Virginia. The Home of the Planter." and "Life in Western Virginia. The Home of the Mountaineer." Wood engravings from Henry Howe, *Historical Collections of Virginia* (Charleston, S.C.: Babcock & Co., 1845), following p. 152. 4⅛" x 7¼" (image). Courtesy of the Valentine Museum, Richmond, Virginia.

upbringing, which valued men who were honest, athletic, strong, and healthy. In contrast, "those living in densely populated communities" practiced "deceit," or at least that was the expression of the agrarian myth that pervaded the thinking of Howe and many Virginians from Thomas Jefferson to the writers of the nineteenth century. While differing in their political philosophies, Jefferson, John Taylor, and Edmund Ruffin all affirmed the role of agrarian culture in maintaining Republican virtue and a Southern way of life.

John Taylor articulated the conflict between agricultural and manufacturing interests in his work Arator, which first appeared in 1810 as a series of essays in the *Spirit of 'Seventy-Six* and went through numerous editions, including Edmund Ruffin's 1840 edition.[10] Denouncing the "manufacturing mania" of the Hamiltonians and their political heirs, Taylor asked rhetorically,

> By exchanging hardy, honest and free husbandmen for the classes necessary to reduce the number of Agriculturalists, low enough to raise the prices of their products, shall we become more independent of foreign nations? What! Secure our independence by bankers and capitalists? Secure our independence by impoverishing, discouraging and annihilating nine tenths of our sound yeomanry? By turning them into swindlers, and dependents on a master capitalist for daily bread.[11]

Like most Virginians, Taylor also saw slavery as a part of the plantation's natural order. Howe likewise viewed the planter positively as genteel, frank, sincere, and uncorrupted by involvement in business affairs or urban living.

Not one to provoke controversy, Howe deferred to a Southerner in his description of the slaves of the tidewater. He cited the response of a Virginia judge to an inquiry on the matter of slavery. Typical of the antebellum Southern attitude, the judge emphasized the humane treatment of slaves and the deep filial connections between masters and slaves. The judge, however, did note his distaste for slave traders:

> The worst feature in our society, and the most revolting, is the purchase and sale of slaves . . . Negro-traders, although there are many among us, are universally despised by the master, and detested by the body of the slaves. Their trade is supported by the misfortunes of the master, and the crimes or misconduct of the slave, and not by the will of either party . . .[12]

Despite the fact that many planters shared such misgivings, they responded to economic downturns by yielding to the temptation presented by constantly rising prices and sold their slaves. Soon Virginia became a center of the domestic slave trade. The economic forces that created the collective angst over the diminishing ranks of Virginia's aristocratic planters also gave rise to the urban slave market. The ruthless buying and selling of slaves contradicted the plantation myth but was also ubiquitous to Virginia slavery.

The slave auction was a part of daily life in Virginia's cities, yet the sale of slave property contradicted the claim of many Virginia planters that they "took care of their people." Virginia planters either sold slaves or took advantage of the hiring system that sent their slaves out on yearly contracts to work in the tobacco factories and iron works of Richmond, Petersburg, Lynchburg, and Danville. There were several English and American antislavery works which grimly portrayed the sale of slaves and their transportation to the deep South. As early as 1834, Virginian George Bourne published a denunciation of slavery that included a wood-engraved illustration of a slave auction in Richmond.[13] Published first in Connecticut and later in Boston, Bourne's *Picture of Slavery in the United States of America* describes the horrors of slavery, including miscegenation, whipping, and other brutalities. Many of his grisly narratives are set in Virginia. English accounts of the American South also included images of the slave trade. J. S. Buckingham's well-known travel book, *The Slave States of America,* describes the progress of a group of slaves going south from Fredericksburg. There is little question Buckingham saw the scene he described. His illustrator, W. H. Brooke, however, probably did not actually witness such an event, as his illustration is too exotic, hardly reflecting the true appearance of Virginia slaves.[14]

Bourne's work appeared at the end of an era when the antislavery position was openly discussed in the South. The 1830–31 Constitutional Convention

in Virginia is noteworthy in that it was the site of one of the last vigorous debates over slavery in a Southern state. As sectional conflict intensified, it became difficult to express even the mildest criticism of slavery. Despite the distaste with which some planters viewed slave trading and its practitioners, it was a fact of life, and became a subject not open for public discussion.

Eyre Crowe, an English artist, found that even the drawing of an image of slave trading created suspicion and fear among Virginians in the 1850s. While traveling through Richmond with William Thackeray on his lecturing tour of America, Crowe read of a slave auction in the local paper and decided to attend. He proceeded to Wall Street, which was also known as Lumpkin's Alley. Lined with traders' jails and auction rooms, this was the center of Richmond's slave trade. Crowe entered the slave auction and began sketching the scene. He was threatened and eventually forced to leave the room.[15] Crowe did numerous sketches and paintings of the slave trade in the South. In 1856 a group of engravings based on his studies appeared in *The Illustrated London News*.[16] The central image shows a black family being sold by an auctioneer before a group of Virginia "gentlemen" (fig. 3).

Crowe began the written description accompanying his illustrations with this caveat: "As no pen, we think, can adequately delineate the choking sense of horror which overcomes one on first witnessing these degrading spectacles, we prefer limiting ourselves to mere description of what we saw." Crowe's feelings about the participants in the sale are very clear. He described the auctioneer as "an eye-bepatched and ruffianly-looking fellow in check trousers, and grimy in every part of his person . . ." The buyers got no better treatment from Crowe: "Their features are callous; and one gentleman we particularly noticed, who had a cowhide-looking weapon, which dangled between his legs in such a way as to make one wonder whether his feet were cloven or not."[17] Such descriptions were common fare in abolitionist literature and in English popular works, but American journals such as Harper's avoided such inflammatory statements in deference to their large Southern readership.

By the advent of the Civil War, English commentators were more careful, but still conscious of their moral position vis-à-vis the South. In an 1861 replay of Crowe's earlier trip, G. H. Andrews took a more subtle approach to the slave auction. Perhaps familiar with Crowe's experience, Andrews' moral tone was less pronounced than Crowe's. Describing the men present at the sale, Andrews stated, "I saw nothing very dreadful in their appearance; they carried neither revolvers nor whips. They were not a gentlemanly-looking lot of men certainly, but seemed quiet, respectable, people, such as one might meet at the sale of books or old china in any part of London." The auctioneer or crier, was, however, described as a vulgar-looking man. Despite Andrews' emphasis on the lack of violence or cruelty shown in the auction, he claimed that he almost fainted at the sight of human beings being sold.[18]

An equally puzzling, and disturbing, contradiction of the Southern order appeared with the rise of urban slavery and the free black population.

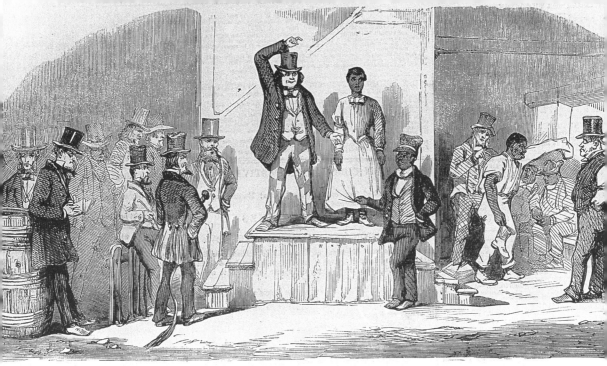

SLAVE AUCTION AT RICHMOND, VIRGINIA.

FIG. 3. "Slave Auction at Richmond, Virginia." Wood engraving
from *The Illustrated London News*, Vol. 29, no. 822, September 27,
1856. 4½" x 9⅛" (image). Courtesy of the Valentine Museum,
Richmond, Virginia.

Changes in agriculture diminished the planter's need for field slaves, causing more and more planters to hire out their slaves to the cities. Already present in Virginia's cities were substantial free black populations that formed an intermediate class of people called by one historian "slaves without masters." Bound by legal and cultural limitations, free blacks contradicted many parts of the plantation myth. According to that myth, slaves were happy with their lot and did not desire freedom; furthermore, it held that African-Americans were unable to survive without the guardianship of whites. Free blacks were increasingly feared as bad examples for the slave population, and legislation was sought in the late 1850s to further restrict them.[19]

An illustrated poem appeared in *Harper's Weekly* in 1858 entitled "Pompey's Philosophy" that dealt with the question of slaves and their potential freedom[20] (figs. 4, 5, 6). Accurate references to numerous Richmond landmarks such as Gallego Mills, the city's largest flour mill, and Rocketts, Richmond's

FIGS. 4-6. Wood engravings from "Pompey's Philosophy," a poem in *Harper's Weekly*, Vol. 2, no. 66, April 3, 1858. 4⅝" x 4½" (fig. 4: image); 4¼" x 4¼" (fig. 5: image); 2½" x 2¾" (fig. 6: image). Courtesy of the Valentine Museum, Richmond, Virginia.

FIG. 5

FIG. 6

138 "THE SOUTH AS IT WAS"

dock area, indicate that the author was familiar with Virginia's capital city. Only a note in the index to the 1858 volume of *Harper's* cites David Hunter Strother as the author-illustrator of "Pompey's Philosophy."[21] The poem tells the story of a rural slave boatman in Richmond who dreams of freedom. He imagines that if he only had a dollar, he could invest in pigs that would breed and multiply and lead to wealth. He could then purchase his freedom from his master. A man approaches Pompey and gives him a dollar. But instead of fulfilling his daydream, Pompey goes to the dock and spends his money on liquor. Strother's Pompey was essentially a harmless, lazy dreamer, unfit for freedom because of his foolish conduct and drunkenness.

The selection of a boatman for the lead character of the *Harper's* poem was significant. Black boatmen, like other slaves in commercial Virginia, moved about more freely than whites would have liked. The positive attributes of slaves, as perceived by the white mind, were strength and a courageous loyalty to their white masters. These attributes characterized Frank Padgett, a slave boatman memorialized for saving numerous whites from the raging North River in 1854.[22] Padgett's story was similar to those of other Virginia African-American heroes such as Gilbert Hunt, who saved many white patricians from the Richmond Theater fire of 1811, and James Armistead Lafayette, a slave spy for the American forces during the Revolutionary War. Not surprisingly, these are two of the few blacks whose portraits have come down to us—Hunt in an 1850s photograph and Lafayette in a portrait by John Blennerhasset Martin, which was later engraved for a broadside.

But boatmen like Pompey and Frank Padgett were part of a commercial system that was threatening to slavery. The system allowed slaves to have mobility and relative freedom from direct supervision. Pompey was from Jefferson County and, like other blacks, dreamed of being free and moving to Richmond, a city he knew well. City life offered distinct advantages to blacks, both slave and free, but the black presence in Virginia's cities disturbed whites. Whites like Strother knew that the city held places where blacks could escape the watchful eyes of whites, like Rocketts, ". . . [A] place to colored boatmen known, [B]ut which the city guard knows not of . . ."[23] Whites also knew that the underground railroad, usually envisioned as an overland route, went by water from Richmond to Northern ports. The well-known story was told about Henry Box Brown, a Virginia slave who was crated and shipped from Richmond to Philadelphia. A lithograph was made revealing the celebrated moment when Box Brown emerged from his long journey to the delight of his abolitionist friends.[24]

Another white concern about the "Pompeys" of Virginia was that city life made slaves covet freedom through self-purchase. Although the artist-illustrator mocked the notion that Pompey would buy his freedom, slave self-purchase, or the purchase of another family member, was frequent enough that every slave and free black in Richmond would know of numerous cases. The historian Ira Berlin minimized the role of self-purchase in emancipation,

particularly in the period from 1820 to 1860, although he affirmed that it was more common in the urban setting.[25] Historian Luther Porter Jackson showed that in Virginia's cities manumission was more prevalent from 1831 to 1860 than in the supposedly more liberal period from 1782 to 1830.[26] In Richmond, 352 manumissions were recorded in the later period, a time when only a handful of rural manumissions occurred. Jackson attributed a majority of these manumissions directly to the self-purchase of slaves. Ironically, self-purchase had resulted from a "system of slave hiring and freedom of movement which grew out of it" and the slave's "increased ability to earn . . ."[27] Numerous examples of manumissions through entrepreneurial activity were cited by Jackson, and many more could be added from other sources. The number of manumissions was relatively small, but the desire for freedom can be appreciated only when the high cost of black emancipations and self-purchases are considered against the small amount of capital available to the black community.

The counterpoint to Pompey was the free black entrepreneur, a figure rarely present in antebellum illustration. Crowe depicted such a black businessman in "A Barber's Shop at Richmond, Virginia"[28] (fig. 7). Here the intersection of the black and white worlds of the South is seen in a far different light from that in the slave auction. Although the free black barber is dependent on the patronage of whites, he owns property and holds a dignified status through his ownership of a business. Many free black barbers had purchased their own freedom, a situation that contradicts the profligate and carefree image seen in the ragged and propertyless Pompey. Crowe's illustration captures a sense of tension from the white-black relationship—the barber is in service to the white men in his shop, yet he holds a razor to the throat of his patrons.

Most illustrators chose to ignore these subtle nuances of white-black relations. In 1859 Strother published a series of cartoons which ridiculed the slave reaction to the Harper's Ferry raid. In a cartoon entitled "A Premature Movement," John Brown hands a slave a pike saying, "Here! Take this, and follow me. My name is Brown," to which a black man named Cuffee replies, "Please God! Mr. Brown, dat is onpossible. We ain't done seedin' yit at our house."[29] In another set of illustrations for *Harper's* Strother depicted "A Southern Planter Arming His Slaves to Resist Invasion" (fig. 8). Here a slave proclaims, "Much obliged to dar ar possum wattomie for dese pikes he gin us—dey's turrible handy to dig taters wid."[30] The underlying theme, of course, is the loyalty of the Southern slave to his master. Strother's attitude rather lightheartedly ignored the great fear that Brown's raid generated in Virginia and the South. The memory of Nat Turner was still fresh, as was that of Gabriel's abortive insurrection in Richmond in 1800. These events made Virginians less sure than Strother that slaves were happy, contented, and not prone to revolt when conditions were ripe.

If Harper's Ferry did not make Strother and other Virginians believe in the seriousness of the black will to be free, the Civil War did. As thousands of

FIG. 7. "A Barber's Shop at Richmond, Virginia." Wood engraving after a painting by Eyre Crowe, from *The Illustrated London News*, Vol. 38, no. 1078, March 9, 1861. 6¼" x 9¼" (image). Courtesy of the Valentine Museum, Richmond, Virginia.

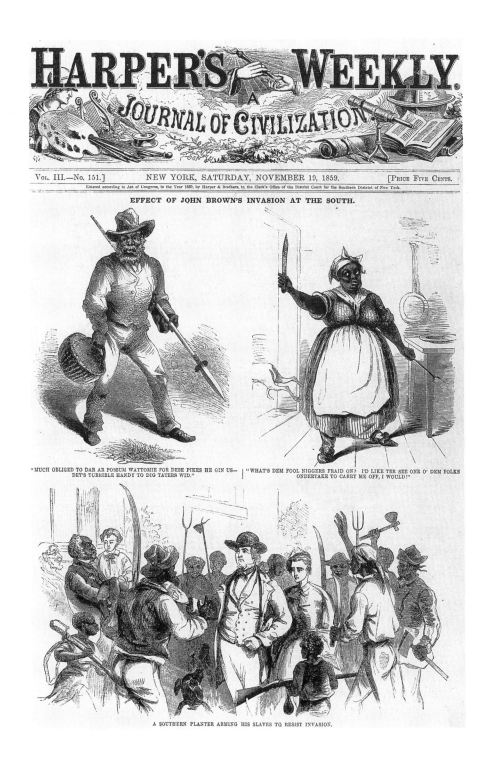

FIG. 8. "A Southern Planter Arming His Slaves to Resist Invasion." Wood engraving from *Harper's Weekly,* Vol. 3, no. 151, November 19, 1859. 4⅞" x 9" (image). Courtesy of the Virginia State Library and Archives, Richmond, Virginia.

slaves fled to the Union lines and deserted their masters, the image of the plantation slave receded into a nostalgic but still potent memory. After the Civil War these memories of the antebellum social order and the contented slave were enlisted to justify a new Southern order of white supremacy. Political propaganda proclaimed "the bottom rail on top," expressing the white fear that Southern race relations had been turned upside down.

The battle over the Virginia State Constitution embodied the fear of most Virginians concerning the political activity of African-Americans and what their participation would mean. Virginia, like other Southern states after military defeat, held a constitutional convention to re-write its state constitution in accordance with Federal guidelines for reentry into the Union. Dominated by the Republican Party, the conventions were largely made up of black delegates, Northern whites, and sympathetic white Southerners. Southern conservatives attended as a distinct minority. "The State Convention at Richmond, VA," from *Frank Leslie's Illustrated Newspaper*, depicts a scene admittedly alien to most of its readers—blacks participating in a major political event that would reshape Virginian society. In documenting the event, which was later referred to as the "Bones and Banjo Convention," *Leslie's* illustrators claimed to "have attempted no exaggeration and certainly . . . have aimed at no caricature."[31]

Racially biased attacks on the Constitution and its creators were far more common. These included gross caricatures, as well as portrayals of new social relations designed to frighten uneasy whites. A broadside titled *Practical Illustration of the Virginia Constitution, (So Called)* attempted to solidify white opposition to the Reconstruction Constitution by exploiting white fears of black control over whites[32] (fig. 9). In one image, a black teacher punishes a white child; in another, a black lawyer questions a white woman before an interracial jury. Showing blacks in authority over whites threatened white ideas of racial order and implicitly raised questions about other realms of life where blacks might interact with whites.

Often the conservatives resorted to racist propaganda to secure the majority white vote. Political broadsides such as one entitled *The Black Vomit; Or, the Bottom Rail on Top*, played on racist beliefs and stereotypes and also revealed white fears of black social and political equality.[33] This particular broadside captions pictures of animals with burlesques of black speeches during a political convention.

A lithograph titled *Custom House Mill, July 6th, 1869*, dated the day of the vote on the 1869 Constitution, raised the spectre of voting corruption.[34] Conservatives often accused a faction of white Republicans known as the "Custom House Gang" of manipulating the black vote. These claims were greatly exaggerated. Blacks exercised their vote with considerable flexibility, but claims of voting fraud encouraged the prevalent belief among white Virginians that outside agitators or carpetbaggers were responsible for Republican victories. This view reduced black voters to innocent dupes, incapable of making decisions for themselves. The image shows two white

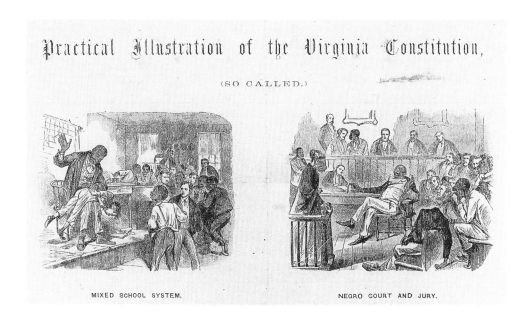

FIG. 9. *Practical Illustration of the Virginia Constitution, (So Called.).* Broadside, wood engraving, ca. 1867. 13¼" x 18¼". Courtesy of the Virginia State Library and Archives, Richmond, Virginia.

Republicans cranking black voters out of a meat grinder. Other election-related illustrations from Virginia underscored the fact that the threat of violence was always present. One depicts an election day riot; in another, black voters register under the watchful eye of a policeman, his nightstick prominently displayed and ready if needed.[35]

The range of black subject matter found in artist-illustrator William Ludwell Sheppard's work represents the varied interpretation of black political and social strivings in Virginia. The Richmond native Sheppard expressed antipathy toward blacks through his many clearly racist images. Other Sheppard illustrations, however, offer a more subtle interpretation of Virginia society. This is not to minimize the stereotypical content of much of Sheppard's work. Karen Dalton and Peter Wood's recent work on Winslow Homer's depiction of blacks harshly claims that "Sheppard consistently depicted Afro-Americans in a condescending fashion and with simian features . . ."[36] This simply is too general a statement to account for Sheppard's work. The stereotypical scenes of Sheppard's well-known "Christmas in Virginia—A Present from the Great House" depict the joy of the former slaves at the arrival of the young mistress with their present. In a similar illustration from *Every Saturday* entitled "Merry Christmas and Christmas Gift, Ole Massa," Sheppard affirmed the deference of the black population to the former master—the plantation order has not been disturbed (fig. 10). Here Sheppard yearns for the supposedly

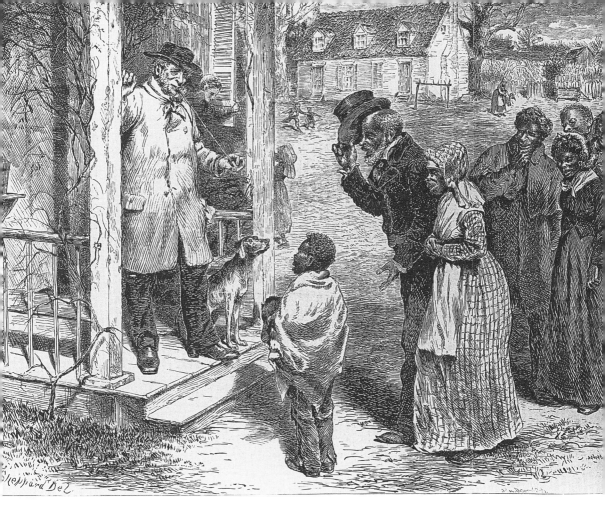

FIG. 10. "Merry Christmas and Christmas Gift, Ole Massa."
Wood engraving from *Every Saturday: An Illustrated Journal of
Choice Reading,* December 31, 1870, p. 873. 9¹/₁₆" x 12" (image).
Courtesy of the Valentine Museum, Richmond, Virginia.

harmonious race relations of antebellum days, when paternalism was reciprocated.[37] But not all of the Virginia-born illustrator's works were as stereotypical as his well-known genre scenes of plantation life. In fact, it is obvious that Sheppard's interpretation changed depending on who the publisher was and what audience the publication served and often followed the changing mood of the public regarding Reconstruction. Sheppard's depictions of the black political situation during Reconstruction are noteworthy. One well-known scene published in *Harper's Weekly* in 1868, reproduced in Eric Foner's history of Reconstruction,[38] shows a political meeting where black men and women listen to an orator (fig. 11). Although the participants' facial characteristics are exaggerated, overall the scene is relatively objective. Sheppard's attitude is reinforced by the accompanying text:

> The illustration on page 468 is one of the most significant possible. It shows the newly-enfranchised citizens of the United States engaged in the discussion of political questions upon which they are to vote; and however crude the arguments of the orator may be, they can not be more so than those which may be heard every evening in the clubs of the "superior race" in the city of New York. The scene is wholly characteristic. The eager attention of the listeners, and the evidently glib tongue of the speaker, reveal that remarkable adaptability and readiness so observable in the colored race. They take naturally to peaceful and lawful forms; they are naturally eloquent, and instead of scoffing loftily at them as incompetent, their white brethren will find it necessary to bestir themselves, or the "incompetent" class will be the better educated and more successful. Does any man seriously doubt whether it is better for this vast population to be sinking deeper and deeper in ignorance and servility, or rising into general intelligence and self-respect? They can not be pariahs; they can not be peons; they must be slaves or citizens. The policy of enslaving them has produced such results as we have seen; and we are now to see that liberty is truly conservative, and that honesty is the best policy.[39]

The tone of Sheppard's illustrations changes to suit the viewpoint of his specific assignment. In a set of illustrations done for Appleton's *Journal of Popular Literature, Science and Art* in 1870, Sheppard's images reflect the waning enthusiasm for Reconstruction. His illustrations accompanied an article titled "Southern Sketches" that compared the transformation of black attitudes before and after emancipation. The author contrasted the aggressive, politically active "new issue" African-American with the docile, happy black who had supposedly existed under slavery. The story focuses on the transformations in the life of a fictional character named Samuel Harris. In Sheppard's pair of pictures titled "Going to Wife's House," we first find the character Sam before the Civil War (fig. 12). Jolly with thoughts of his wife's 'possum and hominy, he carries his Sunday clothes on his back for wear at church in

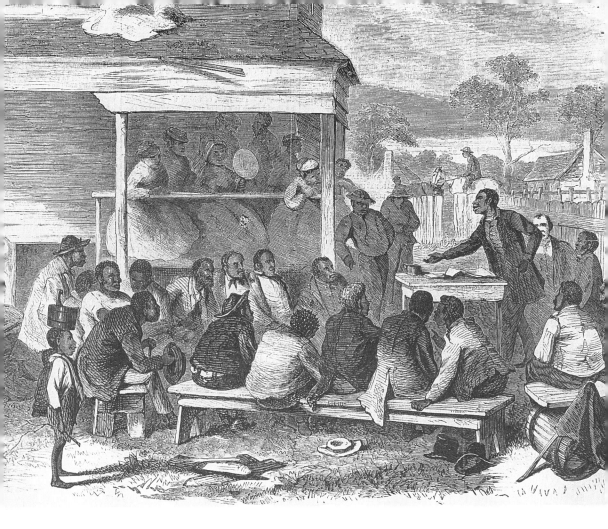

FIG. 11. "Electioneering at the South." Wood engraving from *Harper's Weekly*, Vol. 12, no. 604, July 25, 1868, p. 468. 7" x 9¼" (image). Courtesy of the Valentine Museum, Richmond, Virginia.

" Going to Wife's House."—Old Style.

FIGS. 12, 13. "'Going to Wife's House.'—Old Style" and "'Going to Wife's House.'—New Style." Wood engravings from "Southern Sketches," *Appleton's Journal of Popular Literature, Science and Art,* Vol. 4, no. 66, July 2, 1870, p. 12. 4" x 3" (fig. 12: image); 4" x 3" (fig. 13: image). Courtesy of the Valentine Museum, Richmond, Virginia.

town. The modern Sam, alias Samuel Harris, Esq. (colored), "has removed to town, and become a prominent member of the association known as the 'Rising Sons of Ham,' whose banner displays a rising sun on one side, and a ham of bacon on the other." Mr. Harris's whole demeanor has changed, so it is "evident what an advance he has made as a voter," and "he asserts his freedom by smoking a domestic cigar in the depot, in disregard of rule"[40] (fig. 13). Sheppard evokes a humorous response by drawing Samuel as a black caricature strutting about in the haughty manner of a newly emancipated

" Going to Wife's House."—New Style.

FIG. 13.

slave. This image presented a much more assertive, and for whites probably a more disturbing, view of black conduct after the Civil War.

Blacks did indeed assert themselves quickly during Reconstruction, politically as well as socially. They structured their new communities on organizations and leadership they had known as slaves. Many black mutual-aid societies already existed in the antebellum South before emancipation.[41] Also, the church served as a focal point for the black community. *Harper's Weekly* published an article in 1874 on the First African Baptist Church in Richmond (fig. 14). Illustrated by Sheppard, this story included a picture of the Reverend James Holmes and the old church building, due to be replaced with a larger structure that would accommodate the swelling congregation. The illustrations document a baptismal scene and a church service, showing blacks in control of their own institutions.

Most positive Reconstruction images of blacks in Virginia, whether by Northern or Southern artists, emphasized the role of whites in assisting and uplifting blacks. Typical of these images are the numerous engravings of the Freedman's Bureau, including James E. Taylor's illustration "Glimpses at the Freedmen—The Freedmen's Union Industrial School, Richmond, VA" from *Frank Leslie's Illustrated Newspaper* in 1866[42] (fig. 15). Viewing the former

FIG. 14. "The First African Church, Richmond, Virginia. Interior of the Church from the Western Wing." Wood engraving from *Harper's Weekly*, Vol. 18, no. 913, June 27, 1874, p. 545. 4³⁄₁₆" x 6³⁄₁₆" (image). Courtesy of the Valentine Museum, Richmond, Virginia.

GLIMPSES AT THE FREEDMEN—THE FREEDMEN'S UNION INDUSTRIAL SCHOOL, RICHMOND, VA.—FROM A SKETCH BY OUR SPECIAL ARTIST, JAS. E. TAYLOR.

FIG. 15. "Glimpses at the Freedmen—The Freedmen's Union Industrial School, Richmond, Va." Wood engraving after a sketch by Jas. E. Taylor, from *Frank Leslie's Illustrated Newspaper*, September 22, 1866. 7" x 9½" (image). Courtesy of the Valentine Museum, Richmond, Virginia.

slaves collectively as the "Nation's Ward," the Bureau set up numerous facili-
ties, including schools run by white Northern reformers.

Occasionally, blacks were shown alongside whites as equals. Ironically, that
is the case in Sheppard's "Chain-Gang at Richmond," published in *Harper's
Weekly* in 1868. It shows both white and black convicts under the watchful
eye of an overseer. Given the sensitivity to "social equality" present during
Reconstruction, this is a remarkable piece.[43]

African-Americans played an important role in the emergence of the "New
South." Sheppard illustrated a lengthy article in *Harper's Monthly* in 1873
titled "In a Tobacco Factory." His drawings are among the earliest images of
Virginia to remove blacks from the familiar environment of the plantation
and place them in the "new" situation of factories, mills, and mines. The
illustrations show the various processes in the production of chewing tobacco
in Virginia cities, which differed little from the antebellum process—sorting,
stemming, lumping, and twisting. The image of the twist-room shows a
white overseer keeping watch over the black twisters at their work, maintain-
ing the familiar white dominance over black laborers.

What effect did the industrial setting have on black workers, who had
often been characterized as indolent? Edward King's book *The Great South*
addressed this question by enthusiastically endorsing the industrial potential
of the "New South" in Virginia. Describing a Lynchburg tobacco factory
that Sheppard had illustrated, King stated, "In the manufactories the negro
is the same cheery, capricious being that one finds him in the cotton or
sugar-cane fields; he sings quaintly over his toil, and seems entirely devoid of
the sullen ambition which many of our Northern factory laborers exhibit"[44]
(fig 16). King continued in his optimistic assessment of Virginia's industrial
potential:

> Now that the Virginian has learned to aspire to something besides
> "land and Negroes," and that new railroads enable him to utilize the
> immense coal and iron deposits of the Commonwealth, it is reason-
> able to believe that he will improve his opportunities, and will make
> of the pretty Capital on the James one of the most prosperous of
> manufacturing towns.[45]

This discussion was accompanied by an engraving of the Tredegar Iron
Works, the largest antebellum iron works in the South.

What King did not anticipate was the potency of the resistance of planters
to the growth of manufacturing as ". . . the symbol of the decay of the society
which produced him and his. He [the planter] hates large cities, with their
democratic tendencies, their corruption, and their ambitious populations."[46]
The flowering of plantation literature in Virginia both before and after the
Civil War was a reaction to industrial development and urbanization. King
speculated that, "In twenty years manufacturers will be the aristocrats in

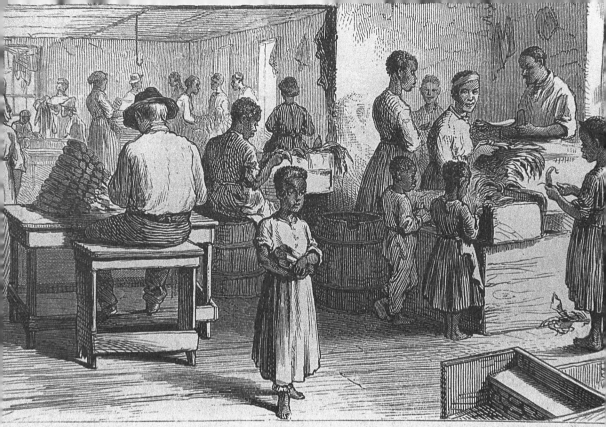

Scene in a Lynchburg Tobacco Factory.

FIG. 16. "Scene in a Lynchburg Tobacco Factory." Wood engraving by William Ludwell Sheppard, based on a sketch by J. Wells Champney, from Edward King, *The Great South* (Hartford: American Publishing Company, 1875), p. 557. 3⁵⁄₁₆" x 5³⁄₁₆" (image). Courtesy of the Valentine Museum, Richmond, Virginia.

Virginia." This was already a reality for ex-Confederate industrialists such as Lewis Ginter and Joseph Reid Anderson.

The plantation themes of Sheppard and other illustrators reached for a view of society and race relations that was forever gone, and, indeed, had never truly existed. The powerful visual images by Strother, Sheppard, and Crowe captured the uncertainty of Americans regarding African-Americans and their role in society. Virginians may have longed nostalgically for the plantation era, but they also seem to have realized that new behaviors and attitudes require a new pictorial vocabulary.

NOTES

1. Donald B. Dodd and Wynelle S. Dodd, *Historical Statistics of the South, 1790–1970* (University, Ala.: University of Alabama Press, 1973), pp. 58–59; 1840 to 1860 percentages are calculated in David Goldfield, *Urban Growth in the Age of Sectionalism: Virginia, 1847–1861* (Baton Rouge: Louisiana State University Press, 1977) from the Dodds' statistics. These numbers exclude western Virginia.

2. Dodd and Dodd, *Statistics of the South*, p. 60.

3. Kathleen Bruce, *Virginia Iron Manufacture in the Slave Era* (New York: The Century Co., 1931), p. 262. Bruce's seventh chapter, "Planters versus Industrialists," pp. 259–74, treats the conflict over city building and industrialization in Virginia. For a more recent and detailed treatment, see Goldfield, *Urban Growth in the Age of Sectionalism.*

4. See John Pendleton Kennedy, *Swallow Barn; or, A Sojourn in the Old Dominion.* Second edition, illustrated by David Hunter Strother (1851). Richmond had its own nostalgic look at the vanishing social order of the new Republic with Samuel Mordecai, *Richmond in By-Gone Days* (Richmond: West and Johnson, 1860).

5. Kennedy, *Swallow Barn*, p. 446.

6. For a brief account of Howe's work on this book, see "Henry Howe, Connecticut Yankee," *Virginia Cavalcade* 15, no. 3 (Winter 1966): 36–47.

7. Henry Howe, *Historical Collections of Virginia* (Charleston: Babcock & Co., 1845), p. 156.

8. Howe, *Historical Collections*, p. 152.

9. Ibid.

10. For the various editions of Taylor's work, see Freda F. Stohrer, "Arator: A Publishing History," *Virginia Magazine of History and Biography* 88, no. 4 (October 1980): 442–45.

11. John Taylor, *Arator; Being a Series of Agricultural Essays, practical and Political, in 61 Numbers, by a Citizen of Virginia* (Georgetown: J. M. and J. B. Carter, 1813), pp. 24–25.

12. Howe, *Historical Collections*, p. 160.

13. George Bourne, *Picture of Slavery in the United States of America* (Middletown, Conn., 1834), p. 111.

14. The image appears in J. S. Buckingham, *The Slave States of America.* 2 vols. (London: Fisher, Son and Co., 1842), unnumbered page between pp. 552–53. See Robert L. Scribner, "Slave Gangs on the March," *Virginia Cavalcade* 3, no. 2 (Autumn 1953): 12.

15. Eyre Crowe, *With Thackeray in America* (New York: Charles Scribner's Sons, 1893), pp. 131–36.

16. *The Illustrated London News*, September 27, 1856.

17. Ibid, p. 314.

18. "A Slave Auction in Virginia, from a Sketch by Our Artist." Wood engraving in *The Illustrated London News*, February 16, 1861.

19. See Ira Berlin, *Slaves without Masters: The Free Negro in the Antebellum South* (New York: Pantheon Books, 1974); Leonard P. Curry, *The Free Black in Urban America, 1800–1850: The Shadow of the Dream* (Chicago: University of Chicago Press,

1981); Claudia Dale Goldin, *Urban Slavery in the American South: 1820–1860: A Quantitative History* (Chicago: University of Chicago Press, 1976); and Richard C. Wade, *Slavery in the Cities: The South, 1820–1860* (New York: Oxford University Press, 1964).

20. "Pompey's Philosophy," poem with engravings from *Harper's Weekly,* April 3, 1858.

21. See Cecil D. Eby, Jr., *"Porte Crayon": The Life of David Hunter Strother* (Chapel Hill: University of North Carolina Press, 1960), pp. 93–96; and Eby, ed., "'Porte Crayon' in the Tidewater," *Virginia Magazine of History and Biography* 67, no. 4 (October 1959): 438–49. Works by Strother include *Virginia Illustrated: Containing a Visit to the Virginian Canaan* (New York: Harper & Brothers, 1857) and *The Old South Illustrated,* edited by Cecil D. Eby, Jr. (Chapel Hill: University of North Carolina Press, 1959).

22. Robert L. Scribner, "'In Memory of Frank Padget.' Did Virginians Ever Erect Monuments to Honor Negro Slaves? This is the Story of One Who Did," *Virginia Cavalcade* 3, no. 3 (Winter 1953): 7–11.

23. "Pompey's Philosophy."

24. *The Resurrection of Henry Box Brown at Philadelphia.* Lithograph, ca. 1850. Prints and Photographs Division, Library of Congress.

25. Berlin, *Slaves without Masters,* pp. 153–57.

26. Luther Porter Jackson, *Free Negro Labor and Property Holding in Virginia, 1830–1860* (New York: D. Appleton-Century Company, 1942), p. 174.

27. Ibid., p. 181.

28. "A Barber's Shop at Richmond, Virginia." Engraving, after a painting by Eyre Crowe, in *The Illustrated London News,* March 9, 1861.

29. *Harper's Weekly,* November 26, 1859.

30. *Harper's Weekly,* November 19, 1859.

31. *Frank Leslie's Illustrated Newspaper,* February 16, 1868.

32. *Practical Illustration of the Virginia Constitution, (So Called).* Broadside wood engraving, ca. 1867. Virginia State Library and Archives, Richmond.

33. *The Black Vomit.* Broadside wood engraving, ca. 1867. Rare Books Division, Library of Congress.

34. *Custom House Mill, July 6th, 1869.* Lithograph by Charles L. Ludwig. Print Collection, Valentine Museum, Richmond.

35. "Riot in Richmond." Wood engraving in *Harper's Weekly,* June 1, 1867. "Registration of Colored Voters." Wood engraving in *Harper's Weekly,* June 4, 1870.

36. Peter H. Wood and Karen C. Dalton, *Winslow Homer's Images of Blacks: The Civil War and Reconstruction Years* (Austin: University of Texas Press, 1989), pp. 90–95.

37. *Every Saturday: An Illustrated Journal of Choice Reading,* December 31, 1870.

38. Eric Foner, *Reconstruction: America's Unfinished Revolution, 1863–1877* (New York: Harper & Row, 1988), following p. 386.

39. *Harper's Weekly,* July 25, 1868, p. 466.

40. "Southern Sketches," *Appleton's Journal of Popular Literature, Science and Art,* July 2, 1870, p. 12.

41. See John T. O'Brien, "Factory, Church and Community: Blacks in Antebellum Richmond," *Journal of Southern History* XLIV, no. 4 (November 1978): 509–36.

42. *Frank Leslie's Illustrated Newspaper,* September 22, 1866.

43. *Harper's Weekly,* December 5, 1868.

44. Edward King, *The Great South* (Hartford: American Publishing Company, 1875), p. 556.

45. Ibid., p. 636.

46. Ibid., p. 637.

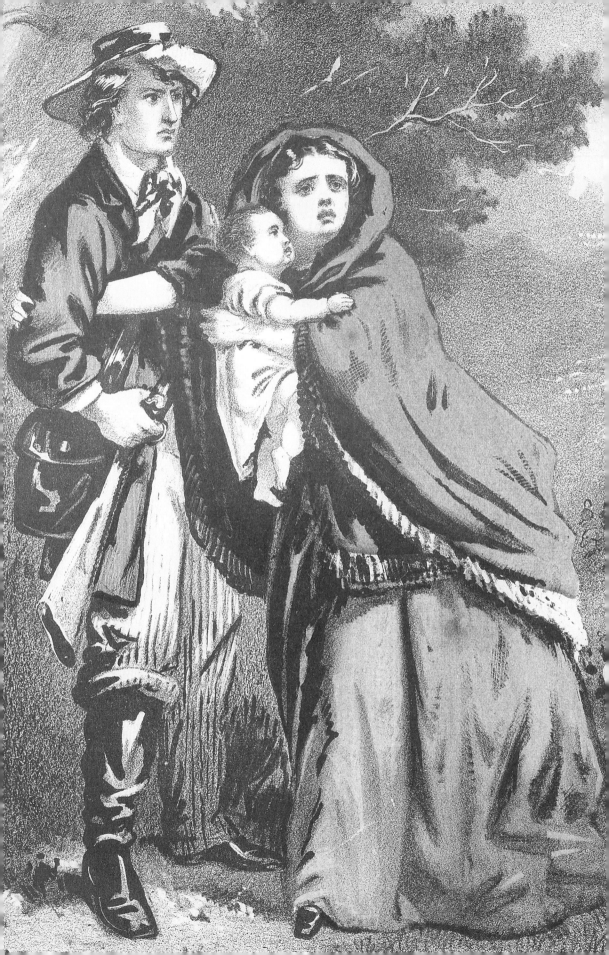

VICTIMS, STOICS, AND REFUGEES

WOMEN IN LOST-CAUSE PRINTS

Mark E. Neely, Jr., and Harold Holzer

This study might easily be entitled "The Strange Case of the Missing Women in Gray," for, given their importance to the Confederacy while it lived and to the "Lost Cause" after 1865, women prove strangely scarce in nineteenth-century prints depicting the Confederacy. They surely deserved better, and the scarcity is surprising because women have enjoyed a larger place in histories of the Confederacy than in similar books about the Northern cause. Several factors help explain the relatively greater role played by Confederate women. For one thing, the whole of Confederate society, including women, was absorbed in its war effort, and that was not true of the North, which was larger, richer, and mostly free from invasion. Moreover, some of the best literary sources for Confederate history happen to have been written by women—in fact, Confederate history can hardly be written without consulting such sources as Mary Chesnut's diary, the journal of Kate Stone, Kate Cumming's journal of a Confederate nurse, and Phoebe Yates Pember's autobiography. All these works rank as "classics" in the source material for Confederate social or cultural history.[1] The Union had no counterparts to these outstanding female writers. Finally, the role of women in keeping the memory of the Confederacy alive after 1865 is legendary, from the Ladies Memorial Associations that sprang up immediately after the war to establish Confederate cemeteries all over the South to the

efforts of the United Daughters of the Confederacy, which continue to this day.[2] When Jefferson Davis published his memoirs in 1881, he dedicated the book to "The Women of the Confederacy Whose Pious Ministrations to Our Wounded Soldiers Soothed the Last Hours of Those Who Died Far from the Objects of Their Tenderest Love; Whose Domestic Labors Contributed Much to Supply the Wants of Our Defenders in the Field; Whose Zealous Faith in Our Cause Shone a Guiding Star Undimmed by the Darkest Clouds of War; Whose Fortitude Sustained Them under All the Privations to Which They Were Subjected."[3]

One useful clue for explaining the lack of images of Confederate women can be found in nineteenth-century *cartes de visites* of Civil War generals, which were the object of a virtual collecting craze in the era. Photographers readily made available *cartes* of Northern generals and their wives. For example, George B. McClellan posed several times with his wife Mary Ellen (fig. 1) and Ulysses S. Grant posed with his beloved Julia. Individual portraits of Mrs. McClellan and Mrs. Grant also proliferated. By contrast we could locate only one Civil War photograph of a Confederate general posed with his wife (the cavalry raider from Kentucky, John Hunt Morgan). Women apparently held a different place in the South, and it can best be described, based on the visual evidence, as less nearly equal to men than their Northern counterparts enjoyed.

Confederate prints confirm this point. There are, for example, no images of Robert E. Lee with his wife.[4] There are prints of Lee and his sons and of the Lee family tree but not of the Lee family, wife and daughters included.[5] Lee's wife was notoriously homely, but Mrs. Grant appears in photographs and prints with her husband, though she was cross-eyed. Photographers and printmakers obliged by executing her portrait in profile. Similar favors might have been extended to Mrs. Lee. Something more was at work in keeping women out of the Southern picture. In part, it was a deeper cultural difference, the power of the cavalier ideal in the South. Aristocrats, like Robert E. Lee, had genealogies; only members of the middle class had families. Of the other Confederate generals, Stonewall Jackson, the middle-class product of evangelical culture, appeared in family prints side by side with the women in his life (fig. 2); no other such prints are known. Jackson's place in Confederate iconography, however, seems unique, because his puritanical image gave him qualities peculiarly admired by Northerners, who often hated the cavaliers like Lee but could not resist the appeal of this flinty and uncompromising evangelical Christian soldier. Since Northerners produced most of the prints with Confederate themes after the war, Jackson may have been especially favored.[6]

Southern society, as historian George C. Rable puts it, has always been divided between a "church-based popular culture and a more secular and extravagant upper class culture."[7] The family parlor scenes that might have appealed especially to the evangelical element also failed to appear in appropriate abundance in part because the Confederate image was dominated after

FIG. 1. *Mary Ellen and George Brinton McClellan,* n.d. Photograph, 4" x 2⅜",
by C. D. Fredricks & Co., New York. Courtesy of The Lincoln Museum,
part of Lincoln National Corporation, Fort Wayne, Indiana.

FIG. 2. William Sartain, *Lieut. Gen. Thomas J. Jackson and His Family*. Mezzotint, 13¾" x 19⅛", published by Bradley and Company, Philadelphia, 1866. Courtesy of the Anne S. K. Brown Military Collection, Brown University.

the war by a Virginia-based cavalier movement to control Southern memory.[8] A second reason was iconographic. Since at least the eighteenth century, the role of women in paintings on military themes has been as mourners who shrank from blood and battle. David's *Lictors Bringing Brutus the Bodies of His Sons,* painted in 1789, offers a famous example. Women were also symbols of the perpetuation of the race. The Roman heroes in David's neoclassical world may go off to battle and be killed, but their wives and children—echoing in pale colors the vivid hues of the soldiers' red republican robes—will carry on the republic, as in *The Oath of the Horatii,* painted in 1784. Similarly, printmakers in America, in order to show that the Confederate republic would *not* carry on, showed no women or children greeting the veteran's return in Lost-Cause prints. For example, Currier & Ives's lithograph entitled *The Lost Cause* (1871) depicted only the dilapidated homestead and graves of a returning Confederate soldier's family (fig. 3). By contrast, several prints portraying the return of Union veterans presented far happier scenes, with soldiers welcomed by wives, children, and parents (fig. 4).[9]

Instead of such warm domestic scenes, in prints depicting the Confederacy, if women are present at all, they were usually depicted as victims, stoics, sacrificers for the war effort, and refugees.

FIG. 3. *The Lost Cause.* Hand-colored lithograph, 7⁵⁄₁₆" x 12³⁄₈", published by Currier & Ives, New York, 1871. Courtesy of The Lincoln Museum, part of Lincoln National Corporation, Fort Wayne, Indiana.

FIG. 4. Anton Hohenstein, *The Soldier's Return to His Home:*
Presentation Plate of the Philadelphia Inquirer January, 1866.
Copyright by W. V. Harding. Lithograph, 14¾" x 20",
[Philadelphia], 1866. Courtesy of The Lincoln Museum,
part of Lincoln National Corporation, Fort Wayne, Indiana.

Among the prints showing the woman as victim, one of the strongest images, created by Baltimore's pro-Confederate etcher Adalbert Volck, was *Valient Men "Dat Fite mit Sigel"* (fig. 5). Printed during the Civil War and widely circulated after peace had been restored, the picture reveals the lengths to which Volck went to make propaganda for the Southern cause. Franz Sigel was a German-born soldier who became a brigadier general in the U.S. Army in 1861 and who fought in Missouri until his transfer to the Army of Virginia in 1862. Atrocities were common to both sides in Missouri's ugly guerrilla warfare, which produced the notorious William C. Quantrill and his raiders, "Bloody Bill" Anderson, and "Jennison's Jayhawkers." Volck's print of "Jennison's Jayhawkers" features the destruction of the home of a rebel guerrilla by Sigel's troops, one of whom is seen taking a potshot at a child who leaps from the window of the burning house while carrying his little brother in his arms. A woman in the foreground pleads with General Sigel for her home, family, and apparently her own virtue as well, threatened by a soldier at left who has torn her dress and exposed her breast.

Valient Men constitutes pure propaganda and not war illustration. As a Marylander, all Volck knew about warfare in Missouri was what he read in the newspapers. Guerrilla war and the Union methods of combating it were

FIG. 5. Adalbert Johann Volck, *Valient Men "Dat Fite mit Sigel,"* ca. 1863. Etching, 5⁹⁄₁₆" x 7¹¹⁄₁₆" (image). Courtesy of The Lincoln Museum, part of Lincoln National Corporation, Fort Wayne, Indiana.

ugly. And although Northern tactics may have included illegal burning of the homes of suspected guerrillas or Rebel sympathizers, women were in fact generally spared violence by both sides throughout the Civil War. Union and Confederate soldiers in Missouri accused each other of committing atrocities against women, but neither committed them often, despite abundant opportunities. Southern women *were* made refugees and suffered much. Union soldiers in Missouri, in order to distance themselves from the sufferings of women, sometimes blamed their difficulties on German-American troops in their own army. Union Gen. E. A. Carr reported, for example: "Men of mine who were with the Germans today in foraging report great excesses on their part, going into the private apartments of ladies and opening trunks and drawers, and ransacking everything and taking what they wanted. If these excesses are permitted we cannot wonder at guerrilla warfare."[10]

Of course, German-Americans were no more likely to violate women than were other Americans. General Carr's statement—and Adalbert Volck's etching—merely document the rampant prejudice against German-Americans. What is astonishing about Volck's etching of Sigel is that Volck was himself a German-American.

General Carr's remarks stand as a reminder of the proprieties and pieties of nineteenth-century society. If "going into the private apartments of ladies

FIG. 6. Adalbert Johann Volck, *Searching for Arms*, ca. 1863. Etching, 5⅜" x 7½" (image). Courtesy of The Lincoln Museum, part of Lincoln National Corporation, Fort Wayne, Indiana.

and opening trunks and drawers" could incite men to guerrilla warfare in the nineteenth century, then Volck's etching called *Searching for Arms* was also powerful propaganda (fig. 6).[11] Had the printmaker focused his satirical attention on the father of the household—the man in his skull-bedcap struggling with the Union soldiers at the rear of the picture—he would have produced an effective but rather routine civil libertarian work. But by relegating the father to the background and focusing instead on the barefooted women in their nightclothes, Volck charged the picture with a more intense impropriety. In the print a Union soldier discovers a tiny Confederate flag, but that hardly constitutes provocation enough for this invasion of privacy, which is tantamount to rape. Women depicted as victims intensify the propaganda message of this anti-Union print.

Illegal household searches were certainly an issue in Maryland, but Volck returned again to Missouri, where there was intense guerrilla fighting, for the theme of another propaganda picture called *Jemison's* [sic] *Jayhawkers* (fig. 7). Actually, the title should have read "Jennison," referring to Col. Charles R. Jennison, who led an infamous Kansas regiment that escalated the "bleeding Kansas" conflicts of the 1850s into revenge on proslavery Missourians during the Civil War. Again, Volck was not content to show Union cavalrymen killing an innocent farmer, rustling his cattle, or wantonly destroying his cabin. The

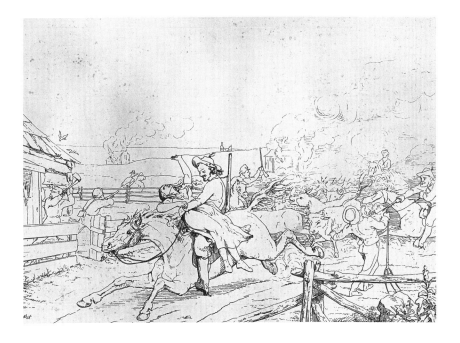

FIG. 7. Adalbert Johann Volck, *Jemison's* [sic] *Jayhawkers*, ca. 1863. Etching, 5¼" x 7³⁄₁₆" (image). Courtesy of The Lincoln Museum, part of Lincoln National Corporation, Fort Wayne, Indiana.

printmaker intensified his message with an image a good deal more advanced than the symbolic rape shown earlier. There can be little mistaking what the cavalryman in the center of the scene has in mind, especially since Volck has provided a clue with the powerfully suggestive ripped bodice. *Tracks of the Armies* portrayed more than suggestive bodice ripping: Volck's subject here was the aftermath of a rape (fig. 8).[12] Note the strands of hair clutched in the dead woman's fingers. Volck had a sulfurous imagination. The overturned empty cradle and the little bones on the ground hint that vultures have already eaten the returning soldier's baby—or maybe (foreshadowing the anti-Hun propaganda of World War I) German-American soldiers ate the baby.

Certainly none of this was based on first-hand observation by Volck in suburban Baltimore, which was not ravaged by war. Most historians now agree that women rarely fell victim to the sorts of horrors depicted in Volck's pictures, even women who stood directly in the path of William T. Sherman's armies. In anarchic Missouri, where civil warfare plumbed its lowest depths, reports of rapes were infrequent and *all* of them secondhand. Even hostile witnesses sometimes admitted that their enemies stopped short of rape. Thus

FIG. 8. Adalbert Johann Volck, *Tracks of the Armies,* ca. 1863. Etching, 5⁵⁄₁₆" x 7⁷⁄₁₆" (image). Courtesy of The Lincoln Museum, part of Lincoln National Corporation, Fort Wayne, Indiana.

an Illinois journalist could report that in the worst summer of guerrilla war-
fare around Independence, Missouri, "Bushwhackers have not yet raised a
hand against a woman, they sometimes burn a house over her head but are
careful not to injure her person."[13] Perhaps the power of the image of woman
as victim was too great to be ignored by a country as desperately at war as
the Confederate States of America. President Jefferson Davis recognized this
almost immediately. In his *Message* to Congress of July 20, 1861, preceding
even the First Battle of Bull Run or any other serious fighting in the war, the
Confederate president declared, "Mankind will shudder to hear of the tales
of outrages committed on defenceless females by soldiers of the United
States now invading our homes: yet these outrages are prompted by inflamed
passions and the madness of intoxication." Drunken rapists assaulting
hearth, home, and the women folk—that was far more potent as a symbolic
rallying cry for recruits than elaborate intellectual or theological defenses of
the slave labor system.

More accurately, printmakers also depicted Southern women as stoic. One
of a series of comic valentines published by George Dunn & Company in
Richmond during the war, entitled *"You look at a star from two motives,"* shows
a courting scene based on memories of antebellum days (fig. 9). In truth the
mobilization for the Confederate war effort was so complete as to leave the
country virtually without men, except the aged, lame, and blind. Suitors,
especially handsome ones of proper age like the man in the Dunn valentine,
were notoriously difficult to find. Though the antebellum pressure on young
women to marry did not abate during wartime, women's chances diminished
desperately. Mary Chesnut wrote about a social gathering in a salon in
Richmond where friends debated the merits of marrying a veteran who had
lost an arm or a leg. One of the humorous young women said gloomily that it
would be her fate to "marry one who has lost his head."[14]

The upper classes were still given to occasional frivolity, which, strangely,
increased in the desperate winter of 1864–1865, in a dancing on a volcano
mood. The portrait of the "shallow and foppish" *Lady Killer,* another of the
Dunn valentines, gives us a glimpse of this (fig. 10). In the same series of
comic wood engravings a print entitled *"Anathema on him who screws and
hoards"* shows a woman as the victim of profiteers within Confederate society
(fig. 11). The handkerchief of the victimized young mother shows up in other
prints, such as *The Starting Point of the Great War between the States,* a litho-
graph published by A. Hoen in 1887 (fig. 12). In this anachronistic print,
most of the women are shown weeping at the thought of suffering to come,
as Jefferson Davis becomes provisional president of the Confederacy and the
country heads for war. In actuality, when Davis spoke on February 18, 1861,
the crowd cheered with lusty confidence and women threw flowers to mark
the dawning of a new and confident nation.[15]

In general, despite the evidence from within the Confederacy itself in the
rare comic valentines, the Confederacy's upper-class women are thought of

FIG. 9. *"You look at a star from two motives."* Wood engraving, 9¾" x 7", published by George Dunn & Company, Richmond, Virginia, ca. 1863. Courtesy of The Boston Athenaeum.

FIG. 10. *Lady Killer*. Wood engraving, 9¼" x 7¼", published by George Dunn & Company, Richmond, Virginia, ca. 1864. Courtesy of The Boston Athenaeum.

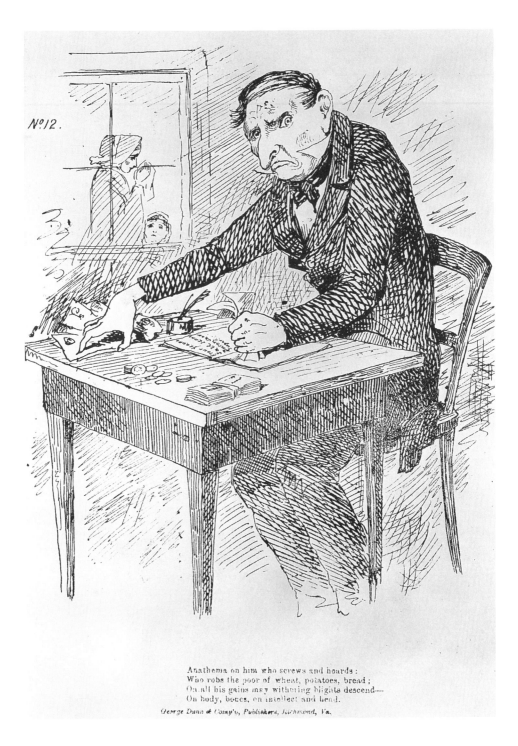

FIG. 11. *"Anathema on him who screws and hoards."* Wood engraving, 7" x 6", published by George Dunn & Company, Richmond, Virginia, ca. 1864. Courtesy of The Boston Athenaeum.

FIG. 12. A. Hoen, after James Massalon, *The Starting Point of the Great War between the States. Inauguration of Jefferson Davis.* Lithograph, 30½" x 23¾", published by Matthew Tierney, Washington, D.C., 1887. Courtesy of the Chicago Historical Society.

less as frivolous revelers than as faithful endurers—precisely the way Jefferson Davis depicted them in the dedication to his memoirs: women of pious ministrations, zealous faith, stoicism, and fortitude. The most important pictorial example is the most famous of all prints depicting women of the Confederacy: *The Burial of Latane* (fig. 13). As historian Drew Gilpin Faust has pointed out, the white women represent a "surrogate family" for the martyred lieutenant from "Jeb" Stuart's cavalry. The woman pressed into service to read the burial prayers because Yankees would not let a proper clergyman through the lines could be the boy's wife; the blonde girl could be his daughter; the other women, his sisters. The print depicts a hierarchical social order, with the loyal slaves, who have contributed their labor to the Confederate sacrifice, shown in shadow and the white women in divine light. These David-like mourners are ready to carry on the Confederate race.[16]

The portrayal of blacks here suggests another aspect of Lost-Cause mythology projected on prints depicting the Confederacy: the myth of the loyal slave. Adalbert Volck's Confederate war etching *Slaves Protecting Their Master from the Enemy* shows a snug cabin with its warm hearth and well-fed children. Ironically, this piece of proslavery propaganda includes perhaps the only picture of unviolated domesticity among Confederate scenes. As for the slave's giving misinformation to the Union soldiers, in reality this happened so rarely that blacks were regarded as prime sources of intelligence about Confederate troop movements. They were celebrated by Edwin Forbes in his portfolio of forty Union war etchings published in 1876 under the title *Life Studies of the Great Army*. In *The Reliable Contraband*, Forbes depicted an escaped slave bringing information to Union pickets. The artist commented on these slaves: "I do not know of a single instance when one of them proved false to a trust."[17]

Volck provided other vivid images of faithful Confederate endurance, such as *Cave Life in Vicksburg during the Siege* (fig. 14). Once again, however, he had trouble with American details: praying before a crucifix was hardly typical in the evangelical South. In Mary Ann Loughbrough's *My Cave Life in Vicksburg*, published in 1864, the author is on her way home from a Methodist church service on the fateful Sunday, May 17, 1863, when Gen. John C. Pemberton's Confederates are defeated in battle and retreat into Vicksburg for the beginning of the final siege.[18] Denominations aside, Volck rendered an affecting scene of suffering and faith.

Another Volck print, *Making Clothes for the Boys in the Army*, successfully bridged the gap between the idea of female endurance and that of female contributions to the war effort (fig. 15). Spinning may conjure up traditional images of Penelope waiting for Ulysses' return, but the revival of the antique arts of spinning, weaving, and knitting constituted a key activity of Confederate women. One South Carolina woman knitted 750 pairs of socks in twice that number of days, all from cotton that was grown, carded, and spun on her own plantation.[19]

Fig. 13. A. G. Campbell, after William D. Washington, *The Burial of Latane*. Engraving, 24" x 31⅞", published by William Pate, New York, 1868 (copyrighted by W. H. Chase). Courtesy of the Eleanor S. Brockenbrough Library, Museum of the Confederacy.

FIG. 14. Adalbert Johann Volck, *Cave Life in Vicksburg during the Siege,*
ca. 1863–64. Etching, 4³⁄₁₆" x 6³⁄₁₆" (image). Courtesy of The Lincoln
Museum, part of Lincoln National Corporation, Fort Wayne, Indiana.

FIG. 15. Adalbert Johann Volck, *Making Clothes for the Boys in the
Army,* ca. 1863. Etching, 5" x 6½" (image). Courtesy of The Lincoln
Museum, part of Lincoln National Corporation, Fort Wayne, Indiana.

Making Clothes embodies a refreshing view of the Southern yeomanry, but Volck focused on the sacrifices made by the upper classes in *Offering of Church Bells to be Cast into Cannon* (fig. 16). Here he depicted well-dressed gentry, male and female, bringing in candlesticks and silver service, along with the bells from their churches, sacrificing symbols of parlor and pew for conversion into the tools of war.

Many Southern women sacrificed not only their valuables but their very homes to the war. Most often this homeless image was reserved for lower-class Southern white women, though women of all classes became refugees. Since refugees were often Unionists fleeing from the South to the North, they were sometimes sympathetically portrayed in Northern art even while the war was going on, as in J. E. Baker's lovely hand-colored lithograph for Bufford's of Boston, entitled *Union Refugees* (fig. 17). More honest, perhaps, was Adalbert Volck's scrawnier refugee in *Formation of Guerrilla Bands* (fig. 18). With her home destroyed and her husband leaving to seek revenge with the guerillas, the woman and child in this etching are about to become refugees. Volck may have owed a debt here to depictions in the Northern

FIG. 16. Adalbert Johann Volck, *Offering of Church Bells to be Cast into Cannon*, ca. 1863–64. Etching, 6¾" x 8⁷⁄₁₆" (image). Courtesy of The Lincoln Museum, part of Lincoln National Corporation, Fort Wayne, Indiana.

FIG. 17. J. E. Baker, *Union Refugees*. Hand-colored lithograph, 9½" x 7", published by Bufford's Print Publishing House, Boston, n.d. Courtesy of The Library of Congress.

FIG. 18. Adalbert Johann Volck, *Formation of Guerrilla Bands,* ca. 1863. Etching, 4³⁄₁₆" x 6¹¹⁄₁₆" (image). Courtesy of The Lincoln Museum, part of Lincoln National Corporation, Fort Wayne, Indiana.

illustrated newspapers, which combined eyewitness reporting with the traditional Republican critique of the South as a backward economy that sustained a small, wealthy aristocracy on slave labor and prevented the growth of a white middle class. Non-slaveholding Southern whites were predictably depicted as emaciated and ragged, toothless and crude. It was not unusual for backwoods Southern women to be depicted smoking corncob pipes.

What can be concluded from these images? Perhaps the most remarkable aspect of Southern womanhood in depictions of the Confederacy was her absence. Certainly, one of her important roles was never visually delineated, a role now much celebrated by feminist historians: her assumption of traditionally male roles while most able-bodied Southern men were serving in the army. The print bins do not yield any pictures of Southern women running plantations, serving as clerks in the Confederate government departments in Richmond, or taking over other jobs abandoned by men for the war effort.

Given their importance during the Civil War and after in keeping the memory of the Lost Cause alive, why are depictions of women so scarce? A principal reason may be a freak of history: Jefferson Davis was captured by

Union cavalrymen in Georgia while disguised in his wife's shawl and rain-coat. Quickly the story was exaggerated, asserting he was trying to escape disguised as a woman in hoopskirts. Some three dozen different Northern political cartoons published in 1865 made ribald fun of this incident (fig. 19). The president of the Confederacy was emasculated, and there was no greater humiliation in nineteenth-century America, with its strict gender spheres. Davis was humiliated by these stories, and so apparently was the entire South.[20] The incident suggests why Southerners could not bear to have their cause feminized in the least. Prints that reminded them of their cause thus became wholly reactionary in subject matter, mostly male and military. Confederate prints are basically antifeminist and, because of the general absence of female figures, almost frighteningly militaristic. The Lost-Cause prints that portray the stubborn survival of Confederate nationalism show it in its military form. The Southern veteran, be he general or common soldier, was never pictorially reintegrated into civilian life as the Northern veteran was. The image of the Southern man remained always ready to do battle for the cause. The image of the Southern woman—as far as the graphic arts were concerned—remained all but invisible.

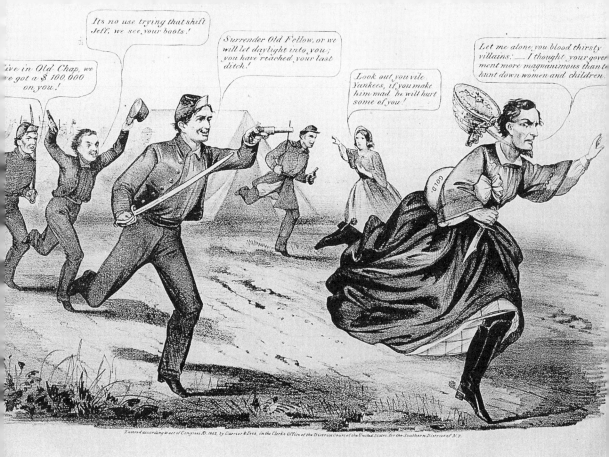

FIG. 19. *The Last Ditch of the Chivalry, or a President in Petticoats.*
Lithograph, 13½" x 18", published by Currier & Ives, New York,
1865. Courtesy of The Lincoln Museum, part of Lincoln
National Corporation, Fort Wayne, Indiana.

NOTES

1. Emory M. Thomas, *The Confederate Nation, 1861–1865* (New York: Harper & Row, 1979), p. 355.

2. Gaines M. Foster, *Ghosts of the Confederacy: Defeat, the Lost Cause, and the Emergence of the New South, 1865 to 1913* (New York: Oxford University Press, 1987), pp. 29–33, 38–40.

3. Jefferson Davis, *The Rise and Fall of the Confederate Government,* 2 vols. (New York: D. Appleton, 1881).

4. Throughout, we have used the term "Confederate prints" to signify separate-sheet lithographs and engravings published in the nineteenth century depicting Confederate subjects. There were very few prints published in the Confederacy itself between 1861 and 1865—in fact, none after 1863. After the war Northern printmakers seized the commercial initiative and offered the reopened Southern market pictures of its past heroes to hang in parlors, soldiers' homes, schools, and meeting halls. See Mark E. Neely, Jr., Harold Holzer, and Gabor S. Boritt, *The Confederate Image: Prints of the Lost Cause* (Chapel Hill: University of North Carolina Press, 1987).

5. Ibid., plate 3 and p. 57.

6. Late in his life Jefferson Davis was depicted in a family print but not as he appeared while Confederate president. Instead, he appeared as a white-bearded elder statesman and grandfather. Ibid., p. 187.

7. George C. Rable, *Civil Wars: Women and the Crisis of Southern Nationalism* (Urbana: University of Illinois Press, 1989), p. 198.

8. Thomas L. Connelly, *The Marble Man: Robert E. Lee and His Image in American Society* (New York: Alfred A. Knopf, 1977), esp. pp. 27–61.

9. Antoine Schnapper, *David* (New York: Alpine Fine Arts, 1980), pp. 74–77, 90–91.

10. Michael Fellman, *Inside War: The Guerrilla Conflict in Missouri during the American Civil War* (New York: Oxford University Press, 1989), pp. 193–230, esp. 202.

11. The title is supplied by George McCullough Anderson; it is not necessarily Volck's. See Anderson, *The Work of Adalbert Johann Volck, 1828–1912* (Baltimore: n.p., 1970), p. 22.

12. Title supplied by Anderson, p. 48.

13. Joseph T. Glatthaar, *The March to the Sea and Beyond: Sherman's Troops in the Savannah Carolinas Campaigns* (New York: New York University Press, 1985), pp. 72–74; Fellman, *Inside War,* p. 207.

14. Rable, *Civil Wars,* p. 51.

15. Hudson Strode, *Jefferson Davis American Patriot, 1808–1861* (New York: Harcourt, Brace & World, 1955), pp. 408–12.

16. Drew Gilpin Faust, *The Creation of Confederate Nationalism: Ideology and Identity in the Civil War South* (Baton Rouge: Louisiana State University Press, 1988), pp. 69–71.

17. Edwin Forbes, *An Artist's Story of the Great War,* 2 vols. (New York: Fords, Howard & Hulbert, 1890), p. 233.

18. Mary Ann Loughbrough, *My Cave Life in Vicksburg* (New York: D. Appleton, 1864), p. 41.

19. Francis Butler Simkins and James Welch Patton, *The Women of the Confederacy* (Richmond, Va.: Garrett and Massie, 1936), p. 20.

20. See Neely, Holzer, and Boritt, *The Confederate Image,* pp. 79–96.

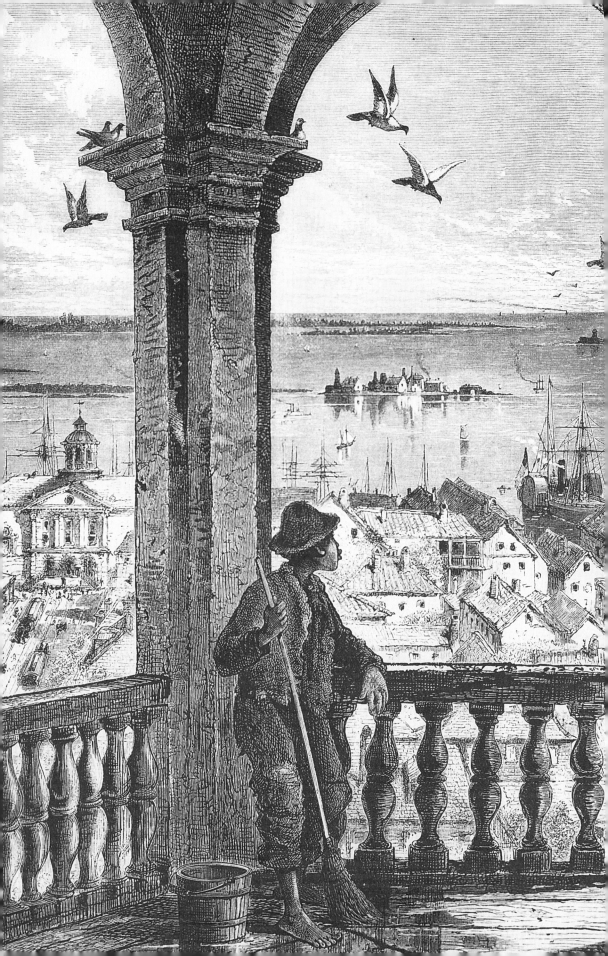

IMAGES OF THE SOUTH
IN *PICTURESQUE AMERICA*
AND *THE GREAT SOUTH*

Sue Rainey

<p style="text-indent">B</p>y the early 1870s most Americans were ready to put the turbulent Civil War years behind them and turn their attention to the opportunities offered by the reunited nation. A part of this healing process involved Northerners becoming reacquainted with Southerners. The period's intensely competitive illustrated magazines played a key role in this process by satisfying the public's keen curiosity about the former Confederate states. This paper will consider how the postwar South was depicted in two of the earliest and most comprehensive series of views—"Picturesque America" and "The Great South." These two New York publications had much in common. Both were ambitious and costly projects, and each appeared first as a magazine series, then as a book.

"Picturesque America" began as a series in the fledgling *Appleton's Journal* in November of 1870 and ran for the next year and a half in the magazine, featuring many of the scenic and historic areas of the South, as well as other regions of the country. These articles, plus numerous additional ones, were then issued by D. Appleton and Co. as a serialized book, published in forty-eight bimonthly parts from 1872 to 1874, with William Cullen Bryant as editor.[1]

A highly successful competitor of *Appleton's Journal*, *Scribner's Monthly*, also sought to profit from interest in the Southern states by featuring a heavily illustrated series of articles written by Edward King called "The Great

South." The series ran from 1873 to 1874. The articles were then rearranged and expanded in a book issued in 1875 by the American Publishing Co. of Hartford.

The positive, multifaceted portrait of the South in these two popular series encouraged the spirit of reconciliation, a spirit already evident in both major political parties, especially in the cities of the Northeast. This paper will focus on the numerous wood engravings in these works, which were based on drawings made on the spot, not only as popular works of graphic art, but also as important cultural documents.

Despite their similar publishing histories, there are striking differences between the two sets of pictures and the projects they illustrated. From the beginning, "Picturesque America" was conceived as a series of views, with accompanying text. The artist Harry Fenn was selected first and sent on a tour of the South, sometimes accompanied by the writer of the text, sometimes not.[2] Primarily a venture in popular art, the "Picturesque America" series in *Appleton's Journal* was most admired for its striking wood engravings, and the book that followed was widely acclaimed as a landmark publishing project whose success paved the way for later illustrated works.[3]

"The Great South," on the other hand, was most valued for its text—a first-hand report of "the material resources" and the "social and political conditions" of the Southern states. The leadership of *Scribner's Monthly* selected an able young journalist, Edward King; the choice of the artist, J. Wells Champney, was secondary. The pictures are small and frequently of more documentary than artistic interest. Although the book has suffered neglect in this century, the writers of an excellent introduction to a 1972 reprint, W. Magruder Drake and Robert R. Jones, consider it "unquestionably the most thorough treatment of the South since Frederick Law Olmsted's analysis" in the 1850s and "the most useful" of the travel accounts from the Reconstruction era.[4]

A further contrast results from the differing emphases of the two projects. *Picturesque America*'s coverage of the South served primarily to demonstrate that the region had natural scenery and historic cities that qualified as "picturesque"—like a picture—and deserved the attention of artists and travelers. Thus the views and the text reclaimed portions of the Southern landscape as national cultural artifacts, linked to a long-familiar and still-valued tradition of touring in search of the picturesque. *The Great South*, on the other hand, put greatest emphasis on the need and potential for economic development of the vast and diverse region. King's viewpoint was in keeping with the period's widespread enthusiasm for increasing enterprise as the cure for the nation's ills. For many Northern Republicans, even former Abolitionists, concern with economic issues came to overshadow concern with equality of rights for black citizens during this period.[5] This interest in economic development is reflected in *The Great South*'s numerous illustrations of railroads, harbors, mines, factories, and laborers.[6]

Appleton's Journal and "Picturesque America"

Between 1865 and 1868, when the scars of the war were still fresh, such popular illustrated periodicals as *Harper's Monthly, Harper's Weekly,* and *Frank Leslie's Illustrated Newspaper* had largely turned their attention in text and pictures to the West. Stories about the South were primarily accounts of the war from a Northern viewpoint or discussions of the issues and problems of Reconstruction. Illustrations were typically political cartoons or pictures of war damage.[7]

Around 1869, however, a change in coverage of the South began, spurred by the public's quickening curiosity, as well as by publishers' desires to reach out to potential Southern subscribers.[8] From the time of its founding, April 3, 1869, *Appleton's Journal* included coverage of the South in both pictures and text and very early welcomed Southern artists and writers to its pages. To obtain a competitive share of the market, and thus a national platform for advertising its books, D. Appleton and Co. had decided its new weekly should feature literature, science, and art, especially through superior illustrations "suitable for framing." It chose a format midway in size between *Harper's Monthly* and *Harper's Weekly*—a format similar to the much-admired French *Magasin pittoresque.*

Among the earliest special illustrations was an 11-by-28 inch foldout wood engraving of "The Levee at New Orleans" (May 1, 1869) by Civil War artist Alfred R. Waud. And in October of 1869, the *Journal* featured the first of its inducements to Southern travel—"Novelties of Southern Scenery," written and illustrated by Charles Lanman (1819–1895). The very sharp North Carolina mountain on the front page supported the author's claim that in "treasures" of mountain scenery the Southern states were "not one whit behind the Northern States," for they could boast of fourteen peaks higher than Mount Washington, "the king of the North."[9]

By mid-1870, plans for more intense coverage of the South had been set in motion. Facing increasing competition from the high-quality wood engravings in *Every Saturday* and *The Aldine* and the prospect of a new rival in *Scribner's Monthly,* scheduled to begin in November, the publishers of *Appleton's Journal* took the initiative to attract and keep subscribers. They decided to launch a series of views of "the most novel and unfamiliar features of American scenery" to be called "Picturesque America." The South was chosen as the first area to receive coverage.

The idea for this series had been sparked when members of the Appleton firm heard one of their regular artists, the transplanted Englishman Harry Fenn (1837–1911), defend America's scenery against another Englishman's charge that this nation had nothing "picturesque" about it.[10] Besides Fenn, the key people involved in the project were George S. Appleton (1821–1878), the most artistic of the Appleton brothers, and Oliver Bell Bunce (1828–1890), who would become the *Journal's* editor.[11] The series fed nicely into

the firm's long-standing leadership in the publication of travel guides, especially with the heightened interest in travel since the completion of the transcontinental railroad in May 1869. Furthermore, the project's association with traveling "in search of the picturesque," a favorite pastime of the British upper classes in the late eighteenth century, and still a highly popular activity in nineteenth-century America, would have appealed to the growing middle class seeking to associate themselves with cultural refinement through appreciation of art and nature.[12] This was just the sort of audience *Appleton's Journal* hoped to attract. Much of the enjoyment of this sort of touring involved the search for natural or man-made landscapes that conformed to conceptions of the beautiful, the sublime, and the picturesque—aesthetic categories long established in art and literature. Thus, the projected series of views could provide new artistic models, as paintings and engravings had in the past. Indeed these views could serve to expand the catalog of picturesque sites in America—and thus inform and guide tourists. They could also encourage nationalism based on pride in America's scenery and cities. The views would include sublime peaks and canyons, and beautiful lakes and pastoral scenery; but there would be a predominance of the type of scenery denoted by the more specific use of *picturesque*—scenery characterized by variety, irregularity of form, rough texture, and contrasts of light and dark. The South, and much of the rest of the United States, abounded in cascading rivers, rock formations, and trees with twisting trunks and intricate foliage. Furthermore, this was the type of scenery the medium of wood engraving, with its dependence on line, texture, and contrast, was best suited to depict. Wherever possible, the series would also emphasize the historical associations that made a scene more picturesque, such as crumbling buildings, old wagons and boats, and idealized rural characters. Thus the views would provide evidence that this nation's cultural landscape was also full of picturesque interest, helping to diminish the long-standing inferiority complex with regard to the Old World's preponderance of historic artifacts.

The team at *Appleton's Journal* commissioned the thirty-three-year-old Fenn as illustrator, finding him the most appropriate artist to undertake the type of mission he had suggested. His career had recently blossomed with the publication of his illustrations for special editions of Whittier's *Snow-Bound* (1868) and *Ballads of New England* (1870), which were widely acclaimed for their nostalgic charm.[13] In the first year of *Appleton's Journal,* Fenn had contributed some of the most striking landscape and city views, such as "The Cape Ann Cedar Tree" (October 9, 1869). Such works had demonstrated his skill at selecting vantage points and elements of a scene that were clearly picturesque but not limited to the now old-fashioned "Claudian formula."[14] Fenn was especially adept at designing effectively for wood engraving, a craft he had earlier practiced himself.[15]

By October 29, 1870, when the first notice of the new series appeared on the back page of *Appleton's Journal,* the project had been underway for "some

months." A longer announcement in the November 5 issue explained that Fenn had already toured parts of Florida, Georgia, the Carolinas, Eastern Tennessee, and Virginia, and returned with a full portfolio. His drawings, claimed the ad, were placed in the hands of the best engravers.

This focus on the South for Fenn's initial journey and the earliest views in the series both reflected and furthered the nation's knitting together during Grant's first term. Yet the role of *Appleton's Journal* and the "Picturesque America" series in this process has been little recognized, largely because the exclusive attention to the South in the beginning of the series is obscured in the book that followed. There, the initial article featured the coast of Maine, and the Columbia River section was inserted between the Florida Swamps and Lookout Mountain, with the obvious intention of covering the farthest points from north to south and coast to coast. Nevertheless, the South remained prominent in Volume I of *Picturesque America,* with one-third of the articles devoted to that region, whereas Volume II has only one—on Mammoth Cave.

To open the "Picturesque America" series November 12, 1870, *Appleton's Journal* chose the nation's most exotic region, Florida, where the unusual plant and animal life constituted picturesque scenery unlike anything in the Old World. The eight-page section printed on smooth, calendered paper included twelve pictures—two almost full-page—and text by the popular backwoods humorist Thomas Bangs Thorpe. He had traveled with Fenn up the St. John's and Ocklawaha rivers by steamer. Thorpe emphasized the strangeness of the region, describing, for example, how in the glow of blazing pine knots lighting the boat's way at night, the moss-covered trees "seem huge unburied monsters" throwing their arms about in "agony" (p. 582). Although parts of Florida had already become a winter haven for invalids and regular steamboat routes had recently been established on the rivers, Thorpe's account and Fenn's views make their journey seem a romantic adventure into regions little touched by man.[16] Fenn depicts a swamp (fig. 1) teeming with birds and reptiles among the cypress knees, hanging moss, and air plants—certainly representative of the "novel and unfamiliar scenery" promised by the series' announcements.

For the remainder of 1870, *Appleton's Journal* tried a different format for Harry Fenn's "Picturesque America" illustrations. Three sets of views were issued as extra sheets, or art supplements—with two full-page wood engravings printed on heavy calendered paper with blank versos.[17]

In the issue published November 26, 1870, the views depict scenery near the French Broad River in North Carolina, an area newly popular with Northern tourists and artists. The text, like that for the earlier "Novelties of Southern Scenery," emphasizes the number of mountains higher than Mount Washington; and it celebrates the French Broad, "whose wild and romantic course . . . abounds in the most picturesque and beautiful scenery," including "gorges of fearful height," huge cliffs, and weird and fantastic masses of

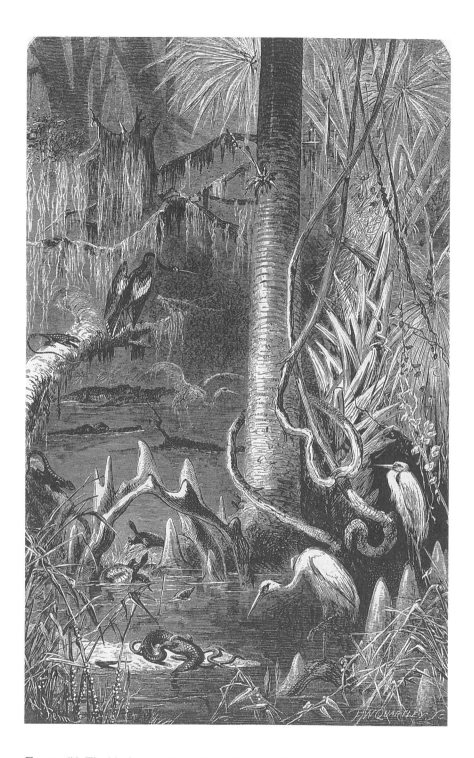

Fig. 1. "A Florida Swamp," *Appleton's Journal,* November 12, 1870, p. 580 [*Picturesque America,* Vol. 1, p. 22]. Wood engraving by F. W. Quartley after drawing by Harry Fenn. 8³⁄₁₆" x 5⅛".

rocks. Fenn's illustrations capture these same features in compositions that dramatize, and sometimes exaggerate, the steepness and height of cliffs and mountains.

The "bold and picturesque" rock called "The Lovers' Leap," only a short distance from the Warm Springs resort where Fenn probably stayed, is the subject of the first pair of views. "The Lovers' Leap—At Early Sunrise" (fig. 2) and "The Lovers' Leap—Approach by Night" are good examples of Fenn's manipulation of light to heighten interest and show depth and distance. In figure 2 the bright sunlight reveals the contours and fissures of the towering rock formation, natural wonders that were of great interest at the time. As the general public embraced the notion of the earth's antiquity, many saw rocks as the best evidence of divine providence at work in forming the earth. (Rock hunting became very popular in this period.) Fenn included the artist at work in this view—at least an umbrella and easel are visible in the lower right. By including the artist, Fenn underscored the contemporary admiration of artists as guides to appreciating beauty in nature.

"The Lovers' Leap—Approach by Night" depicts moonlight reflected on the river, as well as lamplight, which backlights the carefully drawn trees and the shapes of men, horses, and carriage. Night scenes were a regular feature in *Picturesque America*.

The final number of 1870, December 31, contained two virtuoso wood engravings after Fenn's drawings of domestic scenes in Florida towns, one of St. Augustine (fig. 3) and the other Pilatka. Fenn captures the wide range of forms and textures in the tropical foliage, creating images which certainly must have fostered a longing for such temperate weather and lush vegetation when viewed by the Northern subscriber at the end of December!

In 1871 and the first half of 1872, the "Picturesque America" series continued in *Appleton's Journal*, with coverage of Natural Bridge, Lookout Mountain, and the Cumberland Gap, as well as the historic cities of Savannah, St. Augustine, Charleston, and Richmond. Other parts of the country began to receive attention as well, such as the picturesque coal-mining town Mauch Chunk, Pennsylvania, and East Hampton, Long Island. The use of heavier extra sheets was abandoned in favor of full-page and smaller views on the same paper as the text.

With a famous attraction like Natural Bridge, long ranked with Niagara Falls as one of "the most remarkable curiosities in North America" and already thoroughly familiar to Americans through prints and paintings, Fenn lent new interest by choosing an unusual viewpoint and novel approach that exploited the medium of wood engraving. On the title page of a three-page section in the February 11, 1871, *Appleton's Journal* (fig. 4) is Fenn's view of Natural Bridge. He chose to focus on the top of the arch, with a skillful rendering of textures of rocks, foliage, and roots. With his very controlled linear technique and a masterful use of chiaroscuro, he emphasized simultaneously the great height and the lightness of the arch.[18]

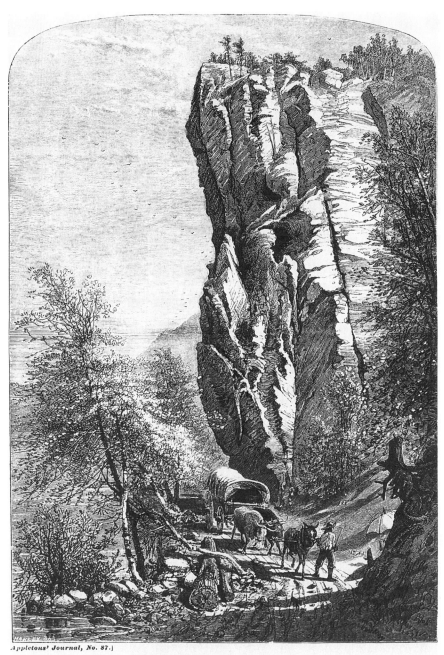

Appletons' Journal, No. 87.]

PICTURESQUE AMERICA.

ON THE FRENCH BROAD RIVER, NORTH CAROLINA.

"THE LOVERS' LEAP"—AT EARLY SUNRISE.

FIG. 2. "The Lovers' Leap—At Early Sunrise," *Appleton's Journal*, November 26, 1870, extra sheet [*Picturesque America*, Vol. 1, p. 139]. Wood engraving by Harley after drawing by Harry Fenn. Page: 10⅞" x 7½"; engraving: 9" x 6³⁄₁₆".

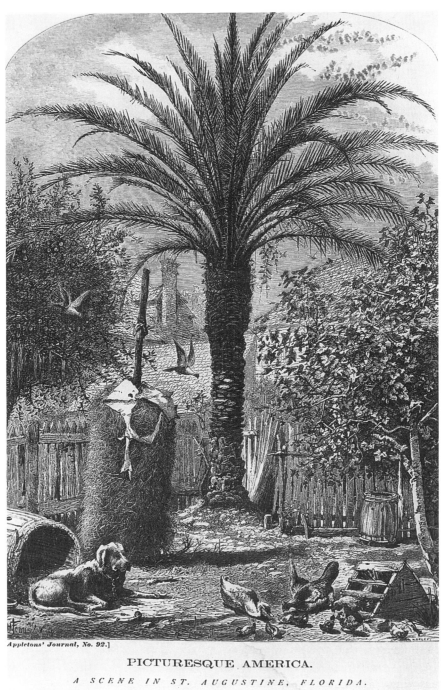

PICTURESQUE AMERICA.

A SCENE IN ST. AUGUSTINE, FLORIDA.

Appletons' Journal, No. 92.]

FIG. 3. "A Scene in St. Augustine, Florida," *Appleton's Journal*, December 31, 1870, extra sheet [*Picturesque America*, Vol. 1, p. 189]. Wood engraving by Harley after drawing by Harry Fenn. Page: 10⅞" x 7½"; engraving: 8⅞" x 6¼".

I.

THE Falls of Niagara and the Natural Bridge are justly esteemed the most remarkable curiosities in North America. So exceptional is the beauty, mingled with sublimity, of these famous scenes, that thoughtless persons have characterized them as "freaks of Nature." But in Nature—great, beneficent, and doing all things in order—there are no freaks. She shows her power in the grand cataract, spanned with its rainbow, and in the dizzy arch of the Natural Bridge, as in the daisy and the violet she shows her grace and beauty.

The Natural Bridge, the character and formation of whose upper portion are displayed in the first of the accompanying sketches, has been, from about the middle of the eighteenth century, an object of curiosity and admiration in Europe as well as in America. Whatever traveller came to the Western World, to compare its natural grandeur with the grandeur of art and architecture in the countries he had left, went first, in the North, to the Falls of Niagara, and, in the South, to the world-famous bridge. Among these may be mentioned the courtly and distinguished Marquis de Chastellux, major-general in the French Army and member of the Institute, who in 1781 visited the place, and from whose rare volumes we present a few paragraphs which may interest the reader:

"Having thus travelled for two hours," writes the marquis, "we at last descended a steep declivity, and then mounted another. At last my guide said to me: 'You desire to see the Natural Bridge—don't you, sir? You are now upon it; alight and go twenty steps either to

FIG. 4. "Natural Bridge," *Appleton's Journal*, February 11, 1871, p. 168 [*Picturesque America*, Vol. 1, p. 82]. Wood engraving by Harley after drawing by Harry Fenn. Page: 10¹⁵⁄₁₆" x 7¾"; engraving: 9⅞" x 6½".

The opening Natural Bridge illustration is also an example of how combining the two relief processes, wood engraving and letterpress type, increased the artist's options with respect to format. Since the text could be worked around the pictures, the artist could experiment with forms other than the rectangle.[19] *Picturesque America* includes numerous examples of such experimentation.

Fenn also enhanced the picturesque aspects of a scene by adding details such as people, animals, and boats when redrawing his designs on the block.[20] The original drawing for Fenn's Lookout Mountain illustration, "View from the Point" (I, 54),[21] differs considerably from the final wood engraving. In preparing the block, Fenn made the dominant tree even taller and fuller at the top so that it fills the space, and added a self-portrait, several tourists, a boat, and additional interest in the sky.

Approximately one-third of the images of the South in *Picturesque America* are of cities. In picturing cities, Fenn selected three main types of subjects: old buildings, bustling harbors and rivers, and recent parks and monuments that gave evidence of civic amenities similar to those in European cities. His views of St. Augustine feature picturesque architecture in this "oldest European settlement in the United States," which the text claims "resembles an old town of Spain or Italy more than anyplace else in America." In their delicacy of line several of these wood engravings look almost like etchings or ink drawings (I, 185, 186).

In the lowland city of Charleston, we learn from the text by editor Bunce that the artist roamed the city for three days before finding his favorite high vantage point, the belfry of St. Michael's church (fig. 5). The text features buildings associated with the war—Fort Sumter and the ancient, well-loved customs house, which was damaged. Fenn's illustration, however, transforms the evidence of past conflict through the picturesque approach. Framing the view through the tower, with a black boy and playful pigeons in the foreground, Fenn emphasizes the timeless charm of the old city.

For a city like Chattanooga that suffered heavy war damage and in its period of rebuilding looked, in Bunce's words, "like a new colony," Fenn chose to depict scenes along the river, including the ferry landing and a spot where flatboats unloaded on the outskirts of the city, rather than the city itself (I, 64, 68).

Among his illustrations of Savannah, Fenn created one of the most striking of his many park views, the fountain in Forsyth Park. It was supposedly modeled after the fountain in the Place de la Concorde in Paris, a connection which was meant to give evidence that Southern cities had sophisticated open spaces comparable to those in Europe (I, 121).

In the serialized book of *Picturesque America* that followed over the next two years, several additional areas of the South were included, and two other artists were involved. Fenn illustrated Weyer's Cave in Virginia; Richmond native William Ludwell Sheppard prepared views of Mammoth Cave, Virginia,

FIG. 5. "A Glimpse of Charleston and Bay, From the Tower of St. Michael's Church," *Appleton's Journal,* July 15, 1871, p. 73 [*Picturesque America,* Vol. 1, p. 201]. Wood engraving by Harley after drawing by Harry Fenn. 9" x 6⁷⁄₁₆".

and West Virginia (the latter from sketches by author-illustrator David Hunter Strother); and Alfred R. Waud contributed scenes of New Orleans and the Lower Mississippi. Their works are similar to Fenn's in the selection of subject matter, although their compositions are seldom as striking as his.[22] When completed, *Picturesque America* contained some 130 images of the South. By focusing on impressive scenery and historic cities, and largely avoiding depictions of the struggle to recover from the war and adjust to the new social order, the project presented the South in a positive and familiarly reassuring light.

Scribner's Monthly and "The Great South"

With the publication of "The Great South," *Scribner's Monthly* intended to examine both "the material resources" and the "social and political" conditions in "a vast region" "almost as little known to the Northern States" as to England.[23] From the magazine's beginning in November 1870, the editor, Dr. Josiah Gilbert Holland (1819–1881), had emphasized fine literature with artistic illustrations, and the periodical had quickly gained a wide circulation.[24] Now Holland hoped to expand its readership in the South, as well as to promote reconciliation.

By January 1873, Holland, at the urging of the magazine's co-owner and business manager, Roswell C. Smith (1829–1892), had decided to commission a comprehensive series on the South. The twenty-five-year-old Edward King (1848–1896) was their choice as author. King had previously worked with Holland as a youthful reporter on the Massachusetts newspaper *Springfield Republican.* He had already published a book, *My Paris,* in 1868, based on his experiences while covering the Paris exposition in 1867. Then in 1870 he achieved acclaim for his distinguished reports of the Franco-Prussian War and the Paris Commune, published in the *Boston Morning Journal.*[25] He was a seasoned writer and a good choice for *Scribner's* Southern assignment.

James Wells Champney (1843–1903) was the artist assigned to travel with King. Born in Boston in 1843, Champney had apprenticed with the wood engraving firm Bricker & Russell and studied drawing before joining the 45th Regiment of Massachusetts Volunteers in 1861. From 1866 to 1870, he studied art in France, Belgium, and Italy, benefiting mainly from the tutelage of the French genre painter Edouard Frère (1819–1886).[26] Champney and King would have been in Paris at the same time, but there is no evidence they met there. At any rate the young artist was beginning to build a reputation as an illustrator, signing his works "Champ" to distinguish himself from other artists with the same last name.[27] Around 240 of his original drawings for "The Great South" are in the collection of the Lilly Library at Indiana University, Bloomington, Indiana. (A little more than half were actually published.) Many of Champney's original drawings were translated onto the block and signed by Thomas Moran (1837–1926) or W. L. Sheppard (1833–1912).[28] Typically, Moran used his monogram and Sheppard his initials to

identify their work for "The Great South." Approximately half the time Champney is given credit, either by a "C" before Sheppard's initials, "C-WLS," or by the words "after Champney" or "Champ." The primary reason that *Scribner's* engaged Moran and Sheppard to redraw Champney's designs on the block was probably to enable the magazine to meet publishing deadlines while Champney was still in the field with King or, at any rate, away from New York. To avoid delay, they turned to two of their regular artists to prepare the blocks for the engravers. Moran's soaring reputation as a landscape artist was doubtless an additional factor.[29]

The "Scribner Expedition," as King called it, got underway in early spring of 1873 in a special train provided by the Missouri, Kansas, and Texas Railroad.[30] King and Champney received a dignitary's send-off in Sedalia, Missouri, and traveled in a luxury hotel car, a necessity as there were few towns along the new route through Indian Territory to the end of the line in Denison, Texas. The first report in the series appeared in July 1873, entitled "The New Route to the Gulf." As with "Picturesque America," the starting point for coverage was significant. In this case, a series titled "The Great South" begins with regions outside the Deep South, indicating the editors' choice of an expansive definition. In fact, this was a re-definition of a truly "great" South, one that included fertile, sparsely settled areas relatively little touched by war and slavery, regions that could easily support King's optimistic view of the potential for development and expansion.

The title page for the series shows the sad remains of a horse and wagon, nostalgically reminding the viewer of the difficulties of the old Texas trail (fig. 6). The image also shows "the new pilgrimage to the land of promise" made "by express-train" on that "gleaming line of rail" so recently completed. From the text, the reader immediately senses King's enthusiasm for the area, as he claims, "The development of the Southwest has begun in earnest! The gardens of the gods are at last open to mortals!"[31]

The visual ideal of a "Wonderland" is suggested by the title page for the section on Louisiana (fig. 7), which appeared in November 1873 as the next installment in the series. Champney's fanciful composition complements King's view that Louisiana has "unlimited, faery, enchanting possibilities." Indeed, some of the creatures are reminiscent of John Tenniel's drawings for the Alice in Wonderland books so popular at the time. King's first sentences reveal his essential optimism about the future of Louisiana and the rest of the Old South, despite present problems. He writes, "Louisiana today is Paradise Lost. In twenty years it may be Paradise Regained." King describes the present economic, political, and social conditions in many parts of the Old South as wretched—primarily because under the regressive slave system the region was not properly developed. To change the situation, King stresses the desperate need for education of both blacks and whites, diversification of agriculture, capital investment in manufactures and mining, and more people—immigrants. Yet King is optimistic that all these things will happen in

SCRIBNER'S MONTHLY.

Vol. VI. JULY, 1873. No. 3.

The Great South.

THE NEW ROUTE TO THE GULF

LIMESTONE GAP.

LIMESTONE GAP! The birds are going mad with joy in the bosquets by the rivulet yonder; the cedars on the far-off hills rustle their boughs gently, as if delighted at the advent of the sun; the squat cactus seems to bristle with pride and emotion as the last vestige of inimical snow melts from around it; the ice dissolves and the long grasses wave; the Choctaw Indian twines a red ribbon about his hat, and dons his calico

FIG. 6. "The Great South, The New Route to the Gulf," *Scribner's Monthly,* July 1873, p. 257 [*The Great South,* p. 204]. Wood engraving by Bookhout; drawn by Thomas Moran after J. Wells Champney. Page: 9½" x 6½"; engraving: 6¾" x 5¼".

SCRIBNER'S MONTHLY.

VOL. VII. NOVEMBER, 1873. No. 1.

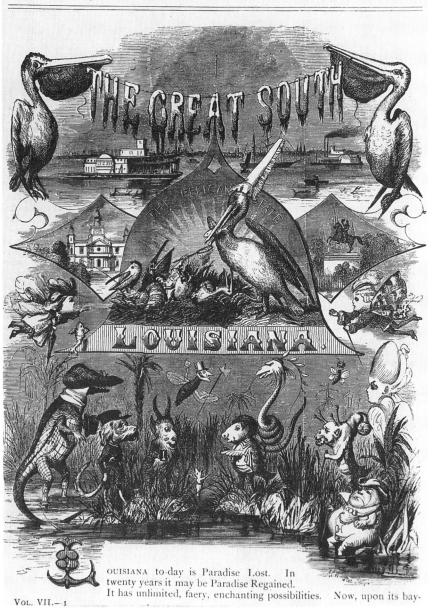

OUISIANA to-day is Paradise Lost. In
twenty years it may be Paradise Regained.
It has unlimited, faery, enchanting possibilities. Now, upon its bay-

FIG. 7. "The Great South, Louisiana," *Scribner's Monthly*, November 1873,
p. 1. Wood engraving after drawing by A. C. Warren, after J. Wells Champney.
Page: 9¼" x 6"; engraving: 7" x 5¼".

twenty years, when Louisiana may be Paradise Regained, when "diversified industry would make of Georgia a second New York" and "manufacturers will be the aristocrats in Virginia."[32] While Champney's on-the-spot drawings could not prefigure King's rosy future, many of them did show recent developments that promised future progress. Champney showed views of the expanding railroad network, increasing cotton production, developing mining operations, growing manufacturing activities, and burgeoning cities such as Atlanta and Augusta. The illustrations presented a great diversity of peoples and attractive scenery, but avoided the extreme difficulties of Reconstruction described in the text, most notably the violence of the Ku Klux Klan and the widespread corruption. Of the more than five hundred pictures that appeared during the next thirteen months and in the book that followed, most embodied a positive point of view.

Champney's numerous railroad images complement King's emphasis on the importance of the railroad in fostering economic growth, immigration, and civilization. Of Sedalia, King said, "the ruder aspects" had "vanished before the march of railway improvement" (186).[33] The illustrations showed freight and passenger trains and railroad depots "crowded with negroes, immigrants, tourists, and speculators" (113). Such subjects support King's emphasis on a population on the move to Texas, Arkansas, and Missouri from the older Southern states, where many were starving due to crop failure and the fall of cotton prices in the wake of the Panic of 1873. A depiction of a group of down-and-out refugees on a train "bound for Texas" ran as the lead image in the second of the articles on "The Cotton States" in September 1874 (fig. 8). (In the book the illustration opened the section on Galveston.) King describes a flood of poor, uneducated emigrants from South Carolina, Alabama, and Georgia making their way to a new life on homesteads on the Texas prairies. Champney's careful, straightforward rendering was changed somewhat by Sheppard, who emphasized the sad plight of the adults by making their faces more vacuous, while transforming the children into symbols of hope with angelic faces.[34]

As already mentioned, the images in "The Great South" also stress the importance of developing agriculture, mineral resources, and manufacturing. Cotton production was, of course, considered essential to the economic vitality of the North as well as the South. Numerous images support King's statistics demonstrating the extent to which cotton production had rebounded since the war. Its locus was shifting away from Georgia, Alabama, and Mississippi to the western Gulf states. The illustration of the New Orleans levee crowded with cotton bales that opened the December 1873 issue of *Scribner's Monthly* underscores the move. Other views included the cotton train—"already a familiar spectacle on all the great trunk lines"—an up-country cotton press, and a cotton mill in Columbus, Georgia, employing hundreds of women and children (110, 357, 373). Several views illustrate other traditional crops, such as cane, rice, and tobacco, as well as a few new

SCRIBNER'S MONTHLY.

VOL. VIII. SEPTEMBER, 1874. No 5.

THE GREAT SOUTH.

*BOUND FOR TEXAS.

IN THE COTTON STATES: II.

THERE was a delicious after-glow over sky and land and water as I left New Orleans for Mobile one warm evening in March, the month which, in the South, is so radiant of sunshine and prodigal of flowers.

Nothing in lowland scenery could be more picturesque than that afforded by the ride from New Orleans to Mobile, over the Mobile and Texas railroad, which stretches along the Gulf line of Louisiana, Mississippi and Alabama. It runs through savannahs and brakes, skirts the borders of grand forests, offers here a glimpse of a lake and there a peep at the blue waters

VOL. VIII.—33

of the noble Gulf; now clambers over miles of trestle-work, as at Bay St. Louis, Biloxi (the old fortress of Bienville's time) and Pascalouga; and now plunges into the very heart of pine woods, where the foresters are busily building little towns and felling giant trees, and where the revivifying aroma of the forest is mingled with the fresh breezes from the sea.

The wonderful charm of the after-glow grew and strengthened as the train was whirled rapidly forward. We came to a point from which I saw the broad expanse of water beneath the draw-bridge over the Rigolets, and the white sails hovering far away, like monster sea-gulls, on either side the railroad. The illusion was almost perfect; I seemed at sea. Along the channel I could see the schooners, and now and then a steamer, coming from the deep

FIG. 8. "Bound for Texas," *Scribner's Monthly,* September 1874, p. 513 [*The Great South,* p. 99]. Wood engraving by F. Juengling after drawing by W. L. Sheppard, after J. Wells Champney. Page: 9½" x 6¼"; engraving: 4½" x 5¼". (Champney's drawing is at the Lilly Library, Indiana University, Bloomington, IN.)

agricultural enterprises, such as orange groves in Florida. Diversification, however, came very slowly.

The reorganization of labor from a slavery system to a wage system was still a great problem. Several views of blacks engaged in wage labor complement King's repeated admonitions that Southern whites needed to develop a sense of the dignity of labor—of fair wages for fair work. Champney's wash, ink, and gouache drawing of black workers lifting salt in the factory in Saltville, Virginia (fig. 9), is especially striking. The graceful gesture of the man on the right is not so well captured in the wood-engraved copy (371).

There are a number of views of coal and iron mines accompanied by King's assessment of the practically unlimited mineral resources in the South. (He considered the lands in Missouri, southeast Tennessee, northern Alabama, and West Virginia especially rich.) Mineral extraction was one of

FIG. 9. J. Wells Champney, "Saltville, Va. 'Lifting,'" [1873]. Wash, ink, and gouache drawing on beige paper mounted on dark green paper. 4¼" x 5⅜". Lilly Library, Indiana University, Bloomington, IN. (The wood engraving after the drawing appeared in *Scribner's Monthly,* April 1874, p. 655, and *The Great South,* p. 571.)

the few enterprises that had already attracted Northern and European capital to the South. Champney's rather minimal sketch of the Aetna Coal Mines in Tennessee was enhanced by Moran, who made it less stark by adding trees with leaves and a dramatic sky (550).

Other illustrations of mineral resources include Southern ironworks. Rockwood Iron Furnaces, northeast of Chattanooga, was a large-scale enterprise that illustrated how quickly economic concerns could overcome animosities. King points out that Gen. John T. Wilder of Ohio saw the great veins of hematite in the region while campaigning under Rosecrans against Chattanooga in 1863. After the war, he purchased the site, organized a company with one million dollars of capital, and began producing pig-iron for rails more cheaply than was being done elsewhere (533).

Like *Picturesque America, The Great South* included many views of the region's cities. Whereas *Picturesque America* tended to concentrate on the picturesque aspects of the cities, *The Great South* emphasized impressive new buildings and institutions. King's emphasis on the vital role of cities as economic and cultural centers is reflected in scores of small, straightforward views of courthouses, post offices, hospitals, churches, universities, banks, and hotels—buildings that would have assured the nation that public order and civic amenities were restored to the region. Interestingly, at a time when we might expect such views to have been engraved from photographs, Champney's sketches show that he took time to make careful drawings of numerous buildings, adding details in the margin to insure their accurate representation.

A major difference between *Picturesque America* and *The Great South* is the latter's greater attention to people. *The Great South* represents the region's rich ethnic and racial diversity in numerous graphic images. This interest, which was consonant with the contemporary local color movement in literature, is also seen in King's text. Champney and King introduce the reader to such diverse characters as Mexican stone cutters and a German family in a beer garden in San Antonio; Creek Indian children in a mission school in Indian Territory; the mountain family of Parson Caton in Tennessee, whose two-room cabin sheltered the party one night; participants in a black prayer meeting in north Georgia; and those in a Mardi Gras parade in New Orleans (162, 158, 211, 479, 520, 43). Champney's depictions of these people are frequently sensitive individual portraits.[35] Unfortunately, many of his drawings were distorted either in the redrawing by Sheppard or others, or in the engraving, so that the facial expressions are changed or the individuals become types—even caricatures. For example, the central figure in Champney's drawing (fig. 10) was altered in the wood engraving (fig. 11) so that he became the kind of racial stereotype some readers would find amusing.

Yet despite such unfortunate misinterpretations of Champney's drawings, the cumulative effect of the depictions of Southern people was positive. King describes ethnic and cultural groups, but is careful to view distinctive charac-

FIG. 10. J. Wells Champney, ["Negro children on balcony,"] [1873].
Pencil drawing on off-white paper mounted with another drawing on
blue paper, on which the title is written. Image: 4" x 4"; Lilly Library,
Indiana University, Bloomington, IN.

teristics of individuals. He is honest in his assessment, characterizing some as
lazy, some as industrious, some as slow of wit, some as bright and capable.
The fairmindedness of both writer and artist in *The Great South* is very differ-
ent from other contemporaneous works such as James S. Pike's *The Prostrate
State*. This report on South Carolina characterized blacks as innately inca-
pable of self-governance.[36] *The Great South*, on the other hand, describes
both blacks and whites involved in government and indicates that in both
races there is honesty and competence as well as corruption and ignorance.
This point is evident in Champney's illustration titled "Sketches of South
Carolina State Officers and Legislators," where the artist chose to depict
individuals of both races who appear quite able (fig. 12).[37]

And finally, in *The Great South*, as in *Picturesque America*, both text and
illustrations extoll the beauty and majesty of the Southern mountains, water-
falls, and rivers. Yet the proportion of such views is smaller, about one in

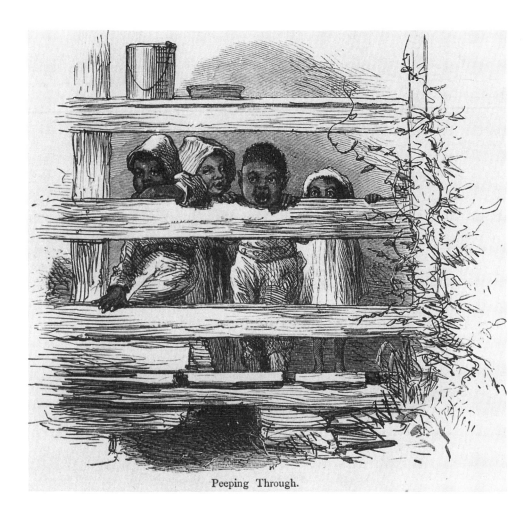

Peeping Through.

FIG. 11. "Peeping Through," *The Great South*, p. 453 [*Scribner's Monthly*, May 1874, p. 17]. Wood engraving after J. Wells Champney (probably redrawn by W. L. Sheppard). 3¾" x 4¼".

seven, as compared to two out of three among *Picturesque America*'s Southern views. Comparing Champney's original landscape drawings with Moran's reworkings, I find that it is immediately clear how much Moran altered the views to conform to picturesque conventions. He made mountains and waterfalls taller and steeper and changed sunlight to storm. A memorable example of this is Moran's transformation of Champney's straightforward view of a tired hiker at the summit of the Peaks of Otter in Virginia into the depiction of a sublime experience (figs. 13, 14).

The Great South's emphasis on picturesque scenery served as a further impetus to travel in the South. Tourism, in turn, could foster reconciliation, for it was more difficult to hold onto hostile feelings once the former enemies

met face to face. King clearly recognized this benefit in his description of ex-Confederate generals in friendly conversation with senators from the North and West at the Greenbrier resort at White Sulphur Springs, West Virginia (678).

"The Great South" series has long been recognized as playing an important conciliatory role.[38] A later editor of *Scribner's* wrote that the series "was the first high note of nationalism struck by the magazine, and was conceived in magnanimity and sympathy."[39] Sales were evidently quite brisk in the South as well as the North, and by helping to restore self-respect among Southerners, the series may have speeded the region's recovery.[40] *Picturesque*

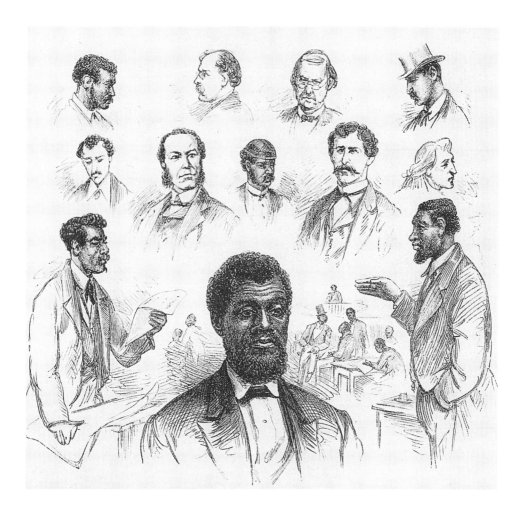

FIG. 12. "Sketches of South Carolina State Officers and Legislators, under the Moses Administration," *The Great South*, p. 462 [*Scribner's Monthly*, June 1874, p. 153]. Wood engraving after drawing by J. Wells Champney. 4¾" x 5⅛". (Champney's drawing is at the Lilly Library, Indiana University, Bloomington, IN.)

FIG. 13. J. Wells Champney, "The Summit. Peak of Otter. Sept. 9, '73." Pencil, wash, and gouache drawing on beige paper mounted on orange paper. 7%₁₆" x 6". Lilly Library, Indiana University, Bloomington, IN.

FIG. 14. "The Summit of the Peak of Otter, Virginia," *The Great South*, p. 564 [*Scribner's Monthly*, April 1874, p. 645]. Wood engraving after Thomas Moran, after J. Wells Champney. 4½" x 3¼".

America also deserves recognition for its complementary role. Yet the growing spirit of national unity promoted by these two optimistic portrayals of the South was not necessarily beneficial to all Southerners. It held disadvantages for many black citizens. As the whites in the North and South joined forces in their endeavors toward economic development and defense of property rights, support diminished for governmental intervention which could have fostered further economic and social changes.

The success and timeliness of both series is indicated by the fact that both spawned imitations. For example, in 1872 *The Aldine* featured views of American scenery, including a number of views of the South, and in 1874 *Harper's Monthly* began a series called "The New South" by Edwin de Leon.

Both books were also distributed in England. By 1873, *Picturesque America* was being published in parts in London; the same year, "The Great South" was the featured attraction when *Scribner's Monthly* entered the English market in November. In 1875, the latter was published by Blackie & Son as a book titled *The Southern States of North America*.[41] This edition added four tinted lithographs, including one titled "The Low-Country Planter Lived in a Luxurious but Careless Way," a fanciful image which revealed English misconceptions about antebellum life (fig. 15).

The wood engravings in *Picturesque America* and *The Great South* were based on on-the-spot drawings; the artist's direct confrontation with his subject matter lends an immediacy to the illustrations and a sense that these are truthful representations. Yet, as we have seen, each series was made up of carefully selected and shaped depictions of the postwar South, corresponding to the intentions of the authors and the publishers and the preferences of the artists. And there was much they chose not to record. The very different emphases of the two projects appealed to middle-class urbanites, North and South, concerned with self-improvement and respectability—whether in the cultural or the economic realm. And, in turn, the projects' images made different aspects of the South attractive to readers. *Picturesque America* helped to reestablish the region as the locus of scenery and cities appealing to the traveler and artist in search of the picturesque. *The Great South* demonstrated the opportunities for enterprise, and its benefits. Thus each provided compelling reasons to welcome the former Confederacy back into the life of the nation.

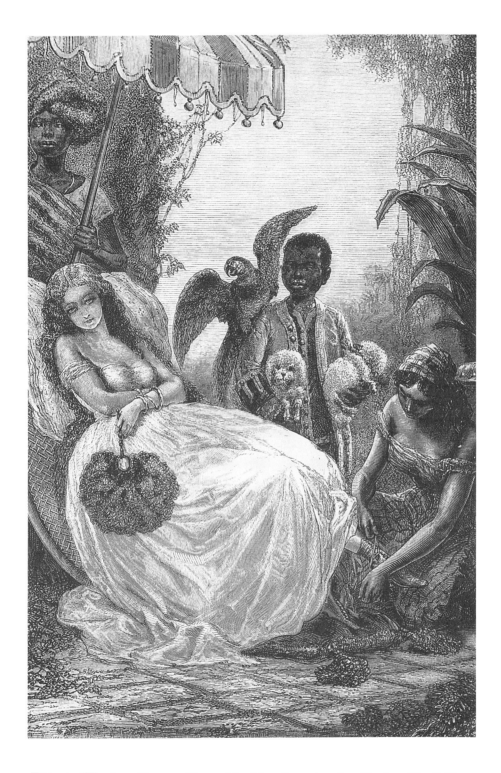

FIG. 15. "The Low-Country Planter Lived in a Luxurious but Careless Way," *The Southern States of North America,* opp. p. 431. Unsigned tinted lithograph. 8" x 5⁵⁄₁₆".

NOTES

1. Bryant first became involved with the project in mid-1872, and his contributions were limited to minor copy editing, reading proof, and writing a Preface. See Parke Godwin, *A Biography of William Cullen Bryant* (New York: D. Appleton & Co., 1883), II, p. 347; and Bryant's letter to D. Appleton & Co., June 24, 1872 (Appleton-Century Mss., Lilly Library, Indiana University).

2. Twenty-eight different writers, ranging from prominent authors to young reporters, contributed to *Picturesque America*. The largest contribution, twelve articles, came from O. B. Bunce, the managing editor of the project.

3. See, for example, F. Hopkinson Smith, *American Illustrators* (New York: C. Scribner's, 1892), p. 62. The book is still valued today for its prints, especially the steel engravings that were added to enhance the appeal of the book.

4. W. Magruder Drake and Robert R. Jones, "Editors' Introduction," Edward King, *The Great South,* ed. W. Magruder Drake and Robert R. Jones (Baton Rouge, La.: Louisiana State University Press, 1972), p. xxi.

5. See Eric Foner, *Reconstruction: America's Unfinished Revolution 1863–1877* (New York: Harper & Row, Publishers, 1988), esp. chap. 10.

6. In its coverage of regions other than the South, especially the North and Mid-West, *Picturesque America* also gives considerable attention to railroads and industry.

7. For example, see the view of the partially destroyed railroad bridge over the James River at Richmond, Virginia, opening the March 1866 *Harper's Monthly*, p. 409, accompanying Edward C. Bruce's article "In and Around Richmond." By the time of *Picturesque America,* the same bridge was shown in use, with the recovered city in the background in a steel engraving after Fenn.

8. For example, announcing "Southern Life and Scenery," with wood engravings after Joseph Becker, *Frank Leslie's Illustrated Newspaper* said these drawings would be published in the expectation that "especially to the Southern population they will be found a very valuable and attractive feature . . ." (May 22, 1869, p. 158).

9. The three-part "Novelties of Southern Scenery" appeared October 16, 23, and 30. The unsigned wood engravings are presumably after works by the author, a well-known travel writer and landscape painter. Southern genre scenes were featured in *Appleton's Journal* in 1870, based on drawings by William Ludwell Sheppard, a popular delineator of blacks: "Charcoal Sketches," February 12, 1870; and the four-part "Southern Sketches," July 2, 9, 23 and August 6, 1870.

10. See the article on Fenn in *The National Cyclopedia of American Biography.*

11. See the article on George S. Appleton in *The National Cyclopedia of American Biography.* Bunce became editor of *Appleton's Journal* in 1872 or 1873, after serving as assistant editor, first under E. L. Youmans, then under Robert Carter.

12. For excellent discussions of travel in search of the picturesque, see Malcolm Andrews, *The Search for the Picturesque: Landscape Aesthetics and Tourism in Britain, 1760–1800* (Stanford, CA.: Stanford University Press, 1989); and Bruce Robertson, "The Picturesque Traveler in America," in Edward J. Nygren, *Views and Visions: American Landscape before 1830* (Washington, D.C.: The Corcoran Gallery of Art, 1986), pp. 187–211. The use of the term *picturesque* can be confusing, for it had two primary meanings in this period—like a picture, and, more specifically, characterized by variety, irregularity, roughness, and contrast.

13. John Greenleaf Whittier, *Snow-Bound* (Boston: Ticknor and Fields, 1868) and *Ballads of New England* (Boston: Fields, Osgood & Co., 1870). Fenn's illustrations in the latter were said to reproduce "all the moods and sentiments of the New England landscape" (*Atlantic Monthly*, December 1869, p. 767).

14. The standard ingredients of the "Claudian formula" were a dark foreground, trees framing the main subject, a light middle ground, and a zigzag of light and dark planes into the far distance.

15. Fenn apprenticed at London's leading wood-engraving firm, Dalziel Brothers. [George and Edward Dalziel], *The Brothers Dalziel: A Record of Work, 1840–1890* (London: Methuen and Co., 1901; London: B. T. Batsford Ltd., 1978). After coming to the United States in 1857, Fenn worked as a wood engraver for *Frank Leslie's Illustrated Newspaper* and probably for other publishers as well. Budd Leslie Gambee, Jr., "*Frank Leslie's Illustrated Newspaper, 1855–1860*: Artistic and Technical Operations of a Pioneer Pictorial News Weekly in America" (Ph.D. diss., University of Michigan, 1963), p. 365.

16. This contrasts greatly with the practical guidebook approach of articles in other magazines about this time (see, for example, George Ward Nichols, "Six Weeks in Florida," *Harper's New Monthly Magazine*, October 1870, pp. 655–67); also with *The Great South*'s coverage of Florida, just three years later, when a journey up the Oclawaha is said to be "as fashionable as a promenade on the Rhine" (Edward King, *The Great South* [Hartford: American Publishing Company, 1875], p. 409).

17. These images are scarcer in this form than as they appeared in the book that followed, with text printed on the verso. Although no evidence for the size of the printing runs for *Appleton's Journal* has been found, it was certainly a smaller number than the total of the various printings of *Picturesque America*.

18. Fenn's close-up of a portion of the bridge was in keeping with the careful depictions of details of nature recommended and practiced by John Ruskin and by such American painters as Asher B. Durand, Worthington Whittredge, and David Johnson in some of their works. Fenn also drew the bridge from a more conventional viewpoint, from below the arch, at sunrise.

19. Comparison of this page from *Appleton's Journal* with the page that opens the section on Natural Bridge in *Picturesque America*, Vol. 1, p. 82, reveals several alterations. To create a nicely balanced page in the larger format in the book, the rustic title was removed from the wood engraving and placed above it in type. In cutting off an inch from the bottom of the wood engraving, the minuscule figures in the valley floor were removed. In a way, this causes the arch to seem even higher, since there is now no indication of where the base is. The larger type of the text in the book, with ample leading between lines, allowed easier reading.

Both the text and pictures of *Picturesque America* almost certainly would have been printed from electrotypes, the usual practice for long runs in this period.

20. For *Picturesque America*, the usual procedure was for the artist to redraw the design in reverse on the whitened woodblock in preparation for the engraver. See J. C. Adams, *William Hamilton Gibson, Artist-Naturalist-Author* (New York: G. P. Putnam's Sons, 1901), pp. 42–43. Photography as a means of transferring the image to the block came into widespread use in the late 1870s and 1880s.

21. This and subsequent textual references in parentheses are to William Cullen Bryant, ed., *Picturesque America* (New York: D. Appleton & Co., 1872–74). The drawing referred to is in a private collection.

22. For reproductions of Waud's drawings, see *Alfred R. Waud, Special Artist on Assignment* (New Orleans: The Historic New Orleans Collection, 1979); "Down the Mississippi," *American Heritage*, June/July 1984, pp. 87–95; and "The Creole Sketchbook of A. R. Waud," *American Heritage*, December 1963, pp. 33–48. A number of Waud's original drawings for *Picturesque America* are in The Historic New Orleans Collection, the Chicago Historical Society, and the Missouri Historical Society. He typically worked in pencil on beige or pastel paper, and frequently added Chinese white for highlights.

23. King, *The Great South*, p. i; "A Greeting to our English Readers," *Scribner's Monthly*, Vol. 7, p. 114.

24. For an account of the magazine's founding, see Arthur John, *The Best Years of the Century* (Urbana, Ill.: University of Illinois Press, 1981). *Scribner's Monthly* became *The Century Illustrated Monthly Magazine* in 1881. On Holland, see Robert J. Scholnick, "J. G. Holland and the 'Religion of Civilization' in Mid-Nineteenth Century America," *American Studies* 27 (Spring 1986), pp. 55–79. By the late 1870s *Scribner's Monthly*, and then *The Century* after the name was changed, was recognized for the fine printing of its illustrations under master printer Theodore Low DeVinne, who directed the magazine's printing beginning in 1876. DeVinne made numerous innovations, including the use of overlays and underlays, dry smooth paper, and photography on the block. See John, *The Best Years of the Century*, pp. 80–81.

25. See Drake and Jones, "Editors' Introduction," pp. xxi–xxvi.

26. Frère was much admired in this period. See "Edouard Frère, and Sympathetic Art in France," *Harper's New Monthly Magazine* (November 1871), pp. 801–14, in which the writer recounts a visit with John Ruskin, who praised Frère for his sympathetic renderings of poor peasants in their cottages.

27. See *James Wells Champney, 1843–1903* (Deerfield, Mass.: Hilson Gallery, Deerfield Academy, 1965); *M. & M. Karolik Collection of American Water Colors and Drawings, 1800–1875* (Boston: Museum of Fine Arts, 1962), Vol. 1, pp. 98–102. Three of Champney's drawings of Florida for *The Great South* are in this collection. A self-portrait by Champney is reproduced as the frontispiece to this volume.

28. Both Moran and Sheppard were regularly employed by *Scribner's Monthly*. Since January of 1871, Moran had drawn most of *Scribner's* illustrations of American cities and scenery, including the influential views of the Yellowstone region. Sheppard, on the other hand, was frequently engaged to draw people, and being a Southerner himself, was considered particularly expert at depicting blacks.

29. With the purchase of his large oil painting *The Grand Canyon of the Yellowstone* by Congress in 1872 for ten thousand dollars to hang in the U.S. Capitol, Moran had become a celebrity in the art world.

30. Pictured in *The Great South*, p. 189. About King's convoluted itinerary, see Drake and Jones, "Editors' Introduction." Champney, evidently hired only for the initial journey at first, was subsequently engaged for further travel at King's urging. Champney took a break to marry and vacation in mid-1873. Letter of King to George Washington Cable, May 9, 1873 (George Washington Cable Mss., Howard-Tilton Memorial Library, Tulane University). King met Cable on his first trip to New Orleans and was instrumental in getting Cable's work published in *Scribner's Monthly*.

31. *Scribner's Monthly*, July 1873, p. 258.

32. *The Great South*, pp. 371, 637.

33. This and subsequent page numbers in parentheses refer to King, *The Great South* (Hartford: American Publishing Co., 1875).

34. Of course, not everyone who wanted to go West could afford the train, and illustrations show people going on foot or by wagon. See *The Great South*, pp. 314, 318.

35. In the 1890s Champney was highly regarded as a portrait artist in pastels.

36. First published as articles in *The New York Tribune,* then as a book, James S. Pike, *The Prostrate State* (New York: D. Appleton & Co., 1874).

37. Champney further supported the book's basically optimistic viewpoint with genre scenes, such as the one on page 773 of both black boys and white boys industriously shelling peas in Richmond.

38. For example, see Paul H. Buck, *The Road to Reunion: 1865–1900* (Boston: Little, Brown and Company, 1937), pp. 130–32.

39. Robert Underwood Johnson, *Remembered Yesterdays* (Boston: Little, Brown and Company, 1923), p. 96.

40. Drake and Jones, "Editors' Introduction," p. xxxiii; L. Frank Tooker, *The Joys and Tribulations of an Editor* (New York: The Century Co., 1923), pp. 38ff.

41. This was available in 1-, 3-, or 4-volume editions.

ALFRED HUTTY AND THE CHARLESTON RENAISSANCE

Boyd Saunders

C ome quickly, have found heaven," wired artist Alfred Hutty in 1919 to his wife, Bess, who was in Woodstock, New York. He had set out to find a warmer winter climate in which to paint and, on his way by train to Florida, had discovered Charleston. After a brief walking tour, he had found the city very much to his liking and had made a connection with the Carolina Art Association, whose members invited him to return as a teacher at the newly founded art school. Classes would be held at the Gibbes Memorial Art Gallery, then fourteen years old. "Since I had no preconceived idea of Charleston," he recalled, "and having seen no pictures of its history or traditions, it was with open vision that I first beheld its quaintness and beauty and tasted the full charm of its old world flavor."[1]

Alfred Hutty was born in Grand Haven, Michigan, on September 16, 1877, the son of Joseph William and Susan Browning Hutty. During his boyhood Hutty moved to Kansas City, Missouri, and still later to the frontier town of Leavenworth, Kansas.

In 1892, at age fifteen, he won a scholarship to the St. Louis School of Fine Arts, and later he took a job with a stained-glass studio in Kansas City as a designer and painter of figure and landscape windows.

In 1902 he married Bessie Burris Crafton. Then he, Bess, and their young son Warren moved to St. Louis, where he was to work as a designer of stained-glass windows.

While in St. Louis, Hutty saw an exhibition of paintings by a well-known Eastern painter, Lowell Birge Harrison. At the time he was twenty-seven, and he longed to paint. He decided to attend classes in landscape painting at the newly formed summer school of the New York Art Students League, located in Woodstock, New York. Arriving there in 1907, he studied under Harrison. He was an apt pupil; his years of training in the stained-glass studios were helpful. At the end of two months he made another momentous decision—he would devote his life to painting.

The necessity for practicality arose, and he went to New York City in search of part-time work that would enable him to further his studies. He luckily landed a job with the Tiffany Stained Glass Studios. For the next ten years he lived in Woodstock, did stained-glass work on a commission basis, studied at the Art Students League, and painted.

Hutty was to be a part of Woodstock, and it a part of him, for the rest of his life. He was one of the original directors of the Woodstock Artists Association. He was also one of the first artists to buy a farm in the community. At the time he and Bessie purchased the old Wesley France sheep farm on Ohayo Mountain, it was considered far from town. In time the house and two barns would undergo extensive changes. Here he opened his Studio on the Hill.

In the beginning, the Art Students League occupied an old barn. There Woodstock saw its first art exhibitions when the students hung their pictures for public view each Saturday morning.

With his stained-glass window work providing a constant inspiration, Hutty's artistic aspirations were fast being realized. In a short time he was exhibiting in many galleries and was becoming well known as a painter in oil and watercolor. But it was 1917, and the United States entered World War I. For the next two years, he and a small group of other artists would contribute their talents to painting camouflage patterns on U.S. Navy ships.

In February 1920, he went to Charleston to begin teaching classes at the Gibbes Memorial Art Gallery. He taught at Gibbes for only four years, but later he taught privately and continued to divide his time between Charleston and Woodstock until three years before his death.

Hutty's discovery of Charleston came when the War between the States had been over a scant 55 years. He was almost 42 years old, and nothing in his past experience would have told him that this sleeping beauty was on the verge of an awakening in which he would play a prominent part. He knew little of what had transpired in the city over the 249 years since the first English settlers had arrived in 1670.

In his book *A Short History of Charleston,* Robert Rosen suggests that, "It should be remembered that the early Charlestonians came to the New World to recreate the luxurious, cosmopolitan, pleasure-filled world of Restoration England. Their mission was to build a miniature aristocratic London in the midst of recreated English countryside inhabited by a landed gentry."[2]

Charleston was the perfect location in which to fulfill such a mission, as

noted historian Dr. George C. Rogers, Jr., explained in the book *Charleston in the Age of the Pinckneys*. He described an interesting geographic reason for the rapid growth of Charleston:

> Charleston's golden age coincided with the last century of the age of sailing vessels. As long as the age of sail lasted, Charleston was on the main Atlantic Highway, which circumnavigated the Bermuda High. Vessels leaving England, or leaving any European port for North America, generally sailed southwestwardly to the Azores to catch the trade winds and then with full sail made for the West Indies, Barbados standing out front like a doorman to welcome all to the New World. They next made their way through the West Indies to the Gulf Stream. From the Florida Keys to Cape Hatteras they hugged the American coast before veering off to England and Northern Europe. It was a great circle, and Charleston was on its western edge. The first settlers . . . in 1669–70 had followed this route via Barbados, Nevis, Bahamas, and Bermuda to Carolina.[3]

Charleston's early wealth was created by merchants whose ships brought first the necessities and later the luxuries, and took forth over the world naval stores, pelts and Indian slaves. In time these merchants became planters. It was a natural transition because many were the sons of English, French, Irish, and Barbadian middle-class yeoman farmers.

Primarily to enjoy the winter social season, many planters built houses in Charleston and thereafter divided their time between city and country. These planters created an aristocratic way of life. They built Barbadian-influenced single houses, Georgian mansions with walled gardens and piazzas, stately public buildings, and dignified churches (fig. 1). The plantation system which came with the rise of rice culture had as its underpinnings the system of slavery. To work their plantations and to maintain their households, they brought in African slaves in ever-increasing numbers. The slaves brought with them not only a knowledge of growing rice, but also their own rich music and folklore.

By 1919, when Hutty first saw the city, Charleston had endured much. Since the War between the States, little had changed. In 1895, a Northern reporter had described it as "a city of ruins, of desolation, of vacant houses, of widowed women, of rotting wharves, of deserted warehouses, of weed-filled gardens, of miles of grass grown streets, of acres of pitiful and voiceful barrenness, that is Charleston" (fig. 2).

Later Charlestonian DuBose Heyward lamented, "After the War Charleston was faced with such a bitter economic struggle that there was no energy left in the people for the development of art in any form."[5]

The 1920s and 1930s Charleston, in spite of the mystique that love and legend have accorded her, was a most unlikely place for an artist to expect to find the base of support (financial or otherwise) to sustain a serious professional career. The population numbered approximately sixty-five thousand, divided more or less evenly between blacks and whites. The rice culture and

Fig. 1. Alfred Hutty. *Ashley Hall*. Etching, 15¼" x 10". The Gibbes Museum of Art/Carolina Art Association; gift of Mrs. Alfred Hutty.

FIG. 2. Alfred Hutty, *In Old Charleston*, 1925. Etching, 8½" x 9½".
Gift of the Helen Calhoun Adams and Robert Adams IV Memorial
Collection, Columbia Museum of Art, Columbia, SC.

market had, for all serious purposes, disappeared. The highly prized, long-staple sea-island cotton had been wiped out by the boll weevil, and even the upland short-staple cotton was no longer being marketed through Charleston as it once had been. The phosphate-mining industry, which had enjoyed something of a boom after the War between the States, had exhausted itself, and there was little in the way of new industry to take its place.

While other Southern ports such as New Orleans, Mobile, and Savannah had managed to flourish somewhat during the preceding years, the seaport of Charleston had lost the prominence it had enjoyed before the war. In short, Charleston at that time had no significant economic base and was a seriously depressed area. Heyward remembered, as a boy, playing on the abandoned and rotting docks and wharves of the city.

Many buildings were in dire disrepair with windows out, doors and shutters hanging half off their hinges, and stucco collapsing (fig. 3).

In such circumstances, no one could expect a cultural renaissance to begin. Yet it did, and Alfred Hutty played a large part in it. To understand his Charleston work, one must see it in the light of this dynamic reawakening. As Charleston playwright Patricia Robinson recalled:

> Charleston was a gentle town, far from prosperous and not yet recovered from the ravages of the Civil War and Reconstruction. There was little money, no industry to speak of and the old saying "too poor to paint and too proud to whitewash" was a way of life. The old town seemed to slumber awash with sunlight, touched only by soft sea winds. But it was far from a "sleeping beauty." Unheralded, Charleston was undergoing a cultural renaissance. There was a flowering of art, literature, drama and music. DuBose and Dorothy Heyward, John Bennett, Hervey Allen and Josephine Pinckney were writing their books and plays. Alfred Hutty, Alice Ravenel Huger Smith, Minnie Mikell, and Beth Verner were at work in their studios. Susan Frost began the work of Charleston preservation. It was the beginning of the Poetry Society of South Carolina, The Footlight Players, and the Charleston Symphony. There was no free money from foundations or government. What happened was spontaneous, growing out of people's will to answer their own cultural needs; the lives of these creative people touched constantly. They enriched and encouraged each other. They gave the town a vitality and an identity which even the onslaught of "PROGRESS" failed to destroy.[6]

It became a fashionable habit in the 1920s and 1930s for Northerners of genteel circumstances to winter in Charleston. They came not as tourists as we have come to know them but as "seasonal residents." They rented houses for the winter season, sending the servants ahead to open them; they took lodging in private homes and inns; they stayed in several of the old hotels—the Fort Sumter, the Francis Marion, or perhaps the Villa Margharita. This

Fig. 3. Alfred Hutty. *Cabbage Row*. Etching 11½" x 12⅜".
The Gibbes Museum of Art/Carolina Art
Association; gift of Mrs. Alfred Hutty.

Charleston tourist movement seems to have begun during World War I, when Europe was closed and the Florida land boom had not really begun.

Many of the seasonal residents took an active part in the civic and cultural affairs of the town and helped provide a strong base of support and patronage for the emerging artists. Understandably, when they returned to their other homes in the Northeast, many wished to take with them mementos of their stay in Charleston. Thus a steady stream of visitors frequented the studios of Charleston artists, visitors with money and pleasant memories, who wanted to buy art which celebrated the look and the feel of the Low Country.

Some bought and renovated town houses, thus becoming a part of the Charleston restoration movement; others purchased plantations and transformed them from their previous status as working estates into recreational retreats. A new aristocracy came into being, moneyed and with a taste for the way of life the old planters loved but were no longer able to maintain.

As a result of the curious combination of these and many other factors, there was in Charleston at that time a vital and dynamic cultural renaissance—a renaissance precipitated by the alignment of the participants, the patrons, the location, the times, and the special indefinable magic that is always a part of the true creative act.

The many productive groups and individuals in Charleston inspired and supported one another. In a community this small there inevitably was much crossing of the normal boundaries of the various artistic disciplines. Therefore, groups such as the Poetry Society of South Carolina, The Footlight Players, the Charleston Etchers Club, the Gibbes Memorial Art Gallery, the Society for the Preservation of Old Dwellings, the Society for the Preservation of Spirituals, the Charleston Symphony Orchestra, and the Charleston Museum often had many members in common who helped one another extensively. The Jenkins Orphanage Band was also a vital force in the Charleston renaissance. Without this degree of cooperation among its participants, this movement would not have had the force it did.

Among the most prominent of these crossover individuals was author and illustrator John Bennett, born in Chillicothe, Ohio, on May 17, 1865. After only one year of high school, he began his writing career as a journalist. He moved to Charleston for health reasons in 1898, and in 1902 he married Susan Adger Smythe. Their home on Legare Street was to become a center of literary activity. There the first informal meetings of what would become the Poetry Society of South Carolina were held.

In 1921, the 135 charter members of the Poetry Society of South Carolina held their first meeting, with John Bennett a dominant member. Of all the groups involved in the Charleston renaissance, perhaps the Poetry Society was the most influential and effective.

Frank Frost was elected president of the Society and DuBose Heyward secretary. Other prominent founders were Hervey Allen, later to write the best-selling novel *Anthony Adverse;* Laura Bragg, director of the Charleston

Museum; Helen von Kolnitz Hyer, whose collected poems were published in *Danger Never Sleeps;* and Josephine Pinckney, who, like Allen and Heyward, was to publish poetry but to become better known for her prose, especially perhaps her novel *Three O'Clock Dinner.* Some of the aims of the founders were to help promising Southern poets break into print, to help develop an audience worthy of such poets, and to bring into creative cooperation with the Poetry Society all Charlestonians interested in any of the fine arts.

Alfred Hutty was born on the edge of the frontier just eight years before DuBose Heyward, who by birth was perhaps as classic a Charlestonian as one could imagine. Yet the two were good friends. One of Heyward's lesser-known novels, *Lost Morning* (1936), clearly uses Hutty as a model for its main character.

It was, of course, the Charleston renaissance that brought these two together. Hutty, the artist and newcomer, depicted visually many of the people and places that Heyward, the writer and native, depicted verbally.

Both Hutty and Heyward drew on real-life Charleston models for their artistic inspirations. For instance, an insignificant item in the *News and Courier*'s account of local court proceedings caught Heyward's attention:

> Samuel Smalls, who is a cripple and is familiar to King Street, with his goat and cart, was held for the June term of court of sessions on an aggravated assault charge. It is alleged that on Saturday night he attempted to shoot Maggie Barnes at number four Romney Street. His shots went wide of the mark. Smalls was up on a similar charge some months ago and was given a suspended sentence. Smalls had attempted to escape in his wagon, had been run down and captured by the police patrol.[7]

Heyward clipped the item and saved it. The tale mellowed in his mind and billfold until he was ready to write his great novel, and then Samuel Smalls, or "Goat Sammy" as he was more commonly known, became first Porgo and then Porgy. The novel was a success and, with the collaboration of Dorothy Heyward, was turned into an equally successful play. It is interesting to muse on the creative force which transformed the insignificant newspaper article about a typical Saturday night shooting scrape into the epic work that *Porgy* became.

According to Merle Armitage in his book *George Gershwin,* "In 1926, George Gershwin read the DuBose Heyward novel *Porgy,* the story of a crippled Negro beggar of Charleston's Catfish Row. Gershwin was impressed, believing he had at last found the proper vehicle for his long-considered operatic plans. He immediately wrote to Heyward, and their meeting in Charleston resulted in an agreement to create an opera, using the story of Porgy."[8]

In July 1934, George Gershwin rented a cottage for two months on Folly Island, about ten miles south of Charleston. This was adjacent to James Island, where there was a large population of Gullah-speaking Negroes, and Gershwin went there often to observe the people and to take part in their

singing and "shouting" at revival meetings. In all, the project took Gershwin eleven months to compose and nine months to orchestrate. The working title had been *Porgy*, but when the manuscript was finished, Heyward suggested calling it *Porgy and Bess* to avoid confusion with the play.

The world premier of *Porgy and Bess*, billed as an "American Folk Opera," took place at the Colonial Theater, Boston, on September 30, 1935. Although it was considered somewhat long, audiences and critics were enthusiastic, with Serge Koussevitzky pronouncing it "a great advance in America opera."

The Broadway opening at the Alvin Theater, October 10, 1935, exactly eight years after *Porgy*, marked for the first time a theatrical work with an all-Negro cast had played a $4.40 top ticket price. Even so, the show closed after playing to mixed reviews for 174 performances and lost all of its seventy-five-thousand-dollar investment. Later, an editorial in *The New York Times* ventured the opinion that "*Porgy and Bess* is utterly innocent of elemental tragedy or anything of real dramatic import." Another critic called the work "falsely conceived . . . crooked folklore and halfway opera." The black press derided the opera as the "most insulting, the most libelous and the most degrading act that could possibly be perpetrated against colored Americans."

George Gershwin died in 1937, but *Porgy and Bess* was destined to be revived again and again—first in 1936, then in 1938, again in 1942–44, yet again 1952–54. In all, it played to wildly enthusiastic audiences and rave reviews in approximately 150 cities in the United States and around the world between 1935 and 1954—but ironically, not in Charleston. For a number of reasons, most having to do with segregation, *Porgy and Bess* was not to be presented in Charleston until 1970.

In one of those small occurrences that cast a strange light on large events, a curious letter was discovered in the back of a picture in a Charleston art gallery sometime during the 1980s. Its author and recipient are uncertain, but it said in part:

> DuBose Heyward, the author of this play and book is a neighbor of mine and I know Porgy for the filthy, evil beggar that he was. He has often parked his odiferous goat cart in front of my office door and no one knows just what end he met, as he was always in trouble and served many terms in prison, although legless.[9]

Certainly, anyone who has experienced the rich texture of Charleston can appreciate the sensuous qualities that inspired the peculiar sensibilities of the artists who found themselves there. The most immediate appeal to the senses comes from the architecture with its Barbadian influence, which, whatever else, is decidedly picturesque. Perhaps more important, everything seems to be designed on a human scale, which provides a sense of access and intimacy. Charleston contemporary artist William Halsey has talked of growing up in a Charleston full of the decadent textures of stucco and cobblestones, of the smell of decaying plaster, of fragments of images glimpsed around a corner

or through the half-opened gate of a courtyard. Others have responded to a particular kind of sunlight that causes strong visual contrasts between light and shadow, a sunlight which in combination with the salt air tends to bleach the colors of man-made surfaces to form a striking contrast with the natural coloration of foliage (fig. 4).

There is the heady sweetness of flowers and the constant chorus of soft, melodious sounds—the peal of church bells, the rattle of palmetto trees, and the wind in the pines. The songs and cries of street vendors, cicadas, birds, boat horns—all combine to create an unrecorded Charleston symphony.

There are also the daily dramas of two cultures, coexisting in time and place, yet vastly different. One such drama Heyward incorporated into *Porgy* with particular resonance. It is set in the first sunlight of morning on the day of the grand parade of "The Sons and Daughters of Repent Ye Saith the Lord" lodge:

> The drowsy old city had scarcely commenced its day when, down through King Charles Street, the procession took its way. Superbly unselfconscious of the effect that it produced, it crashed through the slow, restrained rhythm of the city's life like a wild, barbaric chord. All of the stately mansions along the way were servantless that day, and the aristocratic matrons broke the ultimate canon of the social code and peered through front windows at the procession as it swept flamboyantly across the town.
>
> First came an infinitesimal negro boy, scarlet-coated and aglitter with brass buttons. Upon his head was balanced an enormous shako; and while he marched with left hand on hip and shoulders back, his right hand twirled a heavy gold-headed baton. Then the band, two score boys attired in several variations of the band master's costume, strode by. Bare, splay feet padded upon the cobbles; heads were thrown back, with lips to instruments that glittered in the sunshine, launching daring independent excursions into the realm of sound. Yet their improvisations returned always to the eternal boom, boom, boom of an underlying rhythm, and met with others in the sudden weaving and ravelling of amazing chords. An ecstasy of wild young bodies beat living into the blasts that shook the windows of the solemn houses. Broad, dusty, blue-black feet shuffled and danced on the man-colored cobbles and the grass between them. The sun lifted suddenly over the housetops and flashed like a torrent of warm, white wine between the staid buildings, to break on flashing teeth and laughing eyes.
>
> After the band came the men members of the lodge, stepping it out to the urge of the marshals who rode behind them, reinforcing the marching rhythm with a series of staccato grunts, shot with crisp, military precision from under their visored caps. Breasts cross-splashed with the emblems of their lodge, they passed.
>
> Then came the carriages, and suddenly the narrow street hummed

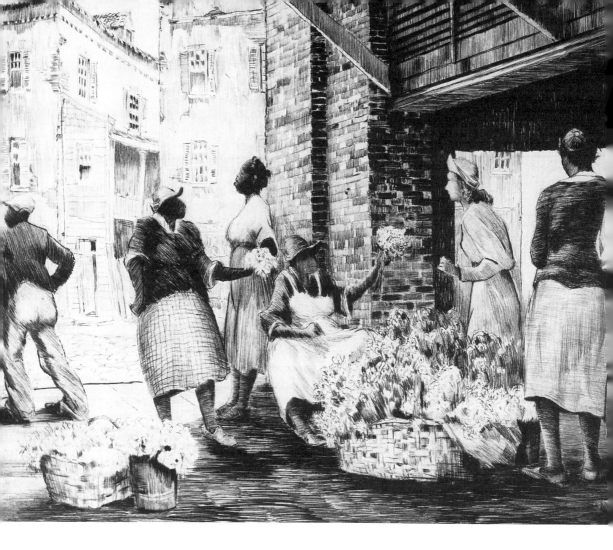

Fig. 4. Alfred Hutty. *Flower Vendors, Charleston Market.*
Drypoint, 7⅞" x 10½". Gift of the Helen Calhoun Adams
and Robert Adams IV Memorial Collection, Columbia
Museum of Art, Columbia, SC.

and bloomed like a tropic garden. Six to a carriage sat the sisters. The effect produced by the colors was strangely like that wrought in the music; scarlet, purple, orange, flamingo, emerald; wild, clashing unbelievable discords; yet, in their steady flow before the eye, possessing a strange, dominant rhythm that reconciled them to each other and made them unalterably right. The senses reached blindly out for a reason. There was none. They intoxicated, they maddened, and finally they passed, seeming to pull every ray of color from the dun buildings, leaving the sunlight sane, flat, dead.

In such a setting, with such an appeal to the senses, it is easy to understand how the look and feel of such a place could have figured so prominently in its art.

The parade is by no means pure invention. Clearly, the inspiration for this passage was the Jenkins Orphanage Band, founded in the 1890s by the Reverend Daniel Jenkins, a black Baptist minister, who started it to help raise funds for an orphanage after he found four homeless young black orphans shivering in a rail yard on a cold winter day. After the orphanage opened in 1892, funded by local and Northern contributions and by the band's earnings, the band continued to play regularly on the streets of Charleston, passing the hat after performances, and traveled throughout the United States, Canada, and abroad. They were in the inaugural parade for president William Howard Taft, and the band starred in the openings of the play *Porgy* in New York (1927) and London, where they had performed in 1905 and 1914 as well.

Much of the magic and vitality of this group is captured in Alfred Hutty's drypoint *Jenkins Orphanage Band* (fig. 5). It continues to be a popular image with collectors of Hutty's works. Perhaps close examination will reveal a youthful "Cat" Anderson, who went on to play with Duke Ellington's band, or "Jabbo" Smith, who later joined Louis Armstrong's band.

In his book *The Preservation Effort*, Harlan Greene says that "Charleston was the proud survivor of earthquakes, fires, flood and wars, and it was finally going down to defeat, this time at the hands of the modern age and tourists. By the end of World War I old buildings were falling like dominoes to make way for new ones, and it had become stylish for the rich to remove quaint flagstones from Charleston walkways to more northerly latitudes. Gates, balconies and old tiles, too, were taken to grace homes on Long Island; and even a three story house was carried off, from the bottom bricks of the basement to the roof. Since Fort Sumter and before, however, Charlestonians have been noted for their fighting spirit, and in April 1920, when it was announced that the Joseph Manigault House was to be demolished for a filling station, a group of concerned individuals banded together to defend it."[11]

Susan Pringle Frost sounded the battle cry and a charge was mounted. She was well qualified to lead this preservation army, having been Charleston's

FIG. 5. Alfred Hutty. *Jenkins Orphanage Band.* Drypoint, 10⅞" x 10⅜". Courtesy of the Boston Public Library, Print Department, Albert H. Wiggin Collection.

first modern businesswoman, its first woman to drive her own automobile, and a leading suffragette.

The Society for the Preservation of Old Dwellings was founded in 1920 and was incorporated in 1928. Through the years, with occasional revisions of name and goals, this group has served as the primary guardian of Charleston's architectural heritage. In Alfred Hutty she had not only an enthusiast for the movement, but also an active participant. The Huttys bought a house at 46 Tradd Street and restored both its charm and its usefulness. The old separate kitchen in the rear became his studio, a building that expressed his personality—quiet and restful, dignified yet inviting (fig. 6).

The restoration at 46 Tradd Street was done with perception and good taste. The ancient kitchen with the brick floor and raftered ceiling was given a skylight and became "The Studio in the Garden." There between the huge fireplace and the quaint mezzanine, Hutty kept his press and made his prints, while he and Bessie entertained a steady stream of the well known and the lesser known. Booth Tarkington came, and Mrs. Joseph Kennedy, as well as many others. They signed the guest book, bought the prints and paintings, and many times wrote back for more.

One of Hutty's abiding interests was Charleston theater, which began its long history with the building of Dock Street Theater in 1736. According to Emmett Robinson, longtime director of the city's Footlight Players, the first production was *The Recruiting Officer,* presented in February 1736 in what the newspapers described as "the new theater in Dock Street." (One month after the theater was opened, the name of the street was officially changed from Dock Street to Queen Street.)

Throughout the next two centuries various theaters came and went until, Robinson said, "In 1931, a small group started what has become for Charleston a theatrical tradition, built and strengthened over many years by hundreds of willing hands, by priceless gifts of time and toil, of faith, enthusiasm and talent, freely offered and in gracious abundance." That group was The Footlight Players, who at various times have performed in Dock Street Theater, and two of those willings hands of which Robinson spoke belonged to Alfred Hutty, who was the Players' president in 1941–42 and also served many terms as vice-president and board member.

Hutty's etching of the *Footlight Players Workshop* at 20 Queen Street is a good example of his ability to depict the character of a structure through well-chosen detail. Robinson recalled Hutty's admonitions against lines that were "too straight" in architectural subjects such as this.

Prints are among the most itinerate of art forms. Because of their abundance, modest cost, and portability, they travel well and widely, serving as effective transporters of visual information. Like wandering troubadours and minstrels, they have for centuries carried their messages from culture to culture and continent to continent. The etchings of Alfred Hutty, Elizabeth O'Neill Verner, and many other contemporary Charleston etchers sprang

FIG. 6. Alfred Hutty. *My Charleston Studio*. Etching, 13½" x 14¾". The Gibbes Museum of Art/Carolina Art Association; gift of Mrs. Alfred Hutty.

from a rich and colorful tradition. It seems appropriate to examine a few of the roots of this artistic ancestry. One such tracing begins in Rome.

In the eighteenth century the Eternal City was dying, an act the great city performed with a grace and finesse born of much practice. Ravished repeatedly by invading armies, convulsed by civil unrest, torn by religious strife, and crumbled by urban decay, this bastion on the Tiber had, in fact, come close to death many times before, always rising again, phoenix-like, from her own ashes. Through it all she remained the spiritual mecca for a large portion of the world's populace, the destination of the penultimate pilgrimage, as alluring in decay as in regeneration and transcendence. In the eighteenth century she staged this performance yet again, this time inspiring a way of thinking and seeing called neoclassicism, which helped shape the entire Western world.

One of the chief high priests of this cult of Roman worship was the young Giambattista Piranesi (1720–1778), born in Venice, the son of a stonemason. He studied architecture in Rome and became passionately interested in Roman antiquities. His primary claim to fame, however, is as an etcher. The ancient buildings and ruins of Rome provided subjects for some thirteen hundred large etchings, which he printed in vast numbers. His images were opulent, grandiose, and melodramatic. The human figures he depicted were diminished in size to give an exaggerated sense of scale to the architecture. The popular demand for his prints came from two primary sources: Roman citizens acquired the etchings to celebrate their veneration of the Eternal City, and tourists and pilgrims bought them to carry home as mementos or souvenirs of this special place. Piranesi's etchings depict the city, if not in the way it looked, at least in the way it ought to have looked, and frequently they were accompanied by descriptions and commentary. Of all the genres of prints that have been published, the most popular by far have been the "views of" one place or another.

A hundred years later, the American expatriate artist James Abbott McNeill Whistler (1834–1903) drew much of his inspiration from the etchings of Piranesi. His painting *Arrangement in Gray and Black No. 1* (1871), best known as *Whistler's Mother,* has long been a popular favorite, but perhaps his most significant contributions to art are his etchings. He began producing etchings seriously after he moved to London in 1859 and continued to do so during a sojourn in Piranesi's home town of Venice. His more than four hundred etchings, many of them views of Venice or the Thames, created the benchmark of excellence for succeeding generations of etchers.

Among Whistler's followers were many American artists whose early training had been chiefly in architecture. With keen entrepreneurial perceptivity, they employed their draftsmen's training and knowledge of historic architecture to realize a pictorial "grand tour" of Europe and the Near East. Where Piranesi had provided travelers with a visual reminder of their journey to take home, these later printmakers themselves did the traveling to picturesque locales and brought images home. The work of these early twentieth-century

artists—most of whom acknowledged Whistler's influence—was pleasant, facile, technically brilliant, and provided collectors with a visual travelogue of European architectural landmarks.

Two of Whistler's artistic heirs were the Americans Joseph Pennell (1857–1926) and John Taylor Arms (1887–1953). Pennell was born in and grew up in Philadelphia, studying at the Pennsylvania Academy of the Fine Arts. His unusual etching ability was quickly recognized with honors in Chicago, Paris, and elsewhere. He was a friend and disciple of Whistler and, like Whistler, he was very much the itinerate artist. During his career he did more than 900 etchings, 621 lithographs, and hundreds of drawings and watercolors.

The name Pennell is frequently mentioned in the same breath as that of John Taylor Arms, who was born in Washington, D.C. Having studied architectural design at the Massachusetts Institute of Technology, he worked as an architectural draftsman in New York City for two years before joining the United States Navy during World War I. After the war he devoted himself to making etchings of the architectural wonders of Europe. His work is typified by a love of the Gothic, a devotion to detail, and a desire to convey the spiritual essence of the subject.

Like his artistic ancestor Piranesi and many of his contemporaries, Arms brought the peculiar perceptions of an architect to his art. During his lifetime he saw his works added to the print collections of prestigious museums in America, England, and France. Having become friends with Hutty at Woodstock, he also traveled to Charleston to visit his fellow printmaker and draw the architecture. The two artists often corresponded and traded etchings.

When the printmakers of the Charleston renaissance in the 1920s and 1930s used the etching medium to celebrate the essence of their Holy City, they continued a time-honored tradition. They readily acknowledged their debt to the dynasty of etchers just discussed.

As did their artistic forebears, they found many of their patrons among travelers to their city, and their etchings became travelers as well. While their works do not usually have the drama or scale of a Piranesi, the audacity of a Whistler, or the technical brilliance of a Pennell or an Arms, they generally have the immediacy, intimacy, and access born of first-hand knowledge and experience. It can best be described as the simple but eloquent, straightforward, and loving celebration of a particular place and way of life.

The formation in 1923 of the Charleston Etchers Club, a group of nine artists, is an event of considerable significance in the history of American printmaking. The founding members were Alfred Hutty, Alice Ravenel Huger Smith, Gabrielle de Veaux Clements, Ellen Day Hale, Elizabeth O'Neill Verner, Alexander B. Mikell, Arthur Rhett, Leila Waring, and John Bennett. Within a short time there were two new members, Selma Dotterer and Robert Whitelaw.

The history of art is replete with tales of ongoing gatherings of artists meeting to discuss and argue their ideas about art, politics, or philosophy.

The artists who formed the Charleston Etchers Club and served as a pivotal force in the Charleston renaissance were also gregarious and supportive of one another, although their meetings took place not in smoky bistros but at studio teas or afternoon garden gatherings. How appropriately Charleston! For one thing, most of the people involved were of genteel inclination and circumstance, a large percentage were women, and, if a common theme may be attached to their work, it seemed to be a celebration of a time and place rather than the impulse to revolution or even innovation.

Perhaps the most inspired and inspirational of such meetings of minds developed around the magnetic personage of Laura Bragg, director of the Charleston Museum from 1920 until 1931. She gathered a family of artists, writers, musicians, and other "interesting people" in a way that is very reminiscent of the Paris salon of Gertrude Stein. Her house at 38 Chalmers Street was the meeting place for this group. She encouraged them to develop their minds and expand their educational horizons through regular group discussions on a variety of intellectual topics, as well as private audiences to which individual guests were summoned.

It was in such circumstances that the Charleston Etchers Club was formed. One of the most successful and influential members of the Charleston Etchers Club was Elizabeth O'Neill Verner, a Charleston native. After attending the Pennsylvania Academy of the Fine Arts, she married E. Pettigrew Verner. In due course, two children were born, and she busied herself being a wife, mother, and sometime artist.

After Pettigrew Verner's death in 1925, she found herself, at age forty-two, with a growing family to support and scant means of livelihood. In an act of great courage she committed herself to being a professional artist, a goal she accomplished with enough success to be able to raise her children and maintain her household. While many artists have seemed to harbor the notion that fine art can only be created somewhere else, she chose to take her stand in the heart of Charleston and drew her inspiration from the same streets she had traversed since childhood (figs. 7, 8).

She worked twelve to fourteen hours a day on her etchings, kept an orderly home, and managed an active social life. By 1939 her work had appeared in most of the major etching exhibitions in this country, and she was in demand in Mexico City, Los Angeles, and many cities in the American South. In time she studied in England, Japan, and the Philippines, wrote several books, and was awarded two honorary degrees by institutions of higher learning. In 1975, a few years before her death, she was named the first Printmaker Emeritus of the Southern Graphics Council. She also was a friend of Dorothy and DuBose Heyward, and an early edition of *Porgy* was illustrated with her etchings.

Verner and Hutty engaged in an intense professional rivalry, drawing many of the same subjects—some have said at the same time—and competing strongly for the same patrons. The etchings of these two artists, while similar in subject matter, display distinctly different and unique characteristics.

FIG. 7. Elizabeth O'Neill Verner. *Philadelphia Street*. Etching, 14½" x 10⅛". Collection High Museum of Art, Atlanta; gift of Mrs. S. M. Inman, 28.21.

Fig. 8. Elizabeth O'Neill Verner. *On Meeting Street, Charleston*. Etching, 16¾" x 11½". Collection High Museum of Art, Atlanta; gift of Mr. Walter C. Hill, 55.99.

When Hutty arrived in Charleston in 1919, he already was highly skilled as a painter, a designer, and especially a draftsman. Whether he had any previous experience as an etcher is doubtful, but it has been alleged that he was trained as an engraver during his tenure with Tiffany Glass Studios.

Hutty's first etching, done in 1921, *In Bedon's Alley,* was followed that year by one of St. Michael's Episcopal Church. This second etching, *The Portico of St. Michael's,* was a prize winner. In one of his columns in *Prints* magazine Charles Lemon Morgan noted, "It was Charleston architecture which induced him [Hutty] to use the needle and it was two years before he did other subjects such as trees or or the human figure. These architectural subjects marked the beginning of his important contribution to American graphic art and [of] etching. The rapid certainty of his bitten lines and the rich bloom and shimmer of his drypoints authoritatively declare his mastery of the medium"[12] (fig. 9).

Art critic and collector Duncan Phillips pointed out that because Hutty had studied only in America, his etching style was not clouded by the dark outlook sometimes found in the work of European etchers. Light predominates in the majority of his studies, and his style of plates is known as "blonde point," which indicates a light, silvery tone (fig. 10).

Hutty enjoyed a wide reputation for his ability to depict the elegance and the sweep of trees. In Charleston, he realized as well the rightness of the bitten line for expressing the linear grace of that city's architectural forms, as well as for the incisive delineation of its inhabitants—black and white (fig. 11).

Because Hutty had waited until so late in life to start this new career, he adopted the snail as an emblem to follow his signature on most of his prints. He was rather casual about dating and numbering them, though, sometimes to the point of exclusion altogether. Titles were subject to change, and a few plates have more than one title.

Hutty's wife, Bessie, was by all accounts an astute business manager and should certainly be given much credit for his professional success. In time their son Warren also became actively involved in marketing the Hutty etchings and publishing *The Crafton Collection,* a series of books featuring outstanding American printmakers, among them, of course, Hutty.

Hutty's snail certainly must have been a speedy one, for within a short time he was receiving much critical acclaim for his etchings and drypoints. In 1922 he had an exhibition at the Corcoran Art Gallery in Washington, D.C. Other honors followed rapidly. Perhaps the recognition most treasured by Hutty was his 1926 election in London, during his first trip abroad, as the first American member of the British Society of Graphic Art. As the list of Hutty's awards grew, his prints became more and more sought after by prestigious commercial galleries.

In April 1930, Hutty's sensitively etched portrait of the well-known Dr. William Henry Welch of Johns Hopkins appeared on the cover of *Time* magazine.

FIG. 9. Alfred Hutty. *Old St. Philip's*. Etching, 14" x 18".
Collection High Museum of Art, Atlanta; gift
of Mr. Walter C. Hill, 55.97.

FIG. 10. Alfred Hutty. *An Oak in Middleton Place.* Etching and
drypoint, 8⅞" x 10¼". Collection High Museum of Art,
Atlanta; gift of the artist, 32.4.

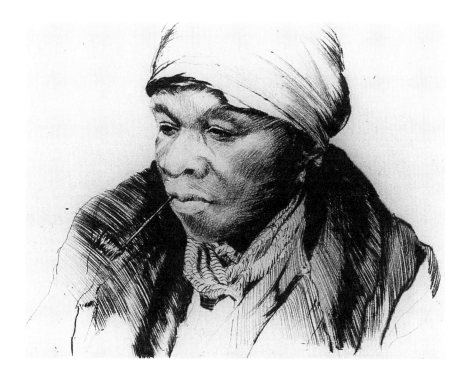

FIG. 11. Alfred Hutty. *An Old Mauma.* Etching, 12⅞" x 11". The Gibbes Museum of Art/Carolina Art Association; gift of Mrs. Alfred Hutty.

Hutty's work began to appear in many private collections throughout this country and also in many museums and galleries here and abroad, among them the British Museum, the French Bibliothèque National, and the Toronto Art Gallery. The Library of Congress acquired 22 of his original prints, and a large collection of 132 was given to the Boston Public Library by Albert H. Wiggen, a New York financier and former president of Chase Manhattan Bank.

Although Hutty had painted in New England, New York, England, and France, his son Warren was aware that his father "was more proud of the work he did in the Low Country than of any other he ever did. Of this Low-Country work his favorite composition was *Toward a New Day*[13] (fig. 12).

Some thirty-four years before, Alfred had wired Bessie that he had "found heaven" in Charleston. It is reassuring to know that Alfred Hutty not only found heaven for himself, but also provided a bit of heaven for others as well through his sensitive artwork and his prominent role in the cultural renaissance of his adopted city.

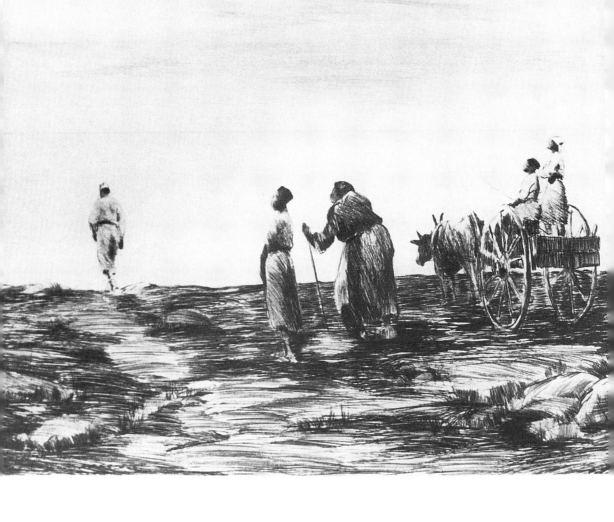

FIG. 12. Alfred Hutty. *Toward a New Day.* Drypoint, 11¾" x 9".
The Gibbes Museum of Art/Carolina Art Association;
gift of Mrs. Alfred Hutty.

NOTES

1. Boyd Saunders and Ann McAden, *Alfred Hutty and the Charleston Renaissance* (Orangeburg, S.C.: Sandlapper Publishing Company, Inc., 1990), p. 13. This paper originally appeared in slightly different form in Boyd Saunders and Ann McAden, *Alfred Hutty and the Charleston Renaissance* (Orangeburg, S.C.: Sandlapper Publishing Company, Inc., 1990).

2. Ibid., p. 17.
3. Ibid., pp. 17–18.
4. Ibid., p. 18.
5. Ibid., p. 18.
6. Ibid., pp. 19–20.
7. Ibid., p. 28.
8. Ibid., p. 28.
9. Ibid., pp. 29–30.
10. Ibid., pp. 32–33.
11. Ibid., pp. 34–35.
12. Ibid., p. 51.
13. Ibid., p. 61.

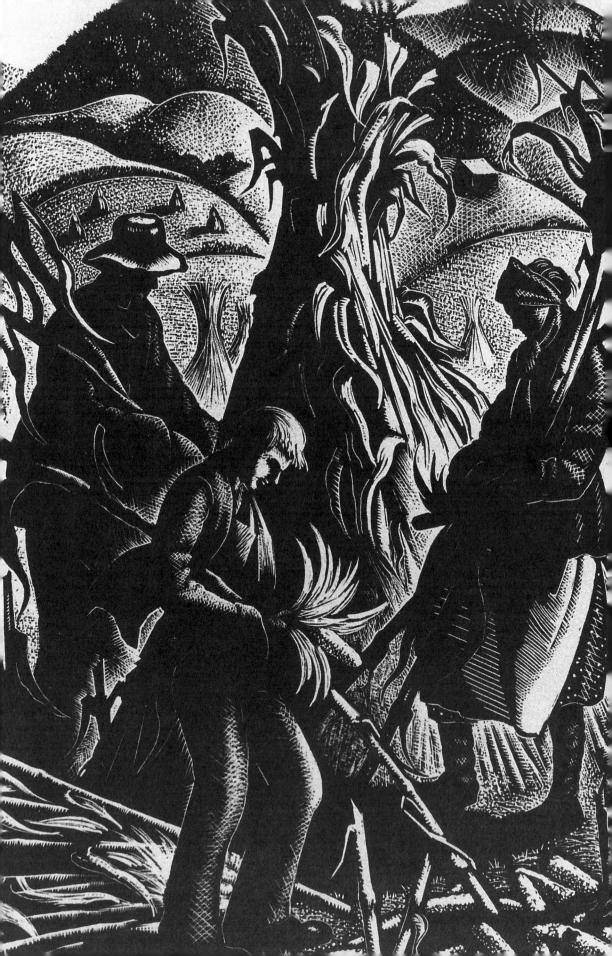

GRAPHIC IMAGES AND AGRARIAN TRADITIONS

BAYARD WOOTTEN, CLARE LEIGHTON, AND SOUTHERN APPALACHIA

Caroline Mesrobian Hickman

Appalachia has inspired an abundance of visual and verbal imagery since it became a fertile ground for artists in the middle of the nineteenth century. Whether artists and writers took the perspective of native or outsider, naturalist, local color writer, novelist, missionary, or documentarian, their attempts to define and categorize the region produced diverse if not contradictory interpretations. The writers and artists brought to their work various preconceptions about the region. Indeed, their decision of whether to confront, manipulate, or move beyond the stereotypes of their day reflects a continuing struggle to place Appalachia in the context of American culture.

Appalachia, by virtue of its isolation from the rest of the country, has been seen both as a distinct "strange land" populated with "peculiar people" and as a microcosm of mainstream American culture. When viewed as quaint, backward, and lawless, Appalachia and its people have inspired picturesque imagery for America's urban population. When viewed as sturdy, pioneering, and self-sufficient, they represent an American ideal. When Appalachian people are called "our contemporary ancestors," they connect us with the hardy stock that settled the country.[1]

These differing perceptions are found in the books on Appalachia illustrated with works by Bayard Wootten and Clare Leighton during the 1930s and 1940s. Wootten's documentary photographs illustrated two books that

perpetuated the picturesque stereotype of the backward, childlike mountaineer, Muriel Sheppard's *Cabins in the Laurel* and Olive Tilford Dargan's *From My Highest Hill*. The photographs were used to supplement the perspectives of the texts and were subordinated to the literary imagery. In contrast, Leighton's text and wood engravings for *Southern Harvest* presented the mountain people as her "contemporary ancestors," a people whose values have remained uncorrupted by modern civilization. This elevation of the common man was rendered successfully by Leighton's skillful blending of verbal and visual images.

Wootten and Leighton eschewed the lifestyle and rapid pace of the big city—both had lived in New York—and chose to live in rural areas. Both found their creative interests centered on the plain folk rather than the well-to-do in society. And they were aware of the changes coming to the mountain region of the South. Wootten's photographs document the changes wrought in the mountain landscape by industrialization and the extraction of its rich mineral resources. Her experience as a portrait photographer enabled her to render sensitive character studies of people whose lives were being rapidly altered by the advance of the modern age. Studied for their own sake, independent of the books they were used to illustrate, Wootten's photographs are a valuable legacy for her native North Carolina.

In *Southern Harvest*, Leighton disregards the physical marks that strip mining and timber harvesting had left on the mountain landscape as well as the poverty of the area. Instead, she portrayed a romantic way of life she believed would endure despite the onslaught of mechanization. The simple agrarian existence of the mountain people, their values and closeness to nature, bound them with laborers of the soil worldwide. Finally, Leighton's wood engravings of the mountain people at their seasonal tasks were commissioned for the multivolume *Frank C. Brown Collection of North Carolina Folklore*. They illustrate a massive effort to record and preserve the customs of the mountain people before progress obliterated the unique qualities of their culture and brought them into the mainstream of modern American life.

Mary Bayard Morgan Wootten (1876–1959)

Bayard Wootten's (fig. 1) photographs documented the landscape and the people of the North Carolina mountains as well as the changes wrought in the landscape by industry. Trained as a portrait photographer, Wootten's true interest lay in recording the great diversity of North Carolina's natural and human resources. She actively sought comprehensive projects that would visually record the rapidly disappearing natural, architectural, and human features of her native state.

Juliana Busbee, who founded Jugtown to revive the potter's craft, said that Wootten's

> determination to portray North Carolina has taken not only intellectual effort, but physical effort. . . . She is peculiarly of the State, with

FIG. 1. "Bayard Wootten," ca. 1935–40, photograph. Courtesy of the North Carolina Collection, University of North Carolina Library at Chapel Hill.

a distinguished lineage. . . . On both sides of her family she comes from pioneer stock; not only world pioneering, but intellectual pioneering. . . .

Busbee characterized Wootten's photographs as both art and record:

> Her place in the sun is from her landscapes, and studies of homey backwoods folk. Her pictures of the mountains are beautiful beyond words. The portrayal of our folk types, which are found from Murphy to Manteo literally, are tremendously interesting; not only as art, but as . . . a valuable record for North Carolina.

Busbee connected Wootten with the larger goal of using artists to capture and preserve the natural resources and history of the state: "North Carolina . . . has overlooked the value of art as a handmaiden to history. Our history is much more glorious than any other state, but we are unsung and unportrayed." She saw Wootten, with her "magic camera," as the one to do the job: "It is to be hoped that this State will recognize Mrs. Wootten and use her to record this changing era, for which [with] the advent of another Ford it will not be long before our folk types will have disappeared. . . ."[2]

By virtue of birth and artistic ability, Wootten was well qualified to portray her state. She became best known for magnificent documentary views of western North Carolina scenery and for sensitive character studies of the mountain folk. In an interview late in her career, Wootten explained that she "climbed those mountains and took those pictures because I wanted to, and made my living at portrait photography." Her work captured a closing chapter in mountain history just before the isolated area was opened to mainstream America by highways and automobiles.[3]

Wootten became interested in the region during the early twenties when her cousin, Lucy Morgan, a founder of the Appalachian School at Penland, asked her to take photographs for the school catalog. The photographs visually define Penland's mission to revive area handicrafts, particularly weaving, while providing a fireside industry and communal interaction for mountain women.

Wootten's work gained exposure through periodic exhibits in the state and in selected Southern cities such as Richmond and Charleston, and the Northern press praised her scenes of the mountains and the folk in an exhibition at the Boston Theater of Fine Arts in 1932. W. T. Couch, director of the University of North Carolina Press, recognized the potential of photographic illustrations for adding visual interest—and thus marketability—to publications of the press. He sought professional photographs for two manuscripts that nostalgically portrayed the history and customs of the hill people. He chose Wootten's photographs to illustrate Charles Morrow Wilson's *Backwoods America* (1934), a book about the Ozarks, as well as Muriel Early Sheppard's *Cabins in the Laurel* (1935), a history of the Toe River Valley in the Carolina Blue Ridge.

A native of New York state, Sheppard lived in Spruce Pine and became

acquainted with Wootten and her photographs while at Penland gathering material for her manuscript. Sheppard submitted her text to the press with a selection of Wootten photographs. Couch was impressed with Wootten's work and wanted more illustrations for the book. He asked Sheppard to select additional images from Wootten's collection of negatives in her Chapel Hill studio. He also commissioned Wootten to accompany the author in an attempt to locate and photograph characters similar to the individuals about whom Sheppard had written.[4]

The photographs chosen for *Cabins in the Laurel* are among the finest images Wootten made in the mountains. Her sensitive character study of "Mrs. Holyfield" captures serenity and grace in a face and hands worn by time and labor (fig. 2). In "Man with a Scythe" (fig. 3), she evokes the age-old conflict of man toiling with nature. Both images transcend time and place and suggest universal values. All 128 photographs are reproduced as full-page illustrations and provide striking visual documentation.

Despite the obvious artistic power of these photographs, they do not exert the impact on the reader one might expect. This failure can be traced in large part to Couch's and Sheppard's ideas about several fundamental issues. Couch did not comprehend the real artistic merits of Wootten's work. Rather, he regarded them merely as illustrations of the text. Sheppard's text emphasizes the long-established stereotypical images of the mountain people as a quaint, backward, childlike, fiercely independent, sometimes lawless people who were associated with feuds and murders, superstition, and moonshine. Couch enhanced these colorful written descriptions by choosing equally picturesque photographs from Wootten's camera.

As was customary in publications of the period, Couch added captions under each photograph which were taken directly from Sheppard's text. These passages were intended to whet the reader's interest in the narrative.[5] The practical effect, however, was the denigration of the subject. The frivolous, often witless captions strip the images of their potential to transcend the incidental circumstances of the story. Note, for example, the captions used for "Mrs. Holyfield": "She has time now to sit down and rest"; and for "Man with a Scythe": "D'ye reckon we could save victuals if we all had our teeth pulled?" The captions make it almost impossible for the reader to separate the power of the photographs from the cultural bias of the text and captions. Whereas Wootten portrayed the authentic qualities of the mountain region in her character studies, Sheppard and Couch accentuated the stereotypical image of the mountain folk and focused on their "otherness."

This pattern is also evident in the treatment of mountain industry. *Cabins in the Laurel* contains lengthy descriptions of the stripping of the land and soil from a sympathetic perspective of the people whose livelihoods depended on the extraction of rich mineral and timber resources. Sheppard's lack of concern about conservation is no surprise since her husband was a mining engineer. Wootten, on the other hand, had a deep respect for the land. She

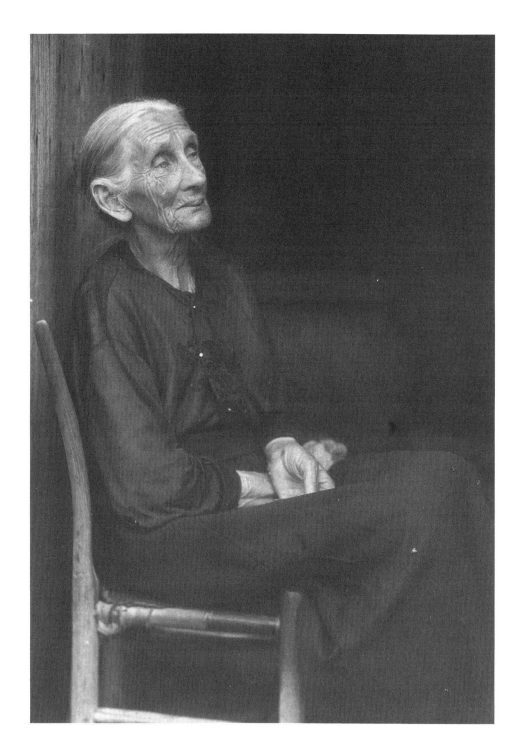

FIG. 2. Bayard Wootten, "Mrs. Holyfield" (used in *Cabins in the Laurel*), ca. 1930–34; photographic print from the original 5" x 7" negative. Courtesy of the North Carolina Collection, University of North Carolina Library at Chapel Hill.

documented the various industries profiting from the rich mineral and timber resources of the mountains, but as her Chapel Hill studio files reveal, few images like these were included in *Cabins*. Sheppard sensationalized her accounts of the opening of the mines to extract mica and other minerals, and of the ensuing murders over disputed land. Couch often chose images which featured primitive forms of industry, such as the water-powered mill, horse-powered sorghum grinder, and human-powered spinning wheel and clothes washer. It often appears that Couch was interested merely in the sensational impact of the photographs on a Northern, urban audience.

The result is a book whose text is often at odds with its illustrations. Although the author recognized that mountain people place more value on leisure and on minimizing wants than on materialism, she twisted these venerated agrarian ideals into anecdotal, picturesque vignettes which emphasized the "otherness" and naivety of the mountain people. In the same way, the captions minimize the power of Wootten's photographs. Her bold yet sensitive images are trivialized by the sentimentality of Sheppard's writing and the commercial motives of Couch's editorial decisions.

In contrast to Sheppard's superficial treatment of Appalachia, Olive Tilford Dargan's *From My Highest Hill* (1941) is a keenly insightful description of the land and its people. Her semi-autobiographical novel was also illustrated with Wootten's photographs and is an account of her life among the mountain people who worked on her farm in Swain County. Written partly in folk dialect, Dargan's books reflect her preoccupation with the social ills of the common people of the hills and piedmont in North Carolina as they faced the upheavals caused by capitalism and industrialization.[6]

The original 1925 version was titled *Highland Annals* and was published without illustrations. The 1939 edition was pictorially augmented with Wootten's works. Dargan began working on a new edition in 1935. Bayard Wootten was commissioned to accompany Dargan to Graham and Swain counties in order to photograph various characters in the book. This proved a difficult task since many of the people mentioned in the book had died. But their friends were substituted to Dargan's satisfaction, and the work was completed in 1939.[7]

Dargan's text emphasizes the contrasts resulting from progress: rural versus urban, farm versus the mill, the unaffected good nature of the yeoman versus the artificiality of the city dweller. In the narrative, Dargan, in the role of Mis' Dolly, asks "Grandpap" if he at times wished he lived in the city. He replies, "No. I have to be whar thar's something happenin'. In a city you don't have seasons. Jest weather."[8]

By means of dialogue Dargan revealed her concern for the unbridled destruction of the forests by both the mountain folk themselves and by outsiders. Len, one of her tenant farmers, gives her this assessment of his wife's father:

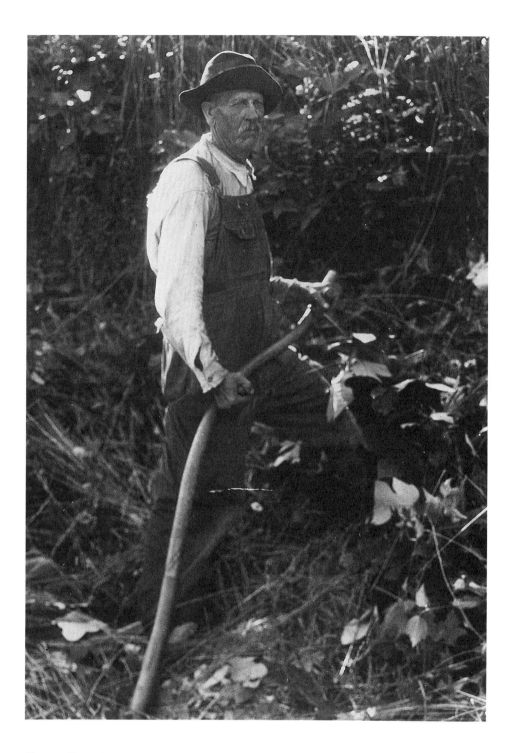

FIG. 3. Bayard Wootten, "Man with a Scythe" (used in *Cabins in the Laurel*), ca.
1930–34; photographic print from the original 5" x 7" negative. Courtesy of the North
Carolina Collection, University of North Carolina Library at Chapel Hill.

He wuzn't a workin' man by nature. Six hundred acres of land was what he owned, an' when one of his fields got wore out he would pick on the richest piece he had, where the big timber growed, an' cut a dead-ring around the oaks an' chestnuts an' poplars, an' next year when they's dead an' dry he'd chop a big hole in 'em an' set fire in the hole. It never went out till the tree wuz burnt up, an' he didn't have no clearin' to do, only pilin' brush.

Dargan as Mis' Dolly interjects her horrified evaluation: "'I shivered. The round earth seemed to be disappearing with those dead-ringed trees.' 'What's wrong, Mis' Dolly?' 'Wrong? Nothing Len. Merely annihilation.'"[9] The reader must form an image of Len's ring-choked forests since the illustrations belie the reality.

Reviewers were struck by what seemed a refreshingly positive portrayal of the mountain people, and they took special note of how well the photographs documented and supported the text's wholesome image of the folk: "Here are no dirt eaters, pellagra-ridden, and Jukes families, but men, women, and children with strong intelligent faces and sturdy bodies, against the background of their cabins and cornfields, and the wild beauty of the Smoky mountains."[10] Wootten's photographs were seen as illustrations of the positive attributes of an agrarian way of life.

Indeed, Wootten's photographs capture the spirit of the stories. Sturdy men, women, and children, neatly dressed and with smiling faces, are shown at work and rest. Phrases from the text are again paired with the illustrations, but here they are generally less demeaning than those used in *Cabins*, because they reflect the good-naturedness of the story. For example, the caption which accompanies the photograph of children at a water wheel reads, "It was never lonesome at the mill" (fig. 4). Although it serves the requirements of the story, the caption also draws the reader away from the "universal truths" that critics found in Dargan's writing. The captions do not maximize the impact of the photographs, but the overall treatment remains superior to that of *Cabins*.

Wootten's main legacy lies in her character studies of the common people of North Carolina (fig. 5). Her honest portrayal of these people stems partly from her experience as a portrait photographer and as official photographer for both the National Guard and the UNC Playmakers. One commentator noted that her work for the National Guard at Camp Glenn and Fort Bragg gave her the ability "to meet pleasantly all conditions of men from every class of society . . . , to sift people and to judge accurately and swiftly."[11] As official photographer for the Playmakers and as part of the intellectual community at Chapel Hill, she was well acquainted with Director Frederick Koch's folk dramas. Wootten was undoubtedly influenced by Koch's belief that writers should focus on regionalist subject matter, drawing on the common experiences they knew best. He wrote that from this "investigation of the specific" would spring "a knowledge of the universal."[12]

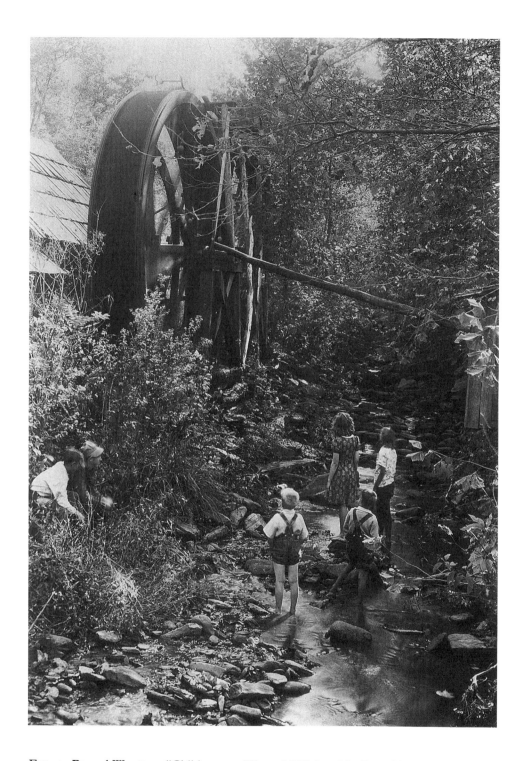

FIG. 4. Bayard Wootten, "Children at a Water Mill" (used in *From My Highest Hill*), ca. 1938–39; photographic print from the original 5" x 7" negative. Courtesy of the North Carolina Collection, University of North Carolina Library at Chapel Hill.

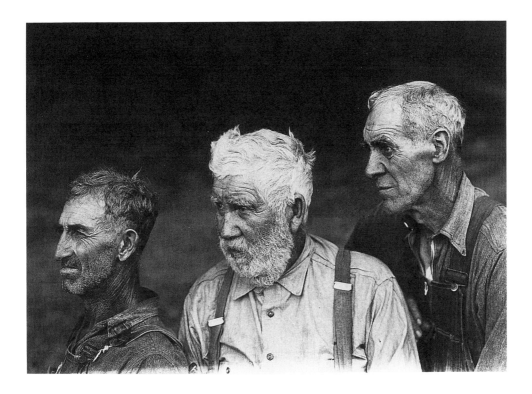

FIG. 5. Bayard Wootten, "Horse Traders," (used in *From My Highest Hill*), ca. 1938–39; photographic print from the original 5" x 7" negative. Courtesy of the North Carolina Collection, University of North Carolina Library at Chapel Hill.

Wootten had a great love for and interest in people. As she told an interviewer, ". . . I have lived and found excitement in the most commonplace people . . . the beauty of a timeworn face, a workworn hand. . . . I love people and places, and they have told me a lot about living."[13] Although she photographed her subjects as they were, no matter how tattered or worn their clothing, Wootten captured their dignity, strength of character, and inner spirit. Wootten did not pity people, no matter how destitute, for she believed that each person was where he was supposed to be. This outlook may have stemmed in part from her belief in Theosophy, a religious doctrine distinguished by its emphasis on reincarnation. For Wootten, this would have explained the inequities in human happiness, misery, wisdom, and ignorance in the present life.[14]

Just as Wootten's photographs often lift the viewer beyond the specific condition of the moment by revealing basic truths of the human struggle with the forces of nature (fig. 6), her photographs of landscape often transcend a specific locale, evoking images of pastoral timelessness and of spiritual quietude. One reviewer noted that Wootten's work is centered "in her own self,

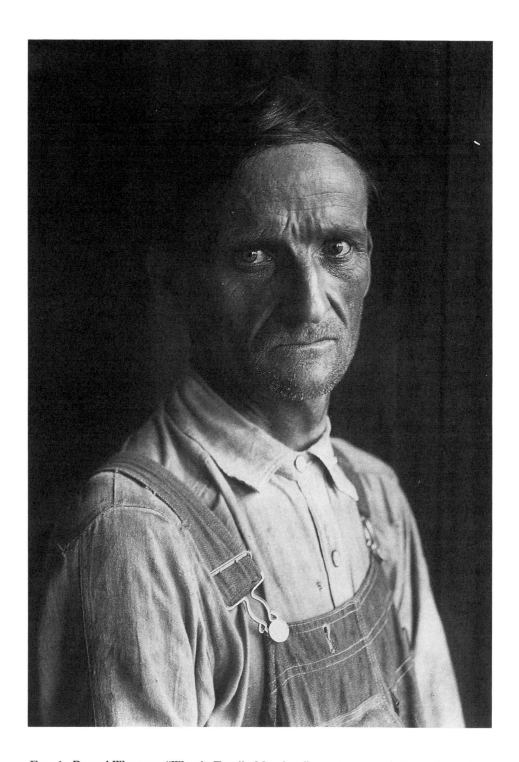

FIG. 6. Bayard Wootten, "Woody Family Member," ca. 1930–39; photographic print from the original 5" x 7" negative. Courtesy of the North Carolina Collection, University of North Carolina Library at Chapel Hill.

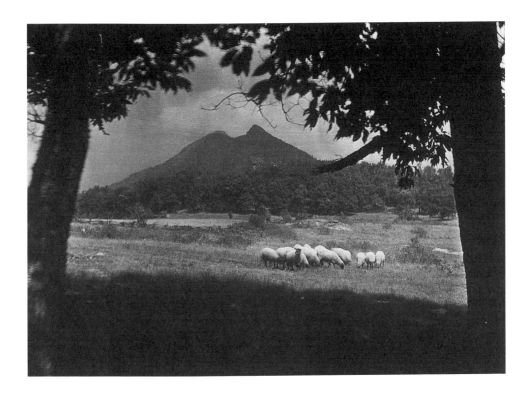

FIG. 7. Bayard Wootten, "Grandfather Mountain with Grazing Sheep," ca. 1930–39; photographic print from the original 8" x 10" negative. Courtesy of the North Carolina Collection, University of North Carolina Library at Chapel Hill.

for who—except one who believes in the good and right—can picture the pastoral scene of sheep grazing under . . . live oaks without feeling quietly religious inside?" (fig. 7). Critics found the artistic qualities of Wootten's photographs similar to those in the poetry of her grandmother, Mary Bayard Clarke. As one observed, her photographs reveal a "lightness of touch, vividness, depth of conception, strength of imagery, rhythmic beauty, love of nature."[15]

Clare Veronica Hope Leighton (1898-1989)

Clare Leighton shared Wootten's deep respect and profound sensitivity toward North Carolina's back country and its people. In the text and wood engravings of *Southern Harvest* (1942), Leighton depicted elemental man and his struggle with the forces of nature. Her distinctive graphic style—flowing, rhythmic line and strong contrasts of light and dark—distilled the essence of what she saw and heard into universal statements about Everyman. She portrayed the commonality of man the world over. As such, her work is imbued with a certain spirituality, a quality John Taylor Arms found in his collection

of Leighton's wood engravings and mentioned in a letter dated March 18, 1949: "I learn much from your work. Spiritual enrichment for others is, I believe, the finest quality our work can possess. A group of your prints hangs with others so I can look at them every day."[16]

Leighton's decision to devote her life to wood engraving was in itself a commentary on the world of mechanization. Her commitment to wood engraving affirmed fundamental spiritual values inherent in a craft which relies on subjectiveness rather than photographic reproduction. Leighton chose the integrity, freedom, and personal responsibility of craftsmanship. Leighton's friend Eric Gill reaffirmed the values upon which the arts-and-craft movement was founded by urging artists to turn from the commercial degradation of the modern world, to the absolute values of Beauty, Truth, Goodness, Quality, and personal responsibility.[17] Leighton's use of this medium is itself symbolic. She perceived wood engraving to be inherently good, making it the appropriate vehicle for portraying the common man whose life is good because of his closeness to God and Nature.

The themes of *Southern Harvest*, a New World chronicle of the enduring values preserved by tillers of the soil despite the intrusion of progress, reflect Leighton's earlier interests in the common man and his relation with the earth of her native England. These themes are evident in Leighton's *Four Hedges* (1935) and *Country Matters* (1937), published before her emigration to America. In the preface to *Country Matters*, she refuted a friend's suggestion that the book is "an obituary" on the passing of the romantic view of the countryside and that she was preserving a way of life which has passed away. Instead, Leighton wrote,

> it shall be the record of an enduring world—a world that is as alive
> and romantic to-day as it was in the times before mechanization.
> Romance . . . can survive the invasion of the tractor and the radio. It
> feeds upon an attitude of mind, and despite all modern inventions
> and conveniences, this attitude of mind persists. For the country-
> man is still close to his earth.

According to Leighton, in a world rife with conflict and artificiality, an essentially agrarian existence offered "the last hope for sanity."[18]

Leighton began planning for *Southern Harvest* soon after arriving in America in 1939. She initially approached the Macmillan Company about publishing a nostalgic book on country life. H. S. Latham, a Macmillan vice-president, described it as ". . . an association of ideas and scenes in this country with scenes in other parts of the world. Your 'uprooting' book, in other words." Although Macmillan rejected the "nostalgia book," they did agree to a book on the "Deep South."[19] That book, *Southern Harvest*, was actually a combination of both these elements. Leighton wrote in the introduction that the book was

> my endeavor to push my roots into their new earth of this American
> continent. For, as in England and in Europe my true happiness lay

always among the people of the earth, rather than in cities, here the same thing would be true, I knew. There is a universality about the people of the earth that is healing, and it matters little whether one be talking about a tobacco farmer in North Carolina or a plowman in Devonshire. So, I knew my sole chance of adjustment over here, in the country of my adoption, and my best cure for the incomparable fret of nostalgia as well as my only hope for becoming one with my new land, would be to wander around among the workers on this earth and learn their habits and their lore.[20]

From 1939 to 1941, when she was not on the lecture circuit or traveling the South to gather impressions for her book, Leighton lived in Baltimore. This is the same city from which H. L. Mencken launched his attacks on the South, including his notorious essay "The Sahara of the Bozart."[21] Leighton was familiar with Mencken's work and was apprehensive about how he would regard her book. In a letter of February 13, 1939, she wrote, "I would like to give you a copy of one of my books—say *Country Matters*. But I must feel certain you would like to have it. It is—as is everything about me—so completely remote from your world." Later, in undated correspondence, though surely soon after the above, she wrote, "What have I that would not bore you? I have yet to discover whether you have any interest in the simple, earthy, unintellectual things of this world. And I can produce nothing but this sort."[22] Subsequent correspondence reveals the evolution of a deep friendship and a mutual admiration for each other's work. Leighton's letters reveal that they shared disdain for two of the South's most distinctive features—evangelical religion and ancestor worship in the form of the Daughters of the American Revolution.

In *Southern Harvest*, however, Leighton put aside all criticism of the South to concentrate on the transcendent qualities she found surviving in the Southern yeoman. Although she referred to her book as a "harvest of impressions of the South," it is obvious that the mythology surrounding the North Carolina mountains appealed to Leighton's heightened sense of nostalgia and belonging. At every turn the reader finds evidence of Leighton's connectedness with the mountain terrain and the mountain people. In an article explaining her reasons for moving from the city to provincial North Carolina, she said that the beauty and warmth of the Appalachians, which she compared with the Old World charm of the Austrian Tyrol and the French Alps, was preferable to the "impersonal, cold grandeur" of the Rockies. In the people she found a noble quality: "These men and women who dare to live simply and with dignity, and who sing their songs and believe their legends as though the world were not suffering from the blight of mechanized standardization make me feel glad that I can call them neighbor."[23]

The water mills of the North Carolina mountains stimulated a sense of nostalgia by reminding Leighton of the magic surrounding water mills during her childhood in England. In her recollection, English millers had a "gentle

kindness" and a "deep wisdom," for they sense their place in life as the feeders of mankind (fig. 8).[24] Whether English or American, a miller was a man whose

> life was in tune with the mythology of earth and ran strong with the pattern of the inevitable suffering in nature. Pain to this man was nothing against which to feel resentment; for the storm-struck tree stands scarred and blasted and does not complain. . . . This man of silence, with the bent shoulders and the limp to his walk, had bridged the division between human and tree and earth. . . .

Another miller provoked her sense of belonging:

> He was singing a ballad that his forebears had brought with them as an imperishable belonging from across the sea. And suddenly it seemed to me as though a tuck had been taken in time and the life of my own forebears flowed without interruption into this life here, in the Carolina mountains. Gratefully, I knew I belonged.[25]

The ancient agricultural practices and craft traditions Leighton found in the mountains were a personal antidote to the mechanization of the modern world and refuted the European idea that all Americans were addicted to the dehumanizing effects of progress. She wrote:

> Here was the answer to the idea that all outsiders, all foreigners, have about this American continent. To their way of thinking this is a vast stretch of land so developed that it is given over entirely to mass production, and mass production based to such an extent upon machinery that the hands of man no longer find work to do and the sense of craftsmanship is starved.[26]

Key elements of Leighton's unvarnished agrarian philosophy are revealed in the primitive process of sorghum milling (fig. 9). Its simplicity connected it with harvesting the world over, which she called "the most completely universal thing in existence." As fundamental as life itself, the by-products of sorghum milling were "sanity" and a "pride in craftsmanship without which man cannot healthily live." The crude process by which cane is crushed and strained reminded Leighton that "behind the simplest procedure lies true knowledge and subtle artistry." Sorghum making also provided an opportunity for social gathering and, on a deeper level, a vehicle by which man reaffirmed his spiritual connection to nature. According to Leighton:

> This year's sorghum, essence of sun and rain and light and earth, was poured. . . . We ate. . . . But over everything . . . hung this sacramental feeling, like a mist of holiness. For deep in the heart of man, though he may live in an age of civilization that can build cities like New York and Chicago, San Francisco and Los Angeles, deep within him lies the need to celebrate and to worship, uncurbed and undestroyed by the machine.[27]

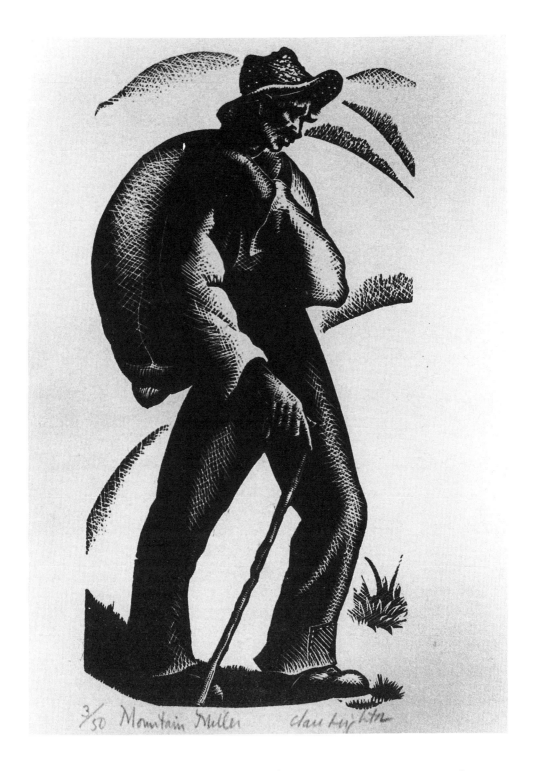

FIG. 8. Clare Leighton, "Mountain Miller," (from *Southern Harvest*), 1942, wood engraving, 4½" x 2¼"; private collection.

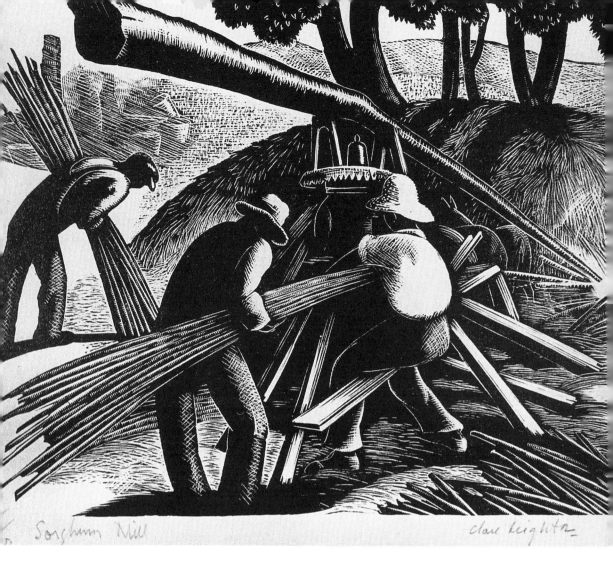

Sorghum Mill

clare leighton

FIG. 9. Clare Leighton, "Sorghum Mill," (from *Southern Harvest*), 1942, wood engraving, 4¹⁄₁₆" x 5³⁄₁₆"; private collection.

"Alone . . . absolute in their unchangingness," in her words, the mountains offered refuge from the chaos and destruction of the World War. The joy she found in the life-giving forces of nature stood in sharp contrast to the painful realization that the world was again in a state of war. This was especially painful because her elder brother, Roland, had been struck down in the War to End All Wars. She found solace in Biblical metaphors of strength and salvation: "The mountains and the hills shall break forth before you into singing . . . For ye shall go out with joy, and be led forth with peace."[28]

Discovering the survival of ancient customs and the language of the British Isles in the isolation of the Appalachian mountains provided some relief for Leighton's homesickness for England and her longing for kinship in America: "As I approached these mountains . . . , though I had never seen them I felt . . . I was coming home . . . returning to my own people . . . these who speak the language of your ancestors, and dance as your forebears danced, and sing the songs that echoed across the Highland glens. . . ."[29]

While Leighton romanticized the mountain folk, nostalgically calling them her New World "kin," her friend Mencken's opinion of the hill folk was more acerbic. His diary entry for July 14, 1944, reveals a perception diametrically opposed to Leighton's:

> The Hanes place at Roaring Gap, N.C. is in the midst of one of these mountain areas that are supposed to be inhabited by "the only pure Anglo-Saxons left in the United States." They turn out, on acquaintance, to be a wretched dirty, shiftless, stupid and rascally people. Every Winter, while the cottages on the mountain are vacant and the hotel is closed, the gallant hillmen swarm in to loot and destroy. . . . Physically as well as morally they are a poor lot. The women are dumpy, puffy and pale, and the men are tall, thin and cadaverous. The war industries have brought thousands of these anthropoids to Baltimore. . . . Along with the lintheads from the Carolina mill-towns they live in old and decrepit houses, a whole family to a room. . . . One of their curious characteristics is their apparent hostility to all growing things. The backyard of any house they occupy is soon reduced to a desert of sand and trash; they even stamp out the weeds. . . . No linthead or mountaineer ever shows any feeling for beauty. They all live like animals, and are next door to animals in their habits and ideas.[30]

Leighton, on the other hand, through the agrarian view she developed in England, found in the simple, earth-bound existence of the mountain folk an affirmative release from the complications of the modern world. Moreover, she refuted the popular "quaint" perception, seeing instead that the mountain folk, in her phrase, "merely kept a hold on the enduring values of life." Leighton romanticized the simplest elements of what she called their "strong simple pattern of life." Satisfied with the essentials, a mountain man explains, "We don't somehow need much money. We can grow almost all we needs—

so what would we be doing with money?" Leighton contrasted the self-respect of the mountain man, the heightened product of a creative life, with what she referred to as the "thwarted, dulled look . . . on the face of the assembly line worker." Though unschooled, the mountain folk instinctively know that the true meaning of life is to be found in growth, work, and living in harmony with nature.[31]

Leighton's visual and verbal imagery are masterfully intertwined. Together they affirm her passion and empathy for the toilers of the earth. In the wood engraving "Chopping Wood," man—Everyman—bends over a freshly hewn tree still redolent with new, vibrant growth (fig. 10). Leighton characterized the wood chopper literally as one with the earth: "As he chops, his figure dappled by sunlight, it isn't easy to see where he ends and the earth and the tree trunks begin, they seem to be so much of a oneness, and of the same color and the same substance."[32] In the engraving "Apple Butter," the trees provide the fruit for man's sustenance and take on a life of their own, bending with expressive, sinuous line (fig. 11). The form of the woman, who bends to stir the contents of the boiling kettle, seems as rooted to the earth as the trees themselves and echoes their sinuous forms.

Leighton's distinctive graphic style is most creatively expressed in scenes which depict man at work in nature. Indeed, she credited man's constant struggle for existence in nature for sparking her creativity:

> For the artist within me is never free of the restless fret of the creator. I am not happy in a setting which is achieved and final. I need to feel around me the process of struggle. As I watch the one-gallus farmer striving to harvest his crop on the rocky, inclined field of a mountain side, I am stirred to creative activity as I could not be were my setting that of the luxury in a city.[33]

Leighton skirted Macmillan's rejection of her request to write and illustrate a book on nostalgia by including the idea in a work they had already approved on her impressions of the South. Macmillan vice-president Latham assured her that *Southern Harvest* was being featured in "The American Scene" section of their fall announcement list rather than the illustrated book section. He praised Leighton, saying:

> I liked much of it immensely. I think perhaps the text is the best text you have ever written. Certainly it is the best from the standpoint of American sales. I have had an independent Southern advisor read it to make sure it does not offend the Southern point of view, and I have been reassured on that point. And incidentally this Southern advisor liked the book. . . . As for the wood engravings, I think they are among your most beautiful work. I am fascinated by them. . . .[34]

Critical response to *Southern Harvest* was positive and focused on her ability to translate her personal impressions of the South into universal meaning in both text and illustrations. *The New York Times* commented:

FIG. 10. Clare Leighton, "Chopping Wood," (from *Southern Harvest*), 1942, wood engraving, 5⅜" x 5⅜"; private collection.

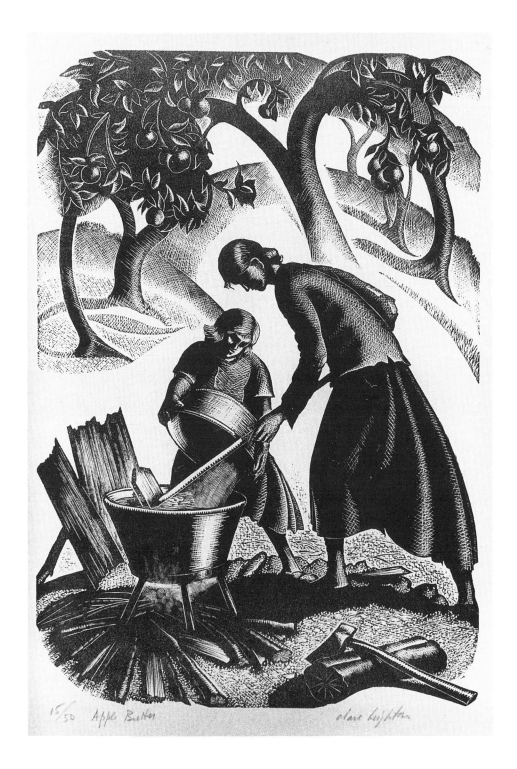

FIG. 11. Clare Leighton, "Apple Butter," (illustration from *Southern Harvest*), 1942, wood engraving, 7⁹⁄₁₆" x 5⁵⁄₁₆"; private collection.

Since this artist in two mediums is also, and first of all, an artist in awareness, her vivid and exquisite text and pictures have a value of communication that reaches far beyond the personal. The reader feels the South. But he also feels more. It is the common quality of man's earth-sustained living that is the broad, deep theme of the book, in text and magnificent engravings alike.

Leighton's ability to ennoble the common man was also noted: "[She] never fails to value the native dignity of man, and more than any writer . . . has a gift for transferring to paper the gentle childlike quality of humble people."[35]

Chapel Hill dramatist and author Paul Green ranked Leighton's interpretation of the South among what he considered to be the best appraisals of the region, comparing her work to that "other earth soaked poet, Elizabeth Madox Roberts, and the vivid Julia Peterkin." Green noted that Leighton, with "no ancient loyalty of attitude or sociology to defend . . . ," wrote of

people—human beings carrying on the warm ritual of their days with the same hopes, ambitions, loves, dreamings and deaths common to us all. . . . She impregnates her material with her own vitality and abounding love of life. And thus her characters are lifted and illumed out of the dull rut of spiritlessness and vacuous romance into the dignity and poetry of living souls upon a living earth.[36]

Green's own work rejected the sentimentality that critics like Mencken saw pervading Southern literature, and he found a balance in Leighton's writing that spoke of the commonality of man.

Leighton stopped in Chapel Hill on her way to sketch in the mountains in 1941, and finding a circle of compatible intellectuals, she settled in the area. Green convinced Leighton, in her words, that "this is a place where the writer and the artist are considered as normal beings, . . . where ideas are rated higher than money or material possessions."[37] Leighton wrote Green the following year that her decision to reside in such a provincial place amused her New York friends: "Strange how poor New York laughs at me that I call North Carolina home. . . . I held them for a whole hour with tales of the gleam on the wet red earth—though they themselves were living in New York streets."[38]

Correspondence between Leighton and Green reveals a similar creative spirit and a shared abhorrence of war. In a letter of January 31, 1942, she wrote Green,

I have been talking to people everywhere on the Artist's Place in a world at war. . . . I have been trying to fill them with courage and the potentialities of joy. . . . Strangely enough, the more confused and war-torn this world grows, the more strength do I feel within me. . . . You and I and the rest of this band of creative persons must help each other. There has never been a time in the world's history when the pattern of life so needed the balance of construction and creativity.

Leighton also revealed an impatience with the public's failure to understand why the artist must continue to be creative, especially in the face of war. As she wrote to Green,

> You are the only person who seems to feel about this war as I do. The tide creeps up and engulfs the sensitivity of more and more of the world. . . . one's most comprehending friends say "Of course when you've finished this book you'll go and do some real war work, won't you?" You and I and our like, how we need each other today.[39]

Leighton's commission to illustrate the *Frank C. Brown Collection of North Carolina Folklore* came while she was a visiting lecturer in the Department of Art and Aesthetics at Duke University from 1942 to 1944. Brown, the man for whom the collection was named, had been a professor of English at the university since 1909, was a founder of the North Carolina Folklore Society, and spent his life amassing a vast collection of Carolina ballads, folk customs, beliefs, tales, and games. Plans to publish the material continued after his death in 1943, and Leighton was asked to provide wood engravings for the proposed four volumes (fig. 12).[40]

Newman White, who succeeded Dr. Brown as general editor of the collection, stressed that the engravings were to be "designed in the main as pictures of various folklore types and activities rather than as specific illustrations or individual bits of folklore." White hoped that the volumes would set a new standard for the field of folklore editing, and he offered what he considered to be the correct methodological approach to folklore and its relevance for the modern world. In his words: "Folklore should be treated not merely as something quaint and curious [It] should be presented as far as possible as a body of beliefs, customs, and art expressions once as vital as those by which we now live. . . ."[41]

White believed that folklore, of all the branches of knowledge, best served as "evidences of the kinship of the human mind in all places and ages." Leighton's gift for celebrating the daily and seasonal rites of Everyman, and for portraying the universal kinship of man, would add meaning to the very purpose the editor hoped the volumes would serve. Whether reporting to the university on the status of the project, or attempting to get publishers interested in the work, or seeking additional funds from private patrons so that the number of illustrations could be increased, White consistently characterized Leighton's expertise and interest in depicting folk subjects as a highlight of the project. Calling her "one of the most distinguished living illustrators," White believed her work would give the publication "a distinction comparable to what might be conferred by the illustrations of a Kate Greenaway or an A. B. Frost."[42]

The correspondence between Leighton and White reveals a mutual respect for each other's work and expertise. He exercised his editorial role by assisting Leighton in the choice of subject matter for specific illustrations and their placement within the volumes, and Leighton appears to have accepted his

FIG. 12. "Clare Leighton at work on the wood blocks for *The Frank C. Brown Collection of North Carolina Folklore*," ca. 1949, photograph. Courtesy of the Special Collections Department, Duke University Library.

suggestions freely. In fact, White felt that edited typescripts were not necessary for Leighton to have before beginning her work since she was to provide her own artistic interpretation, "not so much of the folklore itself as of the land, the people, and the customs out of which it grew."[43]

Although she had made sketching trips to the mountains for the illustrations for *Southern Harvest*, Leighton spent several weeks in the mountains gathering fresh material for her *Brown Collection* illustrations. She wrote her friend, the novelist Charles Mills, "I have been to the mountains since my return to Durham, drawing for the folk lore collection. It was exceedingly beautiful up there, and I met great tenderness and warmth from the mountain people. I also brought back much material, which I am now trying to distill into my designs."[44] In an interview with the *Greensboro Daily News*, Leighton explained she was trying to portray the life of the people of the state and wanted to show the human and natural resources, which she listed as "things like the cock fights and coon hunts—and even the whiskey stills."[45]

Nearly one-half of the wood engravings illustrate the mountain people as they harvest, gather for social rites, or participate in other activities typical of

the area. The range of her subject matter is indicated by the titles: "Corn Shucking in the Mountains" (fig. 13), "Herb Gatherers," "Quilting Party," "All Day Singing," and "Moonshine."

Leighton's working method involved first making several quickly executed preliminary sketches of each subject. A good example of an on-site drawing is found in "Washing Clothes" (fig. 14). A comparison of the preliminary sketches and the final drawings used for the engravings shows that Leighton usually was sure of the compositional effect she wanted from the very beginning of the process (figs. 15, 16). And although Leighton at times used compositional elements from past work when depicting a similar subject, the product is not a pastiche but a creative restatement of an idea.

Leighton completed the wood-block engraving in October 1950 and moved permanently from North Carolina to Connecticut. In a letter to Charles Mills dated October 31, 1950, she stated that she worked eight or nine hours a day to finish the folklore blocks, so that she could leave the state "clean." She wrote:

> Spiritually it has been confusing. One doesn't break with such a deep, lengthy setting with ease. . . . I have coined a new expression for [Chapel Hill]: it's a center of intellectual incest. How's that? And some people were so horrid about my leaving. A dull English woman . . . , whom I met at a sort of farewell party, even tackled me and told me she was disappointed and distressed about me going to the "big cities" (Woodbury is much smaller than Chapel Hill, and I am two miles from Woodbury itself), and that it was my business to sound the clarion call of the New South, etc.[46]

Leighton abandoned Chapel Hill for Connecticut in part because she thought it more appealing to her creative sensibilities. She wrote Charles Mills that she was moving from the "center of intellectual incest" and the "vertical obstruction of the Durham pines" to a state where she found the people, the "wave lengths," and the horizontality of the "stretching, rolling pastureland" more satisfying to her taste. But she left North Carolina a legacy in graphic and prosaic art that is unequaled in its sensitive and dignified portrayal of the yeoman and the mountains. Word and image are woven together to pay tribute to man's continuous struggle with the forces of nature.

Conclusion

Although they brought varying perceptions to their art, Wootten and Leighton found their creative spark not in the drama of the city, but in the simple earth-bound people of the North Carolina mountains. Despite their differences in media and in the image of man their works convey, both artists committed themselves to the dignity of the mountains and the mountain people in the face of industrialization and the rush of twentieth century progress. Leighton transformed the specific into a timeless image of man.

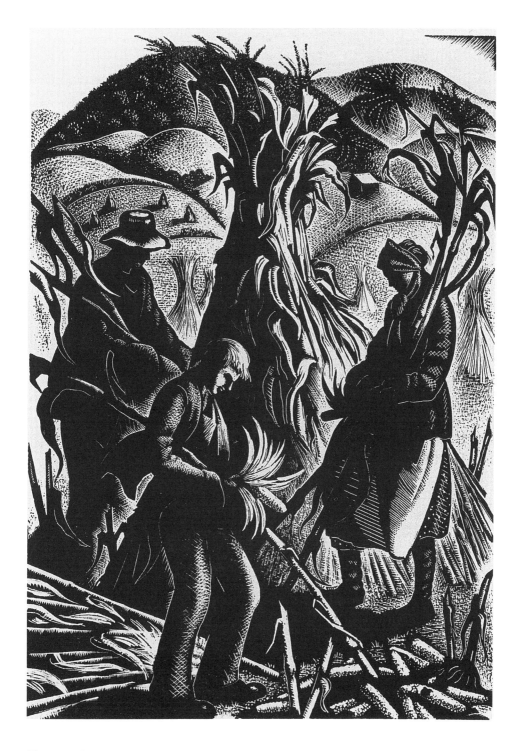

FIG. 13. Clare Leighton, "Corn Husking (Shucking) in the Mountains," (illustration for *The Frank C. Brown Collection of North Carolina Folklore*), ca. 1951, 7" x 4$^{15}/_{16}$"; private collection.

FIG. 14. Clare Leighton, sheet of three sketches for "Washing Clothes," (preparatory sketches for *The Frank C. Brown Collection of North Carolina Folklore*), ca. 1946, graphite on brown paper, sheet: 6⅝" x 9⅛". Courtesy of the Special Collections Department, Duke University Library.

Wootten highlighted the individuality of these distinctive people. Both were at odds with the works of visual and literary artists of the period whose focus was on the massiveness of the urban landscape, the glamour of the city dwellers and progress as represented by the machine.

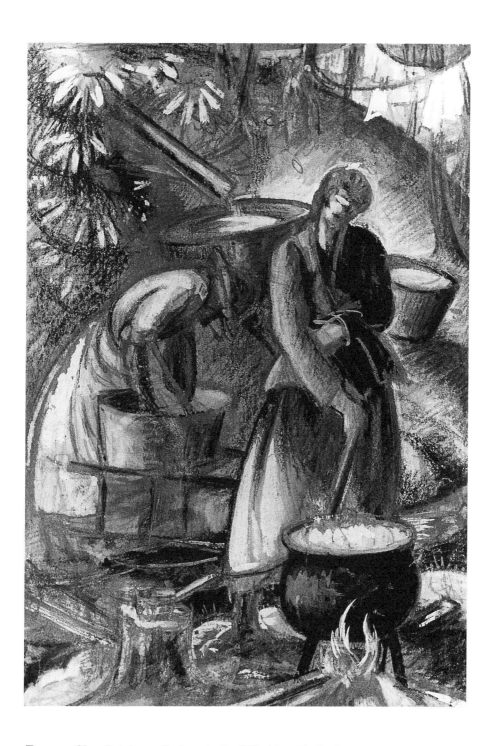

FIG. 15. Clare Leighton, final study for "Washing Clothes" (preparatory drawing for *The Frank C. Brown Collection of North Carolina Folklore*), ca. 1949, pencil heightened with white on brown paper, image: 7" x 4⅞"; sheet: 11¼" x 8½". Courtesy of the Special Collections Department, Duke University Library.

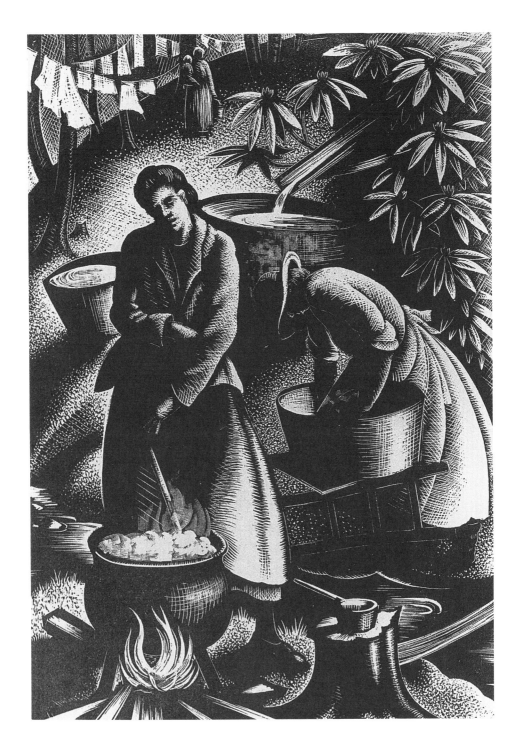

Fig. 16. Clare Leighton, "Washing Clothes," (illustration for *The Frank C. Brown Collection of North Carolina Folklore*), ca. 1951, wood engraving, 7" x 4^{15}⁄₁₆"; private collection.

NOTES

1. The best study on the history of the idea of Appalachia remains Henry D. Shapiro, *Appalachia on Our Mind: The Southern Mountains and Mountaineers in the American Consciousness, 1870–1920* (Chapel Hill, N.C.: The University of North Carolina Press, 1978).

2. Mrs. Jacque Busbee, "North Carolina through the Camera," *The North Carolina Teacher*, 9 (October 1932): 56, 77.

3. Herbert O'Keef, "Fifty Years with a Camera," (Raleigh) *News and Observer*, July 8, 1951.

4. W. T. Couch to Muriel Early Sheppard, September 23, 1934, *Cabins in the Laurel* file, University of North Carolina Press, as cited by Charles Alan Watkins, "Merchandizing the Mountaineer: Photography, the Great Depression and *Cabins in the Laurel*," *Appalachian Journal*, 12 (Spring 1985): 215–38. Watkins provides a more extensive discussion of the working relationship of Couch, Sheppard, and Wootten regarding *Cabins*.

5. Muriel Early Sheppard to Couch, "Fri A M" (1934) and "Secretary to Director" to Sheppard, December 27, 1934, *Cabins file*, UNC Press, as cited in Watkins, "Merchanizing the Mountaineer."

6. Olive Tilford Dargan, *From My Highest Hill* (Philadelphia and New York: J. B. Lippincott Co., 1941). Dargan (1869–1968), a Kentucky-born poet, novelist, and playwright, lived periodically in New York and Europe as well as maintaining a home in Asheville.

7. "Mrs. Dargan's New Book Based on Social Theme," *Asheville City Times*, July 4, 1935; "Mrs. Dargan's New Book Is Placed on Sale in Asheville," *Asheville Times*, August 15, 1941.

8. Dargan, *From My Highest Hill*, pp. 14–15.

9. Ibid., p. 167.

10. L. B. Hill, *Springfield Republican*, October 19, 1941, p. 7e. The contrast here may be with photographs showing destitute individuals and families taken for the Farm Securities Administration, such as Dorothea Lange's, which were published occasionally in newspaper and popular magazine articles.

11. Minnie McIver Brown, "It Was Hard Road, but North Carolina Woman Now an Artist in Photography," *Greensboro Daily News*, August 1, 1926.

12. Frederick H. Koch, ed., *Carolina Folk-Plays* (New York: Henry Holt and Co., 1941): xiv.

13. Bill Rhodes Weaver, "Pictures Tell Story of North Carolina Artistry from Coastal Sand Dunes to Mountain Clouds," *Greensboro Daily News*, April 25, 1948.

14. Wootten was a member of the Theosophical Society. Interview with her niece, Celia Eudy, Kinston, N.C., July 1989.

15. Weaver, *Greensboro Daily News*, April 25, 1948; Brown, *Greensboro Daily News*, August 1, 1926. Clarke (1827–1886), Wootten's maternal grandmother, was a highly regarded poet and editor.

16. John Taylor Arms to Clare Leighton, March 18, 1949, Clare Leighton Papers, microfilmed by Archives of American Art, Smithsonian Institution, Washington, D.C., owned by the estate of Clare Leighton.

17. Eric Gill, "Introduction to Second Edition," in R. John Beedham, *Wood Engraving* (London: Faber and Faber, 1925), pp. 7–12.

18. Clare Leighton, *Country Matters* (New York: Macmillan Co., 1937), pp. xiii–xiv.

19. H. S. Latham to Clare Leighton, December 12, 1939, Clare Leighton Papers; Clare Leighton to Harold Latham, July 13, 1940, and H. S. Latham to Miss Greve, July 17, 1940, from Macmillan "Letters from Prominent Persons" Series (Box 129) of the Macmillan Company Records, Rare Books and Manuscripts Division, The New York Public Library, Astor, Lenox and Tilden Foundations.

20. Clare Leighton, *Southern Harvest* (New York: Macmillan Co., 1942), p. v.

21. H. L. Mencken, "The Sahara of the Bozart," in *Prejudices, Second Series* (New York: Alfred A. Knopf, 1920), pp. 136–54.

22. Clare Leighton to H. L. Mencken, February 13, 1939, undated letter (February 1939), H. L. Mencken Papers, Rare Books and Manuscripts Division, The New York Public Library, Astor, Lenox and Tilden Foundations.

23. Clare Leighton, "English Artist Finds Life Stimulating in Tarheelia," (Raleigh) *News and Observer*, March 30, 1947.

24. The Leighton illustrations for this paper are reproduced from engravings she pulled from the wood blocks used to illustrate the books.

25. Leighton, *Southern Harvest*, pp. 12–19.

26. Ibid., p. 86.

27. Ibid., pp. 88–92.

28. Ibid., pp. 105–6. A gifted poet, idolized by the entire Leighton family, Roland was killed in France in 1915 at age twenty-one.

29. Ibid., pp. 108–9.

30. Diary entry for July 19, 1944, in Charles A. Fecher, ed., *The Diary of H. L. Mencken* (New York: Alfred A. Knopf, 1989), pp. 325–26.

31. Leighton, *Southern Harvest*, pp. 110–12.

32. Ibid., p. 121.

33. Leighton, "English Artist . . . ," (Raleigh) *News and Observer*, March 30, 1947.

34. Harold Latham to Clare Leighton, August 28, 1942, Clare Leighton Papers.

35. Katherine Woods, *The New York Times*, December 20, 1942, p. 5; R. Y. Williams, *Books*, December 20, 1942, p. 3.

36. Paul Green, dust jacket essay for *Southern Harvest*. Green, a classmate of Thomas Wolfe, was a student of and successor to folk dramatist Frederick Koch at the University.

37. Leighton, "English Artist . . . ," (Raleigh) *News and Observer*, March 30, 1947.

38. Clare Leighton to Paul Green, January 31, 1942, Paul Green Papers, Southern Historical Collection, University of North Carolina, Chapel Hill.

39. Clare Leighton to Paul Green, "Monday" (1942), Green Papers, Southern Historical Collection, University of North Carolina, Chapel Hill.

40. *The Frank C. Brown Collection of North Carolina Folklore*, 7 vols. (Durham, N.C.: Duke University Press, 1952–1964).

41. Newman I. White, "The Frank C. Brown Collection of Folklore: Its Organization, Classification, and Publication," speech given to the General Literature Group of the Modern Language Association, New York, December 28, 1944, in Frank Clyde Brown Papers, Manuscripts Department, Duke University Library, Durham, N.C.

42. "Tentative Rearrangement of Brown Folk-Lore Collection According to Volumes and Editors, August 18, 1944," General Editors' Papers, Brown Papers.

43. Newman White to Clare Leighton, September 8, 1945, and project memorandum, 1948, p. 42, General Editors' Papers, Brown Papers.

44. Clare Leighton to Charles Mills, "Tuesday" (1946 or 1947), Charles Mills Papers, Southern Historical Collection, University of North Carolina, Chapel Hill.

45. Gene Miller, "Writer Declares America Land of Art Opportunity," *Greensboro Daily News,* June 13, 1948.

46. Clare Leighton to Margaret and Charles Mills, October 31, 1950, Charles Mills Papers, Southern Historical Collection, University of North Carolina, Chapel Hill.